CHARLES JAMES

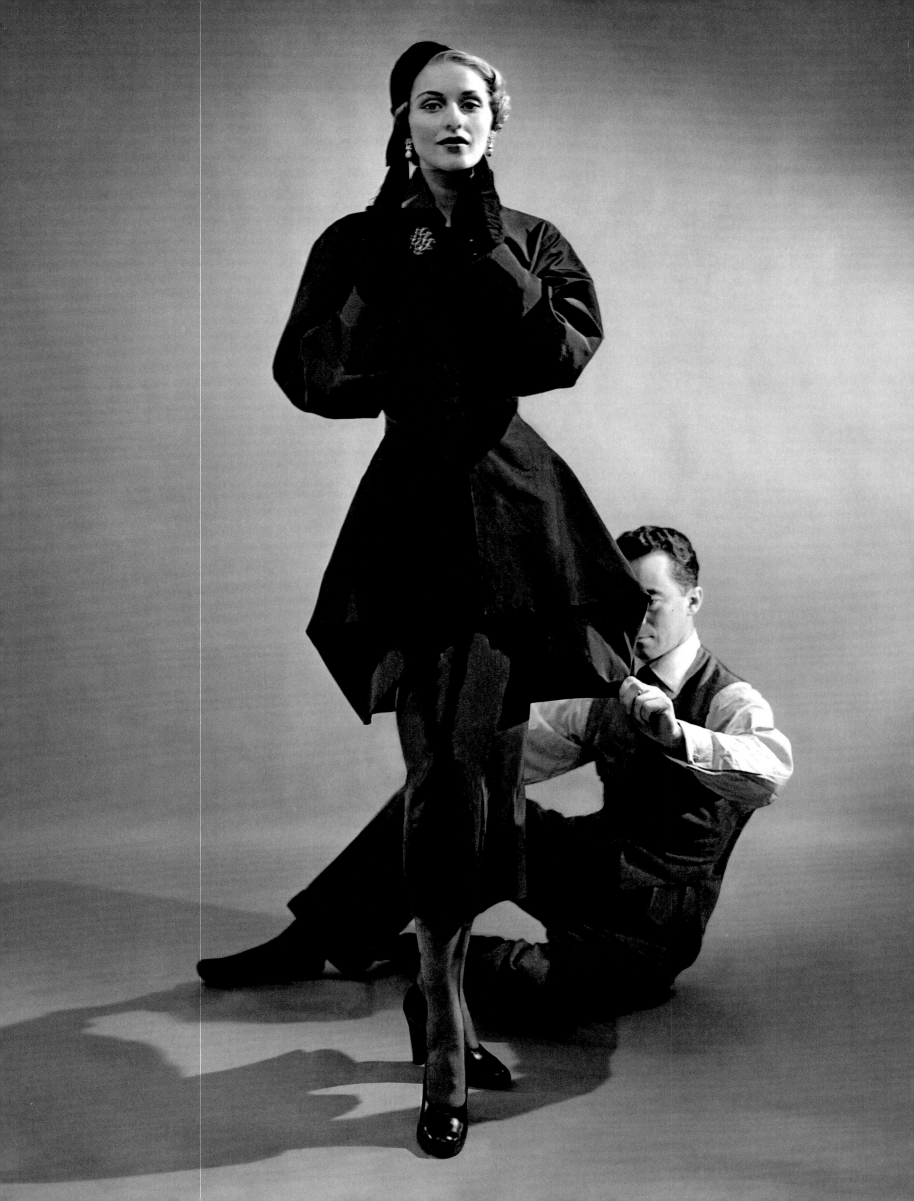

HAROLD KODA AND
JAN GLIER REEDER

CONTRIBUTIONS BY
SARAH SCATURRO AND
GLENN PETERSEN

FOREWORD BY
RALPH RUCCI

Beyond Fashion

THE METROPOLITAN
MUSEUM OF ART,
NEW YORK

DISTRIBUTED BY
YALE UNIVERSITY PRESS,
NEW HAVEN AND LONDON

CONTENTS

SPONSOR'S STATEMENT

AERIN is honored to sponsor The Costume Institute's exhibition "Charles James: Beyond Fashion," the inaugural show in the new Anna Wintour Costume Center at The Metropolitan Museum of Art. The exhibition celebrates legendary couturier Charles James, whose revolutionary approach to fashion had an astounding and lasting impact on design.

As a lifestyle brand, AERIN is classic but always with a modern point of view. Much like the work of Charles James, every AERIN piece has a timeless elegance, and the collection is curated to make life more beautiful, with a sense of ease and refinement.

The sponsorship of this exhibition represents AERIN's unwavering commitment to supporting the arts. The Costume Institute has long been a great New York treasure and a tremendous source of inspiration, and I cannot think of a better exhibition to coincide with its reopening than a retrospective of such a singular American designer. I have great respect for the work of Mr. James and Harold Koda and The Costume Institute team and am excited to see them come together in the new galleries.

Aerin Lauder, founder, AERIN

DIRECTOR'S FOREWORD

The 2009 transfer of the Brooklyn Museum's costume collection to the Met's Costume Institute created an unrivaled representation of the work of the Anglo-American designer Charles James. During his life James directed clients to donate their best examples of his designs to the Brooklyn Museum, intending to create a working collection to inspire students of fashion. Since coming to the Met, this unsurpassed collection has been enhanced by a number of significant acquisitions, including rare pre–World War II pieces and James's archives of sketches, notes, photographs, and other ephemera. The archives were donated in 2013 by Homer Layne, James's last studio assistant. That trove forms the basis of this catalogue and exhibition.

Although James never gave up his British passport, he settled in New York and is considered the only true American couturier. An artist whose métier was fashion, James is a fitting subject for the inaugural exhibition in The Costume Institute's reconfigured galleries. The new Lizzie and Jonathan Tisch Gallery is an open-plan "black box," with technical infrastructure that maximizes spatial flexibility and encourages the presentation and interpretation of costume in ways precluded by the previous fixed vitrine design. The Tisches' vision in supporting this space will allow us to show more of The Costume Institute's superb collection throughout the year. We are extremely grateful to Lizzie and Jon for their generosity, and to Howard and Janet Kagan, the Samuel I. Newhouse Foundation, Inc., and Carl and Iris Barrel Apfel for additional support.

The renovation of The Costume Institute complex, to be unveiled in May as the Anna Wintour Costume Center, was part of a comprehensive project that addressed the department's expanded staffing and programmatic needs. Among the most important updates were state-of-the-art analysis, treatment, and storage facilities, the need for which was underscored by the conservation and installation of the fragile James designs. The transformation of the physical plant was made possible by the extraordinary support of The Costume Institute's exceptional advocate, Anna Wintour, who raised the necessary funds during her tenure as Chair of The Costume Institute Benefit. It is an apt tribute that the space in which the department's work is conserved, stored, and shared with the public be named in her honor. We also extend our thanks to AERIN and Condé Nast for their invaluable contributions to this celebratory exhibition.

James will be a revelation to the public unfamiliar with his work; for his fans, the opportunity to pore over his magnificent creations will only burnish his reputation; and for scholars, the information gleaned from the James archives will provide fascinating insights into a singular man and a visionary designer.

Thomas P. Campbell,

Thomas P. Campbell
Director, The Metropolitan Museum of Art

AN APPRECIATION OF CHARLES JAMES

Not only the greatest American couturier, but the world's best.
Cristóbal Balenciaga

The greatest talent of my generation.
Christian Dior

A single James creation is worth the whole output of a 7th Avenue year's work.
James Galanos

The praise from Balenciaga, Dior, and Galanos—deities of twentieth-century fashion design— beckons you into the extraordinary realm of Charles James, where vision and proportion take precedence over artifice and trend. What you will see in these pages and in the exhibition galleries are not merely clothes, or "shapes," as James would call them: They are three-dimensional sculptures that come alive once on a woman's body, because James was ever mindful of the woman wearing the shape. He was *the* couturier.

Charles James had nothing to do with fashion. Rather, he applied himself to the rigors of mathematics in the creation of fashion. He moved forward as a designer with an obsession for perfection. His mind was fixed upon this ideal, which usually prevented him from seeing his accomplishments. When he could not find a toile solution for a fully realized sketch, he would build a model of the coat, dress, or gown. He would then cut a toile from this three-dimensional sculpture to test the balance, beauty, and fit. In doing so, James created not only timelessness in his shapes but also items that became touchstones in history. At one point he went so far as to build a flexible model, made of foam rubber with metal templates and, in the center, a movable rod, to study the effects of movement and stress on a shape. Extraordinary.

James never created in a void: He made every shape for an individual client. He believed that his dialogue with the client was vital, because each shape attained its own identity and individuality from that woman's personal style, whether she was Gypsy Rose Lee or Elsa Peretti. In the process, each object in his body of work—which is said to amount to perhaps two hundred designs—became iconic and shockingly of the future, without ever appearing too modern for the moment. Nothing else looked like these designs before or has since. To mention only a few of significance: the Figure-Eight skirt, whose fabric curled between the legs to form the number eight, visible only from beneath; the prophetic eiderdown-filled quilted white satin jacket, an incredible feat of biomorphic contouring with respect to the body and a harbinger of the modern-day quilted ski parka; the Taxi dress, blouse, and skirt, which a woman was able to wrap herself into with ease, even in a cab. The year 1929 saw the beginning of his evolution of the masterful bias one-seam dress, where the seam was constructed on the straight grain, causing the fabric to

hit the body in undulating softness, like waves. Unlike Madeleine Vionnet's bias tubes, which had a more feminine fluidity bespeaking the 1920s, James's tube had the rigor of tailoring beneath its bias control. Later he set zippers into the dress so that it opened from the shoulder to the hem.

James had an incredible color sense, contrasting calm and discordant combinations—celadon greens and misty blues with chestnut, puce and rose with black, and sang de boeuf in a *dégradé*. He was enamored with molding clothes using darts and seams at will to arrive at the conclusion of a design. This dart displacement reached its apotheosis in the awe-inspiring Baby Cape coat—a cocoon, in fact, but—with its darts and certain areas on the bias on the side of the body—one that revealed a sensuous, body-conscious shape. He displaced the waist, higher in back and lower in front, allowing different body types to fit into the shape and elongating the body, especially in side view. But his personal favorite and greatest feat of engineering was the Clover Leaf dress in white satin and black velvet. The dress weighed ten pounds but, with the skirt suspended from the bodice's waist, felt perfectly weightless. Layers of taffeta lining, bias canvas, and interlinings were molded together in both the boned bodice and the four-quadrant skirt. It is essential to remember that all the elements were set in by hand; the master's orchestration inside of the dress is mind-boggling. He attained perfection with the shape, and he did allow himself the knowledge and pride to feel this. Emotion.

The genius of certain artists and thinkers moves our civilization forward. Iconoclasts like Leonardo, Palladio, Plato, Balthus, Twombly, and Tennessee Williams are "walk-ins," people seemingly not of their own time and place who are here to teach the rest of us. They bring us to a higher consciousness, an understanding of the divine, and an appreciation of art and of the capacity of the human hand. Charles James is one of them. His name alone stands for a standard of perfection. His life was one of uncompromised determination to find what he was meant to leave with us, like one of the ancients who toiled in the dark, carving mysteries in hieroglyphics for later generations to discover. I am honored and humbled to attempt to participate in his métier. Enjoy this magnificent examination of his work with fresh eyes and a heart willing to be seduced.

Ralph Rucci

INTRODUCTION

Charles James is among the handful of fashion designers who can be said to have transformed his métier. The creator of works of sculptural bravura and sophisticated palette, he is revered as one of the most significant couturiers of the twentieth century by fashion students, designers, and historians. James is, however, largely unknown to the wider public. In fashion, legacy is almost always associated with commercial viability and longevity. Rare exceptions occur, but in a field driven by the accelerated cycle of the next season, even the most important couturiers—Paul Poiret, Madeleine Vionnet, Jean Patou—fall into obscurity, their names resonant decades later to only a relative few.

In his lifetime, James was among the most lauded designers, despite his constrained output and relatively limited commercial exposure. Christian Dior reputedly cited him as the inspiration for his transformative "New Look" collection, and Cristóbal Balenciaga, the éminence grise of midcentury haute couture, noted that he was not simply the greatest couturier in America but, in fact, in the world. The James client list, even from the beginning of his career as a milliner in Chicago, comprised the gratin of society, women of great confidence, substantial financial resources, and, most important, distinctive personal style.

During the 1950s, an especially fecund period for the designer, he began to reap the acknowledgment of the American fashion establishment in the form of the industry's most prestigious awards. Typical of the irascible James, he ultimately returned a number of them after various quarrels, but the awards are evidence of his stature at the time. His renown extended far beyond his colleagues and the privileged circles of his exclusive clientele, and might even appear outsize considering the circumscribed dissemination of his work. But everyone exposed to his craft, even those who found James's relentless and strident advocacy of originality in American design to be more than a little trying, believed he was a singular and inspired artist whose creative gifts deserved the highest recognition and acclaim.

His work is perhaps best remembered through the iconic 1948 photograph by his friend Cecil Beaton, which graces the cover of this book. Eight beauties in sumptuous gowns are surrounded by mirrors and boiserie, some arrayed on eighteenth-century chairs, as if in a retiring room for ladies at a ball. The elegance and glamour of the women in their James dresses epitomize the postwar return of a sophisticated feminine allure. Beaton's image captures the magic of the designer's work but also encapsulates a high point of James's aesthetic evolution and technical virtuosity.

Still, to know only James's postwar evening dresses is to overlook the creative achievements of almost half a century. James the artist was sui generis, and one for whom a compelling idea or innovation could be subject to a lifetime of revision and refinement. His extraordinary accomplishment can be accurately represented only by a survey of his whole career, since a technique from his early days in millinery might emerge in the neckline of a

supple gown from the 1930s or take architectonic form in the skirt of a ball gown from the 1950s. Like the artist Albert Pinkham Ryder, who retained and repainted works over decades, James considered even the most resolved idea to be poised in a penultimate state. For him perfection was a transitive condition that always could be transfigured and enhanced. He was an audacious visionary in fashion design—pioneering garments like the wrap dress and eiderdown jacket, which eventually became ubiquitous—as well as in business practice, introducing concepts such as branding and authorizing copies of his designs, which became mainstream decades later.

James himself never doubted his own stature as an artist and always deemed appropriate the placement of his work in the context of the fine arts. Unlike most of his peers, he believed that his research into and development of new approaches to the creation of a garment were worthy of preservation and study. He began as early as the 1940s to encourage his clients, some of the most stylish women in the world, to donate their James designs to the Brooklyn Museum. In most instances the dresses, suits, or gowns were couture items he had created expressly for the client. Some donors also gave patterns and muslins, so the museum could document the process of creation, and others provided funds for specific James acquisitions.

The Brooklyn Museum's cache of garments, dress forms, sculptures, sketches, patterns, and ephemera associated with James's creative process was transferred to The Metropolitan Museum of Art's Costume Institute in 2009. In 2013 the last group of materials that James had retained at the time of his death was donated to the Museum. The merging of these two archives provided the unprecedented opportunity to reexamine the designer's life and work.

James by all reports could be charming, if mercurial, and, while detailed in his recollections, self-mythologizing. His own accounting of his history and creative output has been vexing for the inconsistencies and contradictions any scrutiny exposed. However, with the consolidation of this trove of photographs, correspondence, official papers and notes, and the many news clippings he retained, a reasonable, if not comprehensive, reevaluation of his personal and professional biography is possible. From the confusion, often the result of the designer's own anecdotal elaborations, a relatively secure timeline has been teased out and synthesized. In addition, the opportunity to study and analyze designs he had retained and never given to the Brooklyn Museum provides a more complete sampling of his creative evolution and output than before.

"Metamorphology" is a James idée fixe, his notion that constancy resides within change. Given his life's drama—characterized by constant shifts of fortune and perpetual reinvention—the recurring yet mutable themes in his designs, and the transformative qualities of his work, it seemed an appropriate title for this book's biographical component. "The Calculus of Fashion," the title of a curriculum James developed to train students in the artisanship of fashion design, here designates the book's in-depth look at his dresses, suits, coats, and evening dresses, with a focus on his technical and structural innovations. This section makes clear that much of James's brilliance and invention reside in his patternmaking; to read the seaming of a James work is to veer off conventional pathways into uncharted territories.

While a James design might suggest the delicate finesse of the couture workroom, the designer himself approached the manipulation of cloth robustly. He was, from his millinery

experience, inclined to pull, contort, and deform materials to submit to his will. He was also cavalier in his juxtaposition of materials, placing delicate chiffons against featherbone-stiffened satin, silk velvet over coarse canvas, or silk faille on acidic Pellon. Like a New York School Abstract Expressionist, he deployed materials for immediate effect with little or no consideration of the future. Willful and impetuous in his pursuit of perfection, he pushed fabrics to their extreme, which has sometimes resulted in an intrinsic physical deterioration of the garments. "Inherent Vice" is an introduction to the challenges the Museum confronts in conserving and preserving his work.

In 1982, on the opening night of "The Genius of Charles James" at the Brooklyn Museum, a small number of original James gowns were presented to the assembled guests. Earlier, during rehearsals for the *défilé*, Elizabeth Ann Coleman, the exhibition's curator, asked a teenage model—small enough to fit into one of the dresses—what it felt like to wear a sculptural masterwork. "It's a lesson in beauty," the girl replied. "The dress is teaching me how to stand, and how to walk."[1] A lesson in beauty is how the designer himself might have characterized any serious scrutiny of his work.

This book and the exhibition it accompanies attempt to reestablish the stature of this singular artist and to revisit the details of his life with the belief that the work and the man, stripped of years of accrued anecdote and myth, emerge fresher and more astonishingly original than ever. James's genius is fascinating to explore; he was a man at once intuitive and calculating, analytical and emotional, doggedly consistent and spontaneous, obsessive and discursive. Charles James resists any simplistic reading, but an attentive survey of his life and work exposes the rich complexity of the creative mind and process.

Harold Koda

JAN GLIER REEDER

METAMORPHOLOGY

*The Personal and
Professional Life of
Charles James*

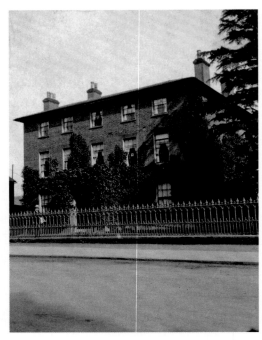

fig. 1. Agincourt House, James's birthplace and one of the grander homes in Camberley, England, was among his maternal grandparents' wedding gifts to his parents.

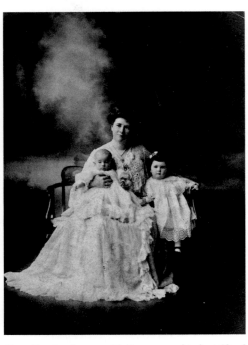

fig. 2. Louise James with Frances and infant Charles, late 1906

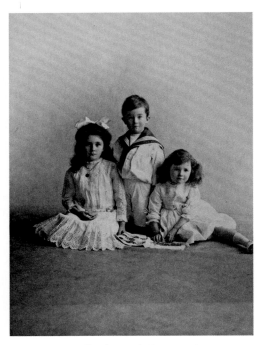

fig. 3. Frances, Charles, and Margaret James, impeccably dressed, ca. 1910. Charles wears a sailor suit with middy blouse, de rigueur fashion for upper-class boys.

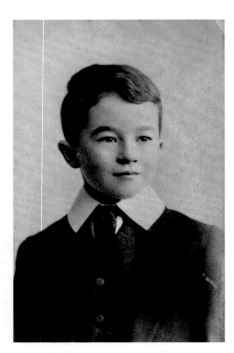

fig. 4. Charles as a young schoolboy, ca. 1914

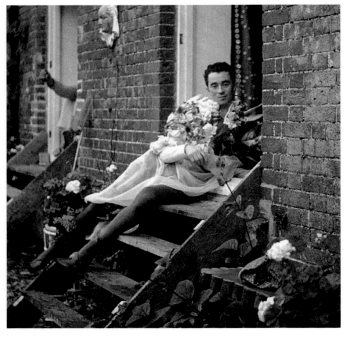

fig. 5. James dressed as Puck in a spontaneous photograph by his schoolmate Cecil Beaton

This chronology of Charles James's life and work is presented in timeline format with sourced references to lend clarity to a complex biography. Sources used in its preparation include articles published over the span of his career, school records, several museum archives, and posthumous publications, notably Elizabeth Ann Coleman's seminal work The Genius of Charles James *(1982). Another essential resource was the Charles James archives that were donated to The Metropolitan Museum of Art in 2013.*

Those archives include the audiotapes, letters, biographical manuscripts, project proposals, and scrapbooks with which James avidly documented his life and work, primarily after retiring from design. While incalculably valuable, the material is riddled with inaccuracies; James relished embellishing stories to suit his audience, and information he recorded in hindsight often proves at odds with contemporaneous documentation. This chronology seeks to present as accurate a record as possible, with independent corroboration of the facts whenever available. Future exploration of the Met's James archives will yield much more about this multifaceted designer and captivating personality.

The Early Years, 1906–25

1906 Charles Wilson Brega James is born into a life of privilege on July 18 at Agincourt House, the family's grand residence in Camberley, Surrey, England, thirty-one miles southeast of London (fig. 1). His father, Ralph Ernest Haweis James, a captain in the British military, is soon to complete a four-year staff assignment at the nearby Royal Military College at Sandhurst. His mother, Louise Enders Brega James, is a wealthy Chicago socialite admired for her style and beauty. Their union was the result of a shipboard romance between the handsome British officer returning to England from a tour of duty in Weihaiwei, China, and the American elegante traveling with her family.

The baby Charles is named for his maternal grandfather, Charles Wilson Brega, who, having made a fortune in Chicago's maritime and real estate industries, left a substantial estate upon his death seven months earlier. Charles is the middle child. His sister Frances was born two years earlier; Margaret arrives fourteen months after Charles (figs. 2, 3).

1910–11 The James family moves to London, settling in a sixteen-room house at 6 Lower Sloane Street in the fashionable Belgravia neighborhood. Charles's maternal grandmother, herself a celebrated beauty and a French couture client, moves from Chicago to London to live with them. They later relocate to 39 Egerton Gardens, in Chelsea, with a butler and five other staff in service. The Edwardian elegance, opulence, and corseted styles surrounding the young James will later find expression in his famed post–World War II eveningwear designs.

Parental friends during James's childhood include Samuel Guinness, of the Irish merchant bank Guinness Mahon, and his wife, Alfhild. They will be generous benefactors in the early years of James's career, and Alfhild and their daughter Marit regular clients. Marit later recalls, "It was always accepted by my family that Charlie was a genius."[1]

1911–14 James begins studying piano and music composition with intensity and precocity. The training will continue through his teens. The aesthetic, structural, and theoretical aspects of music as well as the discipline required to learn it will influence his personal and professional lives. The floor of his London atelier will be scattered with the record albums he hastily selects for personal listening; his fashion shows will always be accompanied by the classical music he chooses (Bach, Ravel, Debussy, and Satie are favorites); and he will analogize musical theory to his structural theories of dressmaking.

In the fall of 1914, following the outbreak of World War I, he is sent to New Beacon School, a boarding school for upper-class boys in Seven Oaks, Kent, England, where he is enrolled throughout the war (fig. 4). His father, now a lieutenant colonel, is head of the British War Office.

1919 The family moves temporarily to Chicago for the funeral of Charles's maternal grandmother. Charles spends two terms at Lake Placid School (now Northwood School) in rural Lake Placid, New York, and the winter term at its campus in Coconut Grove, Florida. Fellow students include two boys from the Pirie retailing family of Chicago, who will later support James's design efforts. His first extended stay in the United States underpins his binational identity.

1920 Charles is enrolled in May at Harrow, Britain's elite public (college prep) school for boys, which offers a rigorous curriculum of academics, sports, and the arts. He becomes involved in the theater, painting, music composition, and poetry writing. Here he meets Cecil Beaton, who will become a celebrated photographer, costume designer, and writer and who will play an indispensable role in developing and promoting James's career.

Harrow's school newspaper records only one prize, related to theater, being awarded to James, but a review of *A Midsummer Night's Dream* states that his performance as Puck "was really good—had he varied his voice and action more he would have been great"[2] (fig. 5).

1923 James leaves Harrow in May, before his final year. His grades have plunged between his second term, when he is eighth in his form, and his third (and last) term, when he ranks twenty-fourth among twenty-seven students, suggesting he has stopped studying. He is experimenting sexually—he is openly homosexual from his late teens on—and, with fellow theater students, dressing up and wearing cosmetics. James later says "a minor escapade"[3] involving such behavior precipitated his departure. As the school has no record of an expulsion or disciplinary action, it is likely that his father withdraws him when he learns of it. (There is no evidence that Beaton—who is two years his senior and had finished his tenure at Harrow a full year before—has anything to do with James's departure.)

James's relationship with his father is fraught with emotional turmoil. His later writings allege that Ralph was physically abusive to Charles at an early age and may have arranged or abetted his sexual abuse at seventeen by someone in his military command—"to make a man of me."[4] The conflict with his father, however, would drive James to succeed: "I attempted the impossible out of a compulsion to be involved in a business of which my father disapproved."[5]

In the latter half of the year James is enrolled at the University of Bordeaux, in what his parents mean to be preparation for a university education. For six months he studies French literature and music. While he does not go on to university, his educational and social experiences in the United States, Britain, and France will facilitate his multinational career trajectory in the 1930s.

1924 Continuing his artistic pursuits, James studies oil painting for four months in Poolewe, an idyllic coastal village in the Scottish Highlands known for its breathtaking scenery. Meanwhile, his parents—in hope of providing him with a business career—use their deep social connections to arrange for family friend Samuel Insull, the legendary industrialist who pioneered the generation and distribution of electricity, to take him under his wing. James, eighteen, is packed off to Chicago, where Insull gives him a desk job in his office at Commonwealth Edison, of which he is founder and president.

Temperamentally unsuited for clerical work and undaunted by his powerful sponsor, James disrupts the office by showing off batik-dyed silks he has been making to sell as beach wraps. Insull reassigns him to the architectural department, which designs the company's industrial facilities. His stint may have lasted only a few months and did not exceed a year, but Insull's decision proves astute. James, a quick study and a prodigious intellect, learns about architectural and engineering concepts, which he later applies to dressmaking. He will identify himself as a "sartorial structural architect"[6] when he sets up business in New York in 1930, and in 1934 will explain to a reporter that "he has never forgotten what he learned [from the study of architecture] of the laws of proportion for symmetry and grace."[7]

1925 James precipitously quits Commonwealth Edison, to his parents' chagrin. He has begun making hats, along with the batik scarves, in "a temporary hide-out,"[8] as he later writes, in a friend's basement (fig. 6).

At about the same time Insull recruits Ralph James, recently retired from the military, to solve a problem regarding coal distribution. Ralph and Louise move to Chicago. By 1928 Ralph has become a vice president in one of the Insull companies and has invested heavily in Commonwealth Edison stock.

Following his son's willful departure from Commonwealth, Ralph limits Charles's access to the family money and effectively severs ties with him, with only occasional thaws, for the rest of his life. His mother remains caring and actively helpful, as do her devoted friends, members of Chicago's wealthiest industrial and merchandising families, who recognize and wish to support his talent. They will provide him with significant financial and emotional support over the coming decades, not only acquiring his creations but also funding his various ventures. His earliest benefactors include Mary Slaughter Field (Marshall Field's); the Pirie family (Carson Pirie Scott Department Stores); Harold Fowler McCormick (International Harvester), his wife, Edith Rockefeller, and their son Fowler; Ada Small Moore (Nabisco); and Mrs. Edward Ryerson (Ryerson Steel).

The great wealth and elevated social status into which James was born give him entrée to the elite social circles from which his clientele

will come. They are also the source of his lifelong desire for and sense of entitlement to the costliest things, regardless of his personal resources. Choosing to live in the finest hotels, lease work space in the most prestigious neighborhoods, and spend lavishly on parties, flowers, and luxuries such as room service, he will always live far beyond his means, with a remarkable disregard for the consequences. The fervor with which he pursues life "at Caviar level"[9] suggests a deep-seated rebellion against constraints of any kind.

Early Design Career, 1926–39

1926 Using money advanced to him against a small inheritance from his godfather, John T. Pirie, James establishes a millinery business that will have three different locations over the next two years, primarily on Chicago's Oak Street, known for its exclusive boutique shopping. He resides on nearby North State Street. As his father forbids him to associate the family name with what he considers an unbefitting trade, he calls his new business Boucheron, imbuing it with an aura of French chic and refinement. Ralph James prohibits his wife and daughters from patronizing the business, but his mother's friends and their associates are willing customers. The actress Helen Hayes and dancer Irene Castle are among those outside the Chicago social circle who will wear his early designs.

James creates both broad-brimmed and skull-hugging hats in unconventional, asymmetrical forms using straw or felt. Approaching his work as a sculptor, he frequently cuts and shapes the material directly on his clients' heads, customizing the fit of the crown and the shape of the brim to complement their features (fig. 7). He will approach dressmaking in the same manner, cutting and pinning muslins directly on the body rather than starting with a pattern.

How he learned the intricate skills of millinery, then largely a working-class woman's field, is shrouded in the mist of time and James's self-mythologizing. A plausible scenario patched together from his various versions is that he was inspired to pursue millinery by the aristocrat George William Frederick FitzGeorge, who himself escaped a difficult family situation through hat making, and that he was introduced to the idea of shaping hats directly on heads at a shop in Paris called Clin-Clin, perhaps when he was studying in France. "Learning how to mold a felt 'body' to the head, steam it to shape and place at the most flattering angle a shaped brim, I set out to do the same thing, but in my own way," he later writes.[10] Further millinery training may have come from someone in Chicago, possibly a Madame de Launay, whose label is in two extant hats attributed to James.

1927 While James is decidedly a renegade, he continues to participate in his parents' social world. He serves as an escort at debutante balls until his flamboyant behavior becomes too outlandish for such formal affairs. He also frequents Chicago's famed South Side jazz clubs.

At some point in the year, anguished over an unrequited love, he makes a melodramatic suicide attempt by inhaling ether from a handkerchief, staged in a mirrored and candlelit room.[11] Racked by the pain in his nose, he screams and is taken to St. Luke's Hospital, which his grandfather and namesake had funded.

fig. 6. James captured by a Chicago photographer at age eighteen, about the time he leaves Commonwealth Edison

fig. 7. James styles a hat on a model's head in New York or London, 1930.

fig. 8. Stephen Tennant in Palermo, Sicily, in 1929, wearing satin beach pajamas by James

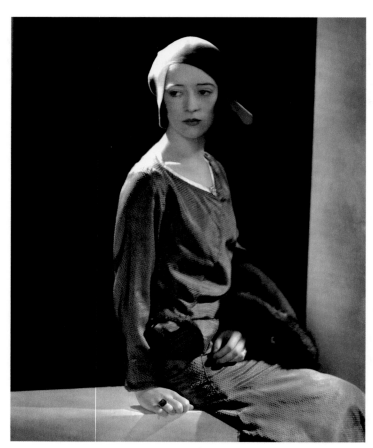

fig. 9. James's dotted red silk afternoon dress and red felt hat with folded "ear" are sold through Laurina, Inc., under the label Boucheron of London, in 1930.

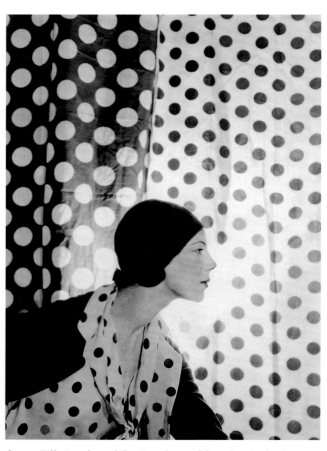

fig. 10. Tilly Losch models a Boucheron felt turban in the first Beaton-James fashion photo shoot, 1930.

1928 Early in the year he takes up residence in the new and prestigious Hotel Ambassador. He will reside largely in hotels, always the most exclusive, for the rest of his life.

In the summer he leaves Chicago behind for the broader social and commercial horizons of New York City, traveling "in a secondhand Pierce Arrow roadster, with its rumble seat packed with hats of his creation."[12] Arriving virtually penniless at the chic Long Island town of Southampton, he spends his last few cents with devil-may-care bravado on a manicure, then charms the manicurist into modeling his hats along the beach. He also serves as a model himself: Diana Vreeland, the future editor of *Vogue,* later recollects seeing him running "up and down the Southampton Beach in beautiful robes showing his millinery on his head."[13] James will frequently rely on himself as his own best model in the years to come.

Within a few months James sublets a space from the socialite Mercedes de Acosta on the second floor of a former nineteenth-century stable at 125 East Fortieth Street, in New York's Murray Hill. His landlord is the playwright and composer Noël Coward. Using what will become his signature mix of elegant and earthy elements, James decorates with unpainted barrels filled with flowers, a crystal chandelier, and deep saturated colors, in this case indigo blue and bright yellow, offset with stark white.

Cecil Beaton, who is now prominent in London's art and theater worlds and has a writing contract with *Vogue,* arrives in New York six weeks after James. Over the next six months Beaton introduces him to Jazz Age high society and to women who will be among his early New York clients: Tilly Losch, the Austrian-born musical theater and ballet dancer; Rosamond Pinchot, the American actress, known for her statuesque beauty; and Gertrude Lawrence, the hugely popular English singer, dancer, and actress. Beaton will mention Pinchot and Lawrence wearing Boucheron items in his March and May 1929 *Vogue* society columns.

For those and other clients James designs hats and custom dresses, from sportswear to eveningwear, under the Boucheron brand. His process, which will continue through the 1930s with increasing variations, is to create a collection of ten to twenty garments, sometimes based on a certain fabric or a particular design challenge; clients could either buy the examples directly or order them for custom fitting by James. He also accepts clients' commissions. Gertrude Lawrence commissions a sporting outfit and becomes one of many subsequent clients who will help him out by paying for it in advance.

1929 American *Vogue* publishes the first fashion reportage on James, with a sketch of a Boucheron asymmetrical slate blue felt hat. Beaton probably initiated the coverage.

James makes a number of important contacts this year, among them Mary Lewis, buyer for Best & Co., the first department store to promote and carry Charles James designs. Lewis is an early champion of his career and will orchestrate his first commercial press a year later. He also meets Mrs. Oliver Burr Jennings Jr., née Isabel de Rivas, the Paris-born Venezuelan coffee heiress known for her exotic good looks, who is married to the grandson of the former director of Standard Oil. Jennings will be one of the few early clients who continue to patronize James after World War II.

James returns to London in the summer after an absence of five years. He is beginning a four-year period of shuttling between London, Paris, and New York—straddling the markets and continents as he strives to establish his reputation. He makes his first London collection of garments and designs the clothes for his sister Frances's wedding, held October 19. Though their father is in attendance, Charles gives away the bride.

Ten days later the U.S. stock market crashes, and Samuel Insull's business empire implodes. Ralph James will lose much of his wife's fortune when Commonwealth Edison goes bankrupt in the early 1930s. He remains employed in the utilities business in Chicago, however, and by 1949 will be president of Chicago District Power and Light Company.

Late in the year James designs an androgynous wardrobe for British aristocrat and cultural avatar Stephen Tennant, a friend of Beaton's. It includes satin beach pajamas (fig. 8) and what Tennant calls "the stunningest fancy-dress [outfit]—black trousers that seem glued to every fissure & ripple of thigh & bottom & an ineffably limp shirt of creamy satin like ultra, ultra Devonshire cream mixed with mother-of-pearl."[14]

1930 James returns to New York. He sells custom dresses and hats through Laurina, Inc., a millinery and perfume shop on the third floor of 35 East Fifty-Seventh Street (fig. 9). It is owned by Princess Laura Rospigliosi (formerly Stallo), a Standard Oil heiress from Cincinnati.

On February 16 James scores what is probably the first advertisement featuring his work when Best & Co. promotes nine "slightly wicked" Boucheron hats in a full-page spread of *The New York Times.* The ad describes James as "erratic, picturesque, amusing . . . [with] the rare spark of genius and the talent for expressing the spirit of his times."[15] In an unusual arrangement for high-level custom designers at the time, James authorizes Best's to sell store copies of his hat designs ($17.50) in addition to his originals ($35— equivalent to about $500 today). The tension between authorized copying and design piracy will plague James throughout his career.

In its May 10 edition American *Vogue* publishes what is the first Beaton-James photographic collaboration, a two-page spread featuring Tilly Losch and socialite Marianne Van Rensselaer wearing Boucheron hats with French designer fashions (fig. 10).

Press coverage in the British and American editions of *Vogue* and *Harper's Bazaar* will be intermittent throughout the 1930s, tending to appear on whichever side of the Atlantic James is on at the time, the result of his promotional hustle. James's voice will echo through most reportage about him throughout his career. At this point the coverage is an eclectic mix of straight fashion editorials (the majority of which involve Beaton), advertisements for retail firms, and promotions for textile and other manufacturers with whom James collaborates.

James returns to London in June. He will remain in Europe for the next three years.

In the depths of the Great Depression, with money he has earned in his New York shop he establishes his first London salon in Mayfair, the city's toniest commercial district, at 1 Bruton Street.

1931 On March 23 James files for bankruptcy, the first of numerous business collapses. With characteristic insouciance and joie de vivre, he throws a party to commemorate the event.

Soon afterward, he is introduced to the designer Elsa Schiaparelli through Beaton and the designer Princess Dilkusha de Rohan. According to the princess's memoirs, the unceremonious meeting occurs as the bailiffs are removing the contents of James's atelier. The four load up a car with left-behind items, including sewing machines and lamps, before heading to tea.[16] Schiaparelli and James will have parallel careers in London from 1933, when she opens a branch and establishes a residence there. Among their shared business and design practices are an iconoclastic approach to dressmaking, use of Surrealist notions, experimentation with novel techniques and materials, and active involvement with the American fashion industry.

After his shop closes James continues to develop new design ideas and build his clientele, living and working in smaller quarters and showing his collections in spaces lent by friends, including Beaton and Beaton's friend the set designer Oliver Messel.

1932 James—who until now has been largely self-taught— purportedly spends time in Paris, informally learning couture methods and absorbing French aesthetics.[17] He also makes time to design the wedding party clothes for his sister Margaret's July marriage.

By this time James has given up the Boucheron label and is designing under his own name. His primary design focus in this period (1930–34) is on creating a more accurate fit and flattering line by rethinking dressmaking conventions regarding the placement of seams, darts, and the grain of the fabric. He does away with symmetrically placed darts at the bust or the hip, instead using darts wherever needed to create the fit he desires; moves side seams further to the front or the back (which he terms the "false profile") or eliminates them altogether; and uses the semi-bias—manipulating the placement of the fabric's grain—to invent unprecedented cuts.

This unorthodox approach frees James to wrap, spiral, and mold fabric around the body, the first of his groundbreaking techniques. James will return throughout his career to spiraling and wrapping in various iterations; each original technique (or thesis, as he calls it) he develops will become part of his ongoing design repertoire.

In 1931–32 he executes his first spiral design, a simple wrap dress that winds around the body from left to right, fastening with clasps at the right hip—a revolutionary idea when shapeless, tubular flapper dresses had been the mode for a decade. James had conceived the design in 1929, during his first trip to New York; inspired by the city's pace, he dubbed it the Taxi dress because it is constructed so simply that it can be put on (or removed) in a cab (fig. 11; see p. 65). It foreshadows the many versions of wrap dresses that would follow decades later.

One of the first women to own the Taxi dress is Mrs. St. John (Mary Barnes) Hutchinson, who describes it to her friend the writer Virginia Woolf as "symmetrical, diabolical and geometrically perfect."[18]

Other such designs James creates at about this time are a sheath dress with an integral shoulder scarf constructed of two pieces of fabric spiraled around the body (see p. 80); the "wear-as-you-will"

dress, which has a loosely constructed bodice the wearer wraps at the waist and ties in the back for an individual fit; and a soft suit in which the spiral technique is isolated to the sleeves.

During this fertile period he also begins experimenting with classically inspired but unconventionally placed draping in skirts and sleeves, including a soft suit with a knee-length cutaway jacket draped in a pouch at back (see p. 92) and an evening gown with side hip drapery, antithetical to the prevailing streamlined silhouette (see p. 103).

1933 In February James goes to Paris to show his latest work to the American manufacturers and retailers, including Marshall Field's, who are in town to view the couture collections. It is a brazen step for James, a self-created London couturier, not only to invade the bastions of the French couture but also to sell originals he authorizes for copying—a practice the couture establishment then abhorred but would come to embrace by the 1950s.

The presentation of his collection garners James's first reportage from *Women's Wear Daily,* the American fashion trade newspaper. The dispatch from *WWD*'s Paris bureau, headlined "Charles James, a Former Architect, Uses Structural Idea in Designing—Exponent of Erotic Theory of Fashion, Shows Collection in Paris After Varied Career Here and Abroad," explicates the twenty-six-year-old's design intentions, techniques, and philosophies about dressmaking.[19] Noting that increased exercise had toned the modern woman's body and made her posture and movement more athletic, James explains that he seeks to develop new dressmaking techniques to flatter the figure and provide what the writer calls the "Erotical It." Gertrude Lawrence later confirms the sensuality of James's early clothes—"the most respectable I've ever bought, though they're utterly indecent"[20]—and the mother of sixteen-year-old Marit Guinness forbids her from wearing James's designs because of their immodesty.

Throughout his life James is at the cutting edge, not only in terms of his design but also in his embrace of new technology and fabrics. He is among the first to use the metal zip fastener, collaborating with Lightning Fasteners Ltd., its British manufacturer, to create a version of his Taxi dress with a spiraling zipper (fig. 12). (Colored plastic versions of the zipper are introduced in 1935, and both James and Schiaparelli adopt them as decorative and functional elements.) At about the same time he designs a line of four day dresses for the British textile manufacturer William Hollins & Co., which produces various fabrics under the brand name Viyella (see p. 63). The dresses are publicized in the March and May issues of *Vogue* and August's *Harper's Bazaar* (fig. 13). He will collaborate with other textile manufacturers throughout his career.

In this year he also creates the Loop-a-Loop, or Mobius, scarf, a ring of twisted fabric designed to be linked to another and worn as a pair. It will be a consistently strong seller for more than two decades.

In early April James throws a midnight supper-cum-showing at his flat. With a bar set up in the bath, a fact noted in the press,[21] he displays twenty-eight designs for sale or custom order. Guests are a mix of London society and buyers for the trade. It is the first of numerous elaborate parties-as-showings he will stage over the next two decades, reflecting the persistent porousness between his business and his personal life.

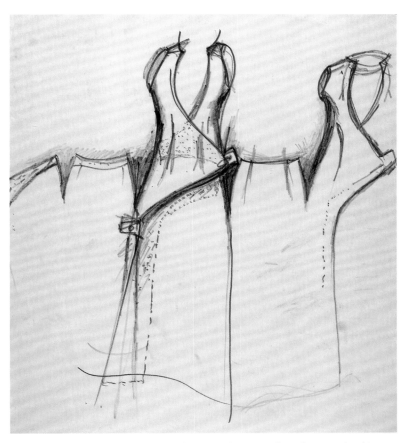

fig. 11. A James diagram (ca. 1965) of the spiraling Taxi dress he conceived in 1929

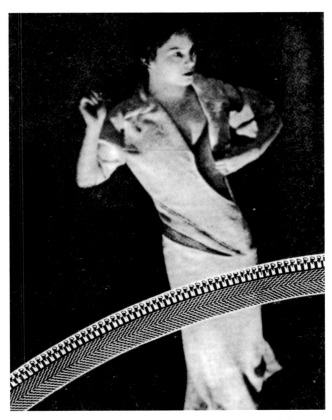

fig. 12. A 1933 advertisement for Lightning Fasteners Ltd. features James's zippered version of his Taxi dress, showing it unzipped.

fig. 13. This two-tone dress, one of four dresses James designs with fabrics sold under the brand Viyella, has an uncommon color combination of dark brown and pale gray, 1933.

fig. 14. Henri Matisse's 1936 portrait of Mrs. St. John (Mary) Hutchinson wearing the James blouse Matisse chose for her sitting. Matisse's response to the blouse convinced Mrs. Hutchinson of James's artistic genius.

fig. 15. A favorite client, Anne Armstrong-Jones (née Messel), poses in 1934 amid a profusion of tulle at James's London atelier at 15 Bruton Street, where the decor contrasts tufted blue satin with bearskin rugs and pampas grasses.

fig. 16. James appraises his one-armed evening wrap, made of a novelty fabric likened to wet white feathers. It was shown in New York in the fall of 1933.

With introductions made primarily by Beaton, Stephen Tennant, and Harold Nicolson, the writer, politician, and husband of the writer Vita Sackville-West, James develops a client base of English aristocrats, European royals, theater professionals, and associates of the Bloomsbury Group, the influential literary set. As he later reminisces, "Tennant is key to the English clientele of note which in turn very much impressed the American clientele which longed to meet the English clientele."[22]

He also meets the period's leading artists and designers, among them the Surrealists Pavel Tchelitchew, Salvador Dalí, and Jean Cocteau, all of whom he will collaborate with over the coming decade. Surrealist displacements, transpositions, illusions, and morphological change will inform James's creative process throughout his career.

His early London clients come from varied backgrounds and range in age but tend to be distinctive characters with an adventurous yet impeccable sense of personal style—an attribute more essential for James than a perfect figure. They include three eminent society hostesses and Bloomsbury associates: Lady Ottoline Morrell, from whom James says he learned "the importance of disregarding current fashion trends";[23] Lady Leucha Warner, whom a friend describes as having "exemplary elegance of her figure and carriage" and being "one of the most open-minded and deeply unconventional human beings I have ever known";[24] and Mary Hutchinson, a writer and cousin of Lytton Strachey, founder of the Bloomsbury Group. One of James's favorite early clients, Hutchinson is "worldly, elegantly fashionable, ugly-charming and [with] wonderful taste in clothes."[25] She later says of James: "I think he has a romantic gift. . . . He made women look exciting and strange."[26]

James's most dedicated client in this period is Mrs. Ronald Armstrong-Jones, the former Anne Messel, sister of Oliver Messel. The 1935 announcement of her engagement to Laurence Michael Harvey Parsons, the sixth Earl of Rosse, would describe her as "lovely, with beautiful manners, and a genius for wearing strange and original clothes."[27] The soon-to-be Countess of Rosse and other devoted clients such as Mary Hutchinson are not only sympathetic to James but forbearing, recognizing that they are not ordering clothes so much as patronizing the arts. Anne Rosse, who was a client from 1931 through 1939, later philosophizes about the clothes: "Not everybody would find they were easy to wear sometimes. But again, they were beautiful drawings. They were wonderful lines. Perhaps like wings of birds going up into the air, or else very, very severe Cossack hats."[28]

Hutchinson would note that James's obsessive artistry occasionally rendered a garment unwearable: "Charlie was sometimes so entranced by the shape he was 'sculpting' over one's own shape, that when the dress arrived finished it was impossible to get into it. It existed on its own."[29] Occasional design difficulties notwithstanding, it is a James blouse that Henri Matisse chooses for her to wear when she sits for a charcoal portrait in 1936 (fig. 14). The artist tells her its lines facilitated his work: "Votre Blouse m'a beaucoup aidé."[30]

In June James opens a salon in an elegant eighteenth-century house at 15 Bruton Street. He decorates the atelier with a magpie mix of materials: tufted blue satin shutters, white bearskin rugs on highly polished floors, feathery dyed pampas grasses in enormous vases, two long mirrors on the walls, and a painting of a nude above the fireplace (fig. 15). He will remain at this location for three and a half years. Here he tends to clients, many of them among the most well dressed and socially prominent women of the day, with his usual disregard for convention. The first time he meets the fashion publicist Eleanor Lambert, he greets her from a nest of tulle he had arranged on the atelier's sofa;[31] he welcomes others to his room at Paris's exclusive Hotel Plaza Athénée standing on the terrace while scantily clad in bathing trunks.

James sails from London in October on the S.S. *Île de France* to show a collection of twenty-five designs made over the past three years at the New York branches of two British retailers, Dunhill and Fortnum & Mason. The press takes note of one example, a day dress with a swath of dark angora on the bodice, inelegantly likening it to "hair on the chest."[32]

By now James has established the merchandising approach he will follow throughout his career: developing ideas with and designing custom couture for a select group of private clients; selling his original designs through specialty shops and upscale department stores; collaborating with textile manufacturers to use their products in his designs; and contracting with clothing manufacturers to copy his originals.

Retail clients in the early 1930s include Best & Co. and the exclusive House of Tappé in New York; Marshall Field's in Chicago; and, in London, Victoire (a specialty shop owned by a friend), H. J. Nicoll of Regent Street, and Harrods, the famed department store, which will be a regular client throughout the 1930s.

In December James leaves New York for Chicago.

1934 In January British and American editions of *Harper's Bazaar* publish a drawing of the debonair designer wearing a loose-legged jumpsuit and boxy tuxedo jacket and gazing approvingly at his evening wrap made from "hairy white fabric that looks like wet white feathers,"[33] actually a new plush uncut velvet (fig. 16). James is thrilled with the binational coverage, which he believes reflects his growing stature in the world of fashion.[34]

James stages an exclusive teatime showing on January 9 in the elegant Wedgwood Room at Marshall Field's, an event organized by his mother and underwritten by his friend and patron Mary Slaughter Field, who sends engraved invitations to Chicago's social elite. Best & Co. and Marshall Field's run advertisements promoting the models he has brought for the Wedgwood Room showing.

He returns to London midyear and embarks on three years of high-profile costume design for the London stage. Most of his work is for productions mounted by Charles B. Cochran, London's greatest theater impresario in the 1930s. Notably, many of James's costumes are for dancers—stars and chorus alike—requiring a keen understanding of the relationships between body, movement, textile, and garment. The theater work provides James wide exposure as well as another outlet for creative experimentation with elements that will become part of his design repertoire. The first production, *Streamline,* a four-hour extravaganza with twenty-six acts, opens in London in September. Continuing to develop his draping, James designs a dramatic, classically draped dress for Tilly Losch's solo ballet number and other dresses for the chorus in the dance finale.

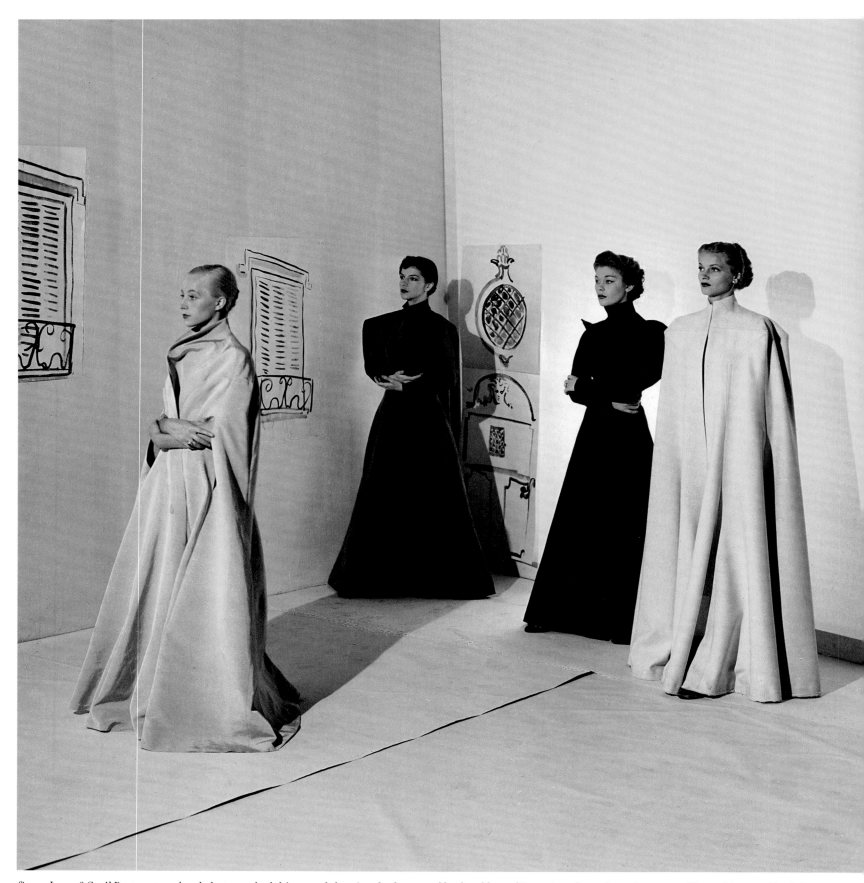

fig. 17. In 1936 Cecil Beaton staged and photographed this spread showing the fronts and backs of four of James's sculptural evening wraps. The architectural backdrop was sketched by Christian Bérard.

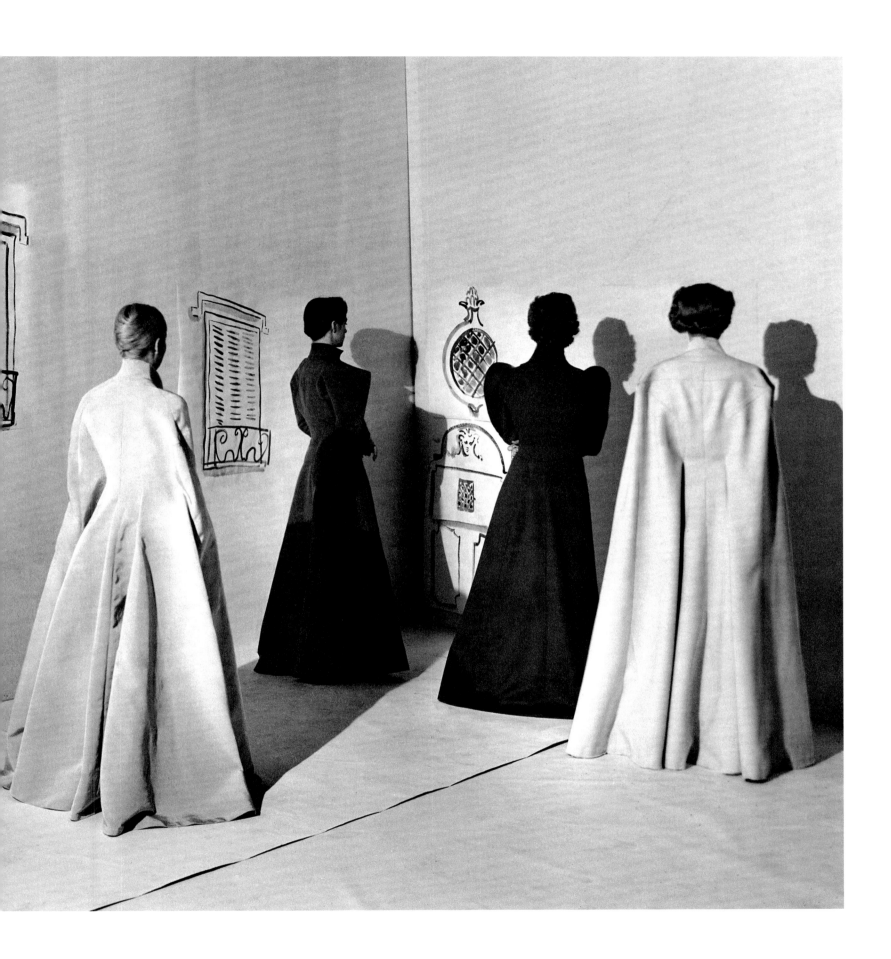

fig. 18. James, working in a hotel room, is caught in a theatrical moment of "active reflection" in a 1937 photograph for British *Harper's Bazaar,* in a spread titled "Creative Agony." An accompanying poem uses the metaphor of silk as a pool into which James plunges with scissors when design inspiration strikes.

He also establishes a working base in Paris, at the Hotel Lancaster, where the artist Jean Cocteau lives across the hall. (Cocteau will rescue him from another suicide attempt the following year, and James will create dresses using Cocteau-designed fabrics in 1937.) The Lancaster will be his primary residence in Paris over the next several years, with occasional stays at the Plaza Athénée, in the heart of the couture.

James makes important contacts in Paris, including Paul Poiret, the revolutionary early twentieth-century couturier, and Christian Dior, then an art dealer, whom he probably meets through their mutual friend the artist Sir Francis Rose. He and Dior will share design ideas and remain friends throughout the 1940s. James also becomes acquainted with Gabrielle "Coco" Chanel and Cristóbal Balenciaga. James's later writings suggest that he traded information and learned couture techniques from each of these renowned designers.

1935 At the request of Oliver Messel, who designs the sets, James designs all of the costumes (characterized as "modern dress" in the program) for *Glamorous Night*, a musical extravaganza by Ivor Novello, which opens in May. For the chorus of dancers he contributes twenty satin sheaths with diagonal black zippers; the necklines are trimmed with cellophane, a relatively new synthetic material (see p. 186). He and Schiaparelli share the distinction of being the first designers to use it in fashionable clothing. Another correlation between James's theater and street designs is evident in the chorus's draped tulle stoles, items that will become a signature James evening accessory, especially in the postwar period.

His third important theater engagement entails designing most of the costumes for Cochran's revue *Follow the Sun,* starring Claire Luce, which previews in December. Reporting on the preview in Manchester, the press notes that James created "sensational frocks"[35] whose masculine tailored lines were created with "the stiffest and most gentlemanly of materials," including "grosgrain, gentlemen's piqué, curtain fabric, and millinery straw,"[36] all of which James will use in his sculptural couture designs. He also contributes flowing chiffon dresses for the dancers in a ballet number, "Love Is a Dancing Thing," demonstrating his understanding of how to articulate and facilitate movement through cut and textile.

1936 By now James has in his employ Philippa Barnes, a woman trained in the techniques of couture fitting and sewing, who will be his trusted London-based assistant and amanuensis in the coming years, when he bases himself in Paris. He counts between thirty and forty women in his client pool. At this point it includes Mrs. Eric Loder, widow of Canadian tobacco tycoon Sir Mortimer Davis; the British socialite Doris Blanche Orr, Lady Orr-Lewis; Edith de Beaumont, wife of Count Étienne de Beaumont, an eminent host in Paris; and Vivienne Woolley-Hart, the American-born German baroness whom James characterizes as "a nice soul and for her odd 60 years very debutantish."[37]

Creatively restless and seemingly wired to test himself, James begins conceiving designs as sculptural shapes. In opposition to the prevailing trend of soft, body-clinging styles, his new designs stand away from the body, changing its silhouette, by way of stiffer fabrics, unique cut, padding, or some form of understructure.

Having met Johan Colcombet, head of a leading textile firm specializing in millinery and ribbon fabrics, James challenges himself to fabricate two sculptural evening coats using eighteen-inch-wide millinery grosgrain Colcombet gives him. Grosgrain, a stiff material woven in narrow widths, usually gives stability to hats; it is not considered pliable or wide enough for garments, but James exploits its rigidity to produce dramatic evening wraps whose structure provides an interesting counterpoint to the slinky, bare dresses beneath. The grosgrain wraps, along with two other wrap designs in equally unusual fabrics—billiard cloth (felt) and whipcord, a heavy ribbed fabric primarily used for sporting wear—receive wide publicity when they are displayed in Harrods' windows. They are subsequently published on both sides of the Atlantic in a fashion spread shot by Beaton and illustrated by the artist Christian Bérard (fig. 17).

James later notes that the grosgrain coats are among his most significant designs[38] because they influence Colcombet to expand some of his grosgrain looms to produce fabric wide enough for garments.[39] He and Colcombet will continue over the next several years to develop various textile projects, including early blends of silk and cotton.

Soon after the grosgrain coats, James makes the first of what will be a legendary line of garments from ribbons (see p. 184) and, later, ribbonlike panels (see p. 194). Using some pre-1914 Colcombet satin ribbons that he finds at a junk shop in Montmartre, and with the counsel of his friend Paul Poiret, he makes a cape. James later recollects that it was "made of fann'd-out ribbons.... The colours, all pale and creamy, meringue pink, banana pistachio, Greuze blue ... all alternating but in an irregular order so as t[o] mystify eye and memory."[40] Upon seeing the finished cape at a dinner held in his honor, Paul Poiret scrawls a message to James on the menu: "I pass you my crown; you do with cut what I have done with colours."[41]

1937 With other Bruton Street designers and Schiaparelli, James makes costumes for Cochran's wildly successful *Coronation Revue: Home and Beauty,* which opens in London in February. Billed as a "feast of fashion" meant to inspire designs for the forthcoming coronation of King George, it features eight hundred dresses for a bevy of stars. James later claims that some of his costumes inspired a renewal of Edwardian styles in mainstream fashion. However, at least one dress, a slinky halter style for the actress Sepha Treble, is undeniably imbued with James's "Erotical It."

In an early public recognition of James as an eccentric genius and martyr for his craft (a public persona he certainly approved, if not invented), British *Harper's Bazaar* in April runs an article about James headlined "Creative Agony" (fig. 18). The accompanying photo shows James in a hotel room (probably at the Dorchester, in London), scissors in hand, wearing shirt and shorts amid a hodgepodge of fabrics, dress forms, and tools of his trade—his characteristic work style in the coming years.

By August James is renting a workroom space in Paris at 14, rue Lincoln, near the Hotel Lancaster. Having heretofore shown his designs informally when in Paris, in hotel rooms, he makes his first formal presentation at a space on the rue des Petits-Champs rented from Princess Dilkusha de Rohan. The show features his ribbon

eveningwear and grosgrain coats. Buyers include the American retailers Hattie Carnegie, Bonwit Teller, Lord & Taylor, and Milgrim.

James's experimentation with outré sculptural forms finds further expression in an evening gown known as the Coq Noir, with a bustlelike sideways protrusion, which he creates for the Countess of Rosse (see p. 89).

Although he has developed a business with the best-dressed women in the world and the most exclusive retail establishments in New York and London, James is forever financially overextended, his accounts in disarray. He constantly juggles expenses for staff, hotel rooms, materials, and workrooms, finagling early payments from clients and delaying payments to workroom staff. Typifying his hand-to-mouth operation, he later writes to Barnes: "I borrowed 1500 from de Leche to buy ... lining, etc., and to eat on."[42]

In early fall, while in Paris, James loses his London showroom for nonpayment of debts. As the Countess of Rosse recalls: "Understandably there came a day when the bailiffs came into Bruton Street and his beautiful collection was quickly thrown into taxis at six in the morning, for me to find piled up on the floors of my little dining room as I was preparing a luncheon party! Such was his generosity that he wanted to give me the lot in the end."[43]

1938 Now in Paris full time, James moves his business to the rue St.-Philippe-du-Roule, in the workrooms of Maison Tessier, a purveyor of equestrian equipment. His French staff consists of four or five employees, including a head seamstress and a tailor. In London, remaining in touch with James almost daily via letter and telegram, Philippa Barnes performs all necessary work to keep the business going—fitting clients with toiles, promoting sales with established clients, developing new contacts, making alterations, collecting money, and managing the packages of fabrics, finished models, and toiles that steadily stream between London and Paris. James is selling mostly to private clients, specialty shops, and Harrods.

This is a particularly creative year for James. His interest in sculptural forms reaches its apex with his white satin evening jacket, padded with eiderdown and quilted in a pattern of rounded arabesques (fig. 19). He conceives it in response to Elsa Schiaparelli's "commonplace short bulky fur jacket,"[44] but only as a "technical challenge and fantasy."[45] He believes the difficulty of reproduction means the jacket will have "absolutely no importance to the fashion industry."[46] However, although only one was made, its concept and shape anticipated the generations of puffer jackets and ski parkas that followed.

James also creates his Umbrella dress, whose skirt, extended by an understructure similar to umbrella spokes, articulates the wearer's movements. It is the first known evening garment with an understructure built into the skirt and also the first strapless evening dress with a separate strapless underbodice (see p. 205). He also creates his first version of the Sirène (or Lobster) dress, his most Surrealist design, which has a tight-fitting sheath with upward tucks radiating from a central spinelike element, suggesting the segmented body of a crustacean (see pp. 105, 107). One of his most popular dresses, it will be in production for the next fifteen years.

1939 James continues to work at a busy pace, fulfilling orders but frantically scrambling to manage finances. He solicits loans and advances from clients while delaying payments to his long-suffering but devoted staff. He writes to Barnes: "I missed the extra 1000 off Lady L [client Leucha Warner] & could not pay Salli & G [workroom staff] ... but poor dears they're tired of asking."[47] He nevertheless is able to hire a tailor who had formerly worked for Madeleine Vionnet, and he exhausts himself filling orders for gowns for the extravagant ball Count Étienne de Beaumont throws every June, which he also attends.

In August, seeing that war in Europe is inevitable, James leaves Paris for London, from which he sails to New York, arriving in October. Mary Lewis of Best & Co. sponsors his entry into the United States. James will obtain permanent residency in February 1942; however, he retains his British citizenship and never seeks to become an American citizen.

He gains traction in the New York fashion world with an extensive article in *Women's Wear Daily*, the first since 1933, about his innovative trouser skirts, which provide the modest appearance of a skirt and the flexibility and ease of movement of pants (fig. 20). One style features a front crossover panel covering the separation between the legs; the other wraps around the legs in a figure eight. While loose-legged pajama pants had become popular for women's at-home clothes and beachwear in the 1920s, James's designs make pantslike fashions suitable to wear in public.

New York Career, 1940–59

1940 James sets up his first workroom in New York at 63 East Fifty-Seventh Street. He designs mostly for established private clients, who now include Bachoo and Edulji Dinshaw, heirs to an Indian industrial fortune. He also continues selling original designs to manufacturers for copying. The influential fashion editor of *The New York Times*, Virginia Pope, James's longtime friend, raises his profile by including him in her 1940 and 1941 reports on New York's top custom designers.[48]

1941 In January the upscale New York department store B. Altman devotes an entire show to twelve versions of James's trouser skirts.[49]

In December the Japanese attack Pearl Harbor. The United States enters the war.

1942 The war brings a new focus on native talent to the American fashion industry, which traditionally took its creative direction from France. Before the war U.S. manufacturers would send representatives and sketch artists to the Paris showings, then adapt, reinterpret, and mass-produce their designs for the American market. Now leading figures in American fashion—including Morris De Camp (M. D. C.) Crawford, editor of *Women's Wear Daily*; Dorothy Shaver of Lord & Taylor; and fashion publicist Eleanor Lambert—work to support and promote the creativity of American designers. (That initiative will have an impact on the ready-to-wear market after the war, when a distinctive American style based on sportswear's comfort and functionality eventually emerges.) Another key player is Michelle Murphy, the charismatic and dedicated head of the Brooklyn Museum's education division (and later of its renowned Design Laboratory,

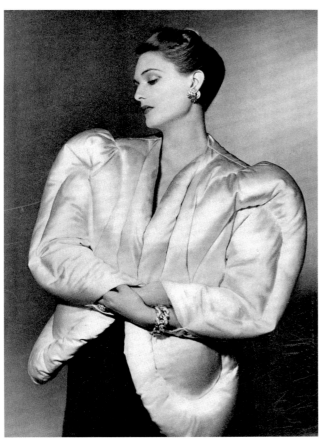

fig. 19. James's one-of-a-kind quilted eiderdown evening jacket is featured in *Harper's Bazaar* in 1938. The artist Salvador Dalí, who himself created soft sculptures, admired the jacket as an example of the genre.

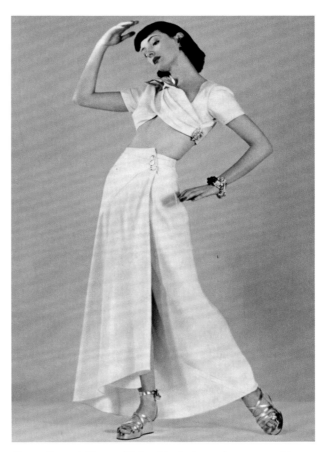

fig. 20. James's Figure-Eight skirt is shown in an ensemble meant for tropical eveningwear, rather than beach attire, in 1940.

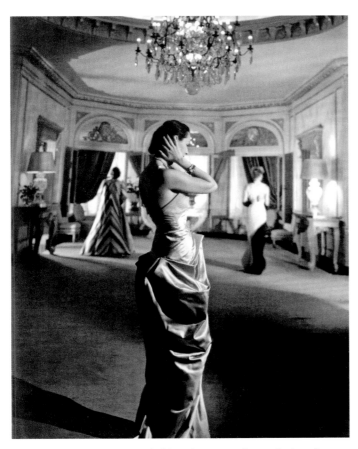

fig. 21. The spacious custom fashion showroom James designed at Elizabeth Arden's salon, 1944. Arden objected to the heaviness of the drapes.

fig. 22. Millicent Rogers in James's showroom, ca. 1946

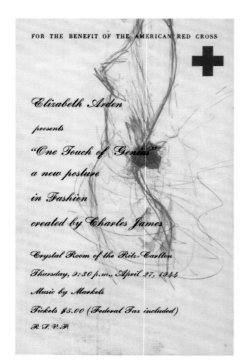

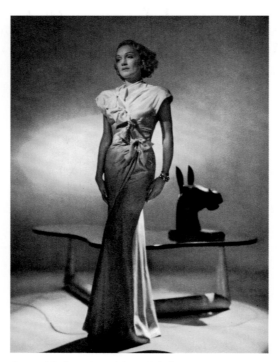

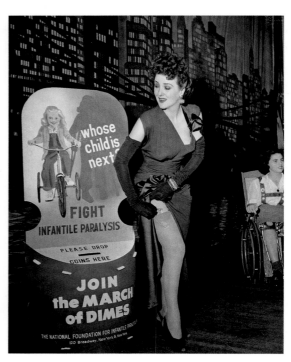

fig. 23. Program for "One Touch of Genius," Elizabeth Arden's 1944 fashion show of James's designs at the Ritz-Carlton Hotel. The sketch illustrates the elongated torso, rounded stomach, and concave back that characterize James's concept of the modern woman's posture.

fig. 24. Marlene Dietrich models for *Vogue* in James's Bow dress, which he had created in Paris in the late 1930s and offers anew in the Arden collection of 1944. He considered it one of his best designs. The bows function as closures as well as decoration, revealing seductive glimpses of skin.

fig. 25. Gypsy Rose Lee, at the first March of Dimes benefit luncheon, held in 1945, lifts her James dress to extract a cash contribution from her stocking top.

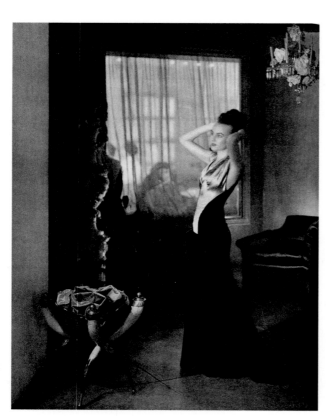

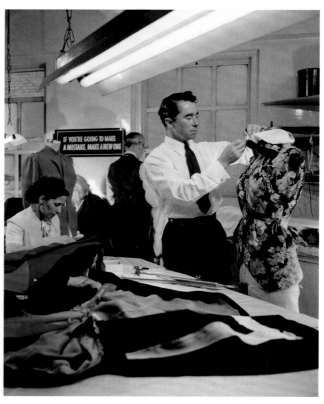

fig. 26. A young Austine Cassini (later Hearst) models a James gown at his new Madison Avenue showroom in 1945. On the left is an elaborate alabaster urn James favored as a decorative device in many of his photographs. At the back, a curtained window provides a glimpse into the workroom.

fig. 27. James and his staff in the workroom at 699 Madison Avenue, 1947. The sign on the back wall reads: "If you're going to make a mistake, make a new one."

established in 1948), which offers the design community educational, advisory, and research services centered upon making its collection available for examination and loans.

James and other American designers will take advantage of the museum's services before war's end. After the war, and for the rest of his career, he will relentlessly and vociferously continue the campaign to improve American design, which others abandon as Parisian fashion regains preeminence.

James begins a long and fruitful relationship with the exuberant burlesque entertainer Gypsy Rose Lee, for whom he designs both a personal wardrobe and theater attire. Lee will be a high-profile client and good friend into the 1950s.

He also designs the trousseau for the wedding of cosmetics magnate Elizabeth Arden to Prince Michael Evlanoff. James and Arden first met in 1929, and since then he had served as her occasional escort in New York and Chicago, but their casual friendship now becomes closer.

1943 Arden hires James for a new initiative: to incorporate a custom fashion department within her beauty empire. He is to design the collections as well as the second-floor showroom, but James expands the project—at his own expense—to include workrooms and a fitting room. The showroom, lit by sparkling crystal chandeliers, is painted pale pink, with substantial green satin curtains offsetting the delicacy (fig. 21).

He creates his first known design for Millicent Rogers, an ethereal beauty, American style icon, and heiress to her grandfather's Standard Oil fortune (fig. 22). James makes Rogers an organdy and lace *déshabillé* when she is bedridden (she suffered ill health after a childhood bout of rheumatic fever). "I hoped it might encourage her to leave her bed," he later says.[50] The charming, artistic, and intellectually curious Rogers becomes his muse, patron, and close friend.

1944 After four years of undocumented lodgings but an undoubtedly nomadic life, James takes up residence in a two-room suite in Manhattan's posh Hotel Delmonico, where he will stay for more than four years.

In April Arden introduces James's collection in a fashion show flatteringly entitled "One Touch of Genius: A New Posture in Fashion" (fig. 23). A benefit for the Red Cross, it is held at the Ritz-Carlton Hotel. The collection, which includes reiterations of designs James made in London in the 1930s, promotes a slim silhouette, as do Arden's new exercise facilities. *Woman's Wear Daily* praises the collection, admiring the rounded shoulder shapes and noting that James creates a new posture by way of elongated bodices that are molded over the hips and scooped out at the hollow of the back.[51] *WWD* also notes that other James designs, which are asymmetrically draped to emphasize volume, are difficult to reconcile with the ideal of svelte beauty. James's work with Arden garners a flurry of coverage in *Vogue* in the second half of the year, after a three-year absence from its pages (fig. 24).

Attracted to the Brooklyn Museum's dedication to teaching and serving design professionals, James meets Michelle Murphy. They take an immediate liking to each other and undertake a study of clothing in the museum's collection. The goal is to determine which body

measurements change and which are constant over time, to better understand fit. With the help of design students, they measure more than one hundred dress bodices spanning 150 years. They discover that some measurements related to bone structure remain the same over time, including the distance from the nape of the neck to the pivot point of the front armhole, consistently about ten and a half inches for women. James then works with the design students to develop patterns using that measurement.

This watershed project foretells endeavors that will occupy James for the rest of his life: scientifically studying the human body; addressing what he sees as a burning need to improve the originality and fit of American ready-to-wear; and teaching design students. It also establishes his determination to make the Brooklyn Museum the repository of his artistic legacy. To that end, he arranges to have three of his most significant designs donated to the museum: a dressing gown, one of the ribbon garments made in Paris in the late 1930s; a bodice, from about 1940, incorporating his ingenious Loop-a-Loop scarves from 1933; and a satin crossover trouser skirt, from about 1940. With the exception of some hats donated by the milliner Sally Victor a year earlier, these are the first examples of a living fashion designer's work to enter the collection of the Brooklyn Museum—and possibly of any other art museum.

James's mother dies on October 26, depriving him of his most important emotional support but leaving him with a modest inheritance that will help him establish his own business in the next year.

1945 Gypsy Rose Lee, "stunningly clothed to the teeth,"[52] wears a green James evening dress that "fitted her like the skin of a banana"[53] to the first March of Dimes benefit luncheon, which is sponsored by Eleanor Lambert's Dress Institute of America (fig. 25). The extravagant March of Dimes events, attended by New York's high society and held annually over the next fifteen years, feature fashion shows with socialites and willing clients modeling the works of America's top designers. James's clothes will appear in twelve of them.

James and Arden part ways professionally, just two years after launching their collaboration. The two strong-willed personalities had clashed over money, design aesthetics, and charges of design piracy. One bone of contention is an enormous ruby red vase that James placed backlit in the Arden store window, suggesting a bordello. The association with Arden, however, has burnished James's reputation in the New York fashion world.

By this time he has met Countess Igor (Austine McDonnell) Cassini, a journalist for the *Washington Times-Herald*, who will become Mrs. William Randolph Hearst Jr. in 1948. Intelligent, slender, sartorially adventurous, and, after her marriage to Hearst, a leader of New York society, she will be an ardent client. Like Millicent Rogers, she is willing to wear his most experimental designs and to support his design projects, particularly his legacy building at the Brooklyn Museum.

World War II ends in August.

Late in the year James opens a small couture atelier and showroom at 699 Madison Avenue (a few doors away from Arden). He will design and produce his most admired and enduring gowns there

over the next seven years. The decor of his atelier features his signature chandeliers, indigo and puce walls, a large framed mirror, and furniture covered in beige satin. A window between the showroom and the workrooms is covered with a translucent curtain, providing clients a shadowy behind-the-scenes glimpse of workers. The first fashion reportage about his new salon appears in December (fig. 26).

1946 James hires Japanese Americans recently released from American internment camps to work in his atelier. "My most important bigger clothes, ball dresses and such, were made in the Japanese workroom; the Japanese having a special quality of precision," he later says.[54] He also hires Kate Peil to head his workroom staff. She will work faithfully alongside him for the next ten years, shouldering much of the responsibility for keeping the enterprise going, as Philippa Barnes did during the London-Paris years.

After six years of a chaotic professional life in America, James has realized his dream of having his own atelier where he can work as a couturier in the French tradition (fig. 27). To James that means not only creating custom, beautifully constructed clothing for the elite (as others in New York do) but also innovating design ideas that will influence the entire fashion industry. Over the ensuing twelve years he works feverishly as an inventor and artist to develop new forms and techniques.

At this time he devises two novel silhouettes: the sculptural Parachute skirt (late 1945), whose mid-thigh stand-away volume tapers to a narrow hem, and the Trapeze coat, form-fitting at the front and free-falling at the back (see p. 178)—which in 1958 will be Yves Saint Laurent's career-making silhouette.

Wishing to soften the hard-edged, mannish shoulders of women's wartime suit fashions, he begins what will be a two-year project to develop a suit sleeve that can be raised and lowered without moving or bunching up the jacket. He allegedly spends twenty thousand dollars on the materials and the many man-hours needed to work and rework the design. One aspect of the "perfect" sleeve is extra width across the back. Set in at the anatomically correct shoulder line, it is only one of numerous sleeve types James uses for jackets and coats over the next ten years (fig. 28).

He also develops and begins to execute at least a dozen versions of elaborately draped and puffed evening gowns, many of which will be presented in Europe the following year (figs. 29, 30).

1947 In February James's friend Christian Dior, who had recently established his own couture house in Paris after years working for the couturier Lucien Lelong, shows his first collection. It takes the fashion world by storm and reestablishes Paris as the fashion capital of the world. Dior's collection—characterized by waist-hugging jackets with rounded, padded hips and soft, narrow shoulders; full skirts using up to fifteen yards of fabric; and dresses with snug, figure-altering bodices—replaces harsh wartime fashions with a full-blown romanticism that is dubbed the "New Look." While James had been developing designs that included those characteristics throughout his career, he did not resent Dior: "No one in the world begrudges Dior his success, for it has been an encouragement to everyone connected

with the creative projection of taste."[55] Nor was his influence on Dior a secret. Sir Francis Rose, a friend of both men, later writes: "Christian Dior told me that Charley James had always inspired him and that the 'new look' came from one of his remarks."[56] James sanguinely sums up his view the following year in an interview illustrated by sketches of his designs since 1933: "There is no such thing [as the New Look]. What people have been going mad over in the last year is nothing more than the summation of 10 years' dressmaking development that bypassed us because of the war."[57]

Exercising his flair for the extravagant, in June James takes a collection of twenty pieces, mostly produced between 1945 and 1947, to London. After a preview showing hosted by his friend the couturier Hardy Amies, he goes to Paris, where the artist Christian Bérard and Count Étienne de Beaumont throw a lavish midnight supper and fashion show planned and presented by James. The glittering affair, illuminated by candles, accompanied by harps, and enlivened with Champagne, is attended by James's cosmopolitan clients as well as the couture establishment, including Elsa Schiaparelli, Jacques Fath, and the House of Mad Carpentier (fig. 31). They and Dior lend their own mannequins to model James's clothes, an unprecedented gesture and a confirmation of their friendship and professional esteem.

James's objective for the event is not commerce but prestige: to show his colleagues in the couture what he has been able to accomplish in New York over the past seven years, as well as to impress upon retailers that clothes designed in America could equal the quality and stature of their Parisian counterparts. He does receive publicity, however, with a spread in *Collier's* magazine.[38]

At summer's end James returns to New York on the ocean liner S.S. *Veendam*.

In addition to completing the "perfect" sleeve project begun the previous year, James designs an ingenious dolman-sleeved coat for the singer Lily Pons (see p. 148). It will be one of his most popular coat designs in the 1950s.

1948 Although James's reputation is growing, the status, industry influence, and financial rewards afforded his French counterparts continue to elude him. The American manufacturers and retailers who fawned over him when he was working on French soil have not wholeheartedly embraced him in America. His disgust with the industry is magnified by its postwar rush to re-embrace Paris designers, effectively abandoning the wartime effort to invigorate American design. Frustrated and angry, he begins a relentless attack on the industry via the media, decrying the characterization of those who adapt Parisian designs for the American market as designers when they are "plagiarists" who have not gone through the "birth struggle" of originating the designs.[59]

His ire, while personal, does raise awareness of two issues he is not alone in considering problems: rampant plagiarism in the fashion industry and a failure to encourage home-grown originality. He constructively suggests that the industry nurture and support American talent by subsidizing it, as France does its couture industry, recommending that manufacturers and retailers spend some of their funds for advertising and European travel on teaching and research programs.

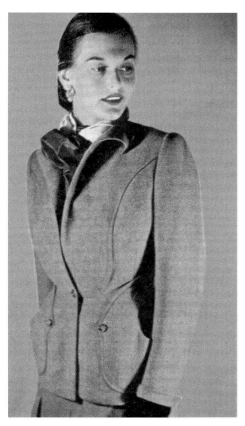

fig. 28. James's perfectly designed set-in suit sleeve allows the jacket to remain in place when the arm moves. He develops it in 1946–47.

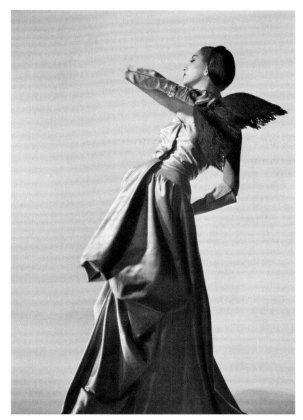

fig. 29. This ball gown of 1946 exemplifies James's mastery of manipulating masses of sumptuous fabric into elegant forms. Photograph by Louise Dahl-Wolfe as it appeared in *Harper's Bazaar*, April 1947, p. 181

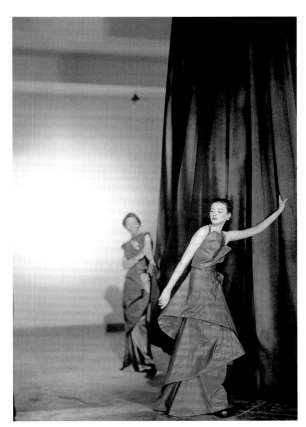

fig. 30. An exception to the soft draping and puffing that will characterize James's eveningwear in the next several years is this spiraled gown of 1946. Executed in a stiff fabric, it anticipates spiral examples he will create in the early 1950s (see pp. 71, 75).

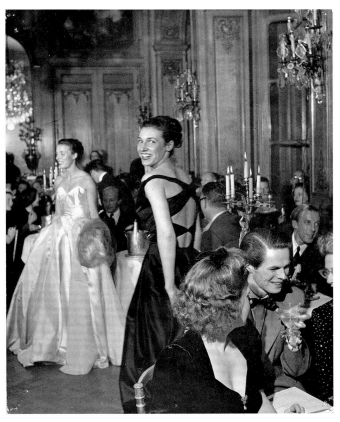

fig. 31. Models show two of James's ball gowns in the historically evocative candlelit setting of his midnight party at the Plaza Athénée in Paris, July 1947.

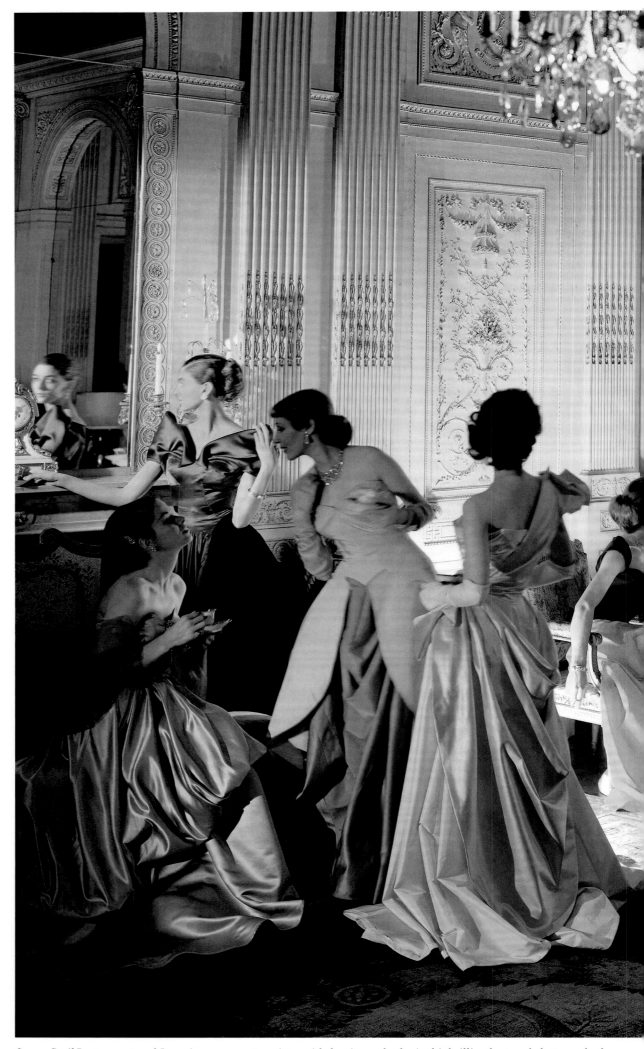

fig. 32. Cecil Beaton captured James's consummate artistry with draping and color in this brilliantly staged photograph of models caught in elegant repose. They are wearing ball gowns James created between 1946 and 1948.

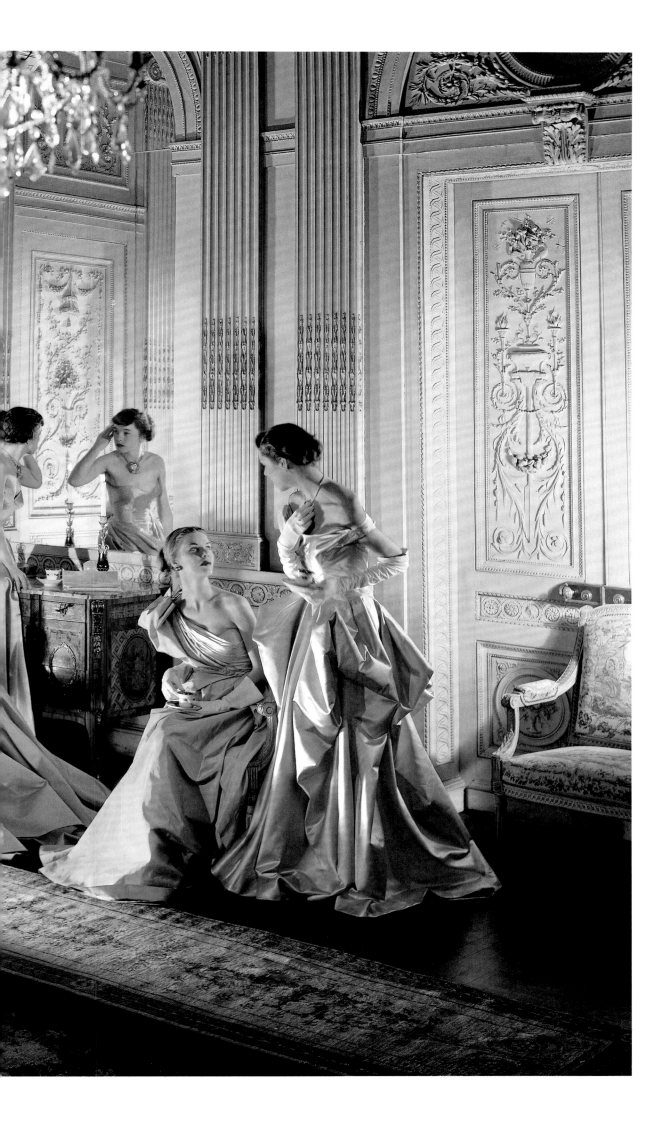

fig. 33. Cecil Beaton photographed five James gowns for the Modess sanitary napkin campaign—three of them, including this one, on location in Venice. James created this gown earlier, but its design, with front gathers over the ovaries, aptly alludes to the product advertised.

fig. 34. Millicent Rogers wears a James bodice and evening skirt with jewelry of her own making at the opening of "A Decade of Design" at the Brooklyn Museum in 1948.

fig. 35. A Jennie dress form and the plaster mold in which it was made. The mold was created by plastering over the original clay or plaster form James sculpted in 1949.

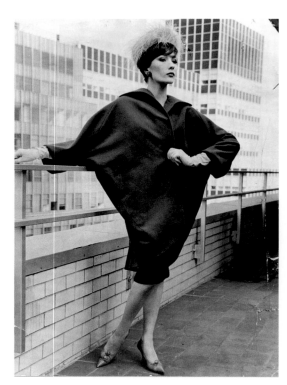

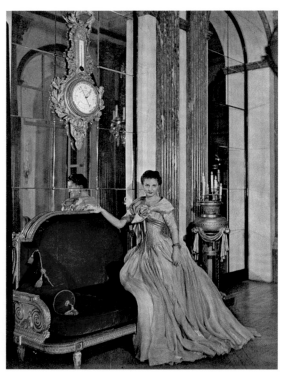

fig. 36. James's popular dolman coat, originally designed in 1947 for Lily Pons, is featured in the program for the fashion show benefit at the Wadsworth Atheneum, Hartford, Connecticut, in 1964.

fig. 37. Patricia Lopez-Willshaw wears James's tour de force ball gown at her home in Neuilly, France, in early 1950. Cecil Beaton took this photo in return for Mrs. Lopez-Willshaw's permission to shoot another photo of the gown, modeled by Maxime de la Falaise on the staircase in the entry hall of the Neuilly house, for a Modess ad.

James and Cecil Beaton collaborate on two photographic projects—one an editorial assignment for *Vogue*, the other an ad campaign, both published in June—that highlight both men's talents. From the shoot for the first project emerges Beaton's now-famous photograph of eight soignée models wearing James's sumptuously draped and richly colored ball gowns in the paneled eighteenth-century drawing rooms at French & Company Antiques in New York (fig. 32). Encapsulating America's aspirations for aristocratic Old World elegance, Beaton's photo secures James's reputation as master of the ball gown and in retrospect has become the defining image of postwar glamour.

In a similar vein but for a very different purpose, James enlists Beaton to participate in an advertising campaign for the Mennen Company's Modess sanitary napkins. Beaton photographs a series of five James gowns, four in lush, romantic interiors and the fifth in a Surrealist setting (fig. 33). "The spice in the Modess campaign is the idea that any woman at a difficult moment can imagine herself a Duchess," James later writes.[60] The photos, which are published without crediting the designer or photographer, run as full-page ads in several major women's magazines, raising awareness of James's aesthetic if not his name.

At the end of the year, in conjunction with the opening of its new Design Lab facilities, the Brooklyn Museum presents "A Decade of Design," an exhibition of twenty-four dresses James made for Millicent Rogers in the 1940s, as well as patterns and sewn muslins created to explicate his design process (fig. 34). The following January Rogers donates the materials and the dresses to the museum, cementing both James's relationship with the Brooklyn Museum and his reputation as a museum-worthy artist of dress. The donation also initiates the Design Lab's rush of acquisitions of twentieth-century couture over the next decade.

Having conquered the challenge of the set-in tailored suit sleeve the previous year, James begins work on a soft, unstructured sleeve shape based on the arc, exploring his love of geometry. He will introduce the sleeve in several garment types in 1951. He also resumes hat making on a limited basis. One design is a four-lobed hat that *Vogue* dubs a "4-leaf clover,"[61] heralding the shape and name of what will be James's most famous ball gown, which he will design four years hence (see p. 226).[62]

1949 James is now clothing a Who's Who of America's best-dressed and most fascinating women. Among them are Mrs. Cornelius Vanderbilt (Eleanor Searle) Whitney; the film star Jennifer Jones; Mrs. William S. (Barbara "Babe" Cushing) Paley, wife of the chairman of CBS; and the elegant Mrs. Leland (Nancy Gross) Hayward, then wife of the film and theater impresario. James later explains: "All my work was inspired by women who were not merely lovely or rich but personalities, and who seemed to share some of my own feelings about life in general."[63]

As he has throughout his career, he develops his original concepts by working directly on the bodies of the most patient among them. The prestige and pleasure of wearing his garments outweigh the frustrations of long fittings, financial difficulties, and James's unconcern about completing the work on time. The first garment resulting from such a collaboration is executed for the client-model;

eventually the design is produced for other clients, sometimes a year or more later.

In his designs for eveningwear, James turns his attention from the ball gowns with "marvelously massed"[64] drapery that have dominated his aesthetic for the past three years and begins to build his structured gowns as an architect and engineer, experimenting with rigid supportive understructures of layered materials, such as buckram and boning. He makes the Tulip, the first of three sheath designs with dramatic structured shapes sprouting from knee level (see pp. 206, 210, 221). He also creates a ball gown for Millicent Rogers with a padded hip yoke in the shape of rose petals, but does not put it into further production until 1951 (see p. 199).

James returns to his quest to improve the fit of American mass-produced clothes. Seeking to design a dress form that more closely adheres to the natural lines of the modern female body than the circa 1915 forms used by ready-to-wear manufacturers, James works in a sculptor's studio creating a form from which a plaster cast is made, the first step toward the papier-mâché dress forms he will call "Jennies" (fig. 35). Using the constant measurements he charted at the Brooklyn Museum five years earlier, he bases his dress forms on the proportions, posture, and slim figures of Millicent Rogers and Jennifer Jones (the Jennies' purported namesake). The resulting form has an elongated, anatomically curved waist, a repositioned underarm that follows the curve of the rib cage, and a slightly slouched posture, with shoulders back, a convex stomach, and tucked-in buttocks.[65]

In January 1950 fashion writer Eugenia Sheppard reports on the Jennies in the *New York Herald Tribune*, hailing their potential to revolutionize the fit and posture of American women's clothes.[66] They go into full production within the next year or two through the Cavanaugh Form Company, to be sold to wholesalers and custom designers. Schiaparelli and Hardy Amies buy the dress forms, according to James,[67] as do more than twenty small manufacturers, but the Jennies do not then have a significant impact on the industry. As so often was the case, James was ahead of his time. Some years later the National Bureau of Standards adjusts one of its standard measurements for dress forms downward, in accordance with James's dimensions.

Having had by far his most prosperous year to date but desiring greater visibility, he establishes Charles James Services Inc. The goal is to expand the business beyond his couture work by "render[ing] fashion services to industries in various fields of design."[68] By establishing exclusive rights to his name, the company is also intended to protect and promote the Charles James brand. James, who observes that the designer's name is "capital,"[69] anticipates by decades the importance of branding, which, beginning with Pierre Cardin in the 1970s, will become mainstream marketing practice for designers in the 1980s.

Over the next ten years James will launch a total of five more business entities, with names such as Charles James Proprietorship, Charles James Associates, Ltd., and Charles James Manufacturers, each funded by friends and relatives, ranging from Mary Ellen Hecht, heiress to the Hecht retail fortune, to his elderly great-aunt Margaret Enders. Each company is conceived to generate new business but increasingly functions to cover debt the previous ventures incurred.

James's association with Lord & Taylor, initiated in 1946, gains momentum when the department store buys an original James coat of Linton tweed and in October advertises authorized copies of it for sale for about a third of the original's retail price. In perhaps his only uncontentious commercial association, Lord & Taylor will continue selling original James garments of all types along with authorized copies, especially of his tailored garments, through 1956. The store's prominent advertising effectively promotes James's name.

1950 James puts into production the dolman coat he designed in 1947 for Lily Pons, marketing it through high-end department stores (fig. 36; see p. 148). It will stay in production for the next seven years. Returning to his 1930s spiral concept, he creates what will be his most successful dinner dress, an asymmetrical cut *Vogue* notes "looks like a different dress from every angle"[70] (see p. 71).

He also produces two stunning ball gown designs. One is a tour de force, one-of-a-kind model made for the glamorous socialite Mrs. Arturo (Patricia) Lopez-Willshaw to wear at the opening of the new ballroom in her palatial home in Neuilly, France. The bodice is constructed of narrow strips of gold military braid, which descend like tentacles and disappear into masses of fine starched gray organdy (fig. 37). The design is one of James's four personal favorites.[71]

The other new design is a three-section ball gown, with a red velvet bodice and a two-part skirt of asymmetrically draped red satin above a white pleated organdy flounce (see p. 125). At least thirteen clients will own one of these grand gowns, including Lily Pons, Gypsy Rose Lee, Gloria Swanson, Babe Paley, and Elizabeth O'Dwyer, wife of Mayor William O'Dwyer of New York.

In addition to fashion, James undertakes interior design. His couture client Dominique de Menil and her husband, John, art collectors and philanthropists, hire him to decorate their new home in Houston, which architect Philip Johnson had designed in the minimalist International style. To soften and personalize the interiors, James designs curvilinear furniture, including a sinuous chaise longue; a banquette that is the forerunner of the conversation pits that would be de rigueur in the 1960s and 1970s; and his most famous piece of furniture, a curvaceous two-piece sofa known as the Butterfly (fig. 38). He makes the first Butterfly sofa for the Menils but markets it to others at least through 1954.

"The sofa echoes the shape of the human body, and if nature could grow a sofa it might be like this," James says.[72] He remarks that the sofa supports the body whether one sits up straight, curls in a corner, or lies down, and that "the curves are the indentations that would occur if you sat on wet cement."[73] Surrealist influences underlie the anatomically friendly sofa, whose shape alludes to Salvador Dalí's Mae West Lips Sofa, conceived in 1936.

In the house decor James gives full rein to his quirky yet brilliant sense of color, texture, and line, using startling accents in unexpected places, such as on the underside of the chaise longue and the insides of drawers and closets. He covers the hallway to the children's rooms with amber felt and fuchsia velvet, reminiscent of the tufted satin and velvet flocking he used in his showroom interiors. The clients and even the initially skeptical architect deem the work a success. The Menils will be James's avid patrons and staunch supporters, notably

of his legacy-building efforts at the Brooklyn Museum, through the 1950s.

While engrossed in the Menil project, he takes a radical step toward winning the broad recognition, financial success, and influence on American ready-to-wear he desires: He contracts with Ohrbach's, a department store on Fourteenth Street in New York known for making good, low-priced copies of couture clothing. The plan is for James to produce twenty designs for suits, coats, and dresses for the store's manufacturers to copy while he personally supervises the production. (One garment is a blouse featuring the arc sleeve he began developing the previous year.) Saying he has been waiting "24 years for an opportunity such as this," James and his new partner jointly express hopes that the project "may pave the way for greater development of fashion creativeness on the part of American designers . . . by the retailer in the mass market."[74] Whether the collection was ever made is not documented, but James does not help his cause at a celebration of the collaboration in California, where he ruins a grand piano by filling it with water for a floating orchid arrangement.

In October James wins the prestigious Coty American Fashion Critics Award, for "great mystery of color and artistry of draping"[75] (fig. 39). *Life* magazine's article about the event is headlined "An Unknown Wins a 'Winnie'"[76] (the nickname for the women's wear awards), indicating that James is still not a household name, despite his efforts.

1951 During this year James puts into production two recently developed concepts and begins work on a third. He executes new versions of the ankle-length Swan gown, which he originally made for Jennifer Jones to wear to the 1949 Venice Film Festival; it is the first of his designs to feature profusions of multicolored tulle. Full-length Swans will follow within the next two years and become one of his most legendary designs (see p. 214). He also deploys the arc sleeve (also known as the barrel or Louis-Philippe sleeve and based on the soft, full sleeve shapes of the 1830s and 1860s), which he has spent three years developing to his satisfaction. He now uses it in a two-piece day dress of taffeta and silk, a wool jacket, and a town coat called the Cossack coat (see p. 152). The arc sleeve lends the garments an updated Old World elegance; *Vogue* notes that the sleeve provides "a deep, wide, rounded look to the whole bodice."[77]

He begins four years of work on his Pagoda suit, which, when completed, he considers his chef d'oeuvre of tailoring.

1952 James takes steps that will make this year a pivotal one in his career. Closing the 699 Madison Avenue salon and atelier, he moves his workroom into more spacious quarters at 716 Madison Avenue and adds more work- or showroom space in the Sherry Netherland Hotel, where he also takes up residence.

In a second major initiative to enter American mass production for fame and profit, he strikes deals, announced simultaneously, with two ready-to-wear manufacturers: a two-year contract with Samuel Winston Inc., an undistinguished blouse manufacturer, to create thirty designs each year of a full range of garments; and a similar one-year arrangement for suits and coats with William N.

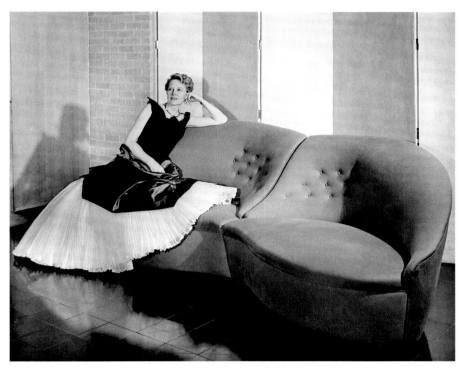

fig. 38. Dominique de Menil strikes a casual pose on her James Butterfly sofa. She is wearing her version of James's red satin and velvet ball gown with a pleated white organdy flounce (see p. 125), ca. 1951.

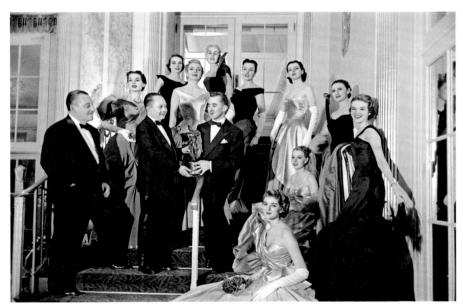

fig. 39. James is surrounded by models wearing his ball gowns at the Coty Awards ceremony in October 1950.

fig. 40. James's client Mrs. Cornelius Vanderbilt (Eleanor Searle) Whitney models his Chesterfield coat at the RCA Building in New York City, 1952.

fig. 41. The Pear sheath dress is so named because James designed it to add curves to less than voluptuous figures, 1954.

fig. 42. James's Pagoda suit was inaccurately but dramatically styled by *Harper's Bazaar* editor in chief Diana Vreeland in 1955. Infuriated, James says the jacket looks like a locomotive's cowcatcher.

Popper Company, an upmarket coat manufacturer. Both lines are to be marketed exclusively through Lord & Taylor, which advertises them in 1952 and 1953. The projects are initially successful. Popper immediately sells ten of the designs to Lord & Taylor for the purpose of copying, and Winston's profits increase sixty percent in the first year. Nevertheless, the Popper contract is not renewed, and the Winston contract ends after two years with acrimonious litigation from both sides.

In the second year of the contract James discovers that Winston is not only neglecting to put his label into the clothes but also pirating his ideas, incorporating them into a lower-priced line under the label Roxanne. He stops supplying his designs, and Winston sues for breach of contract. James countersues on grounds of piracy. From 1954 through 1956 James will spend considerable time, money, and psychic energy gathering evidence to prove his claim. In 1956 he wins a partial victory that awards him back pay. However, he loses his battle against piracy, which the judge points out could have been successful "absent so much temperament and balderdash" and with "more constructive marshaling of the available facts"[78] on James's part. James later rationalizes the ruinous episode: "I couldn't bear to see all the experimental cuts and personal convictions which had cost me fortunes attributed to those hired to exploit them."[79]

Despite the rancorous outcome, the two projects are the genesis of a shift in James's emphasis from eveningwear to innovative tailoring in coats, suits, and day dresses—practical attire that caters to a broader market and can be produced by manufacturing rather than couture methods, with the potential for higher volume and greater financial gain. Over the next four years he will give full rein to his interest in rearranging the proportions, lines, and shape of the body with daywear of unprecedented cut and masterful tailoring, for manufacturers as well as custom clients. "My dresses help women discover figures they didn't know they had," he explains.[80]

One of James's first coat designs of this period is his straightbacked Chesterfield coat for William N. Popper. It has a slightly raised waist at the back and is loosely based on the cut of early nineteenth-century gentlemen's overcoats (fig. 40). Many of James's subsequent coat designs fit closely above the breastbone and shoulder blades and around the armholes, while the body is volumetric—transforming coats from mere outerwear into wearable sculpture, much like his grosgrain wraps of the 1930s.

"The commercial buyers knew the greatest genius of Charles James was the ingenious cut of his daytime cloth coats and suits," Bill Cunningham, his longtime friend and a legendary *New York Times* fashion photographer, later writes. "It was this body of work that prompted Christian Dior to call James 'the greatest talent of my generation.'"[81]

In the spring Austine Hearst commissions him to design a dress to wear to Dwight D. Eisenhower's presidential inauguration on January 20, 1953. He begins developing what he later considers the master thesis of all his designs, the Clover Leaf ball gown, so named for the enormous four-lobed skirt that sits lightly on the waist and hovers just above the floor (see p. 226). The gown incorporates aesthetic and technical ideas James has been developing throughout his career. The anatomical shaping of the corsetlike bodice; the semi-bias in the

asymmetrical outer layer; the engineering that balances a ten-pound skirt lightly on the hips; the attention to movement, resulting in a gentle sway when the wearer walks and a lilt when she dances; the biomorphic form reiterated in a swath of black velvet; and the enlivening reflections from the sheen of satin and the subtle texture of faille all come together in James's masterpiece.

1953 Millicent Rogers dies at age fifty on January 1. James writes of her: "She was recognized throughout the world as a symbol of inspiration to fashion designers, artists, and writers.... Mrs. Rogers had a rare and peculiar quality, in being able to make others know exactly what they ought to do.... When she came into a workroom, she brought decision into the mind of the designer and workers."[82]

The Clover Leaf dress is not ready for Austine Hearst to wear to the president's inaugural ball on January 20, but she debuts it at the March of Dimes gala several weeks later and wears it to Elizabeth II's coronation in June. James will produce additional examples of this gown in black and white (five are known to exist) and numerous variants with different materials and flounce treatments.

In August James receives the Neiman Marcus Award, considered the Oscars of fashion, which is bestowed annually for "distinguished service in the field of fashion.... James is cited as the American designer who 'touches fashion with genius and immortality in his flawless timeless designs of beautiful clothes.'"[83] To the ceremony he wears blue jeans (topped with a white silk evening jacket and cummerbund)—decades before denim becomes ubiquitous, much less acceptable for formalwear. "The Bluejean is the only art form in apparel and I've been saying this ever since I appeared at the Neiman Marcus Award Show, dressed in jeans," he later states.[84]

Diverging from the body-curving cut James has worked with until now, he develops a sheath dress. Exacting horizontal seams dissect the bust and the hips, bypassing the waist altogether and attenuating the body (see p. 141).

1954 Surprising many of his friends and colleagues, as he has heretofore been strictly homosexual, James marries Nancy Lee Gregory, twenty years his junior. They had met a few years earlier through Nancy's former husband, Keith Cuerdon, a British-born costume designer who worked for James. James's best man is Patrick O'Higgins, assistant to beauty tycoon Helena Rubinstein. The bride is attended by a relative and Gypsy Rose Lee. Nancy, who was educated at Bennett Junior College in Millbrook, New York, and studied painting at the Art Students League, comes from a wealthy family in Kansas City. Although some assumed he "married Nancy for her money," James later asserts that he "stupidly married her because I loved her."[85] She had begun supporting his endeavors even before their wedding, and her slim Modigliani figure inspires him,[86] notably resulting in the sheath dress of the prior year. The couple takes up residence at the Sherry Netherland Hotel.

With his marriage bringing a new source of funds, James takes a three-year lease for a 3,500-square-foot space at 12 East Fifty-Seventh Street for a wholesale manufacturing facility and showroom. Although James's trained staff works alongside manufacturers of his clothes in their factories, his designs' exacting standards of cut

and construction make mass manufacture difficult, often with results James deems unworthy of his name. At the new facility he intends to maintain quality control by personally overseeing production. The clothes produced in the facility bear the label "An original design by Charles James" and are sold to retail stores and private clients. The clothes were to have been produced and sold by CJ Services, but the company is close to bankruptcy at the time of the new venture and is being supported by a successor.

Despite the bitter outcomes of his recent collaborations, James contracts with a little-known clothing manufacturer, Dressmaker Casuals, to create a line of coats. To ensure that it will be made to his standards he supplies the company with a workroom at 12 East Fifty-Seventh Street. He himself oversees all stages of production, including color dyeing and pattern cutting. The resulting collection garners him a special Coty Award for "influencing the entire ready-to-wear market with the new shapes of his coats."[87] Lord & Taylor advertises one of the coats in the October *Vogue,* lauding it as the "shape-of-the-future coat,"[88] while *The New York Times* hails the shapes as "a perfect balance of design 'in the round' of almost architectural perfection."[89] Detracting from that success, financial disputes, likely pertaining to the cost of having James oversee production, result in his bringing legal action against the company for monies owed.

James inaugurates his Gothic line of dresses and coats, named for the arch shape featured high atop the bust (see p. 180).

Returning to curved lines, James's sheath style this year is the Pear dress, which adds amplitude to the hips (fig. 41). James maintains that the design is a forerunner of the loose chemise shape the French couture presents the following year.

He promotes his two-piece Butterfly sofa in the press and contracts with the high-end furniture maker Brierleigh Ltd. to produce it. He also designs a line of maternity clothing for Lane Bryant Inc. to use in a film celebrating the retailer's fiftieth anniversary. At least one design is sold through Lane Bryant and gets notice in the fashion press (see p. 171).

Finally, James designs a line of costume jewelry for Albert Weiss Jewelers. Just as his clothing designs relate to anatomy, his necklaces are sculpted to fit the natural shape of the neck they adorn.

1955 James presents three noteworthy new designs, including the Pagoda, or tunic, suit he began developing in 1951. The jacket, inspired by shapes of the Far East, seamlessly flares out from the bust, a perfect cone shaped in part by elegant diagonal seams that nearly converge at the center front. James says the Pagoda is his best tailoring result and is infuriated with *Harper's Bazaar* editor Diana Vreeland for styling it in a Lillian Bassman photo with the cone jutting forward, not as he had intended (fig. 42).

He also debuts his magnificent Butterfly ball gown (see p. 222), which he designed the previous year, taking the extra step of manifesting the silhouette by first sculpting the shape, as he did for his Jennie dress forms (see p. 55). The gown makes its first appearance at this year's March of Dimes luncheon, modeled by Austine Hearst. James proclaims that the dress has "the highest bust line in 125 years."[90] The tight sheath is the Butterfly's body, and the magnificent tulle bustle represents its wings.

Finally, he presents the last of his three ball gown designs that feature multiple layers of tulle—the Tree dress, named for his client Mrs. Ronald (Marietta) Tree (see p. 221). James later writes that the most important aspect of the design is the particular way the flounce is applied, which "in movement . . . creates a lightness not found in dresses where the flounce has been joined diagonally to the torso."[91]

Returning briefly to his mother's hometown, James presents a grand retrospective fashion show for hundreds of attendees at a convention of dry cleaners in Chicago (fig. 43). He delivers a speech arguing for better content labels and cleaning directions on garments—another of his far-reaching visions, as such labels would not be implemented until the 1970s.

1956 The Jameses' first child, Charles Brega Haweis James, is born in January. The couple leaves the Sherry Netherland after the birth and resides in various private residences and hotels, never settling for long in any one place over the next two years.

In response to fatherhood James negotiates a contract to develop a line of infants' clothes for Alexis Corporation, an Atlanta-based manufacturer of children's wear. Like his adult designs, the clothes are attuned to movement and anatomy. He designs a capelike coat with elliptical armholes to encourage the baby to thrust its arms forward rather than flailing (fig. 44), and uses curved rather than straight straps on the playsuits to avoid the usual shoulder slippage. The original examples are exquisitely crafted and expensive. Princess Grace of Monaco purchases a number of them for her daughter Caroline's layette. By the end of the year more than thirty department stores are carrying Alexis's copies. He continues designing for Alexis for another year.[92] Enamored with the Baby Cape design, James translates it into a notable coat for adults, the Cocoon (see p. 160). The sleeve, needing further development in the adult version, is inspired by a wood mold for an elbow pipe from the New York City sewer, which James had salvaged at the behest of patron Dominique de Menil.

1957 James creates another great sheath evening dress, this one for Mrs. Byron Harvey Jr. (see p. 190). Like his black-and-white Clover Leaf gown, it reflects the period's biomorphic aesthetic. At the same time he pays homage to Surrealism by outlining an abstracted female form in contrasting fabrics on the back of the sensuous silhouette. It is dubbed the Diamond dress because it purportedly premieres in Chicago at a lavish dinner and fashion show given by the diamond industry, adorned by a large De Beers diamond brooch pinned between the two layers of the cantilevered bodice.

In July, just days before the birth of the couple's second child, Louise Brega James, Internal Revenue Service agents seize the contents of James's showroom at 12 East Fifty-Seventh Street for nonpayment of $80,000 in withholding taxes (equivalent to about $660,000 today). Eugenia Sheppard reports in the *New York Herald Tribune* (no doubt repeating what James has told her) that ten of James's original designs were stolen from his showroom while he was at the hospital awaiting his daughter's birth.[93]

Revisiting his interest in unusual fabrics, including novelty synthetics like the "hairy white fabric that looks like wet white feathers"[94] from which he fashioned an evening cape in 1933, James

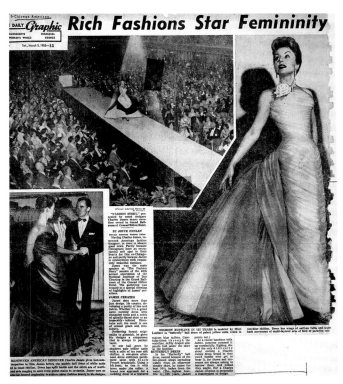

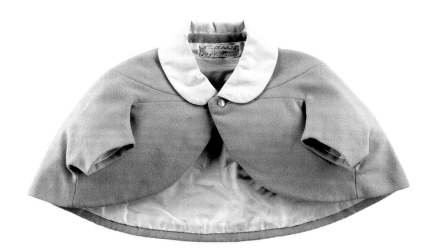

fig. 44. The Baby Cape coat of 1956 was inspired by the cut of mid-nineteenth-century dolman wraps.

fig. 43. James's fashion show at the 1955 convention of dry cleaners garnered full-page coverage in the *Chicago American*. The Clover Leaf dress is pictured radiating its star power on the runway.

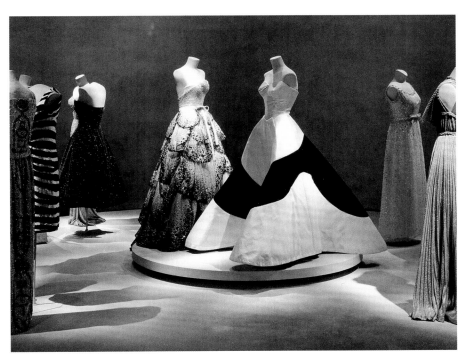

fig. 45. The Clover Leaf dress is exhibited alongside Christian Dior's Junon ball gown in The Metropolitan Museum of Art's 1967 exhibition "The Art of Fashion."

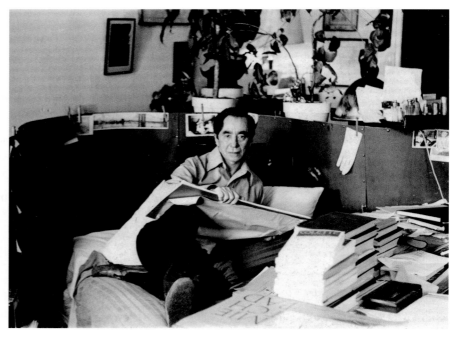

fig. 46. Charles and Nancy James pose with their children, Charles Jr. and Louise, in Scarsdale, New York, early 1961.

fig. 47. James at work in bed at the Chelsea Hotel, ca. 1976

fig. 48. Antonio Lopez sketches a James evening dress while the designer fits it on a model, ca. 1970.

designs a line of Borgana coats for E. Albrecht & Son. Borgana is a plush synthetic fur—a type of fabric that does not succeed at the time but becomes popular twenty years later. He negotiates with officials to show the collection in the premises they have appropriated.

In another act of legacy building, James persuades two longtime Chicago friends, one an heir to the Ryerson Steel fortune, to purchase from him more than three hundred of his sketches and donate them to the Brooklyn Museum.

1958 James tenaciously pursues short-term contracts with manufacturers and, with the help of friends, establishes the Charles James Foundation, a nonprofit organization meant to reduce his tax liability. He continues, as always, creating custom clothes for special clients. No efforts are enough, however, to stem the impending financial ruin.

In May *The New York Times* runs an article lamenting the lack of originality in American fashion and the industry's near total reliance on French creativity, echoing James's longtime frustrations.[95] However, it cites Charles James, James Galanos, Pauline Trigère, and Norman Norell as the most original of the American designers. His aspiration for parity with the French couture would be realized nine years later, when his Clover Leaf dress is given pride of place on a platform alongside Christian Dior's iconic Junon ball gown of 1949 in the Metropolitan Museum's 1967 exhibition "The Art of Fashion" (fig. 45).

New York City officials seize the contents of James's office at 716 Madison Avenue to satisfy creditors' judgments against him.

The Jameses' marriage begins to falter. Nancy has depleted most of her funds by subsidizing James's various businesses and paying legal fees.[96] The strain of constantly moving with two babies in tow to avoid creditors proves too much for her. She struggles with depression and eventually decides to return to Kansas City to be with her mother. At around this time, possibly earlier, James comes under the care of Dr. Max Jacobson (the notorious "Dr. Feelgood," known for prescribing amphetamines); he will be drug-dependent for the balance of his life.

James makes the first of numerous attempts to write an autobiography. He negotiates with the publisher Ivan Obolensky and begins a manuscript, "Beyond Fashion," but the project never comes to fruition.

He becomes friendly with a fledgling milliner new to New York, Roy Halston Frowick (later known as Halston). They had been introduced in Chicago several years earlier by Margaret "Peg" Zwecker, fashion editor of the *Chicago Daily News*. Halston apprentices briefly with James, and James will be an influential mentor and friend through the 1960s, when Halston works as a milliner for Bergdorf Goodman; he will establish his own dressmaking and millinery business in 1968.

1959 James creates the last of his important coat shapes, the Great coat (see p. 164). Each side is constructed with dramatic, curving front seams that meet at a point just below the bust. James aptly calls the full, rounded cut of the back the tortoise shape; it suggests a protective shell. He subsequently sketches the front of this design obsessively,

emphasizing with muscular marks where the seams confront each other at acute angles.

The Post-Design Period, 1960–78

1960 James moves to Scarsdale, a Westchester suburb of New York City. Nancy and the children join him, but their reconciliation is short-lived (fig. 46). Divorce proceedings will consume much of James's energy and resources through 1966. In his writings of this period he affirms the love he and Nancy share and their work as a team developing his career, despite their difficulties. They will remain in touch throughout his lifetime, and Nancy will work to preserve his legacy and reputation thereafter.

The strain of the breakup, lack of financial resources, and unstable living arrangements will accentuate James's irascible side in the coming years. He becomes more volatile and increasingly alienates friends and colleagues. For instance, he will pick fights with Diana Vreeland for omitting his work from her 1975 exhibition "American Women of Style" at the Metropolitan Museum's Costume Institute, and he will return his Coty Awards to rebuff Eleanor Lambert, who he believes misrepresented his litigation with Winston. Even the Brooklyn Museum becomes a target of his ire: He accuses the staff of stealing his materials, which he had repeatedly refused to pick up, despite numerous requests by the registrar's office.

Despite the bouts of fury brought on by artistic despair or perceived professional slights, James continues to charm and captivate those who meet him with his wit, intellect, and charismatic disregard for convention. The department store heiress Mary Ellen Hecht, who was close to him between 1955 and 1960, affectionately remembers the time they spent together: "He taught me the fun and also the price of dissipation."[97]

James begins moving away from designing but with characteristic energy and passion focuses on his artistic, educational, and personal legacies. He develops several college courses, and he reaches out to museums regarding acquisitions and documentation of his work, to design schools for potential projects, and to publishers for writing contracts.

The first course he develops, in conjunction with Robert Riley, a curator at the Brooklyn Museum, is a four-week seminar entitled "The Calculus of Fashion." It is "designed to be to a fashion student what advanced calculus is to a mathematics student."[98] With a focus on science and technique rather than design, the curriculum's goal is to create "fashion engineers"[99] who can inject efficiency, creativity, and eroticism into mass-produced American apparel. The curriculum is multidisciplinary, complex, and deeply intellectual.

The course is inaugurated at the Rhode Island School of Design in the fall of 1960. It was to be taught at several other institutions, including Pratt Institute but, owing to its complexity and James's cantankerousness, it ends after one term and is not taken up elsewhere. James will, however, teach at Pratt at a later date.

1962 James contracts with E. J. Korvette, the discount department store, to create basic designs for three dresses, a coat, and a suit. Rather than finished garments, the designs for each garment type

are coded parts that can be put together in various combinations, resulting in up to twenty different garments. Like his earlier manufacturing arrangements, the deal begins promisingly but seems to fall away without gaining much traction after a year or so. James will not design clothes again for another ten years.

1963 James designs a sculptural line of costume jewelry—his first in almost a decade—for Corocraft, yet another manifestation of his interest in biomorphic forms. Although the line is never produced, Bill Cunningham describes the designs as "fascinating," likening them to the shapes of James's clothes.[100]

1964 James takes two rooms in the Chelsea Hotel, a formerly fashionable hotel on West Twenty-Third Street that had become a haven for down-on-their-luck creative personalities. He will remain for fourteen years, conducting classes, perfecting former designs, and holding forth to members of the press and devoted friends. Florence Turner, a resident at the Chelsea at the time, later describes his accommodations as "so untidy that the maids refused to clean it. The result was chaos and a kind of awful charm. Dusty memorabilia were everywhere. A Matisse drawing of a Charles James wrap-around blouse . . . photographs of Marlene Dietrich, Gypsy Rose Lee, Millicent Rogers, Ruth Ford, all wearing magnificent Charles James gowns. . . . Charles usually reclined on his double bed, covered with books, drawings, half-eaten sandwiches, papers"[101] (fig. 47).

In April James is tapped to serve as "fashion history commentator" for a fund-raiser for the Wadsworth Atheneum's costume department. Historic items from the collection are modeled in a fashion show whose finale features several James designs. In one of his unpredictable spells, he locks himself in the curator's office the day before the event and emerges only when he hears the rapturous final applause.[102]

He meets Antonio Lopez, a talented young illustrator, in a restaurant. Lopez, captivated by James's work, asks if he can sketch the clothes, initiating an ambitious documentary project that involves late-night gatherings of James's students, clients willing to model, photographers, and sundry others (fig. 48). Over the next ten years Lopez makes hundreds of drawings, interpreting and effectively memorializing James's works, apparently inspired by their sculptural figuration, much as Matisse was inspired by the line of a James blouse in 1936.

Ralph James dies in December at age eighty-seven, never having made peace with his son and, in fact, after having cut Charles out of his will. Nevertheless, James writes: "It may well be that I alone, knowing all there was to know . . . bad and good . . . could and did love my father the best."[103]

1966 Young friends and associates and longtime clients and benefactors join James at a party to celebrate his sixtieth birthday. In this milestone year he initiates a number of educational, research, and documentary projects.

He begins connecting his work to the concept of metamorphology, Goethe's term for the study of form's simultaneous transformation and constancy. The idea reflects James's overall approach to design, in that

"there are not many original shapes or silhouettes—only a million variations."[104]

He uses the term in his teachings and other projects to explain the variations that can occur within a given form—for example, the different cuts that can be used to achieve the same shape, illustrated in a series of sketches of his Cocoon coat design (fig. 49). He also applies the term to the repurposing of a form or technique from one entity to another: a drapery technique deployed first in a dress, then in a jacket, or a bodice pattern piece that can translate into a skirt. He later devises a session on the abstruse subject as part of a series of electives he offers at Pratt Institute in 1970. Metamorphology can be seen as an apt metaphor for James's career: continually evolving creativity undergirded by the constants of fit, movement, eroticism, and structural soundness.

He begins a project in connection with the Art Students League to build what he calls his "flexible sculpture." A dissected Jennie dress form with a flexible rod in the center, it can be manipulated to represent different postures (fig. 50). Its twofold purpose: to allow for greater customization to a couture client's posture and to help garment manufacturers create patterns that accommodate a wide range of postures and thereby provide better-fitting garments to a variety of people.

He also initiates the "Sound of Shape and Design," a project to tape-record friends, clients, and students to produce "a live documentation of Charles James['s] work and world, which will become a permanent record available to students of fashion design and after an interval of years, to writers who may desire to do research on the same."[105] About fourteen interviews are recorded.

1969 James organizes a grand multimedia retrospective, including eighty of his designs. Halston produces the event, which takes place in December at the Electric Circus, the hip nightclub on St. Mark's Place in New York's East Village. Longtime clients like the Countess of Rosse and Mary Hutchinson lend some of his earliest pieces, and Keith Cuerden, Nancy's former husband, choreographs and designs the sets with Antonio Lopez. Mrs. Michael (Betsy Pickering) Kaiser, a James client and benefactor of museum fashion departments, subsidizes the event. Social doyenne Patricia "Pat" Buckley has a pre-event cocktail party, even providing bus service to the downtown venue for her guests. The models, lent by Halston, walk the runway against a backdrop of enlargements of Lopez's drawings. At the end of the runway, a rotating platform glitters with mosaic mirrors; the models mount it to provide a 360-degree view of each design (fig. 51). Proceeds from the ticket sales go to Pratt Institute's engineering department, reflecting James's disappointment with the design department and his belief that his work is applicable to fields beyond fashion.

1970 Halston hires James as a "fashion-consultant engineer"[106] to help him improve the shape of his clothing. He provides James a small studio on his new premises, where James produces part of the collection for Halston's show in June. Fashion reporter Bernadine Morris comments, "The Jamesian notes were the gently flaring, wrapped evening skirts that turned out to be pants."[107] The association between former mentor and protégé does not last. From James's

fig. 49. This is James's most abstracted depiction of his Cocoon coat, a 1967 drawing in mixed media, including shoe polish. Subsequent silk-screen versions were titled *Meta Morphology*.

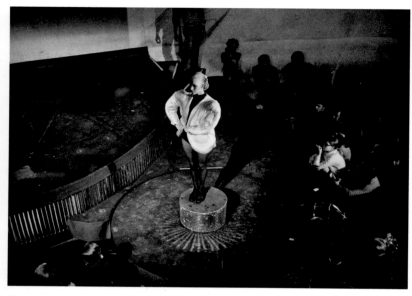

fig. 50. James's "flexible sculpture" is a dissected Jennie dress form showing cross sections of the body, ca. 1970. The white disks on the black boards are cross-section templates.

fig. 51. A model displays James's quilted eiderdown jacket atop a rotating platform at the Electric Circus benefit in December 1969.

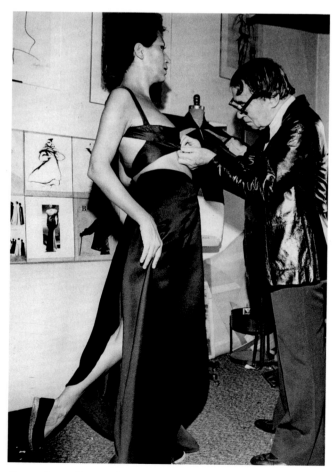

fig. 52. James fits a cupless bra and Figure-Eight skirt on the jewelry designer Elsa Peretti in early September 1978.

perspective, Halston is less interested in developing new ideas than in stealing his iconic shapes, while Halston finds James's process incompatible with fast-paced production demands. Notwithstanding the importance of Halston's original contributions to American style, much of his work, notably his bias-cut tubular dresses, angular necklines, and bifurcated skirts, undeniably is strongly influenced by James.

In the wake of the rupture with Halston comes a new disciple: Pratt design student Homer Layne. One of the few students to complete James's twelve-session seminar in the fall of 1970, Layne becomes James's right hand and friend. His dedication to James will continue for decades after James's death, as Layne personally preserves James's material legacy, settling upon a home for it at The Costume Institute at The Metropolitan Museum of Art in 2013.

1972 After several years of experimentation, including making sculptures to determine how the penis affects the fit of trousers,[108] James completes a unique design for unisex pants. Its diagonal waistline, slanting from back to front, accommodates waist sizes from twenty-four to twenty-nine inches. Over the next several years he will create two other innovative designs: a cupless bra that supports the bust through its bias cut rather than traditional cup shaping, and a blouse that unfurls like wings of a butterfly when worn. He works out the new designs by enlisting friends and patrons as fit models; among his favorites are the sculptor Elizabeth Strong de Cuevas and the jewelry designer Elsa Peretti (fig. 52).

1973 James and Beaton have kept up with each over the years, but James's increasing volatility has strained the relationship. He will never forgive Beaton for creating dress designs for Samuel Winston while James was embroiled in litigation against him, and his rage overflows when Beaton characterizes him as "embittered" in his diaries, published in 1972.[109] He sends Beaton a scathing eight-page letter of complaint, whereupon Beaton writes: "Such a pity he is so difficult because I would like to like him and feel he is a genius *manqué*."[110]

1974 James writes an autobiographical article, "A Portrait of a Genius by a Genius," for the July issue of *Nova*, a British women's magazine known for its intellectual content and radical politics. Accompanied by photographs and Antonio Lopez's drawings of some of his greatest designs, the summary of James's career is peppered with frank commentary from those who know him well. His former assistant Philippa Barnes is quoted: "Charles was a genius but impossible. He had his own ideas for designs and fitted them to the customers whether they liked them or not."[111]

1975 James is awarded a fifteen-thousand-dollar Guggenheim Fellowship to write a textbook on his techniques of dressmaking, the only fashion designer ever to receive the award. The proposed textbook, "Meta-Morphology—or Fashion Engineering Procedures," which he never writes, is to be a "Mathematical & Geometrical analysis of the shape of apparel as it relates to the body in movement."[112] Clients and prominent members of the contemporary art world, including

Richard Oldenburg, director of the Museum of Modern Art, and William Segal, publisher of *American Fabrics and Fashions*, had written in support of the fellowship. The artist Robert Motherwell, who had served on the Fellowship Committee, later states: "I have never met him. I don't particularly need to, but I think Charles James is a genius.... The drawings which he submitted were more powerful and more to the point, than any of the works submitted by so-called 'regular artists,' that is, painters and sculptors."[113]

With the assistance of Homer Layne and other friends, James mounts an exhibition at the Everson Museum of Art in Syracuse, New York. It includes more than two hundred of his original drawings supplemented by photographs of his work, sculpted jewelry molds, a Butterfly sofa, and fifty Antonio Lopez drawings of his designs.

Also this year, publicist R. Couri Hay and filmmaker Anton Perich commence a video project to document James's work. Over the next three years they will produce sixteen hours of interviews with James and his friends. During that period, James continues to work—doing fittings and advising students and other visitors—within the confines of his Chelsea Hotel rooms, accompanied by his beagle, Sputnik, the last of his many canine companions.

1978 In September James falls ill, his body weakened by years of drug dependency and irregular living habits. As it happens, Hay and Perich's documentary about him is airing on cable television in New York City at this time. After several days in bed he is taken by ambulance to Cabrini Medical Center on the evening of September 22—but not before keeping the ambulance attendants waiting as he freshens up his appearance. In response to their inquiry about his identity he announces: "It may not mean anything to you, but I am what is popularly regarded as the greatest couturier in the western world."[114] James succumbs to bronchial pneumonia and arteriosclerosis at two o'clock the following morning.

A press strike on the day of his passing deprives James of a nationally distributed obituary, in keeping with his lifelong frustrations about obtaining appropriate recognition. Bill Cunningham takes up the slack. In a tribute published in the *Soho Weekly News*, Cunningham heralds James as "the poet laureate of American fashion."[115]

Years later Austine Hearst sums up the paradox of James's career: "His greatest of many mistakes was to have wished to make a fortune in a business which in the United States could barely provide a living.... He wasn't trained or temperamentally suited for Seventh Avenue any more than Michelangelo would have been to fashion photography."[116]

But leave it to James to have the last word on the meaning of his work and on the life-giving power of the creative process: "There is no short cut to creation. There may also be no profit in it. But the search for the idea itself, found after a long exhausting struggle, the idea which stands on its own merits throughout time, that is RADIUM."[117]

HAROLD KODA

THE CALCULUS OF FASHION

Process and Oeuvre

Charles James believed that his idiosyncratic study of the body and of dress could be an invaluable tool for future designers. In the late 1940s he began to archive his pattern pieces, muslins, and finished garments to illustrate his developmental process, and he directed them, often through his best clients' donations, to the Brooklyn Museum. When he closed his salon in 1958 he came to a somewhat different view: Rather than train the designers, it might be more effective, in the context of mass manufacturing and the ready-to-wear business, to expose the trade's artisans— the sample makers—to the techniques of the haute couture and custom dressmaking.

"Original styling is the work of a few rare artists," he said at the time. "But most of what is known as design today is really adaptation, and we are dealing mainly with artisans who make what another has originated. . . . Without these artisans fashion couldn't operate as a mass production industry, and it is important to have thinking minds among them."[1] To rectify what he believed were the deficiencies of Seventh Avenue, in 1960 he devised a seminar called "The Calculus of Fashion" with Robert Riley, curator of the Brooklyn Museum's Design Laboratory. "No one has had any training in anything except stealing and sloppy copying," James said. "Since they must copy, I am concentrating on the artisans who do the adapting, and giving them good, scientific schooling. After all, knocking off is a science."[2]

In framing his ideas as science, James embraced the empirical and rational aspects of his transformation of two-dimensional cloth into three-dimensional form. It was a science largely of his own invention, although he had spent some time in 1932 in Paris studying with or exposed to the practices of an haute couture atelier. While he mentions deploying classic dressmaking techniques—working on a sleeve *à cheval* or executing a *calage*—his methods are frequently at odds with common practice. He does not begin with a sketch, in the way of many couturiers. Because his designs are essentially imagined, then constructed with his own hands rather than executed by others, there is a quality of spontaneity to their resolution. Any "science" is primarily a tool for his intuition.

Because James created for a private clientele, which required individualized fittings, his understanding of the body accrued over time, with exposure to an individual woman's specific shape as well as to the female form's more universal contours. In 1949 he developed a dress form that he said "strikes a good anatomic average of a woman. Its actual dimensions are the same as an ordinary dummy, but they are differently allocated, with a more realistic relationship between width and depth."[3] The science he would seek to convey in his seminar a decade later thus began with a much earlier reconsideration of the body. The final result, a summation of James's research and ideas about design predicated upon anatomy, was a slightly elongated torso with a V-shaped front and back waist and elliptical, rather than conical, breasts (fig. 1).

James also sculpted a full-length mannequin while developing his Butterfly gown in 1954 (fig. 2). It is significant both as evidence of the James ideal and as the structural form upon which he realized his designs. Among its most notable attributes are a convex abdomen, a tucked derriere, and a plane across the shoulder blades that extends farther back than the buttocks. Its stance is similar to the corseted upper torso of a fashionable woman of the 1890s.

Nevertheless, James recognized that women's posture changes over time and across cultures, noting that the 1950s American had an "erect, courageous 'chin-up' look" while the

fig. 1. James using calipers to measure the dimensions of his custom dress form. Photo by Bill Cunningham, ca. 1970

fig. 2 (opposite). Full-length forms made to the shape of Charles James's Butterfly gown, ca. 1954. The white one is plaster-covered papier-mâché, wood, and metal. The blue form is papier-mâché and metal.

fig. 3. James demonstrating his "flexible sculpture," created to study the effect of posture on fit. Photo by Bill Cunningham, ca. 1970

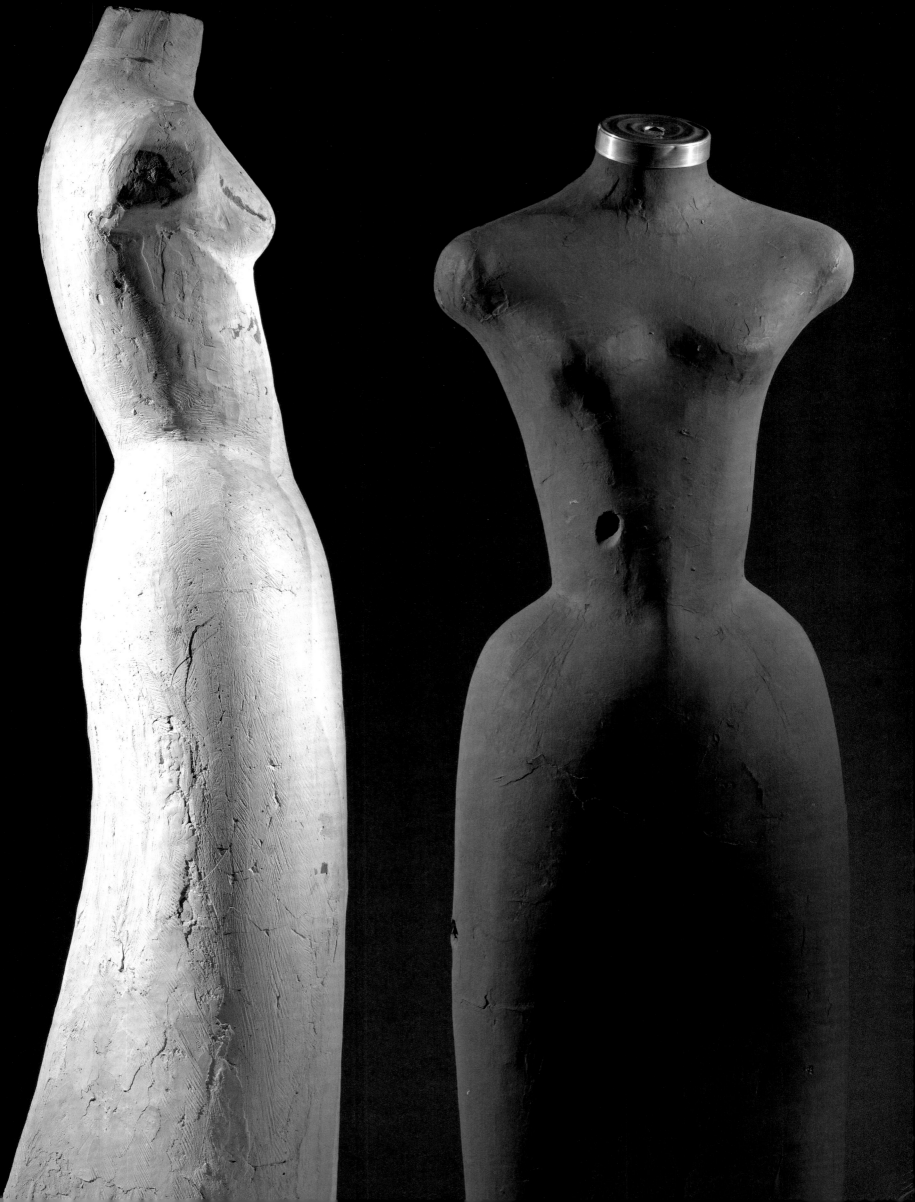

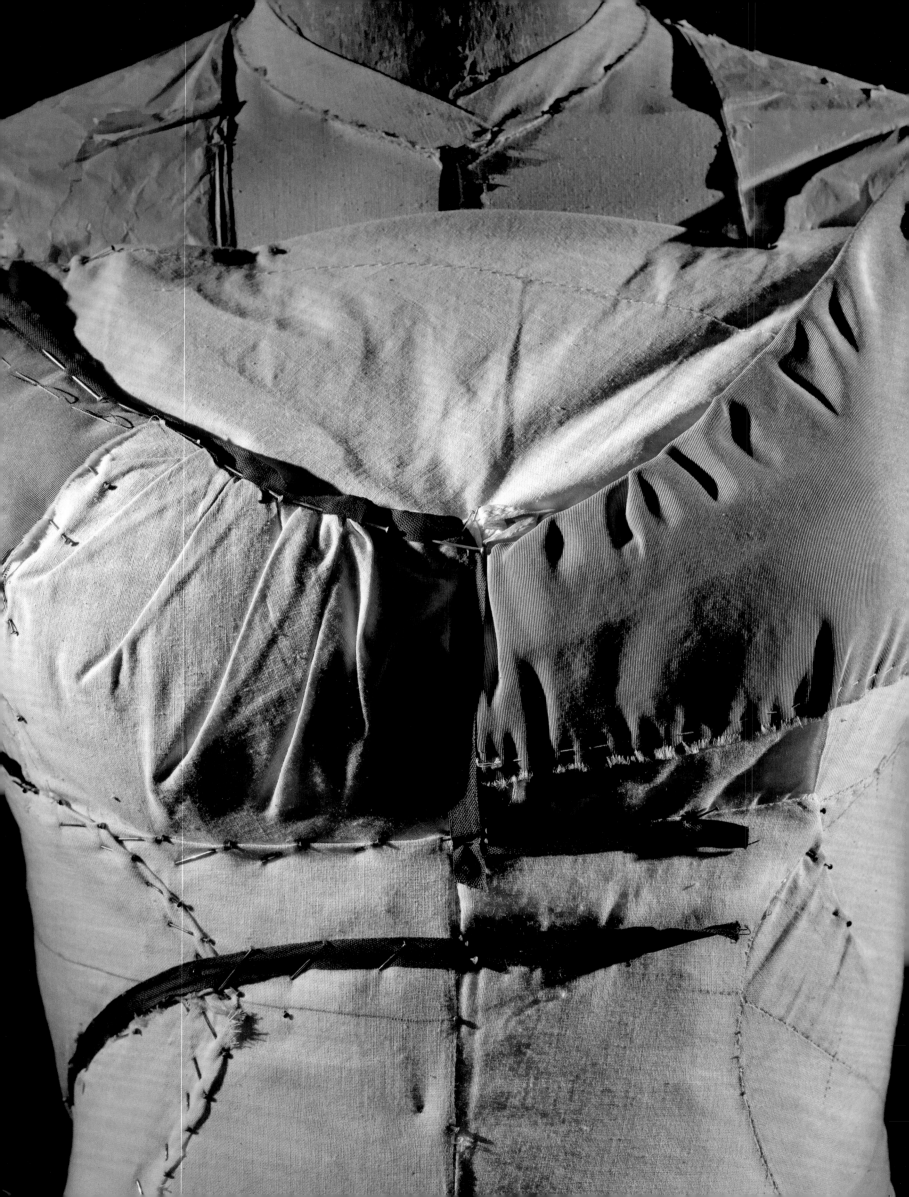

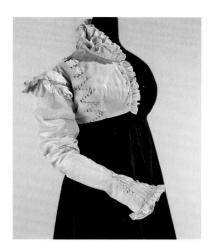

fig. 4. This half-sewn muslin bodice is a direct copy James made about 1950 from the bodice of a ca. 1820 dress à la Hussar that Austine Hearst donated to the Brooklyn Museum collection.

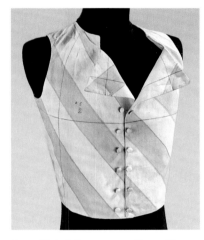

fig. 5. This full-sewn muslin vest is a direct copy James made about 1950 from a ca. 1820 man's silk vest donated by Austine Hearst.

fig. 6 (opposite). James made this dress form, padded out into his Empress Josephine, or Empire, bodice shape, about 1956.

French, with their lower bustline and tucked-in derriere, had a "'look of capitulation.'"[4] Given the transience of fashionable posture, he believed his ideal form would require updating every ten years or so. In fact, sixteen years after developing his dress form he used it as the basis of a "flexible sculpture" to study how various postures affect fit. A series of photographs by Bill Cunningham documents how James articulated the form by cutting through the torso with metal plates at different points and inserting a flexible rod through the center, allowing him to manipulate the torso as if it had a spine (fig. 3).

Although his work was characterized by innovation and continuous refinement, James was fascinated by historical precedent. In the 1940s Austine Hearst supported his interest by acquiring nineteenth-century dresses, including Directoire and Empire examples, for him to study and replicate (figs. 4, 5). The foundation of his characteristic high bustline was related to the bodices of gowns from the early nineteenth century (fig. 6). Cunningham described seeing the designer and Lady Diana Cooper rushing up the stairs of The Metropolitan Museum of Art with the elbow joint from a suit of armor to discuss movement with the curator of Arms and Armor.[5] But if earlier dress informed his ideas and tradition enthralled him, he rarely suppressed his impulse for radical revision and personalization. Precedent for James was only a beginning and never inviolate.

That is clearly seen in his creation of the "perfect" tailored sleeve, which he claimed took years and twenty thousand dollars to develop. His design shares a high-cut armhole and sleeve silhouette with both military jackets and women's garments of the 1860s, but with a critical difference. In conventional tailoring the straight grain of the sleeve is established at the top of the armhole and drops in a plumb line to the wrist or cuff; in James's permutation the straight grain originates at the two o'clock point of the armhole, and the grain at the apex therefore deviates forward—thereby acknowledging and accommodating the natural angle of the arm at rest, which is generally canted forward.

Like any artist, James worked signature elements into his designs, resulting in a strong stylistic autograph. The aesthetic markers that make a James a James are underscored in the following illustrations of his extraordinary creations, which are grouped by their primary construction and technical approaches: spirals and wraps, drapes and folds, anatomical cut and platonic form, and architectural shaping. Although James often combined a number of his distinctive approaches in a single piece, the classification by each design's foremost focus illuminates his creative process and the leitmotifs that appear throughout his career.

Each of James's designs was an expression of his restless experimentation and endless research. Although his technical and computational models led to innovations, some quite eccentric, each discovery inevitably yielded further questions. Every creation was in a state of transitive resolution, retaining the potential to be revisited, refined, and perfected. James's science of fashion, fixed in its principles, resulted in a fluid, ever-evolving art.

SPIRALS & WRAPS

Early in his development as a designer James established a hands-on approach to dressmaking, directly draping fabric on the human form. Like Paul Poiret, the master of haute couture of the first two decades of the twentieth century, and the designer Madeleine Vionnet, who pinned her muslins on a half-scale doll mounted on a rotating piano stool, James reveled in the sculptural possibilities of cloth; his eccentrically shaped pattern pieces made for maximal three-dimensional effects. His interest in manipulating the fluid qualities of cloth is apparent in his development of the concept of a continuous run of fabric that spirals around and cleaves to, or on occasion takes flight from, the body.

In the early 1930s James promoted a garment that had evolved from one of his ideas of the 1920s, a dress that undid itself with such ease as to allow disrobing without having to pull the piece over the head. He dubbed the design his Taxi dress, provocatively suggesting that a woman could slip out of it even in the confines of a cab. The image of someone unzipping herself from a spiraling panel of cloth was inspired public relations—James was ever the savvy promoter—but the design was also an example of James's penchant for the new. Here was a completely original wrapped garment that had no side seams, employed a technical novelty, the Lightning Zip, and rendered the recto-verso aesthetic of the 1920s chemise obsolete.

The Taxi is James's archetypal spiral; its 360-degree spiraling construction informed much of his work throughout his career. In examples that pre- and postdate the Taxi, James angled his fabric to wrap the body and articulate its curves through the displacement of the straight grain into bias. Certain details—for example, a deeply angled neckline skewed toward the underarm, or the tapered sleeve of a one-armed garment—are the direct consequence of the designer, uninhibited by the codified practices of traditional dressmaking, working fabric around the body.

James subtly employed the spiral in much of his work from the late 1920s through the 1930s, resulting in supple, languorous sheaths, but the postwar period witnessed a dramatic new dynamism in his silhouettes that made his spiral construction more readily discernible. By using fabrics with a stiffer hand than those of the prior decades, he was able to express vividly the calibrated vortex of his pattern pieces. His evolving interest in structural forms that extend the outlines of the body is seen in cycloning necklines with freestanding wings and skirts unfurling from a tapered core. The James spiral designs, whether languid and body conforming or exuberant and sculptural, reveal the designer's passion for a direct physical engagement with his materials. Nowhere is James's hands-on process, with its seemingly improvised refinements, as immediately apparent as in his wrapped and spiraling works.

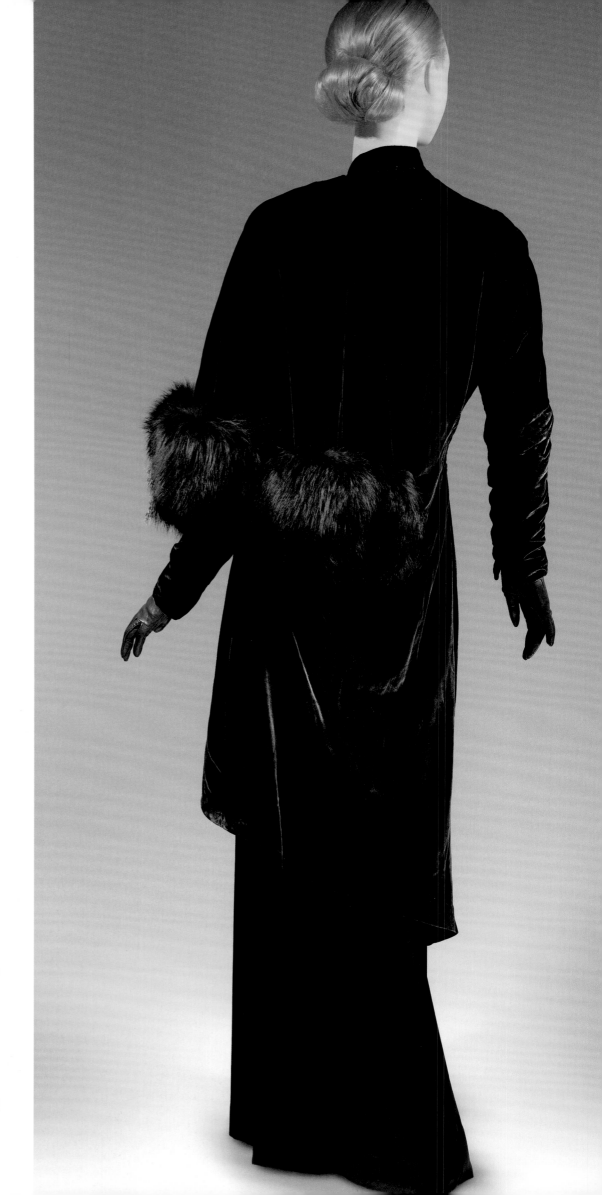

Evening Coat, late 1920s–early 1930s. *Black silk velvet and fox fur*

This elegant minimalist construction is the earliest example of James's spiral draping in The Costume Institute's collection. The main body of the coat is one piece of silk velvet, horizontally wrapped counterclockwise. The long sleeves are a simple raglan construction with a triangular, fur-edged piece contour-seamed to the coat's body along the shoulder line. The piece is balanced and draped to give the impression from the front of a wide-cuffed sleeve and, from the back, of a scarf.

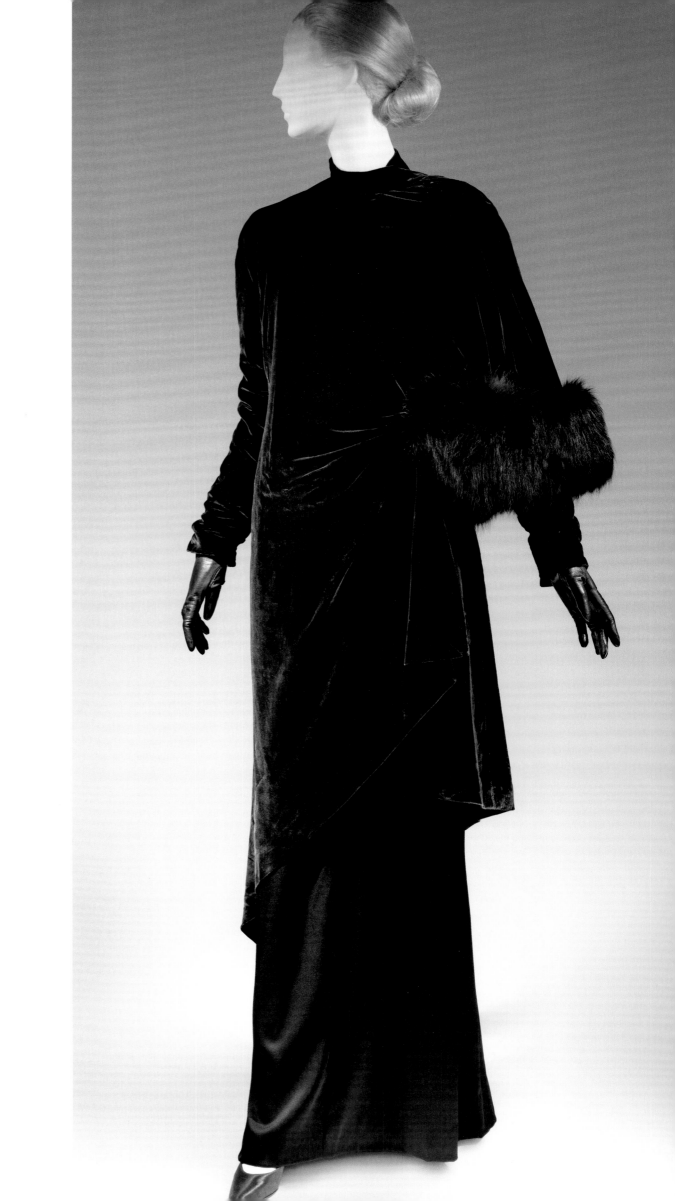

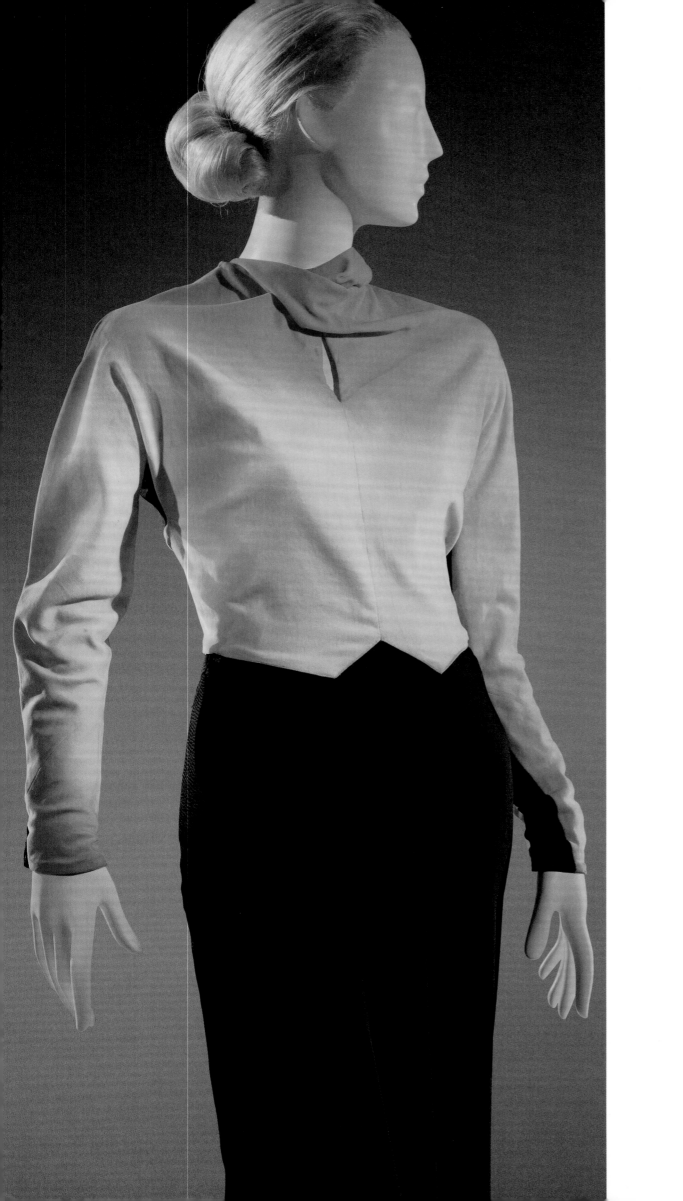

Day Dress, early 1930s. *Black silk crepe and ivory cotton velveteen*

In this long-sleeved example of his trompe l'oeil gilet (or vest) dress, James extended the front neckline in two triangles to crisscross like a softly draped scarf. The ivory velveteen front bodice panel extends across the small of the back to form a surplicelike waist cinch. The sleeves, velveteen at the front and black silk crepe at the back, are stitched into a wide flange that runs from the elbow to the back neckline and folds over at the shoulders. This was likely one of James's four day dresses for Viyella.

above: A model wears a similar two-tone silk crepe day dress that James designed for Viyella. Photo by Howard Coster. *British Vogue,* March 22, 1933, p. 88

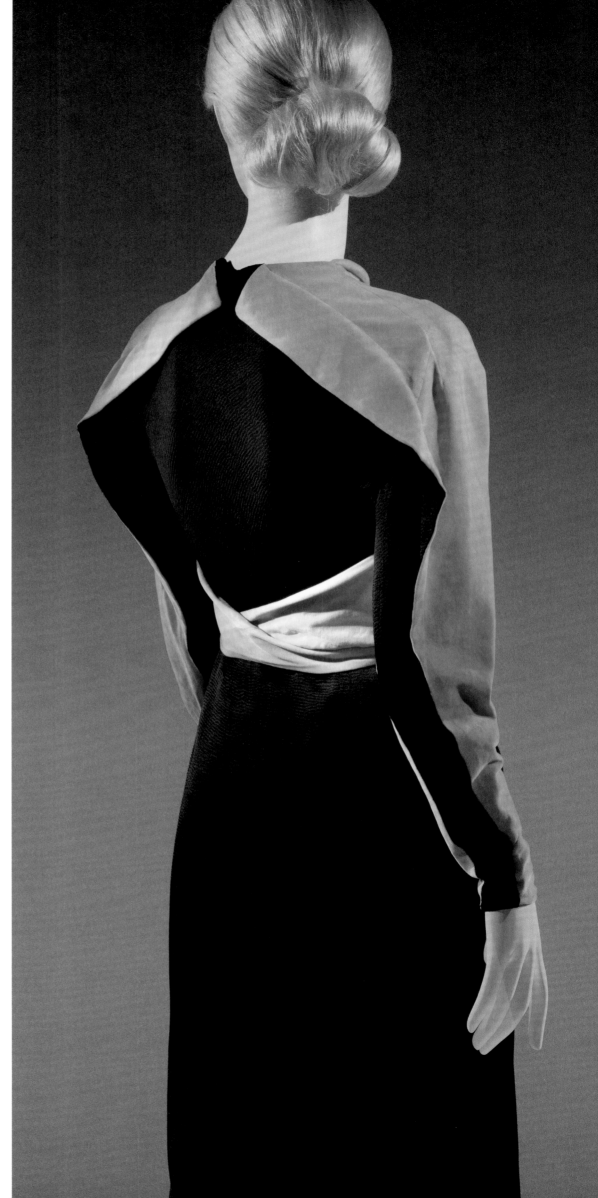

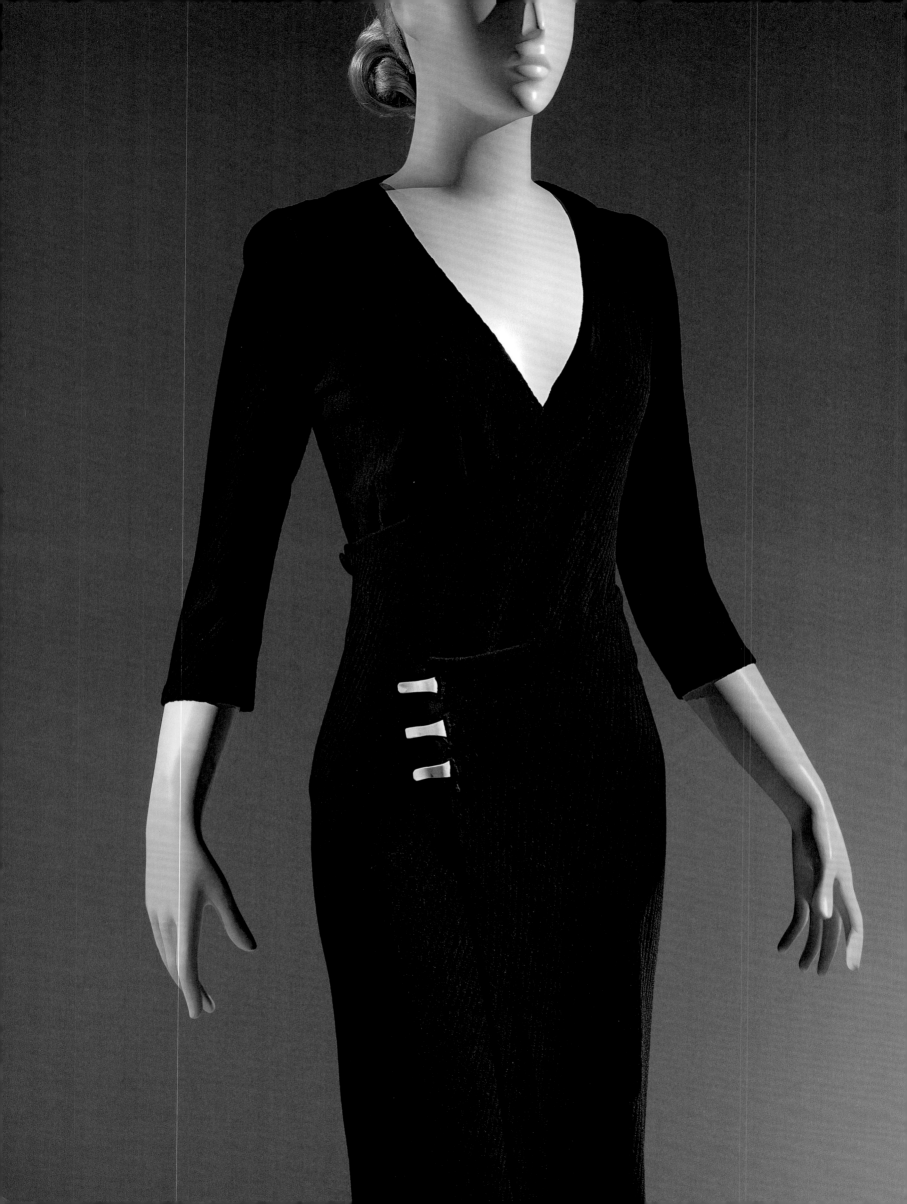

"Cut in dressmaking is like grammar in a language."

Taxi Dress, ca. 1932. *Black wool ribbed knit*

James considered this dress one of his most important designs, both commercially and artistically. Though difficult to manufacture—one side of the top and the spiral wrap-over skirt being made without seams—it was the first dress to be sold in a department store's accessories department, along with sweaters, in sealed cellophane packages. It was made in two sizes and sold at Best & Co. in 1933–34 for twenty-two dollars. James conceived the spiral design in 1929, and this sample piece in a novel ribbed wool appears to date from before his commercial version for Best's, exemplifying how the designer continuously refined his ideas.

above: Two views of a sketch by Charles James, ca. 1967. Ink and shoe polish on paper, with hinged paper flaps (one missing). The view on the right, with the paper flap open, illustrates how the wraparound piece overlaps in front to fasten with clips.

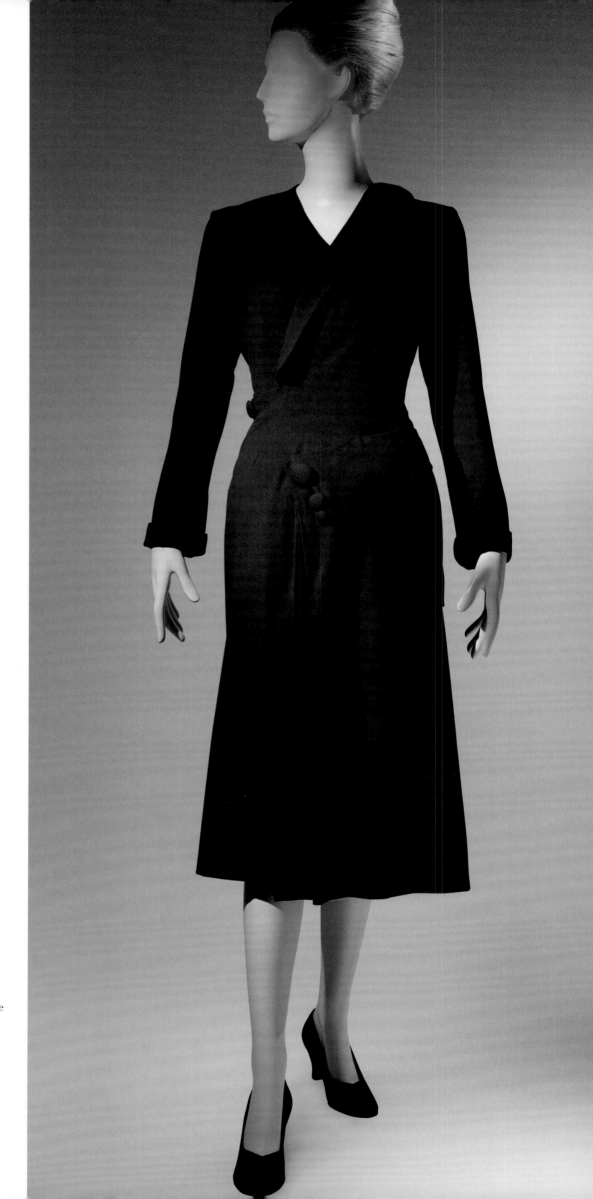

Dress, ca. 1950. *Navy brushed wool twill*
A James pattern is challenging to understand,
not because it is complicated but because it defies
convention. This dress demonstrates his impulse to
eliminate superfluous cut lines and, when possible,
merge separate pattern pieces into one. Its two-piece
skirt has one center back seam. James eliminated
the right back waist seam, resulting in an eccentric
construction where the left bodice is a continuation
of the right skirt panel. Graduated buttons, a
curved lapel, and a single patch pocket shaped like
a reversed apostrophe are the only ornament other
than the arcing seams.

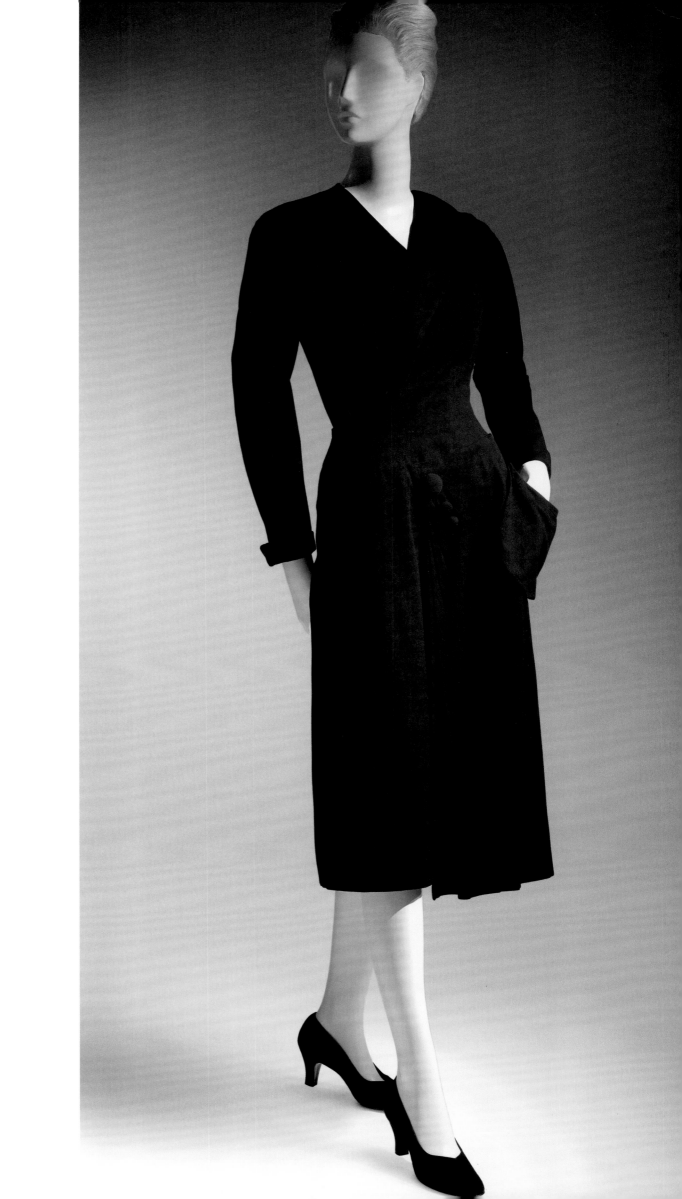

"To my knowledge it [the Taxi dress] was the first fashionable use of Zipper . . . hitherto mostly relegated to use on tobacco pouches and similar products."

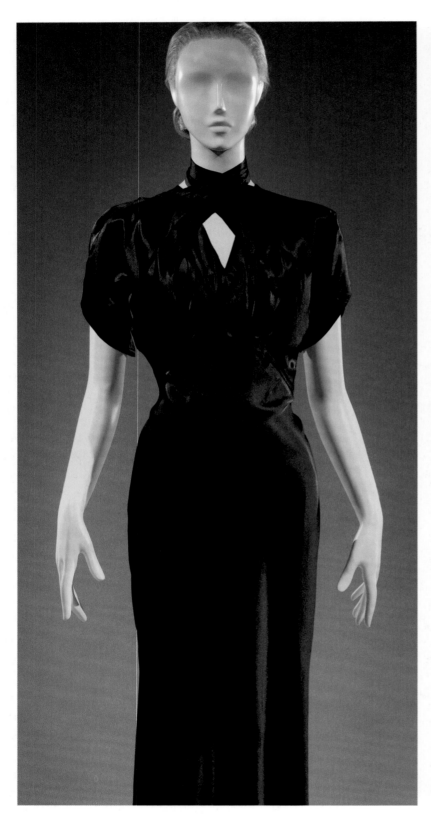
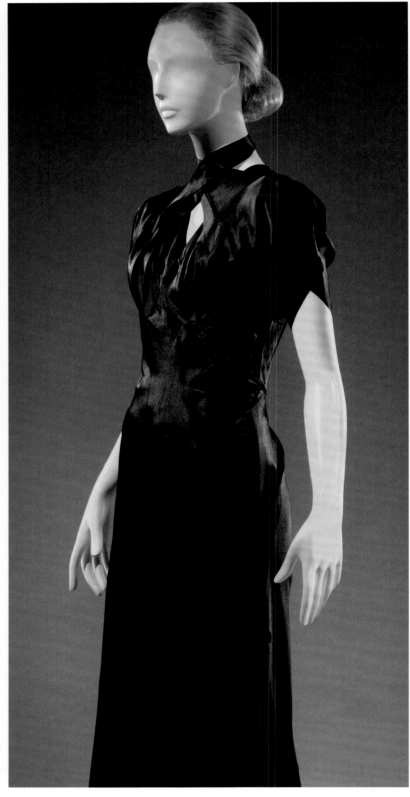

Cocktail Dress, 1933. *Black silk satin*
A black metal zipper at the left side of this elegant dress emphasizes the oppositional spiraling seams that crisscross from the front neckline, continue around the waist, and meet at the center back. Crisscrossing folded extensions of the front bodice pieces continue the theme and form the high-throated neckline. In other James designs, similar wrapping elements of the front bodice serve as a neckerchief-like drape or a more conventional halter. *detail:* Left side waist

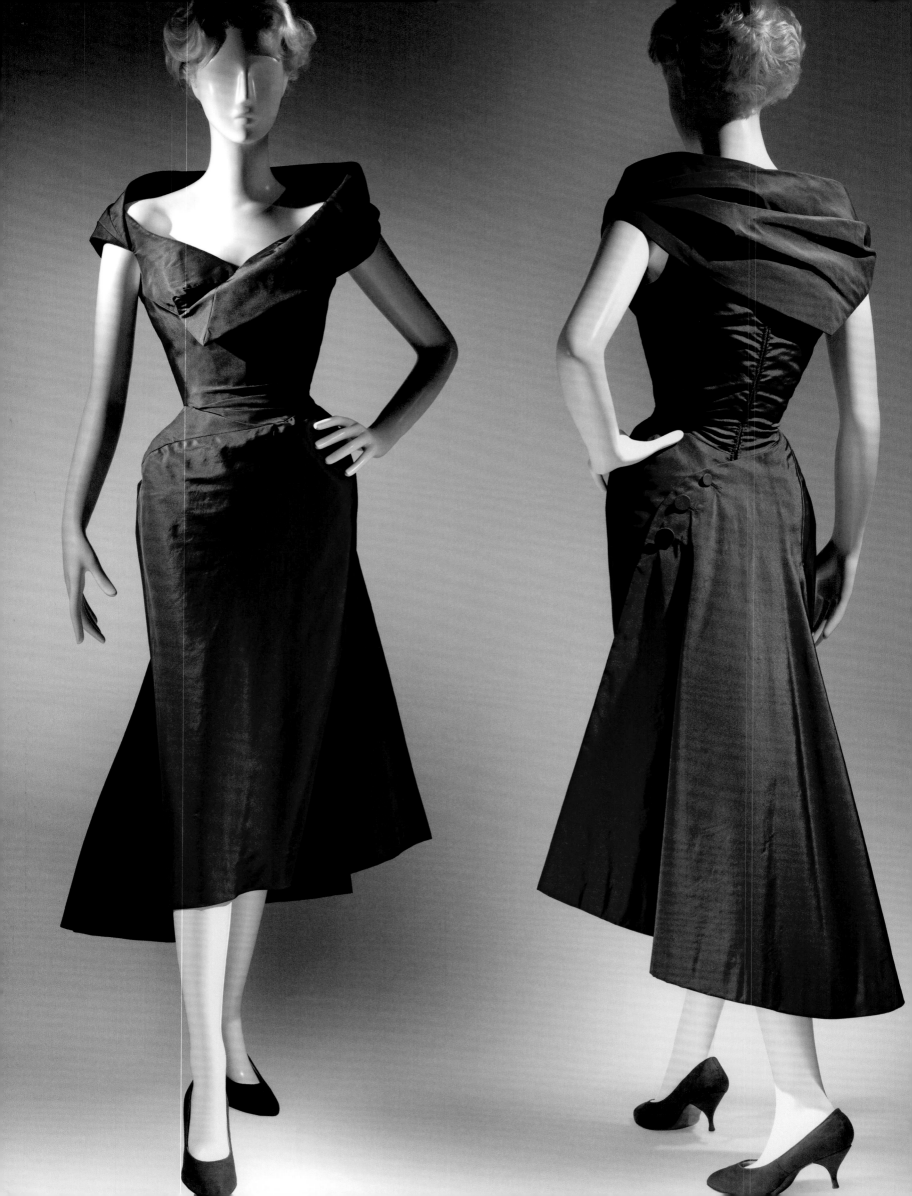

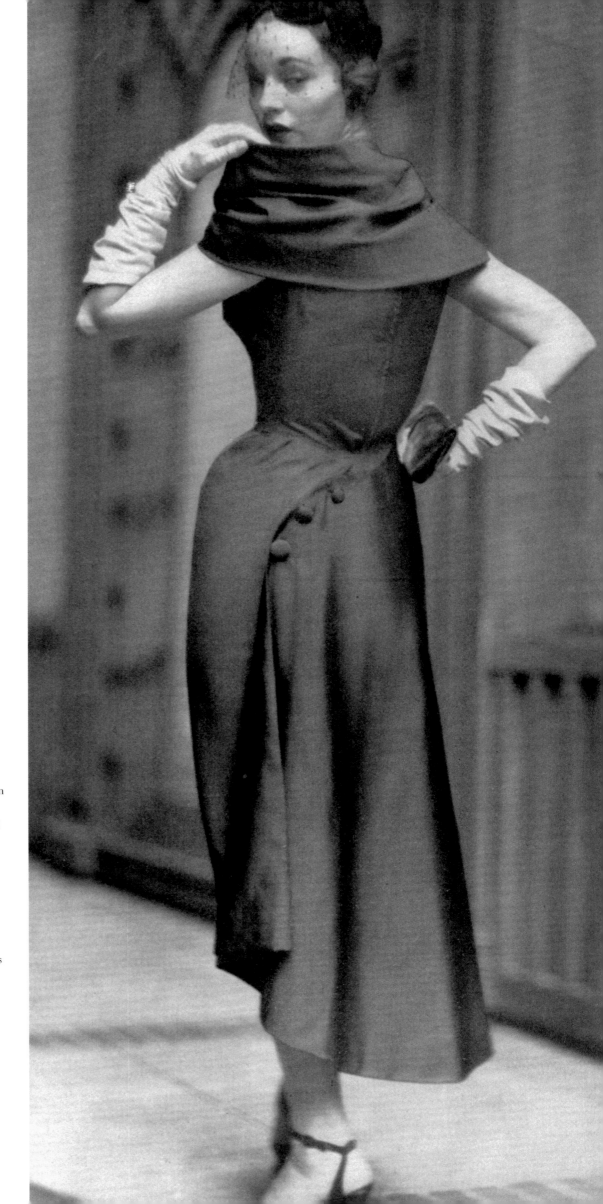

Dinner Dress, ca. 1950. *Brown silk faille*

The bodice of this dress is asymmetrically draped to form a diagonal neckline with the effect of a stole at the back shoulders. Although the bodice is built on a symmetrical understructure, the grain of the fabric angles off the straight grain at the center back and joins the side seams in what James called the "A grain." By introducing the bias, James eliminated the need for darts. The skirt has no side seams, except for a join seam to extend a panel forming the flared, curve-hemmed back. Its center front is true bias. Exploiting the elasticity of the bias, James cleaved the fabric to the waist while introducing fullness at the hips to diminish the wrinkling across the lap that occurs when sitting. This dress served as the prototype for one of twenty designs James adapted and sold to Ohrbach's in 1950. In 1951 its pattern was sold to Lord & Taylor and was the basis for commercial applications of asymmetrical dresses and the use of "off-grain" cuts.

right: The model's pose emphasizes the dress's dynamic spiral cut. Photo by Frances McLaughlin. *Vogue,* November 15, 1950, p. 79

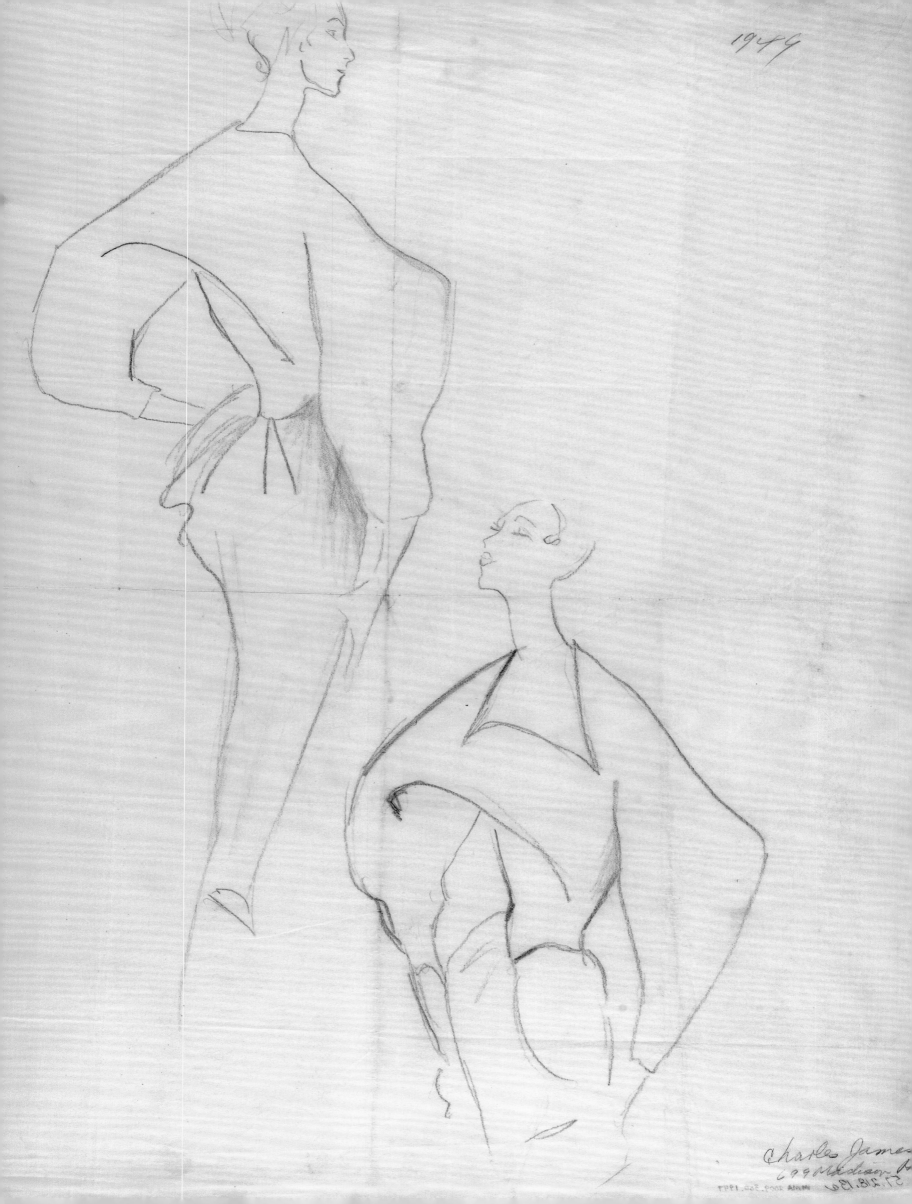

1949

Charles James

"You can't really tell why it's erotic—it's the mystery that makes it good. It has to do with the movement of a dress."

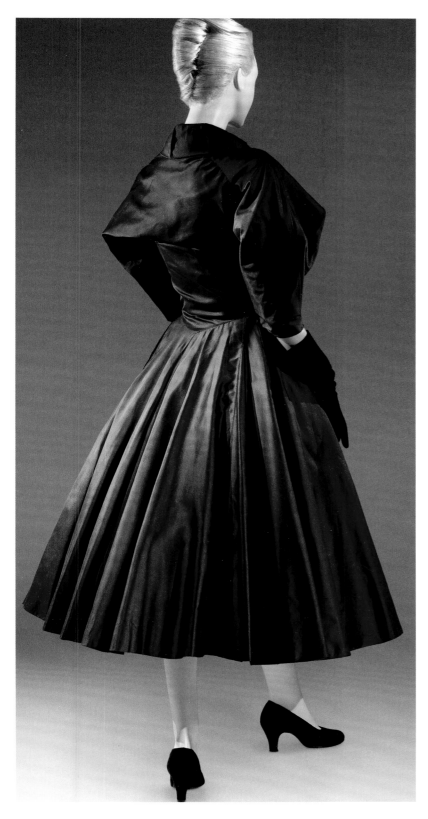 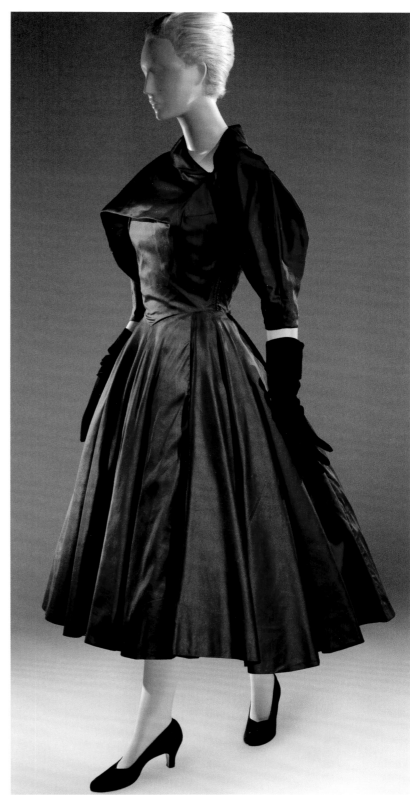

Dinner Dress, 1950. *Dark red silk taffeta with black pinstripes*
This design was worn by one of James's most important clients, Millicent Rogers, a woman of exceptional chic. The asymmetrical neckline, a James signature, is formed by two interlocking pattern pieces. The front bodice extends to form the upper right sleeve, and the back bodice extends to form the upper left sleeve, each with such an excess of fabric that a deep horizontal fold across the bust and shoulder blades creates a loose yoke effect. The waist seam, pointed at the center front and curving low at the back, is typical of James, who asserted that a straight line cutting across the waist did not reflect anatomical reality.

opposite: Sketch by Charles James, 1949. Graphite on paper

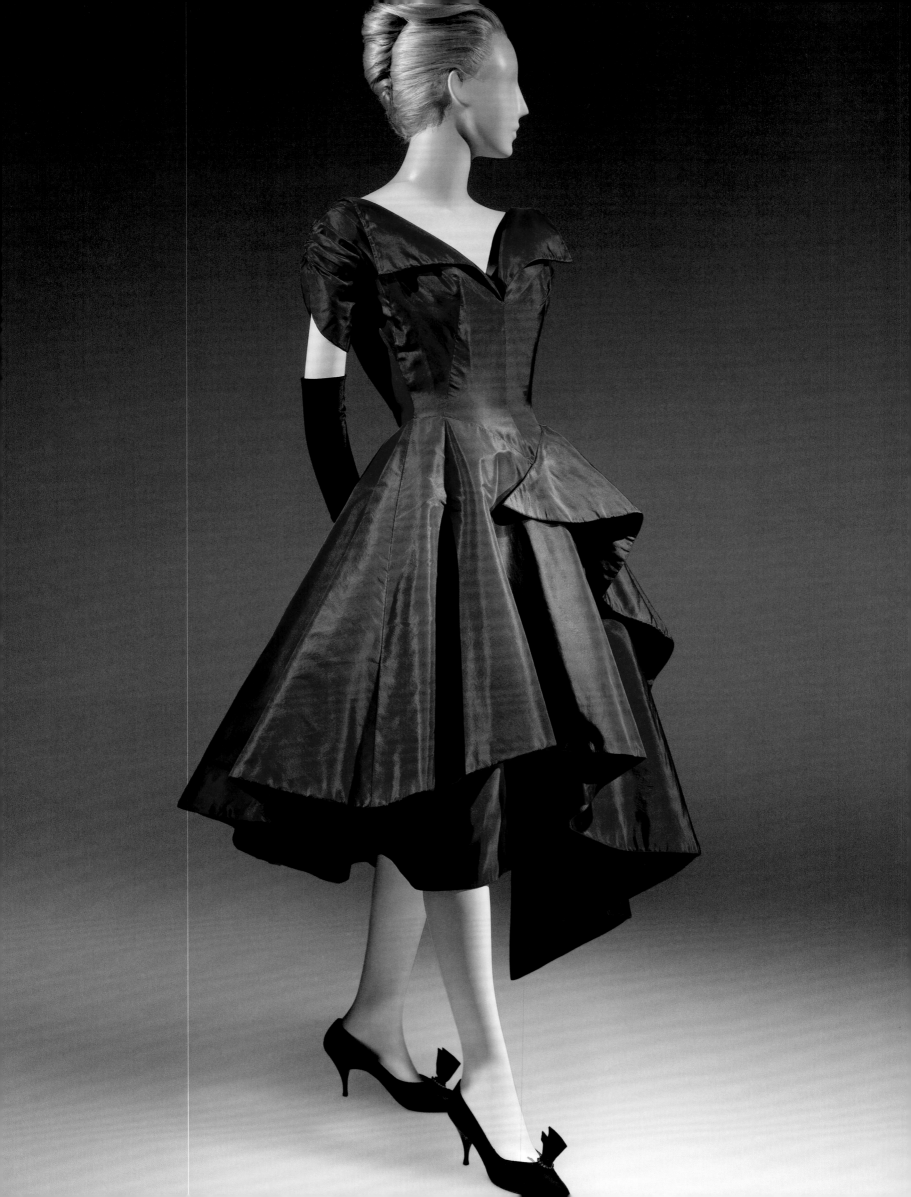

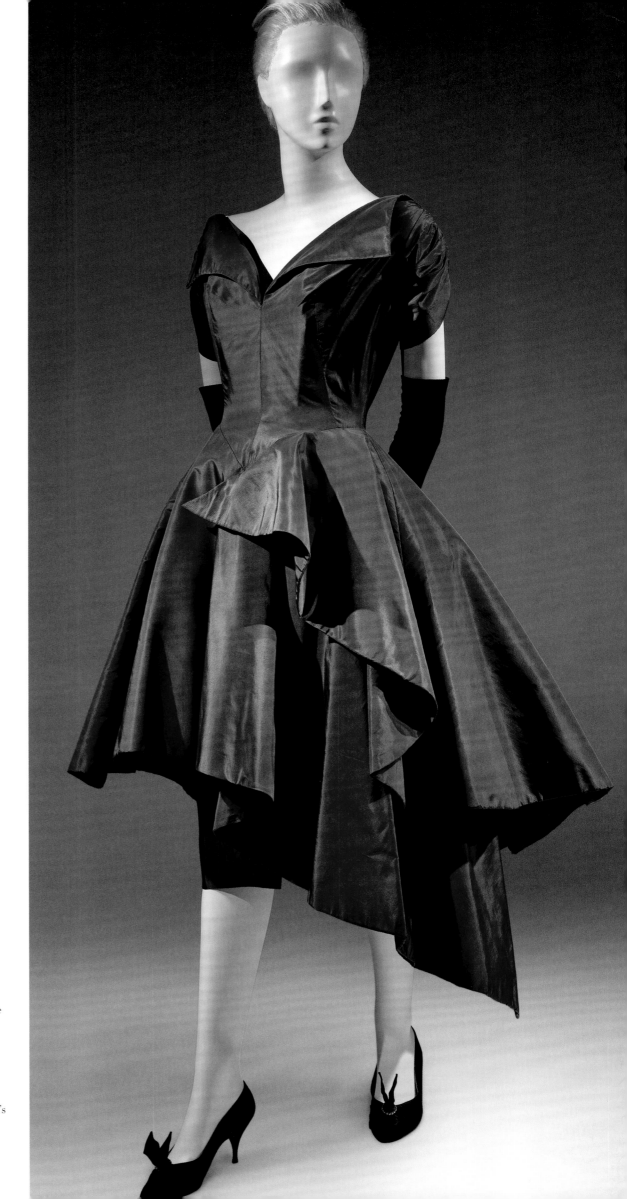

Dinner Dress, 1952. *Brown silk taffeta*
The skirt of this dress is an especially exuberant
rendering of James's spiral draping. He cut away the
below-knee-length hem as it winds clockwise over
itself, terminating in a disengaged point at the left
front waist. The narrow underskirt, barely visible,
suggests a continuation of the spiral but is cut
separately. By exploiting taffeta's natural body and
ability to hold its form, James exaggerated the skirt's
animated and layered effect.

"Elegance is not a social distinction but a sensual distinction. The mind combines with the body to exploit its senses, its functions, its appearance."

Evening Dress, 1932. *Black silk-rayon satin-faced chiffon crepe*
James excelled at the implementation of bias but often deviated from the use of "true" bias, or the angling of the fabric forty-five degrees. In this rare instance he deployed it, exploiting the natural draping qualities of the supple satin-faced chiffon crepe. The dress's surplice top has an extended shoulder line, creating the effect of cap sleeves. Rather than a shoulder seam, James used a short neckline dart, leaving the body of the sleeve undisrupted. The skirt's center front and back seams both originate from the hem to split in a Y at the pelvis. The resulting extensions are two sets of crisscrossing waist ties that cinch the gown with small bows ending in asymmetrical streamers. The designer was especially proud that the dress, made in two sizes, accommodated a wide range of figures.

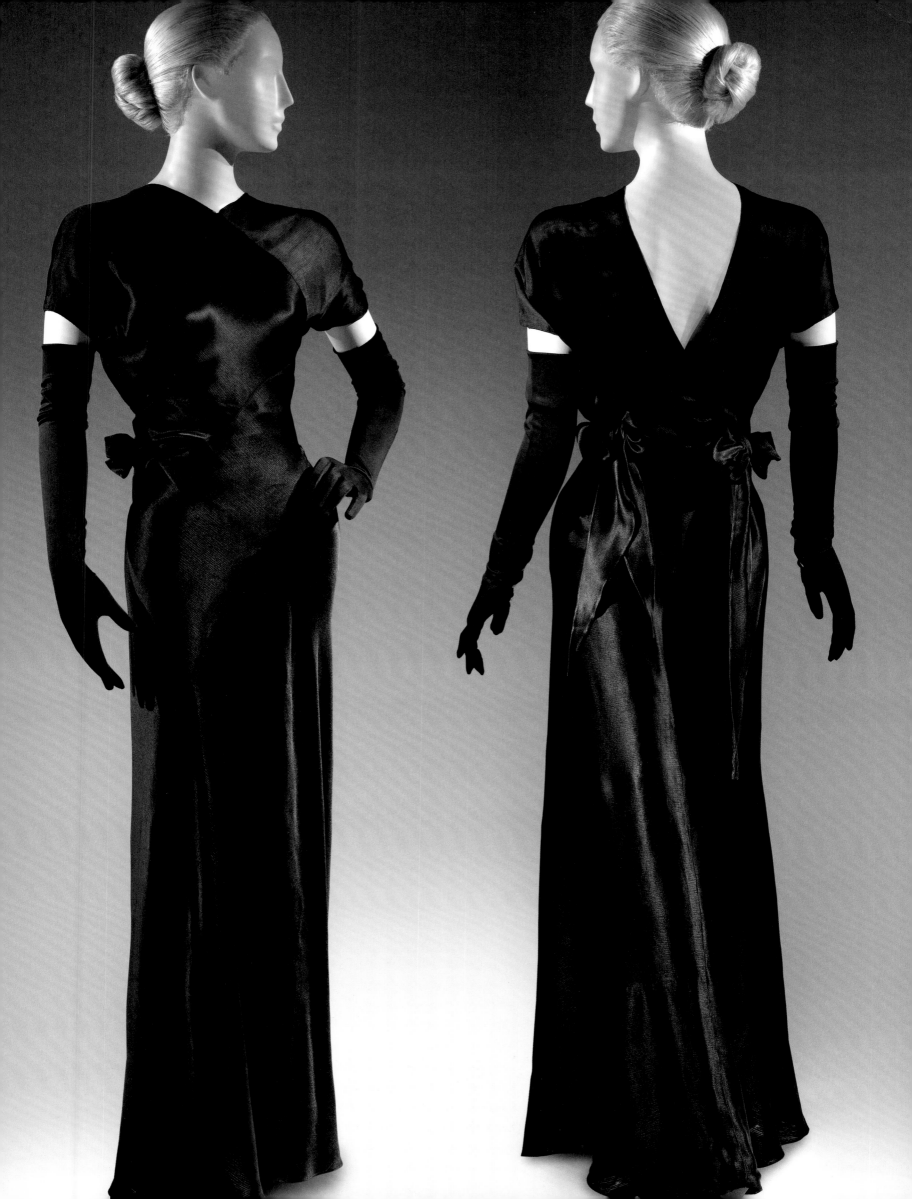

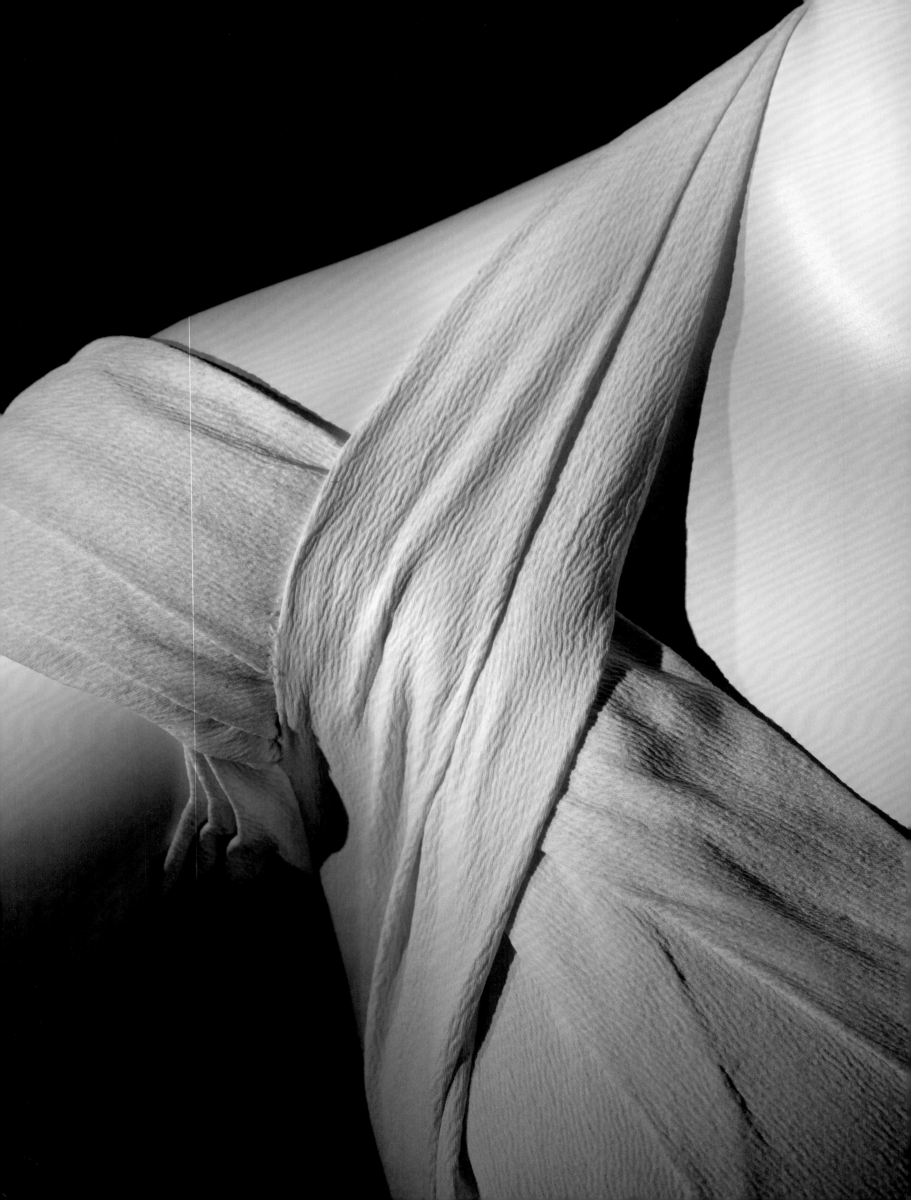

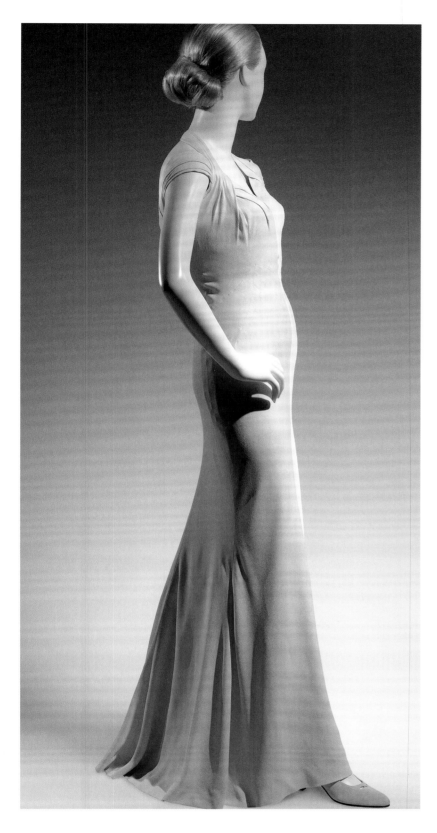
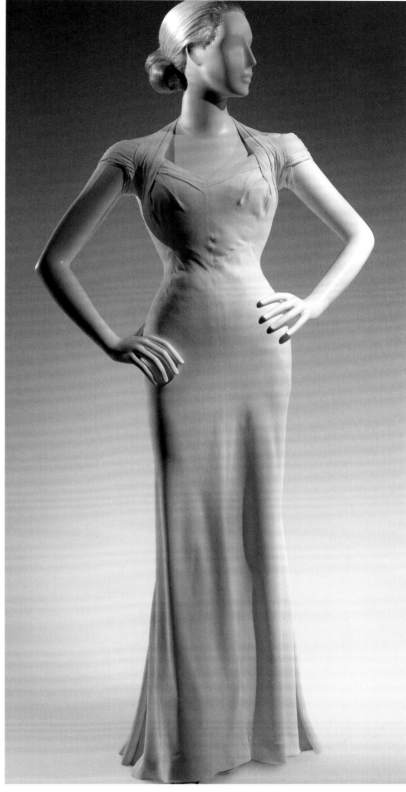

Evening Dress, 1933. *Ivory rayon pebble crepe*

James, a piano prodigy, manipulated favorite arrangements of structural details into varied compositions, much like musical themes and variations. The neckline, halter, and cap sleeves of this lithe crepe dress are a riff on the designer's predilection for splitting and overlapping pattern pieces and their extensions. As opposed to the soft bias flutes of its skirt's flaring hem, the flattened pleats that loop around the neck and spiral over and under the cap of the arm introduce a crisp discipline to the dress's otherwise languorous lines. *detail:* Right front shoulder

Scarf Evening Dress, 1937–38. *Black silk crepe*
This dress with an integral scarf is draped on the
semi-bias, with a diagonal seam across the front
from underarm to knee. The seam begins several
inches forward of the usual side seam. That subtle
shift appears to narrow the bodice and skirt panels
and thus became known as the "false profile" seam.
The individualized fit of the unforgivingly narrow
sheath was achieved by first making a conventionally
cut organdy undersheath to the client's dimensions
and proportions. The crepe was then draped and
manipulated through *calage* (molding by pressing,
pulling, and steaming the cloth "off-grain") to
conform to the undersheath's measurements.
In 1976 a popular design by Halston incorporated
James's asymmetrical neckline, formed when the
scarf wraps over the shoulder.

above: Sketch by Charles James, ca. 1973. Ink and
correction fluid on paper
far right: The Scarf evening dress, illustrated
front and back, appeared in the quarterly fashion
magazine published by and sold exclusively at
Marshall Field's, Chicago. Illustration by Jean Pagès.
Fashions of the Hour, Spring 1934, p. 9

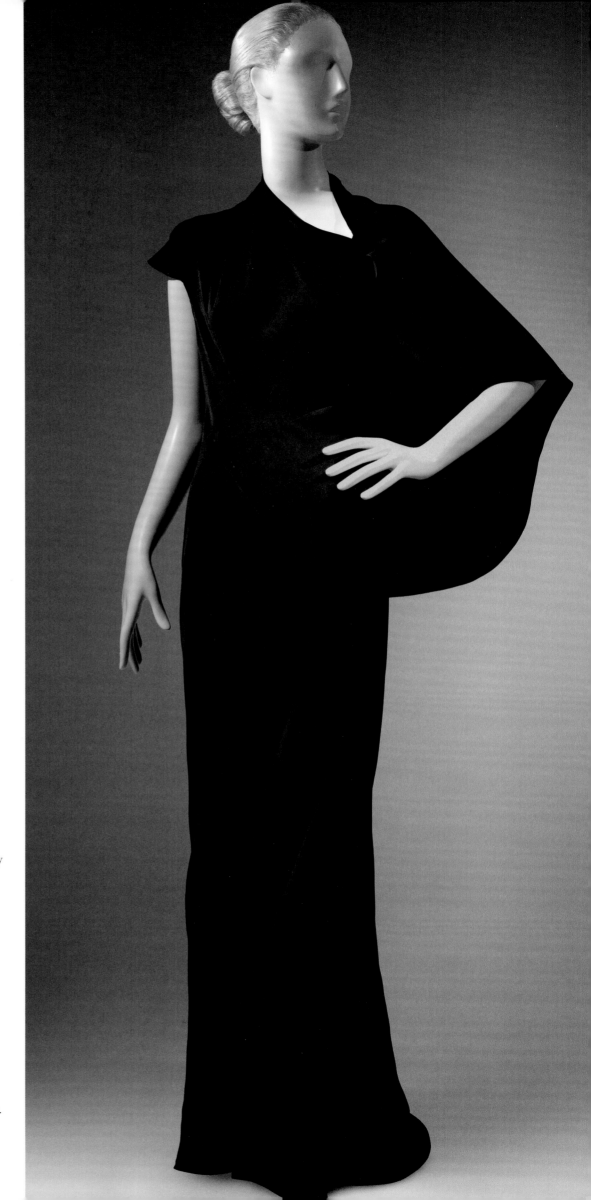

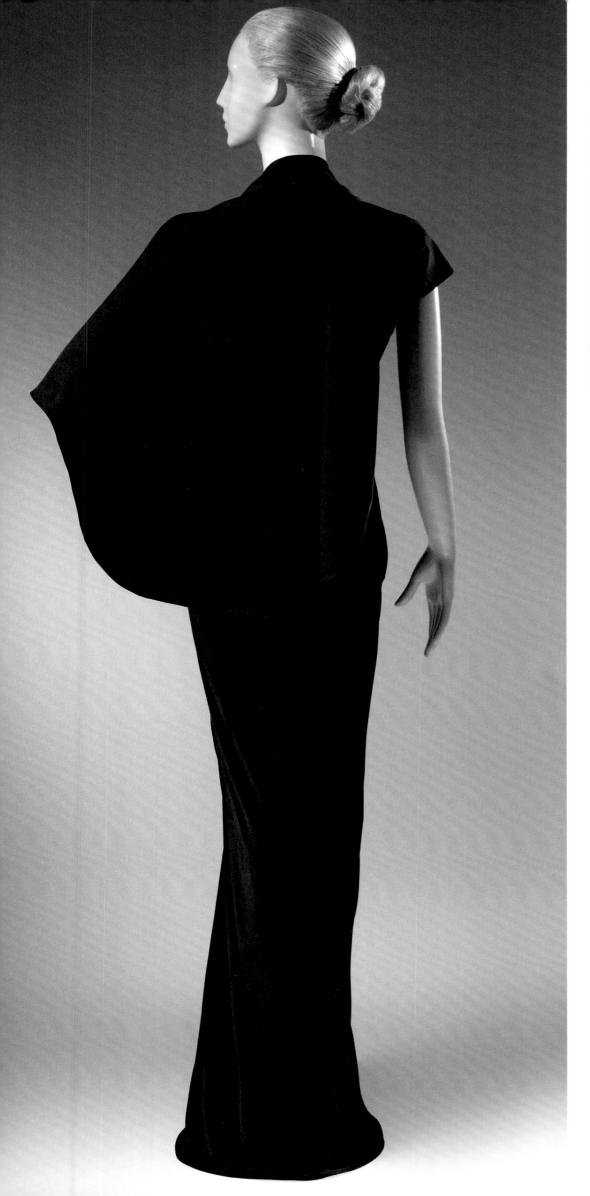

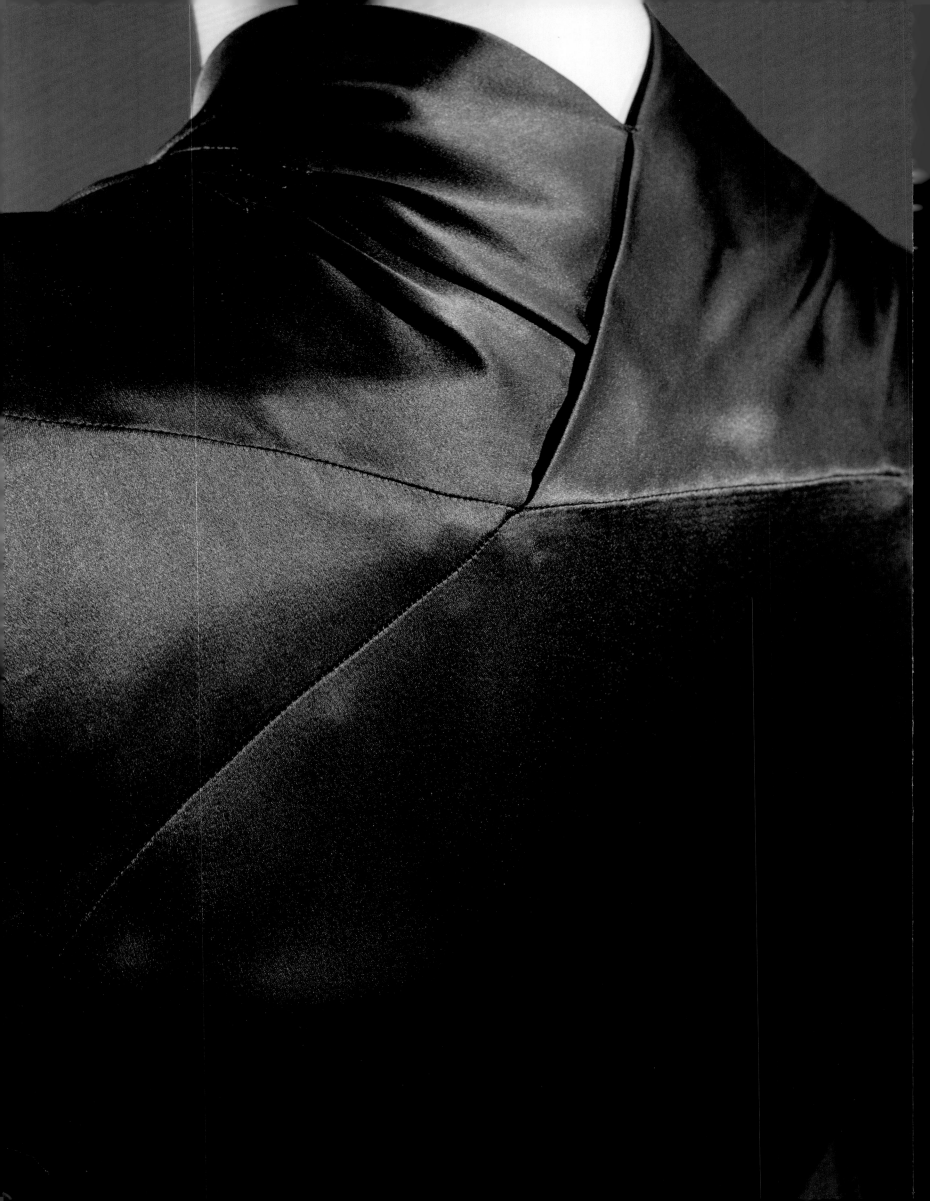

> *"My designs are not luxuries.*
> *They represent fashion research."*

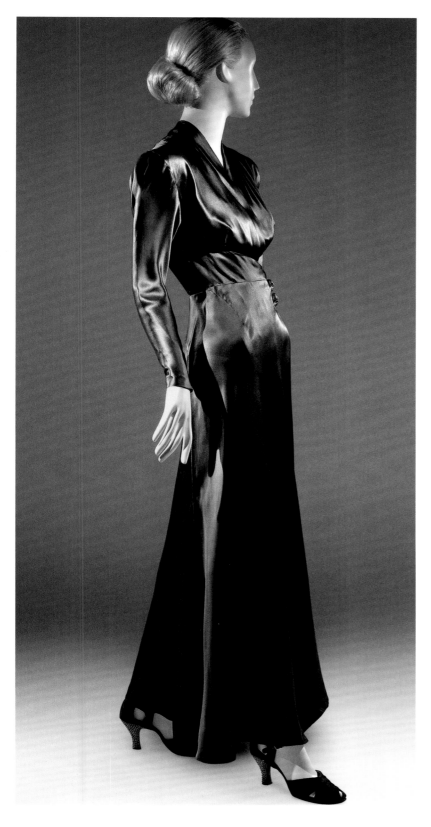
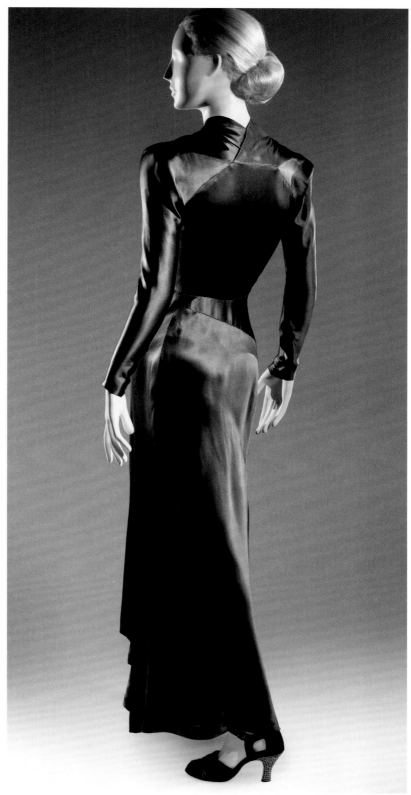

Figure-Eight Dinner Dress, 1939. *Green-gray silk satin*

A series of wrapping pattern pieces is incorporated in both the bodice and skirt of this dinner dress. While the bodice discloses the complications of its cut, the greater innovation is in James's novel construction of the skirt. It was conceived as a figure-eight spiral. Beginning at the right front side, it wraps around the left leg, passes between the legs, then wraps over the right leg to cross to the left side back. As with many of James's constructions, the skirt's structure is comprehensible only when the garment is taken apart. *detail:* Back neck

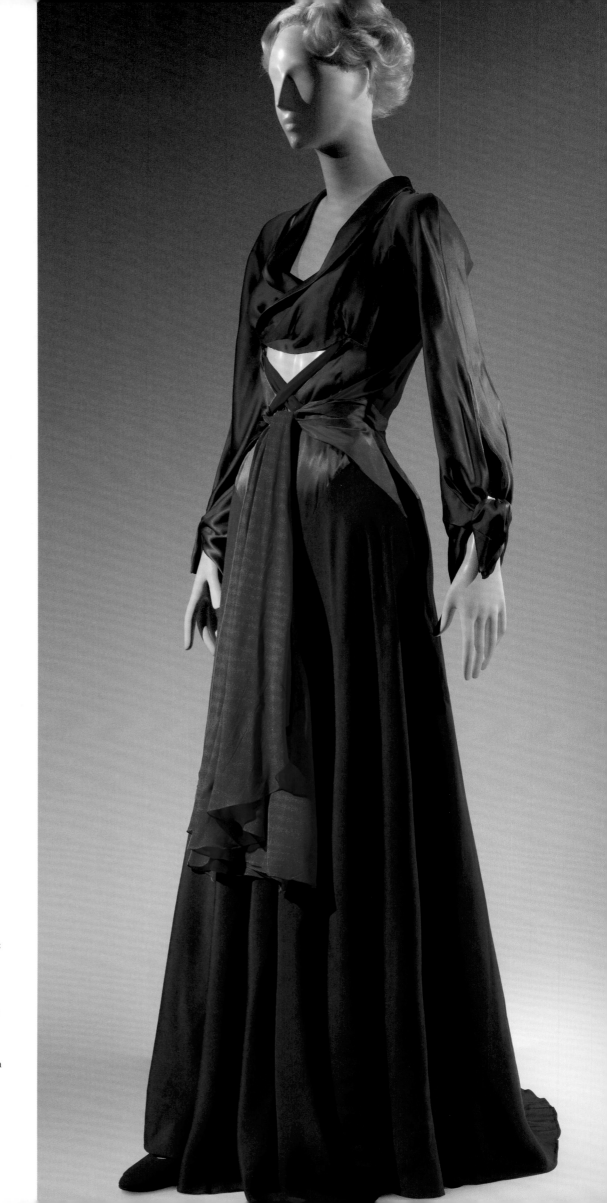

At-Home Dress, 1941. *Blue silk charmeuse and silk crepe and light blue and pink silk chiffon*

This dress is surprisingly symmetrical for a James design. It derives its vivacity from James's signature use of matte and shiny fabrics in vividly contrasting colors, together with the complex triangular and diamond-shaped insertions and interlacing sash extensions. Here his investigation of various techniques to create fit relies as much on the wrapping at the exposed midriff as on his implementation of the bias. Wrapping extends to the slashed and draped sleeves tied at the wrists.

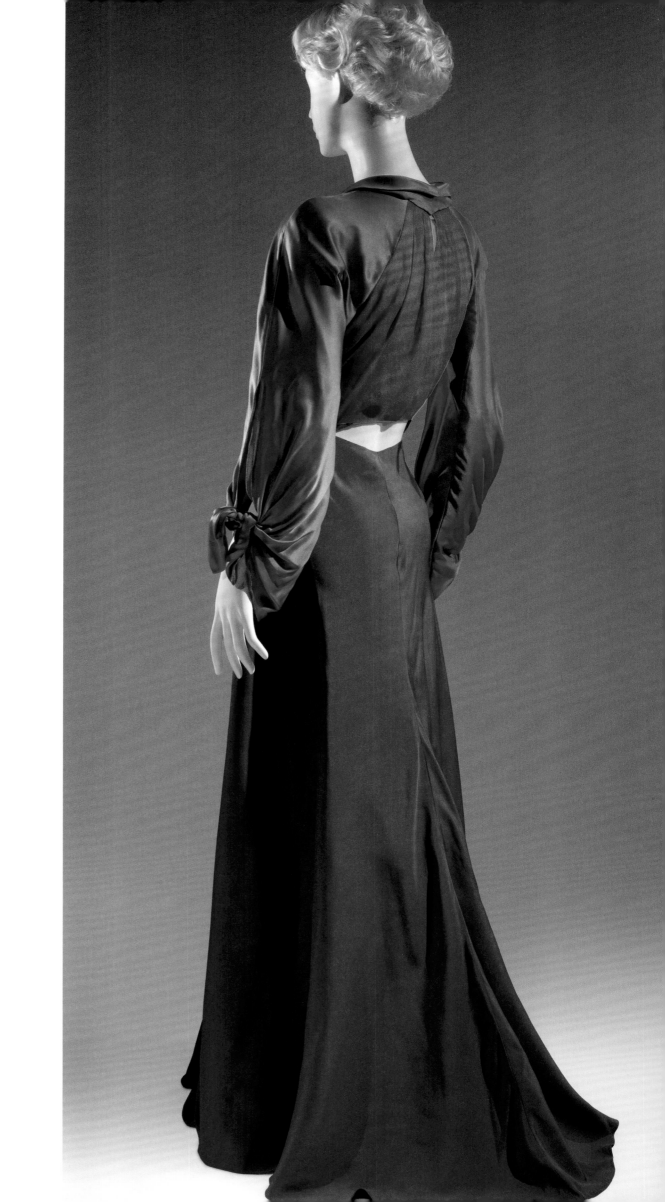

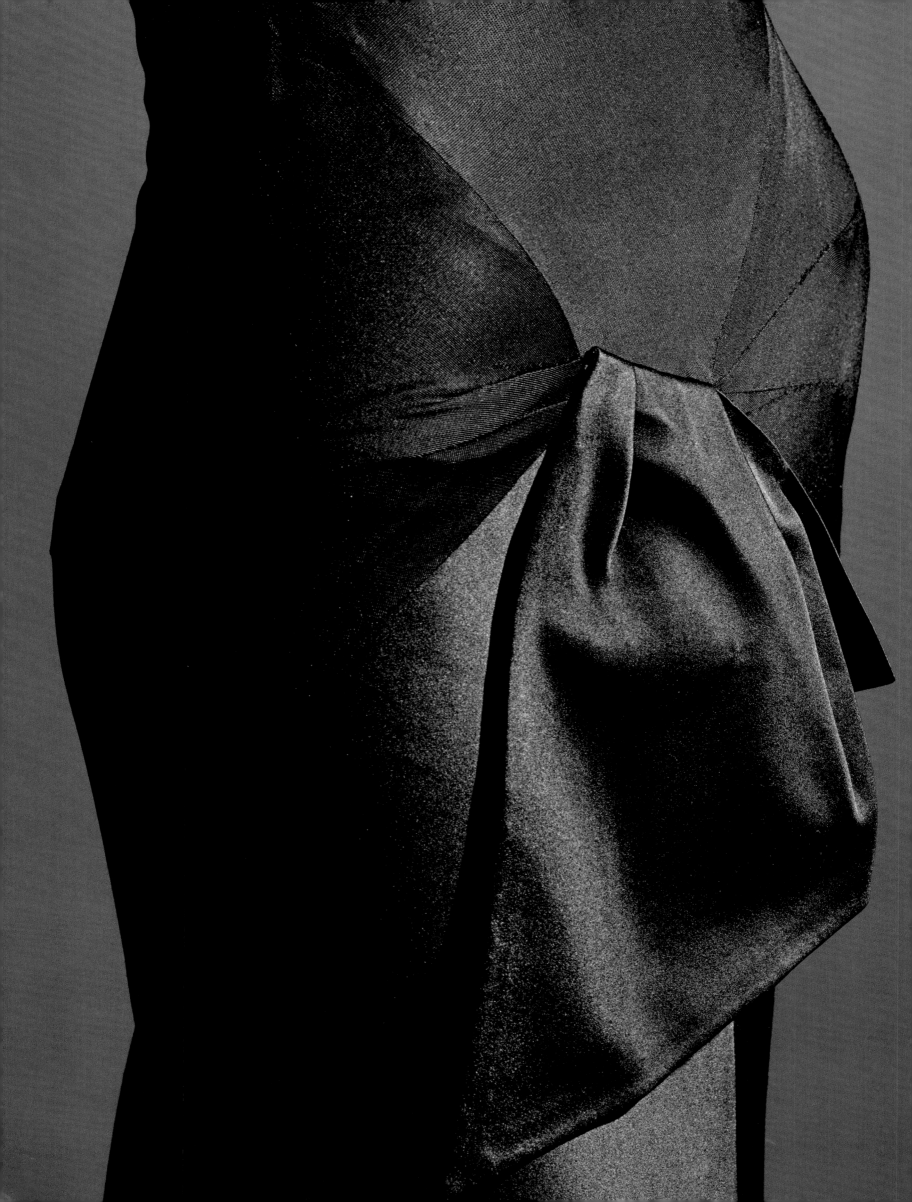

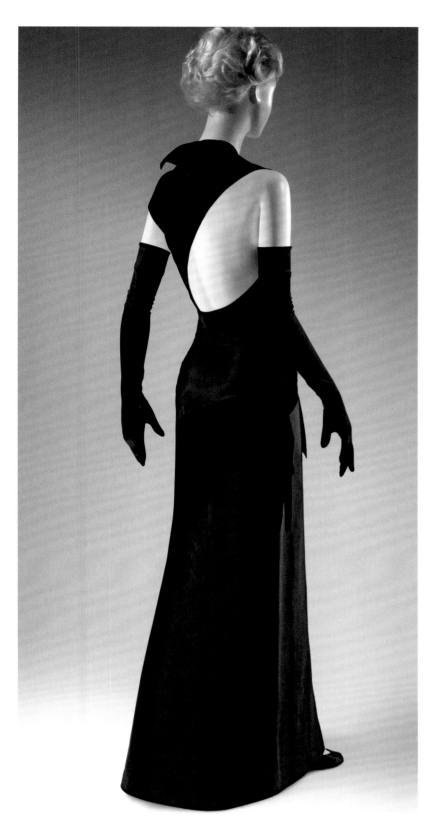
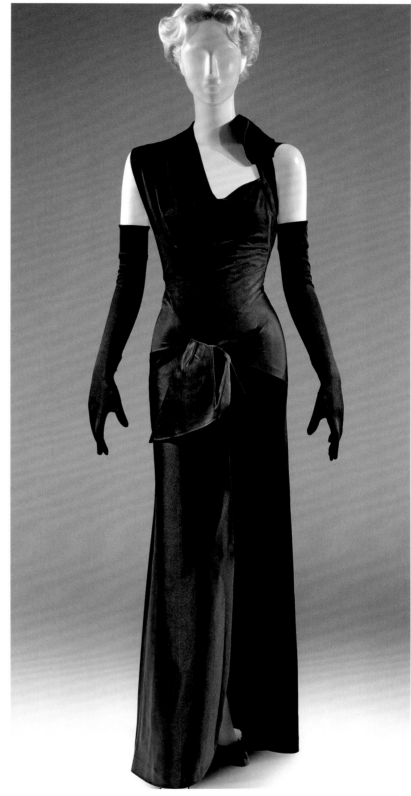

Evening Dress, 1947. *Black silk satin and silk jersey*
In the postwar period James was increasingly drawn to the muted sophistication of contrasting materials of differing luster. In this evening dress's monochromatic duet of blacks, the dull sheen of jersey juxtaposes with the high shine of satin. Only after the eye has absorbed the nuanced surface contrasts is the rich geometry revealed. James eliminated the side seams, and the angled satin panel that constitutes the front bodice wraps over the shoulder to form an oblique panel across the back, resulting in an astonishing exposure of skin. Bill Cunningham likened this spiral of inky black fabrics to a stick of licorice. *detail:* Right front hip

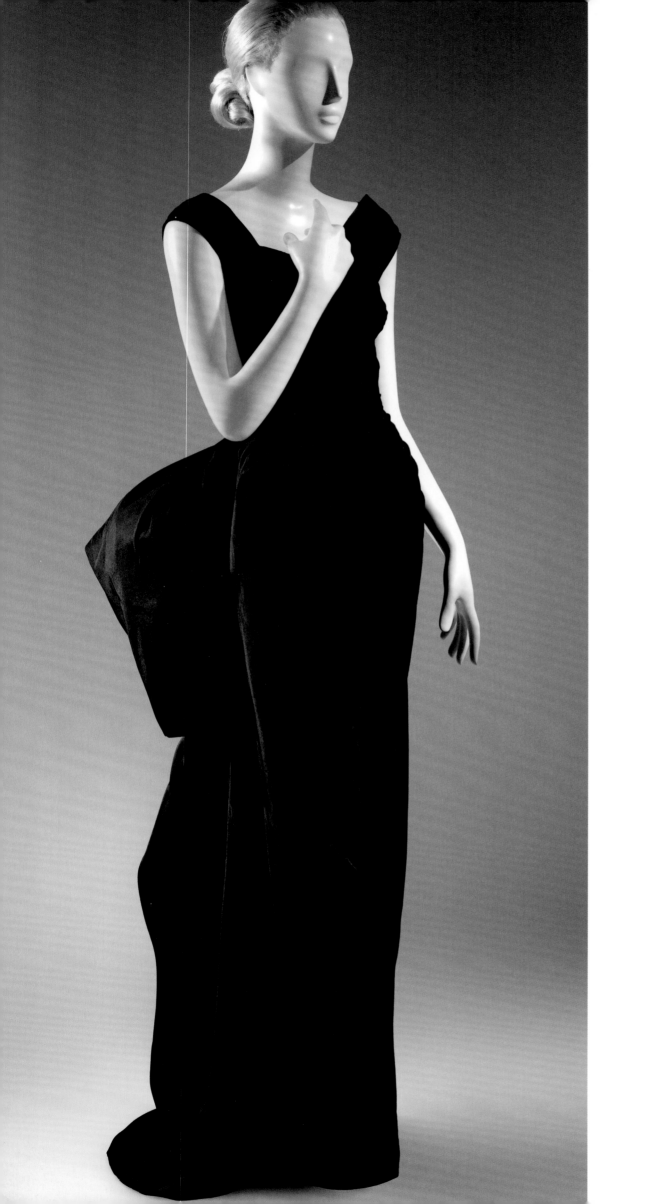

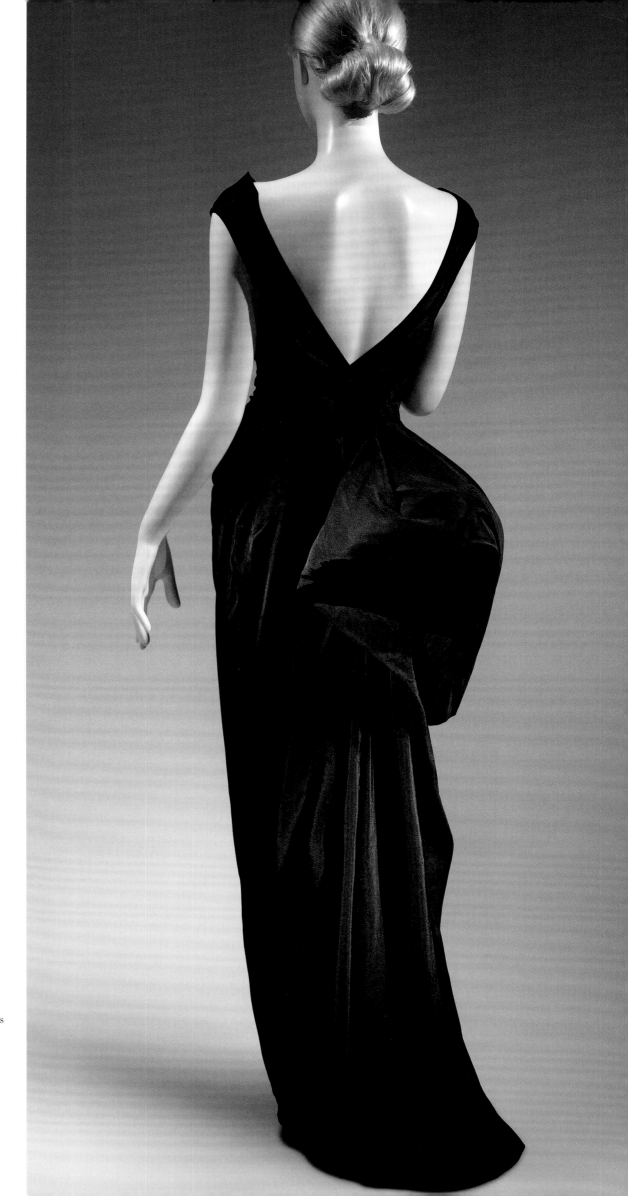

Coq Noir Evening Dress, 1937. *Black silk rep*
At once lithe and sculptural, this dress includes a
number of Jamesian preferences. Asymmetrical, it is
uninflected by traditional patternmaking practices;
it eliminates the side seams; and it incorporates the
excess fabric that results from the draping (what
Schiaparelli called the "super flou") in the finished
design. Here James buttressed the super flou with
canvas to form a dramatic flute at the right back hip.

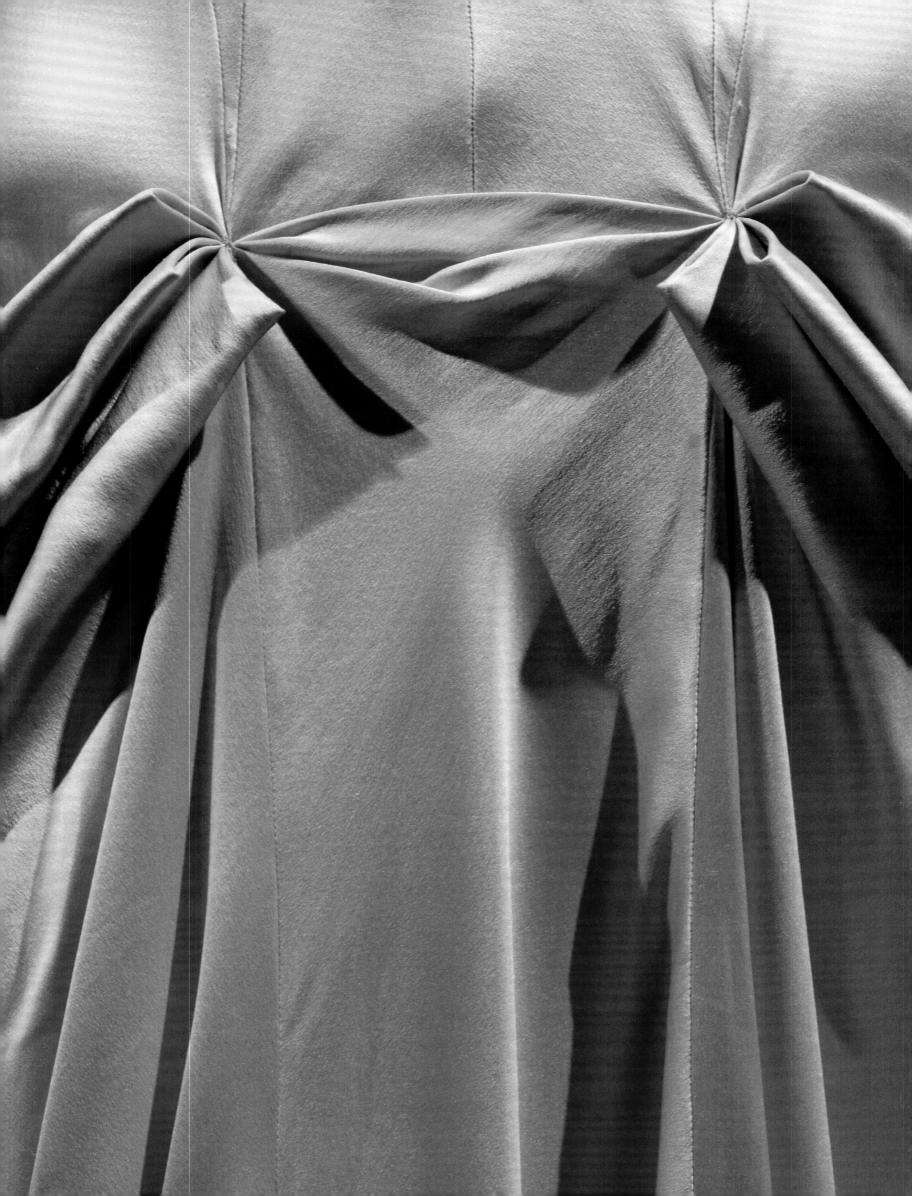

DRAPES & FOLDS

Among the most striking James designs are those animated by flanges and wings of stiffened, linear folds or loose gathers and puffs of airy drapery. Those signature effects originated not with a drawing but in the designer's careful manipulation of fabric beyond the requirements of a typical fitted pattern piece: James could work them out only *alla prima,* shaping the cloth by hand as he draped, pinned, and cut on the form. (Although a number of sketches appear to be the designer's initial jottings and croquis drawings, they are invariably later renderings and often include modifications that evolved after the garment's original execution.)

Manipulating the fabrics with obsessive care, James introduced the desired fullness to achieve shapes that were then fixed into permanent forms. To accentuate his love of full, airy, and almost baroque volumes, he generally employed fabrics with an ability to hold their shape, like taffetas, failles, or duchesse satins. But, ever willful, he was not dissuaded from using supple, liquid fabrics like silk velvet if they held aesthetic interest for him, though they are generally incompatible with such self-sustaining structure.

A James dress, suit, or gown incorporating these draping techniques suggests serendipity in the fall of cloth or in the casually rendered folds that form the collar, peplum, or ballooning skirt, but a closer examination reveals the structural devices—crow's-feet darts, often displaced in unconventional ways, canvas interfacings, boning, and welt tucks—that arrest the cloth in the configurations the designer imposed. Even with flourishes of seeming abandon, textured woolens, napped cashmeres, silk failles, velvets, and satins were subject not to their own attributes of "hand" and "hang" but to the designer's aesthetic intentions—which are often in direct opposition to his materials' ordinary physical properties.

For James design was not simply an intellectual or conceptual pursuit. His physical engagement with the materials and tools of his trade, together with his dramatic resculpting of his mannequin's form, has a visceral component as well. In the gathers of his sculptural draping and in the deep folds with channeled openings are anatomical references similar to those in many Georgia O'Keeffe paintings. James's sharply flattened or softly inflated shapes often allude to the recesses of the female sex and a distinctly labial configuration. While the designer never explicitly addressed the inherent sexual miming of V-shaped creases at the groin of an evening dress or the yoni-like opening of a coat collar, his affinity for Surrealism and the evidence of his own erotic drawings suggest a strong channeling of libido and the subconscious into his work. The designer's lifelong interest in the body's mutable proportions and his desire to create from them an abstracted but sensual beauty are expressed in his controlled arrangements of cloth that fix an idealized expression of the female form, extending it into the space around the wearer while alluding to her most intimate and physical self.

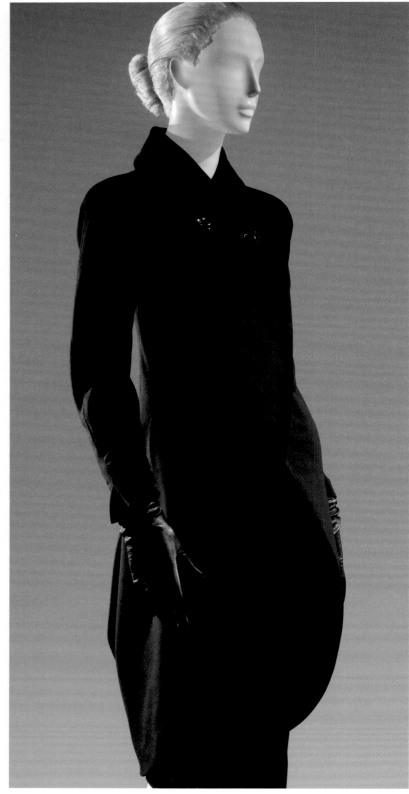

Incroyable Suit, 1933. *Black brushed wool*
The coat of this suit references the jackets worn by the Incroyables of the French Directoire and the dandies of the English Regency. The collar, cut high as in the historical precedents, falls in soft folds and wrinkles, like the neckerchief of a fop. In a typically subversive gesture, James skewed the double button closure at the neck to suggest a deliberate nonchalance. The narrow sleeves are on the bias and cut in one with the front and back. James seamed together the tails of the coat to form a low back cowl, like a deflated bustle. The skirt has a calculated displacement of fullness, introducing ease and amplitude at the abdomen and the front of the hips but cleaving sensuously to the back of the thighs because of the fabric's angled pitch. *detail:* Right back waist

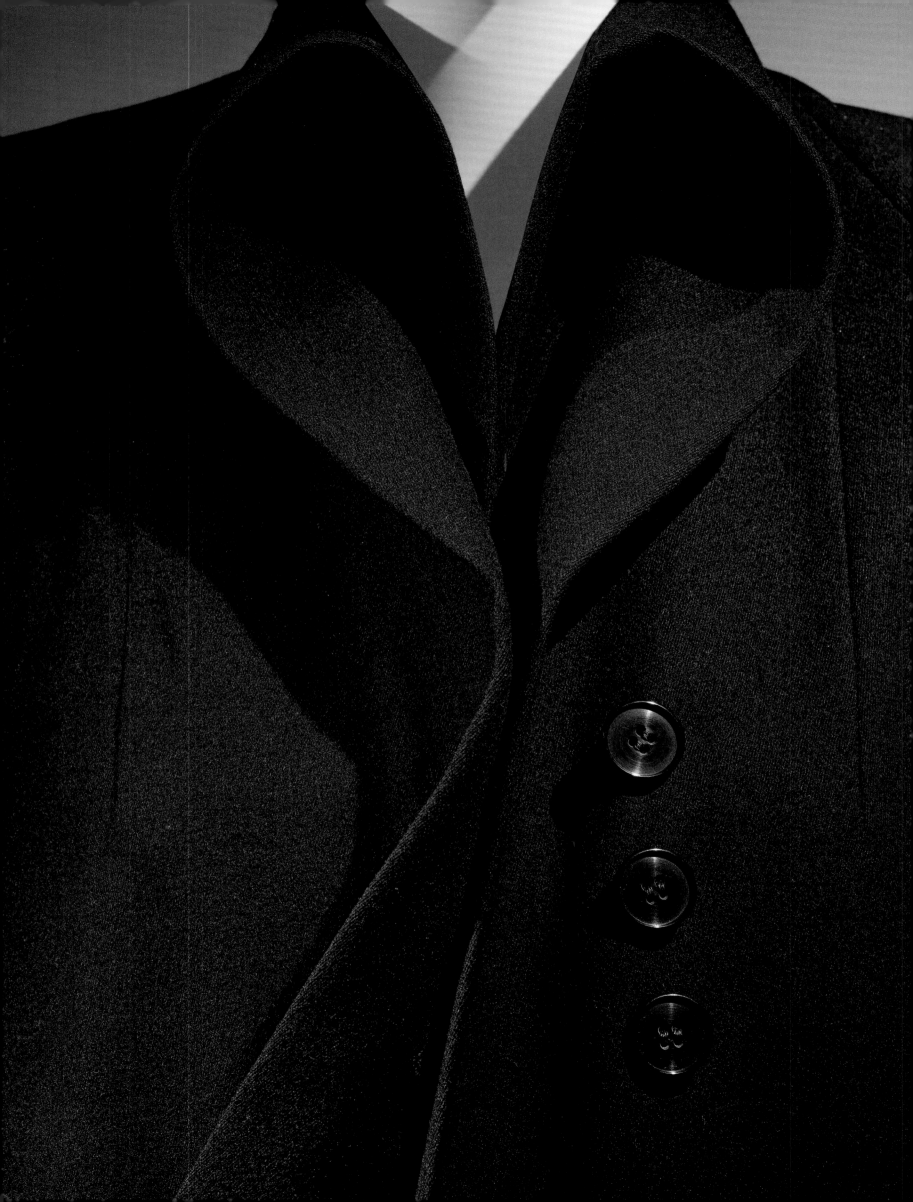

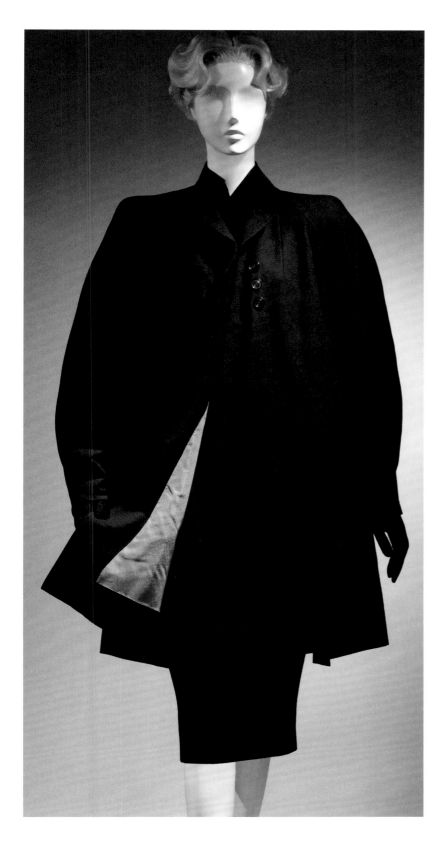
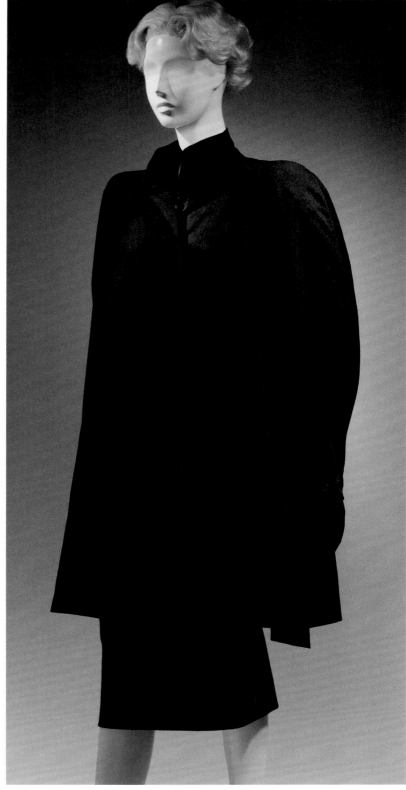

Coat, 1943. *Black brushed wool twill lined with pink silk taffeta*
James inserted a signature detail at the collar of this otherwise conventionally tailored swing coat with softly padded shoulders. He firmly believed that the facings of collars should be a continuation of the fabric backing itself. In this instance, the collar doubles over to form a supple, self-faced funnel. A second Jamesian gesture is the shock of the hot pink silk taffeta lining, typical of his sophisticated and often unexpected color choices for linings and petticoats. *detail:* Front bodice

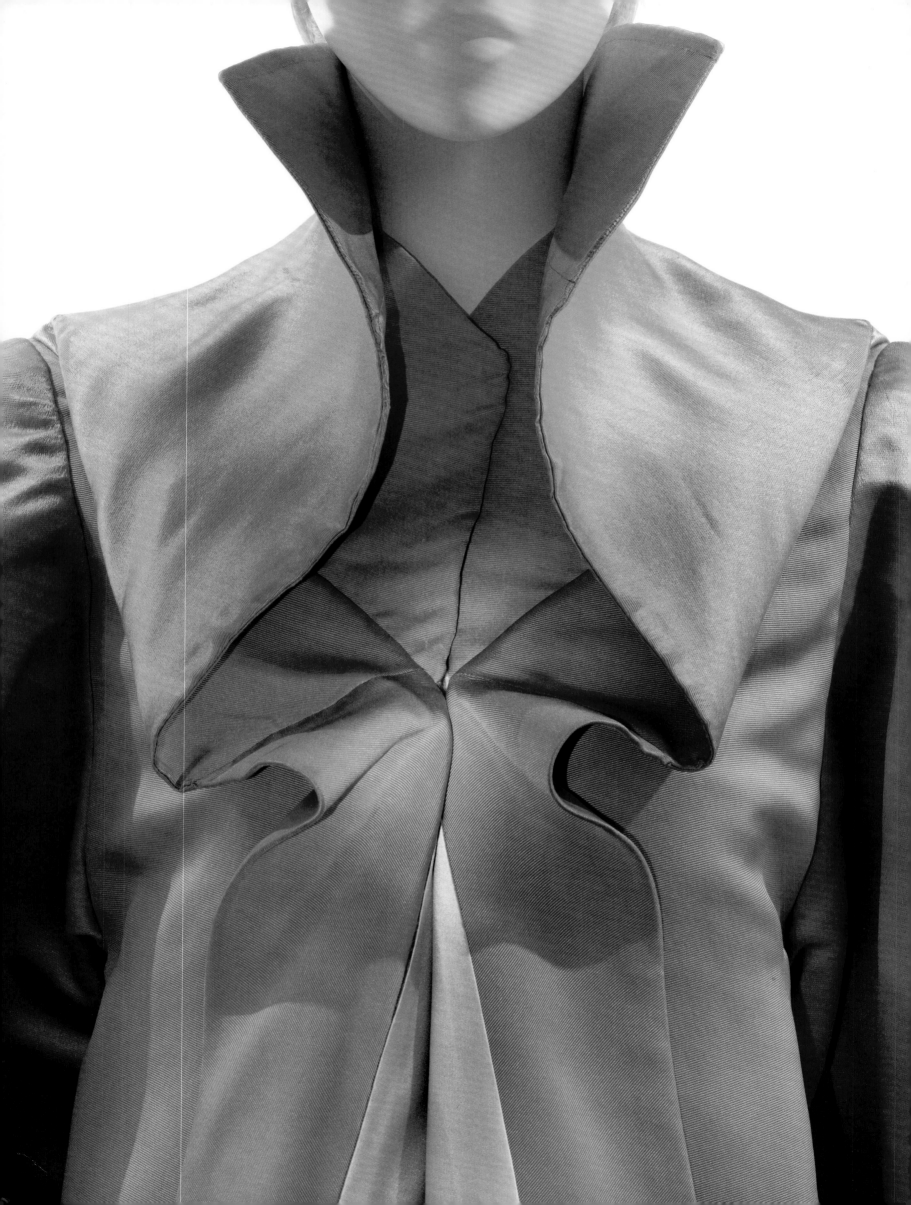

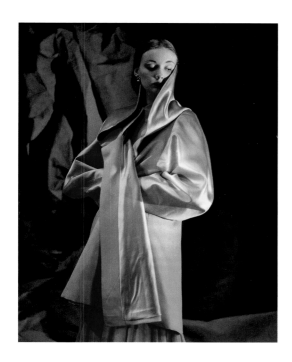

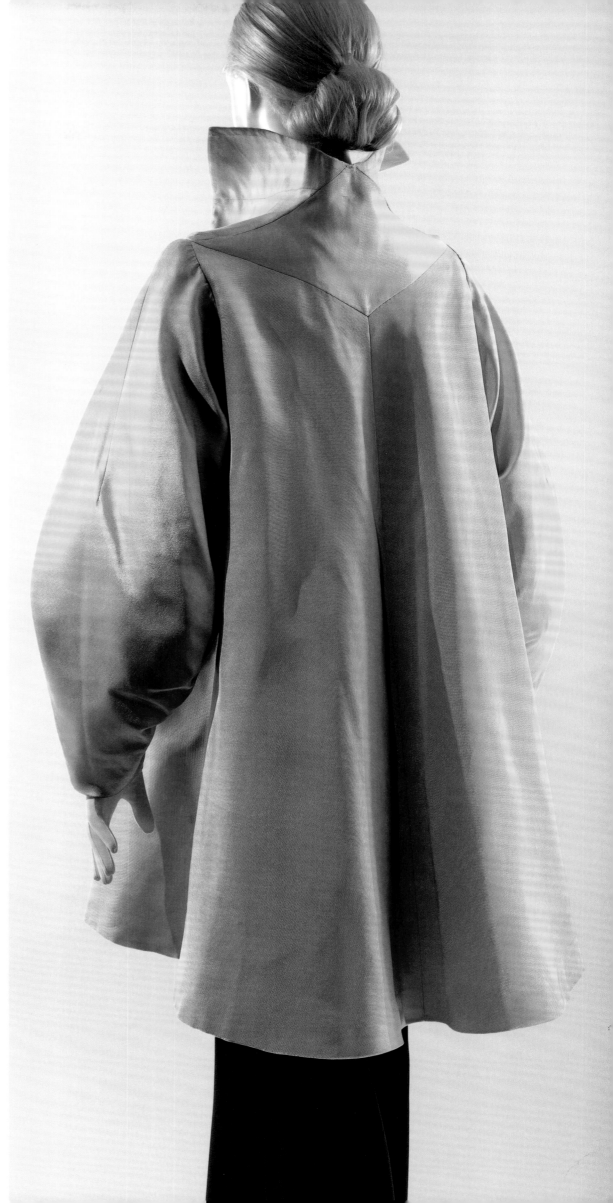

Evening Coat, 1947. *Yellow satin-back silk faille lined with pale blue silk duchesse satin*

A complex mix of textures distinguishes this evening coat with origami-like folds at the high portrait collar and eccentrically constructed bishop sleeves. James pieced the flat-ribbed silk faille with its reverse, a glossy satin, to highlight his ingenious pattern cutting. The contrast is especially pronounced at the back, where the slick-surfaced satin of the collar yoke and sleeves shines against the faintly dull sheen of the coat's flaring body. *detail:* Front bodice

above: This striking photograph highlights the coat's elegant combination of yolk yellow silk and pale blue satin. The model has unfolded the collar to demonstrate its height. Photo by John Rawlings. *Vogue,* August 1947, p. 113

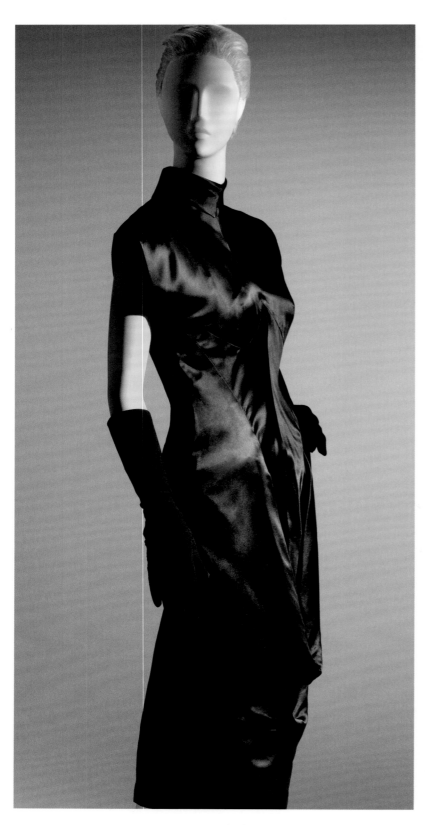
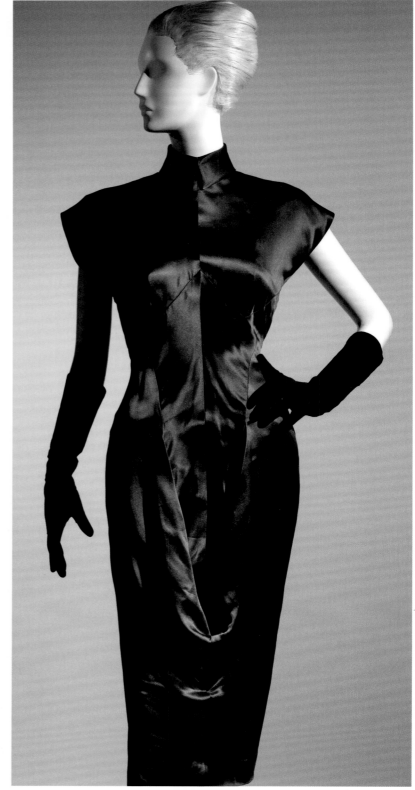

Cocktail Dress, ca. 1944. *Dark brown silk satin*
Although the bodice of this dress has center front, center back, and side seams, its second-skin fit was accomplished by molding the bust *à calage* (steaming in the shape) and using back shoulder darts. The body of the dress has center front and center back seams. A long dart curves from under the arm over the front hipbone and into the low front cowl. With its high neckline, shoulder line extending into a cap sleeve, and sheathlike fit, this James design suggests the exotic influence of the Chinese *qi pao*, a style promoted at the time by another American couturier, Mainbocher, on his client Wallis, the Duchess of Windsor.

opposite: Illustration by René Bouët-Willaumez. *Vogue,* July 1, 1944, p. 56

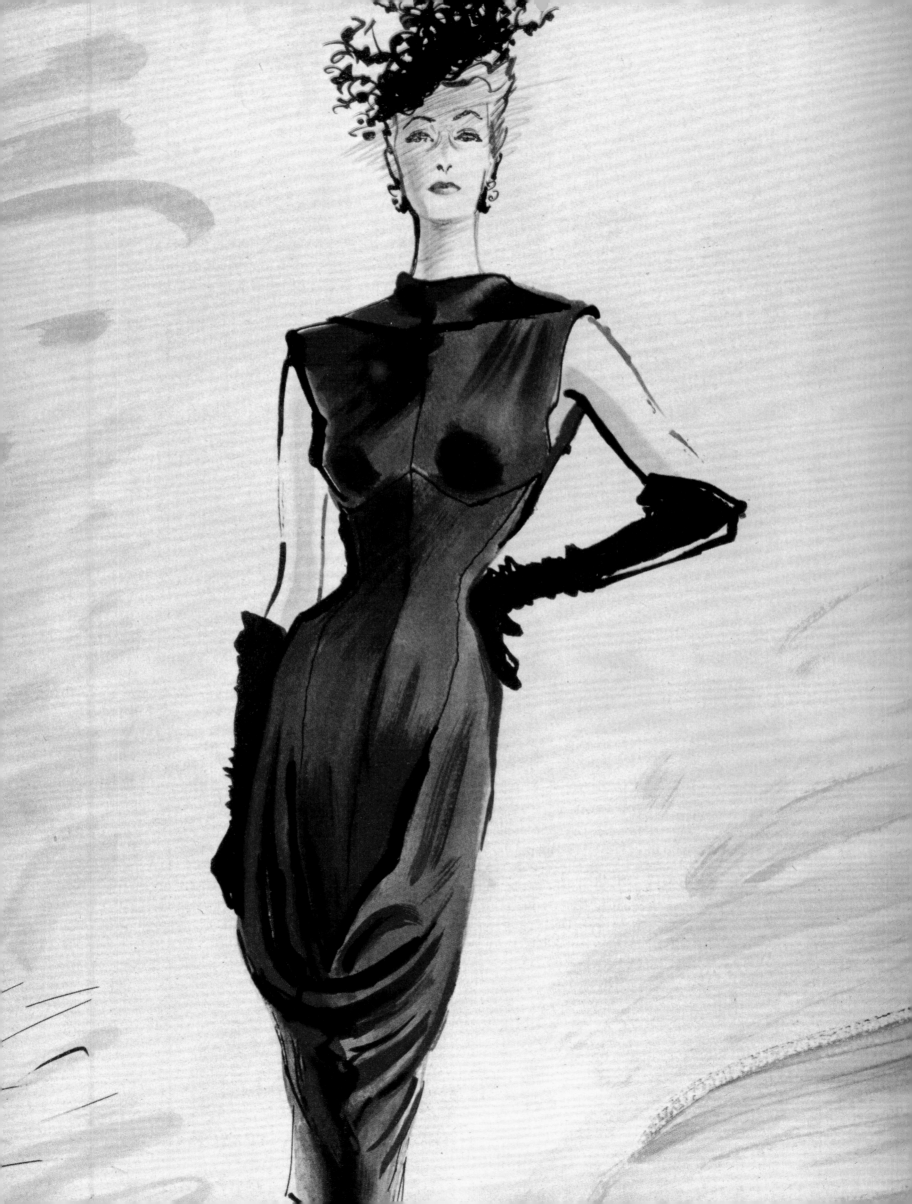

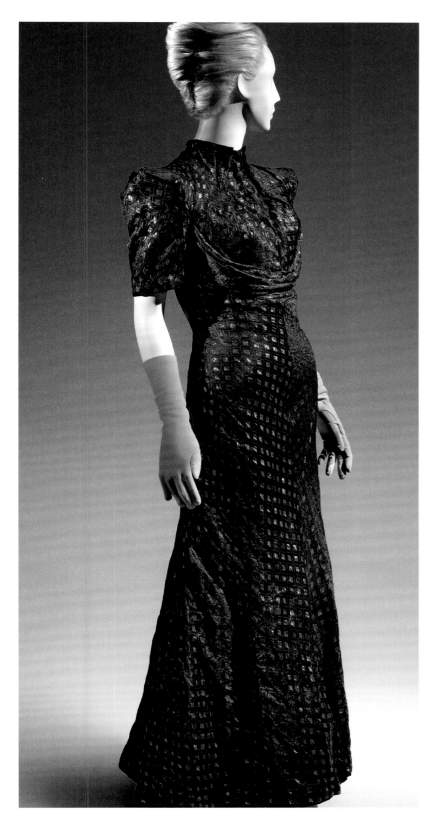
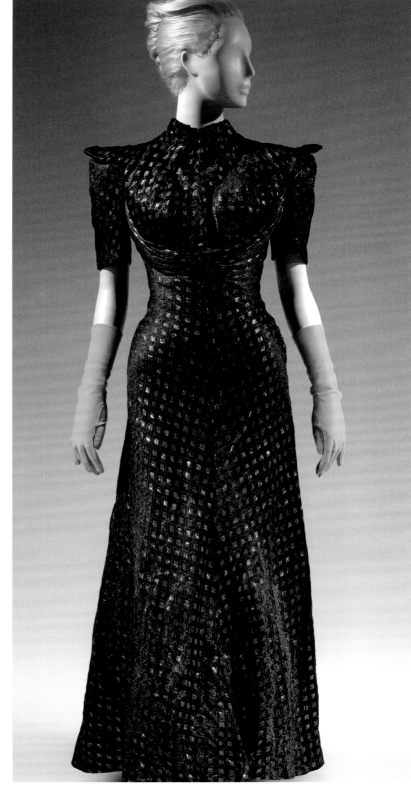

Beetle Evening Dress, 1930s. *Black silk compound weave with blue-green and pink metallics*

The dramatic shoulder line of this dress introduces the square shape that Schiaparelli and other designers achieved with padding, which James avoided in his eveningwear. The unusual fabric, with an iridescent mix of synthetic threads in a black grid, has a crisp hand that holds its shape. Soft gathers cradling the bust contrast with the flattened folds over the square capped sleeves, suggesting the fabric's mutability. James claimed that the folding and pressing in shape was done before cutting the sleeve, a more complicated process than if he had simply draped it to fit. Two finishing details are James signatures: the lack of a lining and the folded edges of fabric to avoid a facing. Though the latter technique was typical of the ready-to-wear industry, incorporating it here allowed him to add release darts and angled pleats perpendicular to the fold edge, creating shape without the seam lines that were anathema to him. *detail:* Center front lower torso

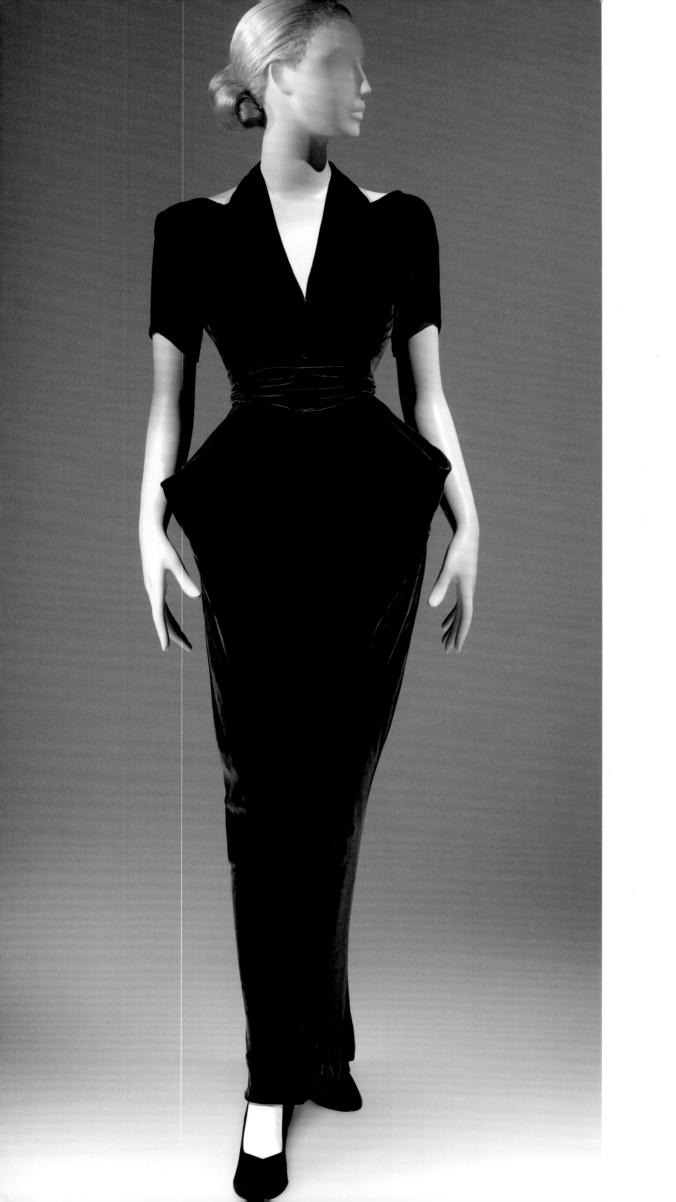

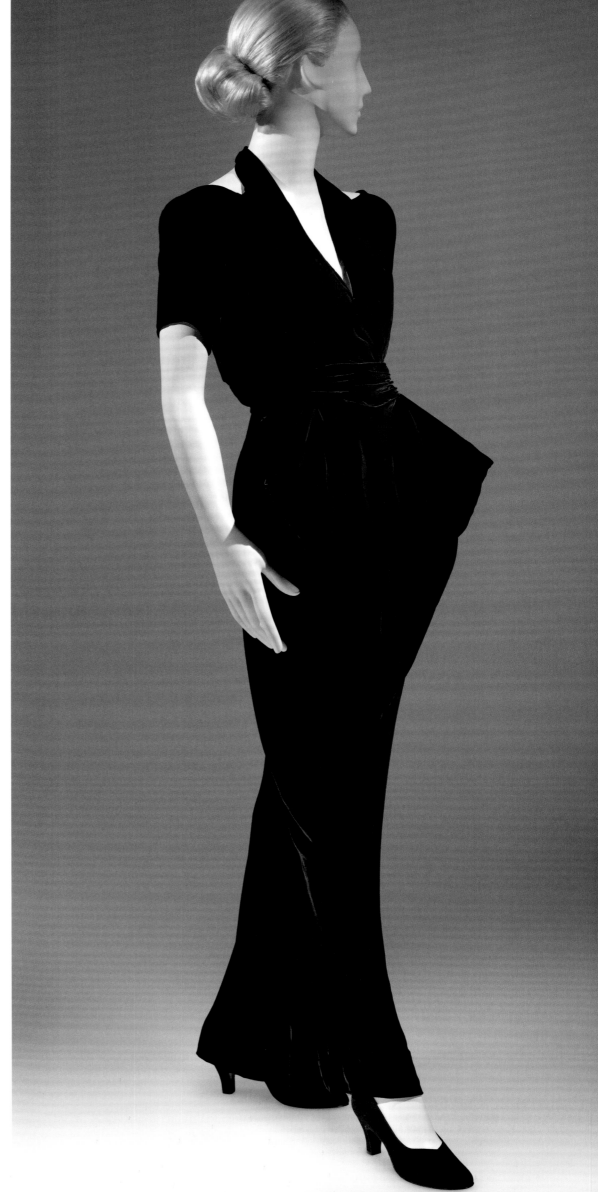

Evening Dress, 1937. *Black silk-viscose velvet*
This dress, with its minimal cut, is the result of several iterations in muslin, in which the many original seams were eliminated one by one at each fitting. James described the pattern of the skirt as a long triangle, cut on the bias, with one seam at the center back. The graceful taper of its silhouette is created by pulling up the front waist, which also produces the pocketlike side drapes. The dress is slashed at each center shoulder line, resulting in triangular extensions that form a small halter and sleeves cut in one with the bodice.

above: Sketch by Charles James, 1969. Charcoal, ink, and chalk on paper

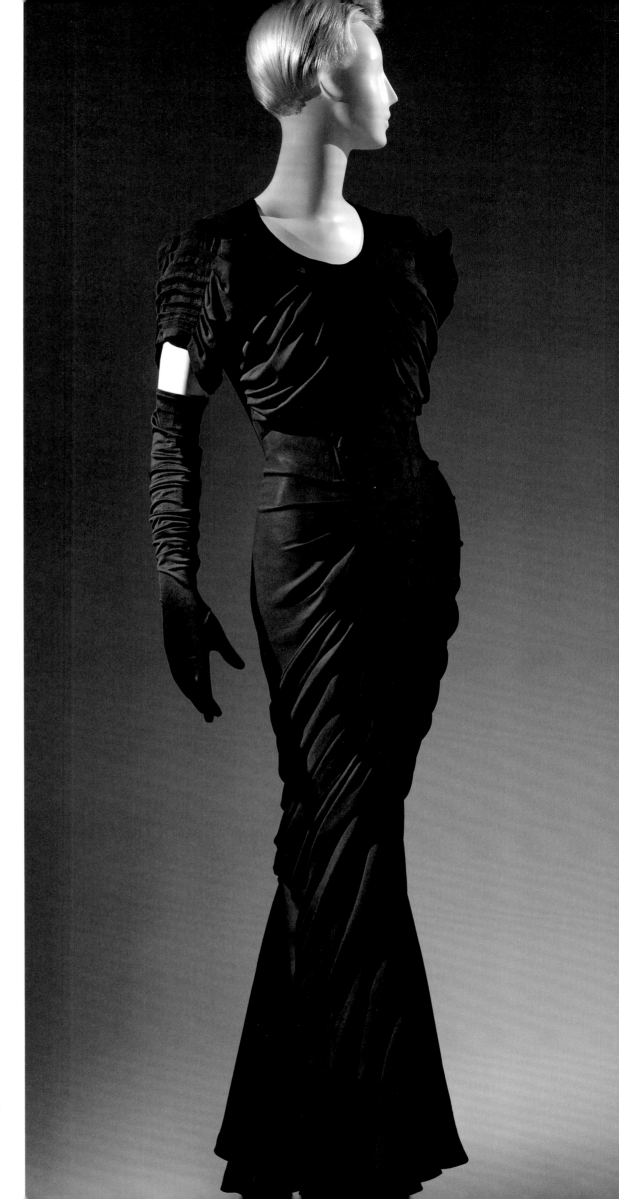

La Sirène Evening Dress, 1941. *Black silk crepe*
This sensuously shaped dress, popularly known
as the Lobster dress, is essentially a gathered tube.
With the exception of the draping to form the bust
and back bodice, the gown is created by a series of
horizontal release tucks.

opposite: The statuesque Mrs. George P. (Marta de
Cedercrantz) Raymond wearing an early version of
the Sirène dress, which was in production for almost
twenty years. Photographer and source unknown

"What, after all, is the true function of fashion but to be a rehearsal for propagation?"

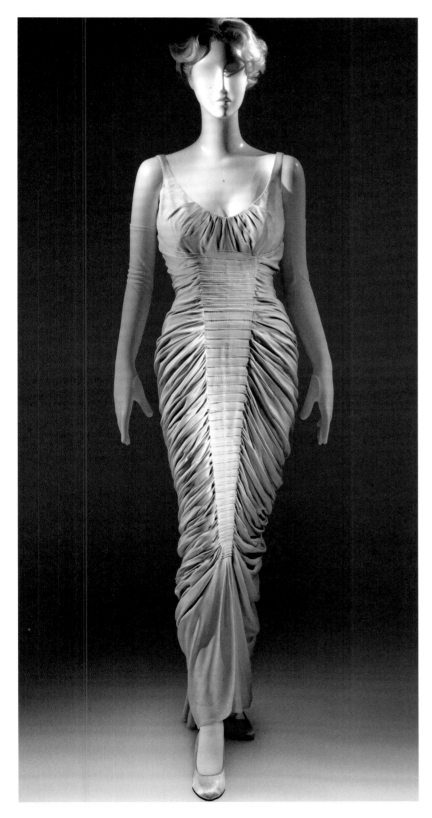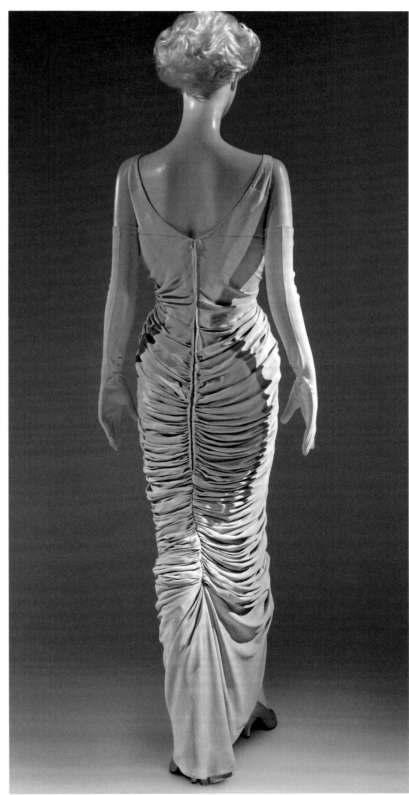

La Sirène Evening Dress, 1951–52. *Ivory silk crepe*
The fabric is shirred into the seam at the center back, stopping below the knee to accommodate movement.

opposite: A Sunday-morning view of the dressmaking workroom at Elizabeth Arden's salon, where the Sirène dress is in process. Illustration by Cecil Beaton. *Vogue,* December 15, 1944, p. 55

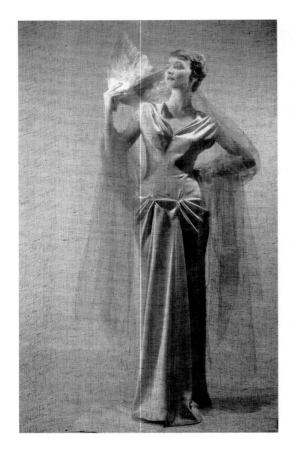

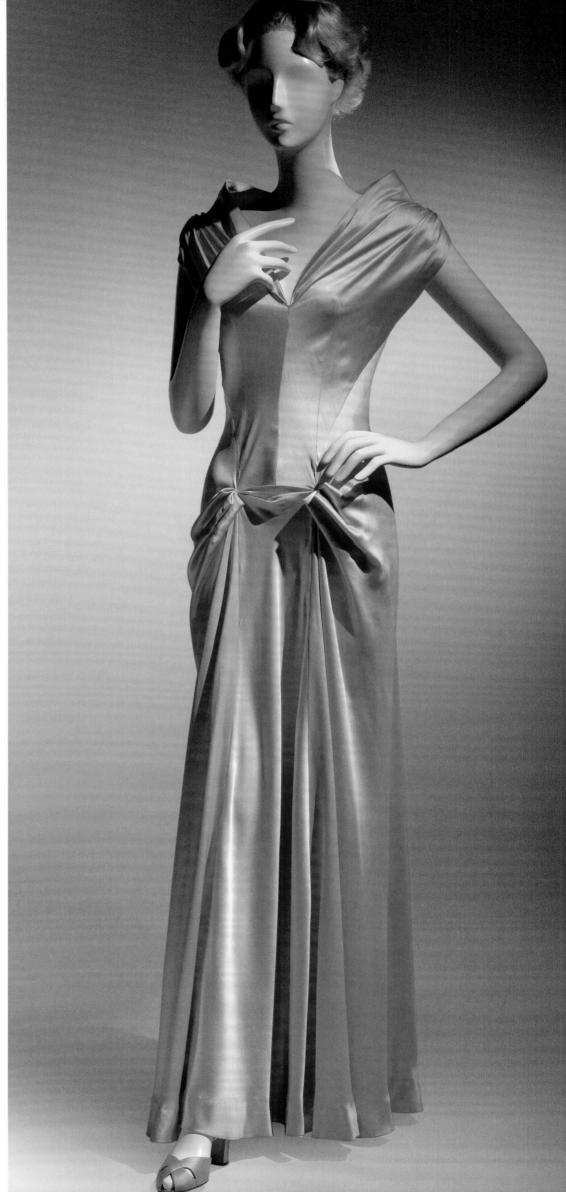

Evening Dress, 1945. *Peach silk charmeuse*
A center front seam and side seams that originate
from the back armholes and then arc to the front
hipbone create streamlined front panels that cleave
to the torso. The panels split into a deep neckline at
the base of the sternum, split again at the shoulder,
wrap over the cap of the arm, and then form an
open halterlike collar. Three tucks on either side
of the pelvic area—a zone of interest for James,
who believed designs should exude a procreative
allure—gather fullness and focus decorative interest
on an otherwise uninflected design.

above: Photographed through a scrim, the dress is
accessorized with two James signatures: a winglike
feather fan and a tulle stole. Photo by Erwin
Blumenfeld. *Vogue*, April 15, 1947, p. 123

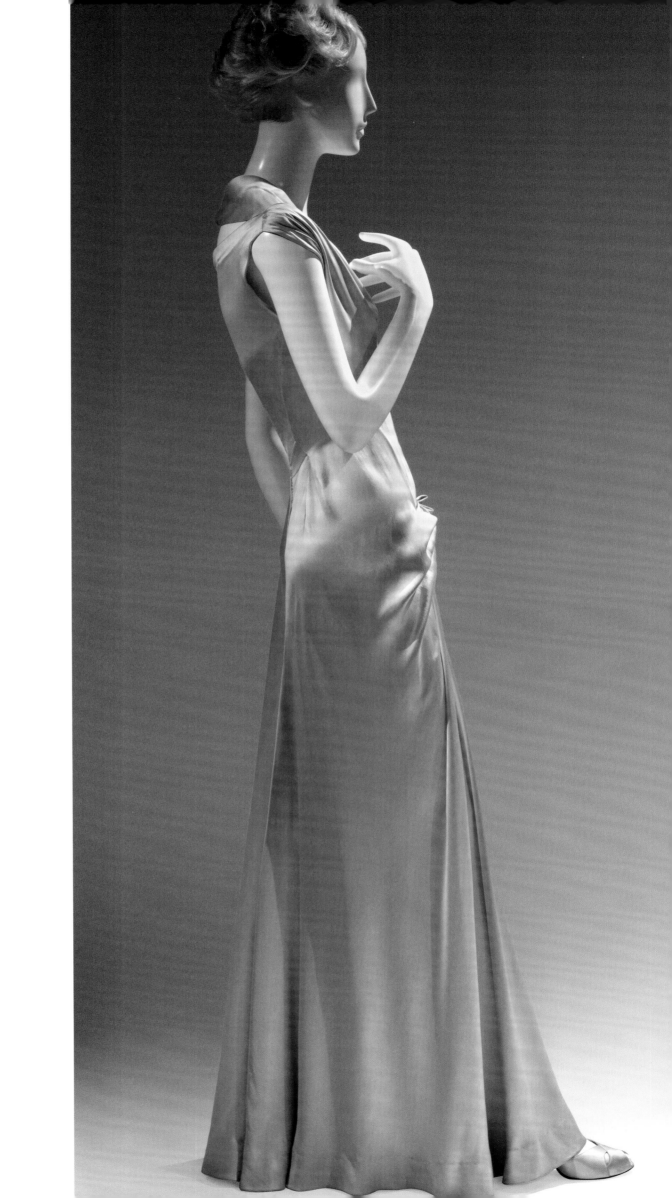

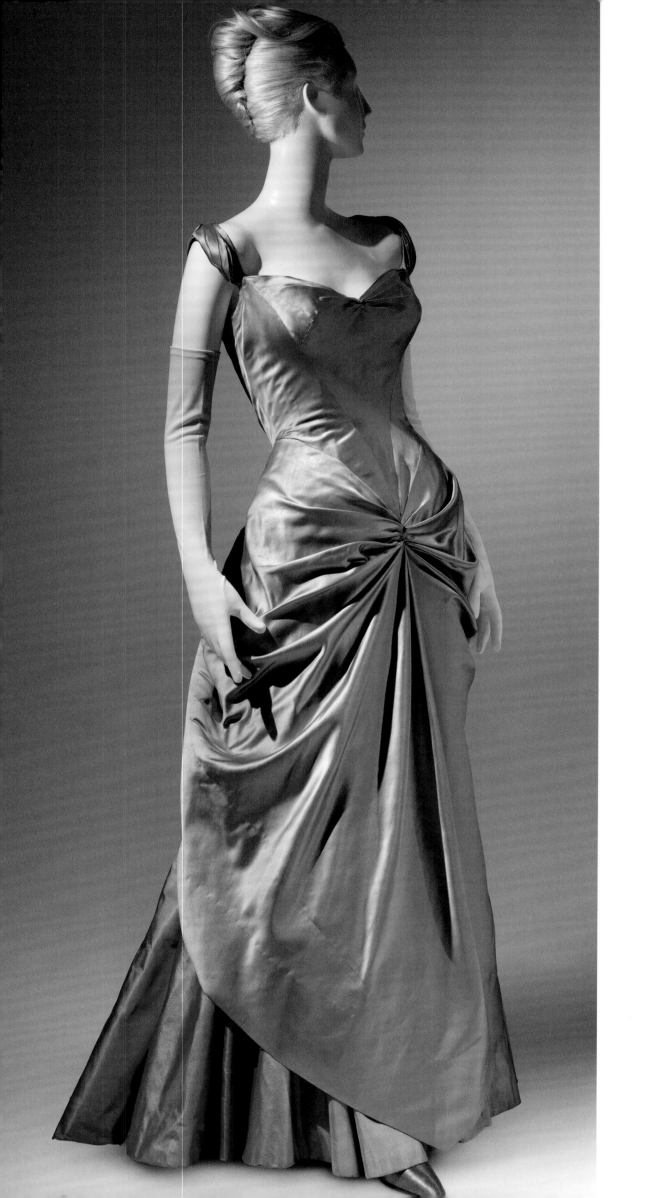

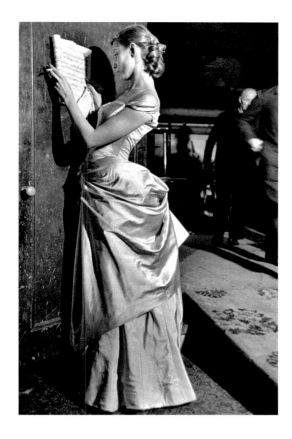

Ball Gown, 1950–52. *Pale blue silk satin and blue-green silk taffeta*

This design incorporates a detail seen in late nineteenth-century dresses: The torso seems to emerge out of the folds of the skirt. In his rendering of the historicist effect, James generated a sophisticated technical solution to conform to his preference for continuous pieces of fabric that are draped, tucked, and darted to fit. The fabric is shaped and fitted over the hips of the torso to become the draped apron.

above: A model studies a musical score backstage at the Coty Awards fashion show that James organized in October 1950. Her swayback pose underscores the design's inspiration in 1880s bustle dresses. Photo by Eliot Elisofon

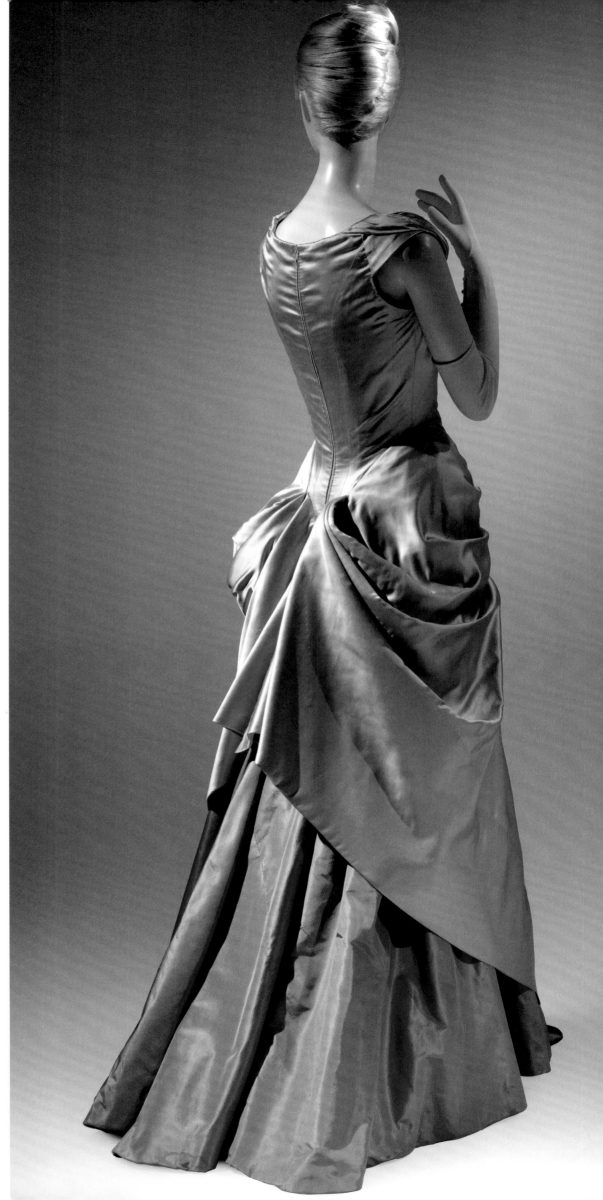

Evening Dress, 1952. *Ivory silk satin*
The asymmetries of this evening dress begin with
the diagonal seaming of the bodice and the tucks
at the bust and resolve in an arcing peplum that
is integral to the skirt. The two-paneled skirt is
constructed with a left front and right back seam,
which narrow it despite the fullness at the thighs
and the flare below the knees.

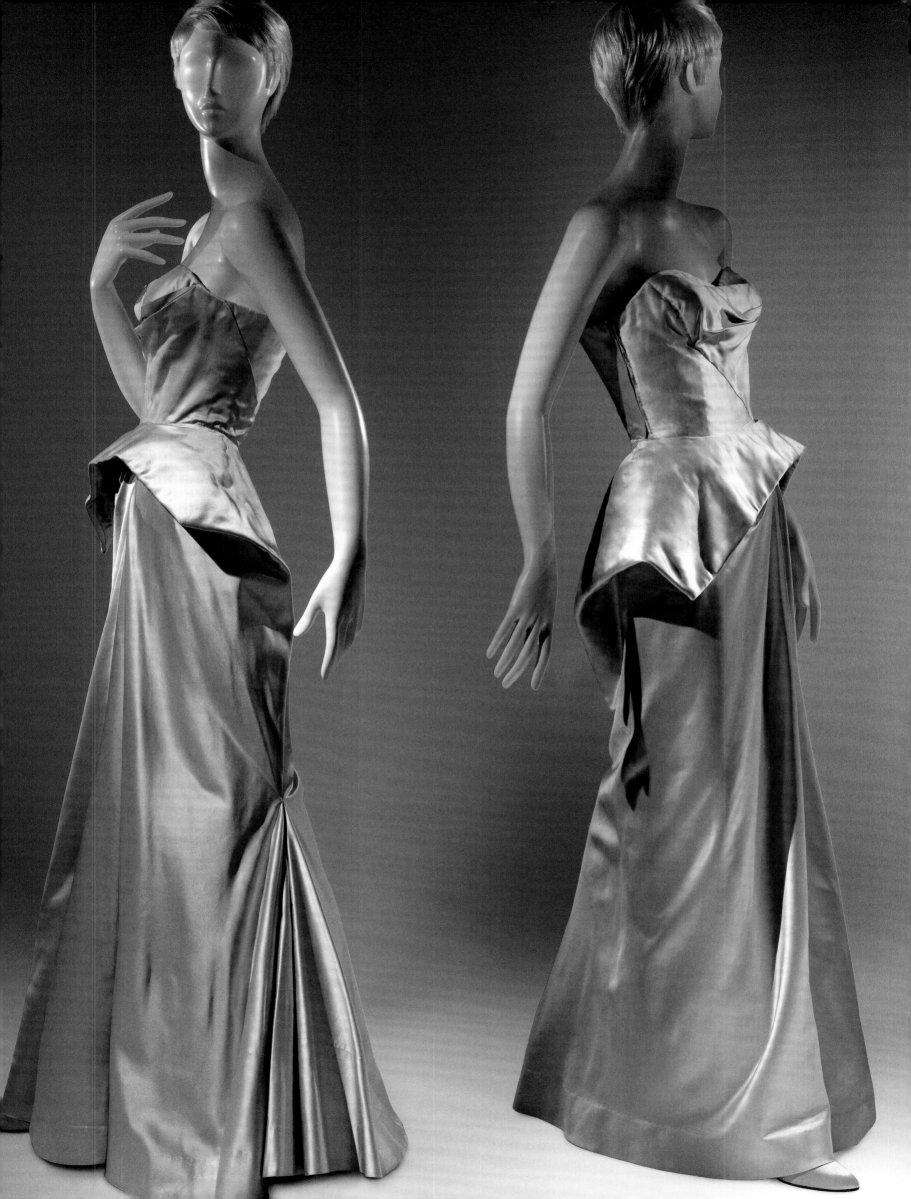

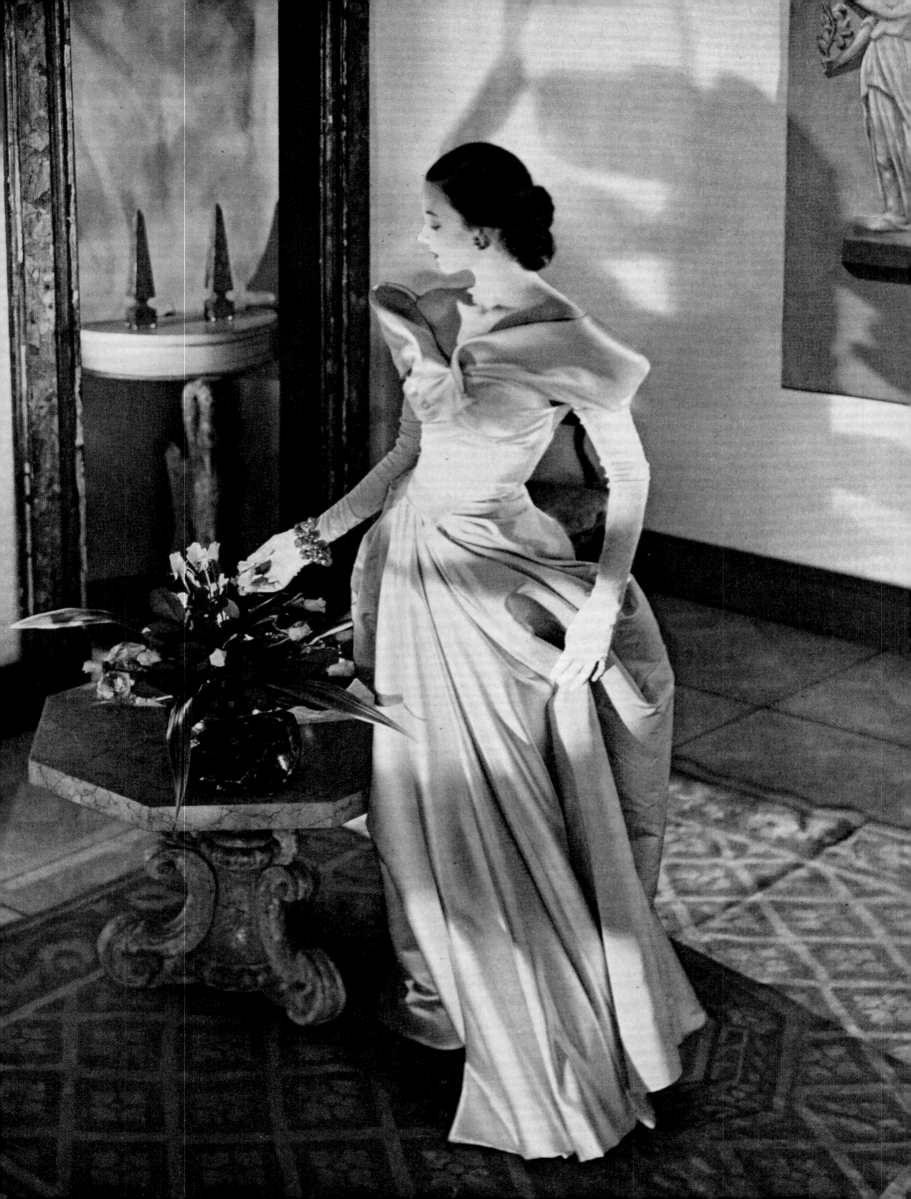

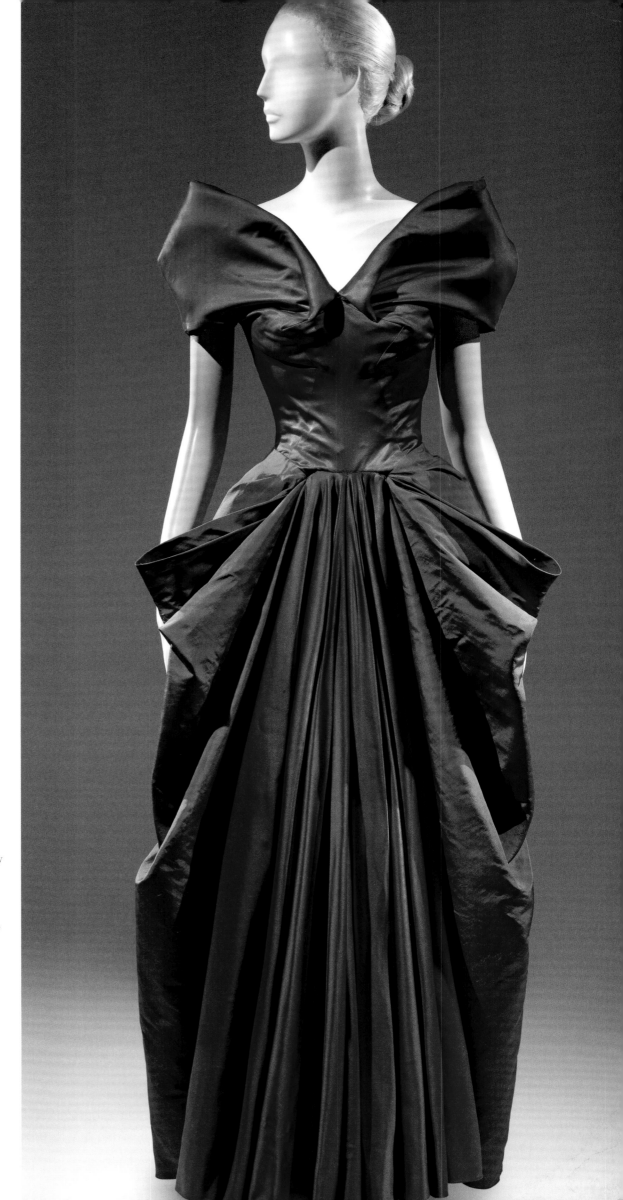

Ball Gown, 1946. *Red silk satin and brown silk faille*
James often revisited his designs, producing a variety
of permutations. Some changes were structural—for
example, a reconsideration of a draping component
or a simplification of a pattern piece. In other cases,
simply a substitution of materials was transformative
in effect, as can be seen here in the two versions of
this evening dress: one, a subtle monochromatic play
of satin and faille, the other a dramatic juxtaposition
of dark red satin with rich brown silk faille, which
suggests an eighteenth-century open robe and
petticoat. The constant is the baroque draping of
fabric frozen in winglike forms, an effect original
and peculiar to James.

opposite: This monochromatic version of the gown
was featured in the Modess ad campaign. Photo by
Cecil Beaton. *Vogue*, June 1, 1948, p. 32

Fashion is "what is rare, correctly proportioned, and, though utterly discrete, libidinous."

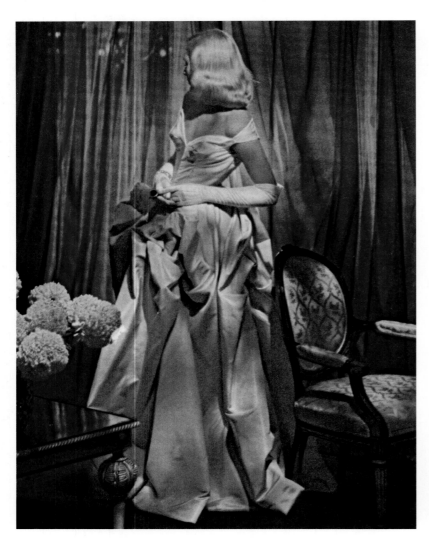
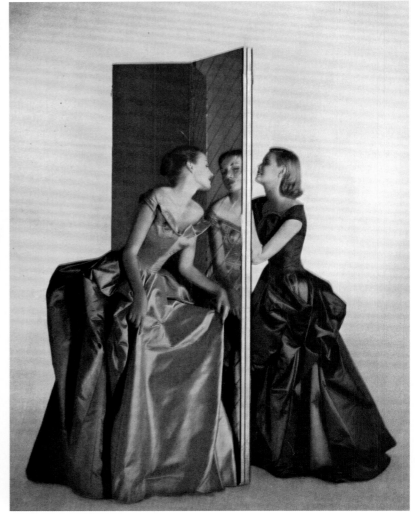

Ball Gown, 1951. *Ivory silk satin*

In a few notable instances James created skirts that appeared to be symmetrical front and back and side to side. These multilobed designs relate conceptually to the Clover Leaf gown (see p. 226), which James considered his greatest achievement. However, whereas the Clover Leaf epitomizes sculptural suavity, this gown demonstrates a virtuoso handling of abundant cloth. It is draped with such an excess of fabric that its pillowlike crescents, for all their volume, do not require any inner support.

above left: The Modess ad campaign included a version of the gown with a variation in the skirt drapery. Photo by Cecil Beaton. *Vogue,* November 1, 1948, p. 107
above right: Another version of the gown features a variation in the bodice. James pronounced this the best fashion photograph of his clothes ever taken. Photograph by Louise Dahl-Wolfe as it appeared in *Harper's Bazaar,* December 1948, p. 104

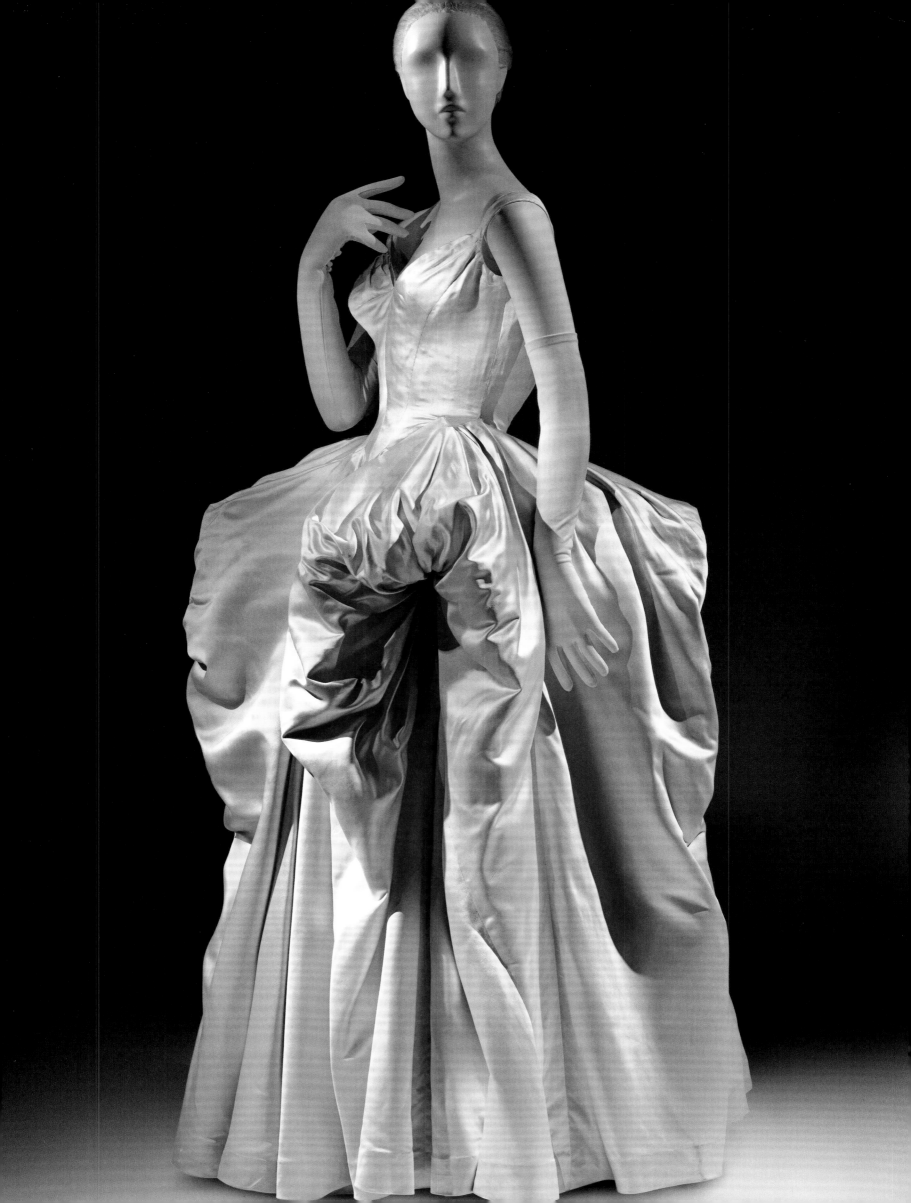

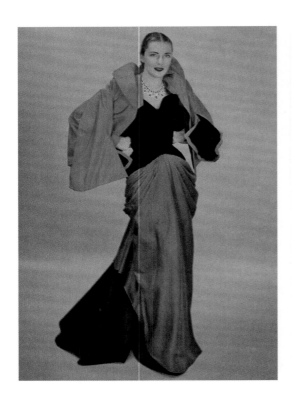

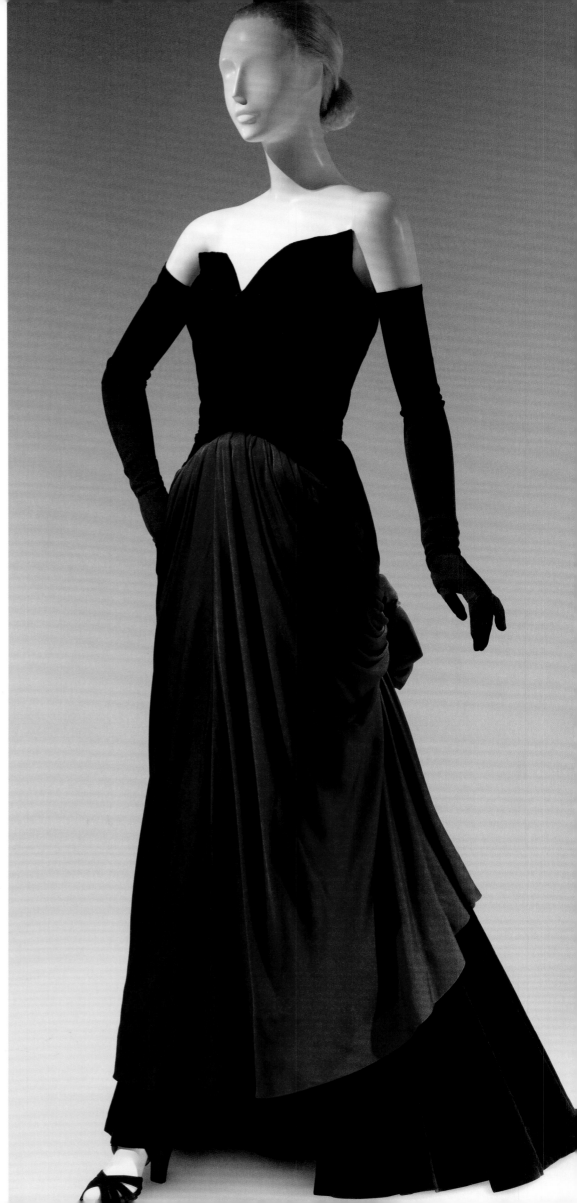

Evening Dress, 1947. *Black silk-rayon velvet and brown silk crepe*
Most strapless dresses are supported by an infrastructure of boning. In this case, James placed the bare minimum to support the bodice: bones at the center front, at each side seam, and, surprisingly, over the bust as a shaper. The brown crepe skirt, cut as one continuous panel, gathers up into a rosette at the back, where it releases into a slight train.

above: Mrs. Leland (Nancy Gross) Hayward (the future "Slim" Keith) embodying what *Town & Country* called the "James Look." Photo by Fernand Fonssagrives. *Town & Country,* October 1949, p. 71
far right: Millicent Rogers striking a pose *Town & Country* described as "reminiscent of Bouguereau," the nineteenth-century painter known for his voluptuous nudes. Photo by Gene Fenn. *Town & Country,* July 1948, p. 38

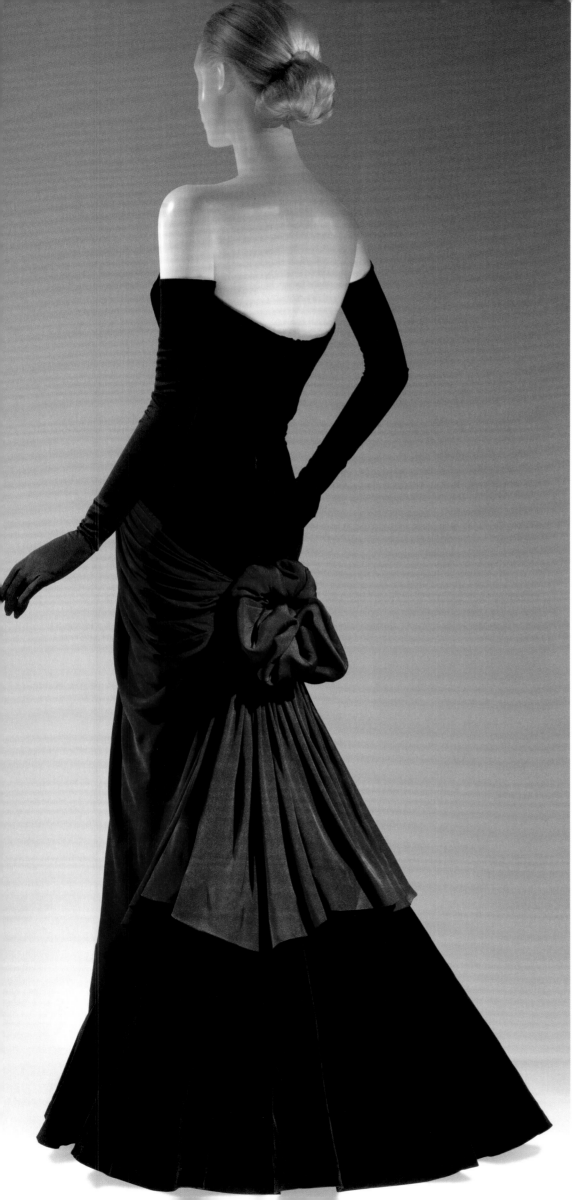
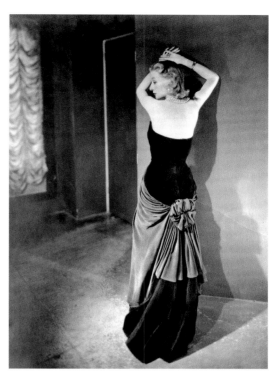

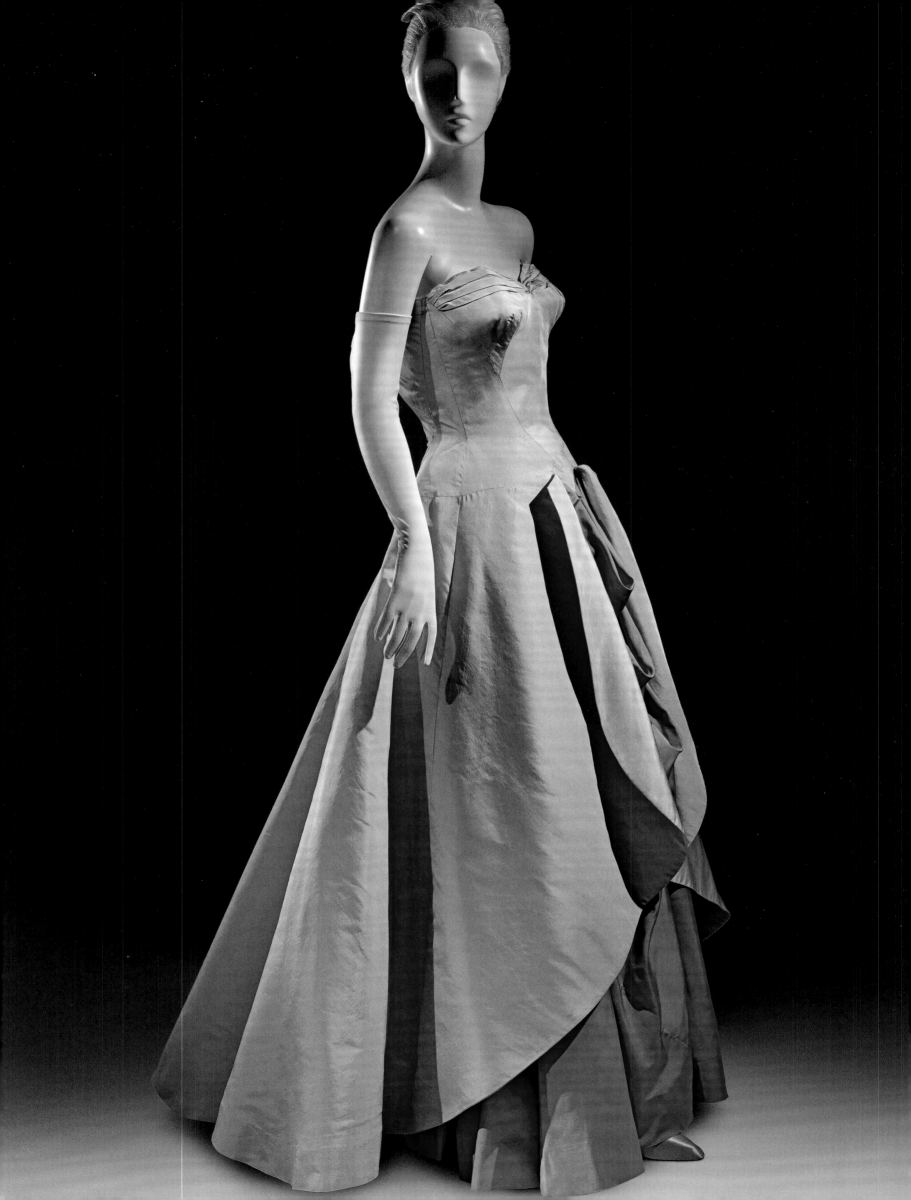

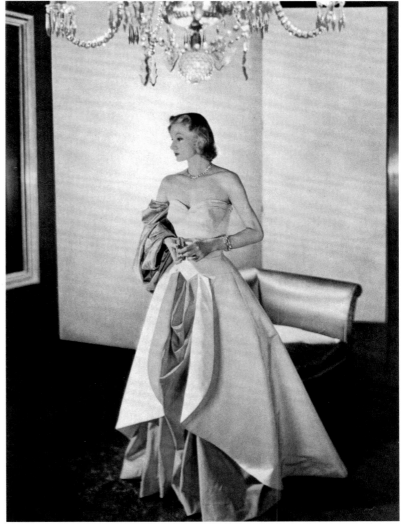

Ball Gown, 1948. *Peach silk faille and orange silk taffeta*
This ball gown, which appears in Cecil Beaton's iconic group portrait of James designs (see pp. 36–37), was ordered by two of his most stylish American clients, Austine Hearst and Millicent Rogers. Referring again to the style of the eighteenth-century open robe and petticoat, James gave it a distinctive stamp. The overskirt frames the cascade of drapery on the underskirt like a shawl collar, with a rather explicit libidinous allusion.

above left: James arranging the front drapery of the ball gown, modeled by Austine Hearst. Photo by Ruth Orkin. *Coronet,* December 1948, p. 79
above right: Millicent Rogers in James's studio, wearing a stole in contrasting wisteria panne velvet. Photo by Gene Fenn. *Town & Country,* July 1948, p. 39

"Make the grain do the work."

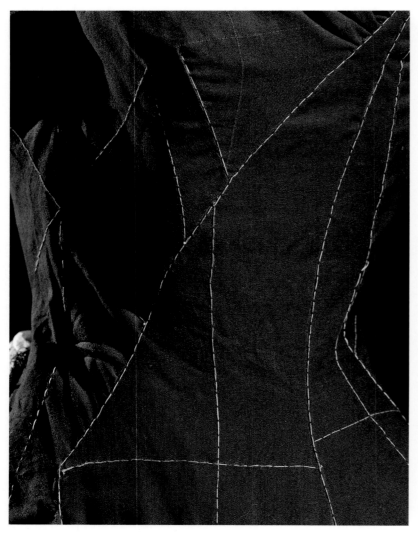 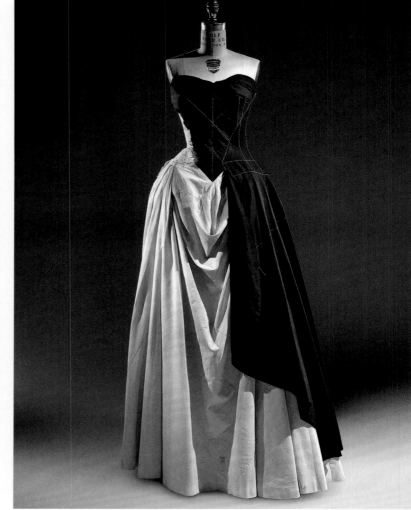

above: Half-Sewn Muslin, 1947. Black and white cotton muslin

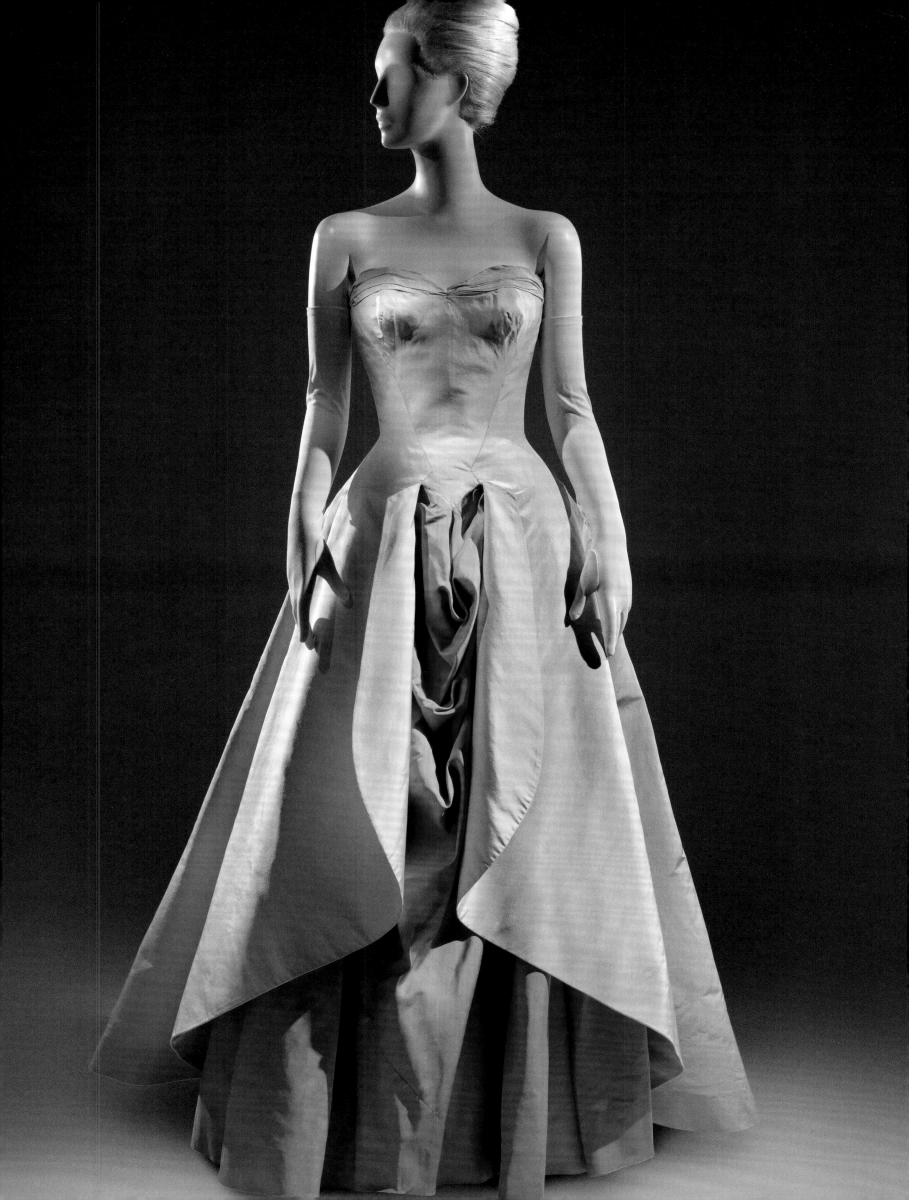

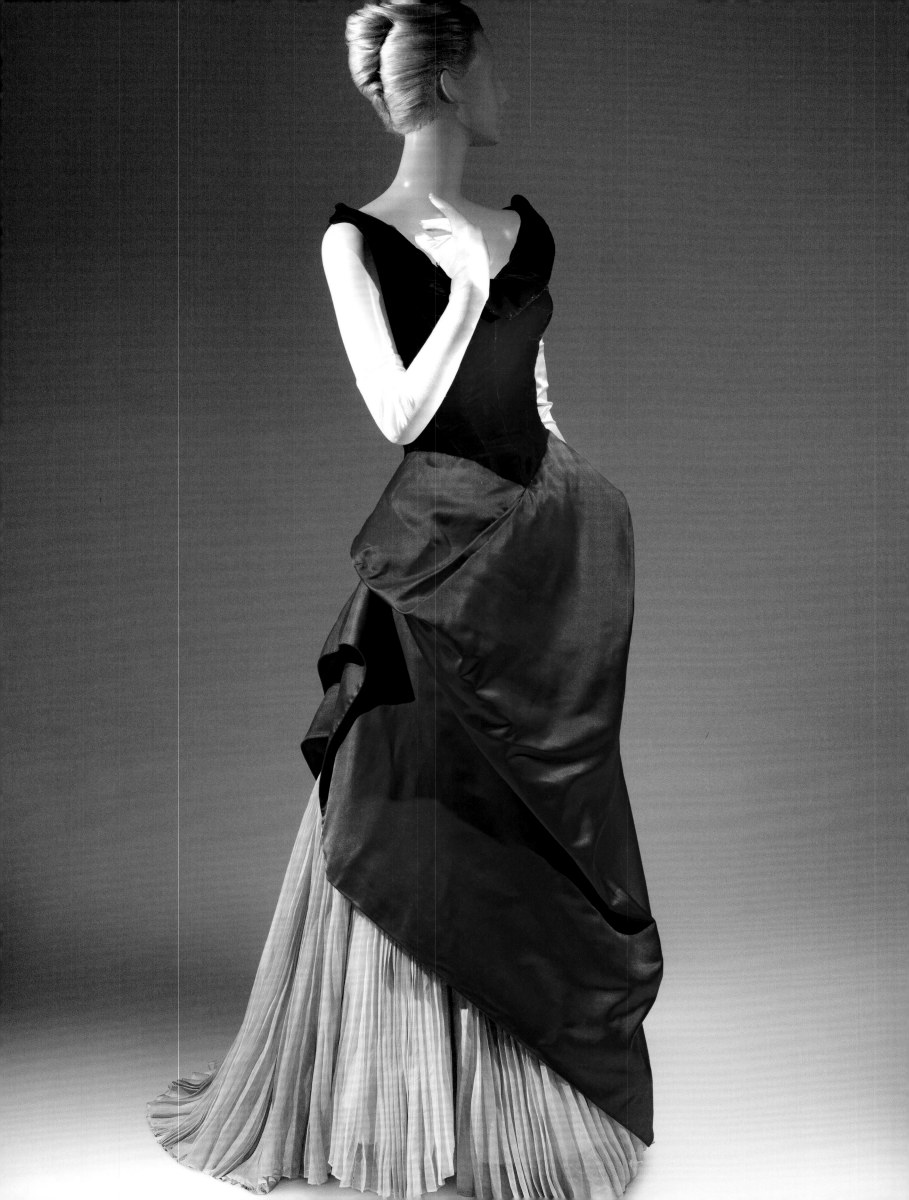

Ball Gown, 1949–50. *Red silk velvet and satin and white cotton organdy*

James claimed that this was the simplest dress to put together because it had three distinct parts: the velvet bodice, the organdy skirt, and the satin overskirt. The draping of the overskirt, however, is impossible to understand without close study. The long, extended panel is torqued and wrapped. The complex shaping at the back is achieved by a deep incision to create the self-yoke.

above: Mrs. William S. (Barbara "Babe") Paley at her home, Kiluna Farm, in North Hills, Long Island, New York. Detail of photo by John Rawlings. *Vogue,* November 1, 1950, p. 115

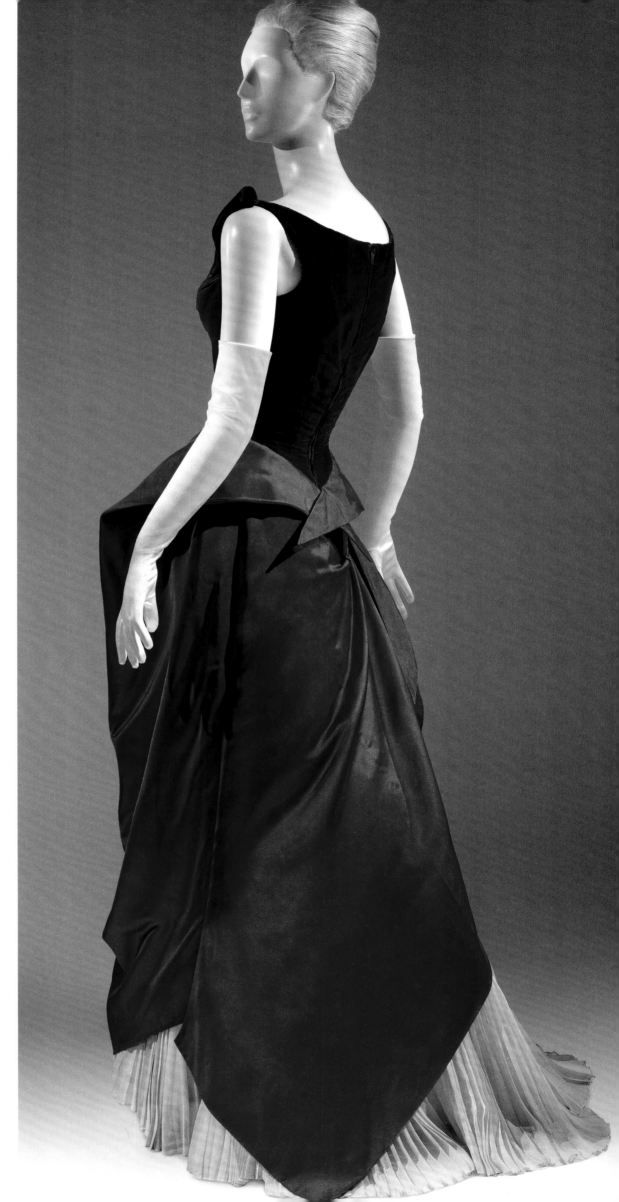

ACCORDING
TO
CUSTOM

Evening Dress, 1951. *Brown silk taffeta and green silk satin*

The slightly structured strapless bodice is overlaid with a diagonal panel that originates at the right side waist and is draped loosely around the back to curve in a fan over the shoulder. The skirt is similarly unconventional. Many of James's other draped effects are made from continuous panels, but this asymmetrical skirt has multiple parts, each seamed in a pronounced curve. The seams lightly buttress the final draping. The effect may appear spontaneous, but the construction reveals James's deliberate intentions.

above: Rendering of Eleanor Searle Whitney in the dress she later donated to The Costume Institute. Illustration by Joe Eula. *Town & Country,* October 1951, p. 122

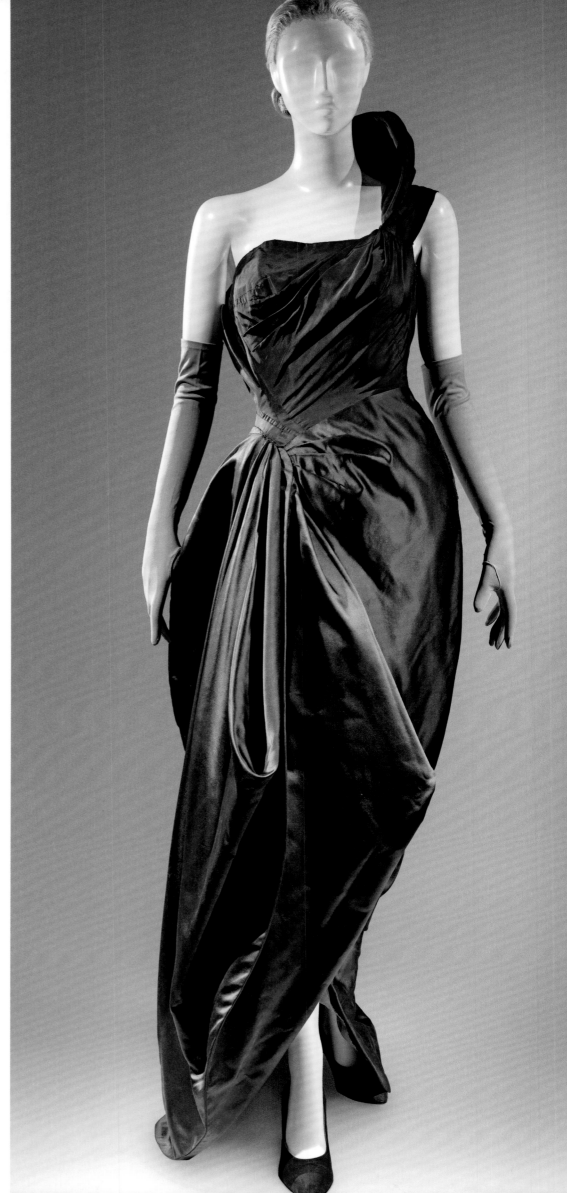

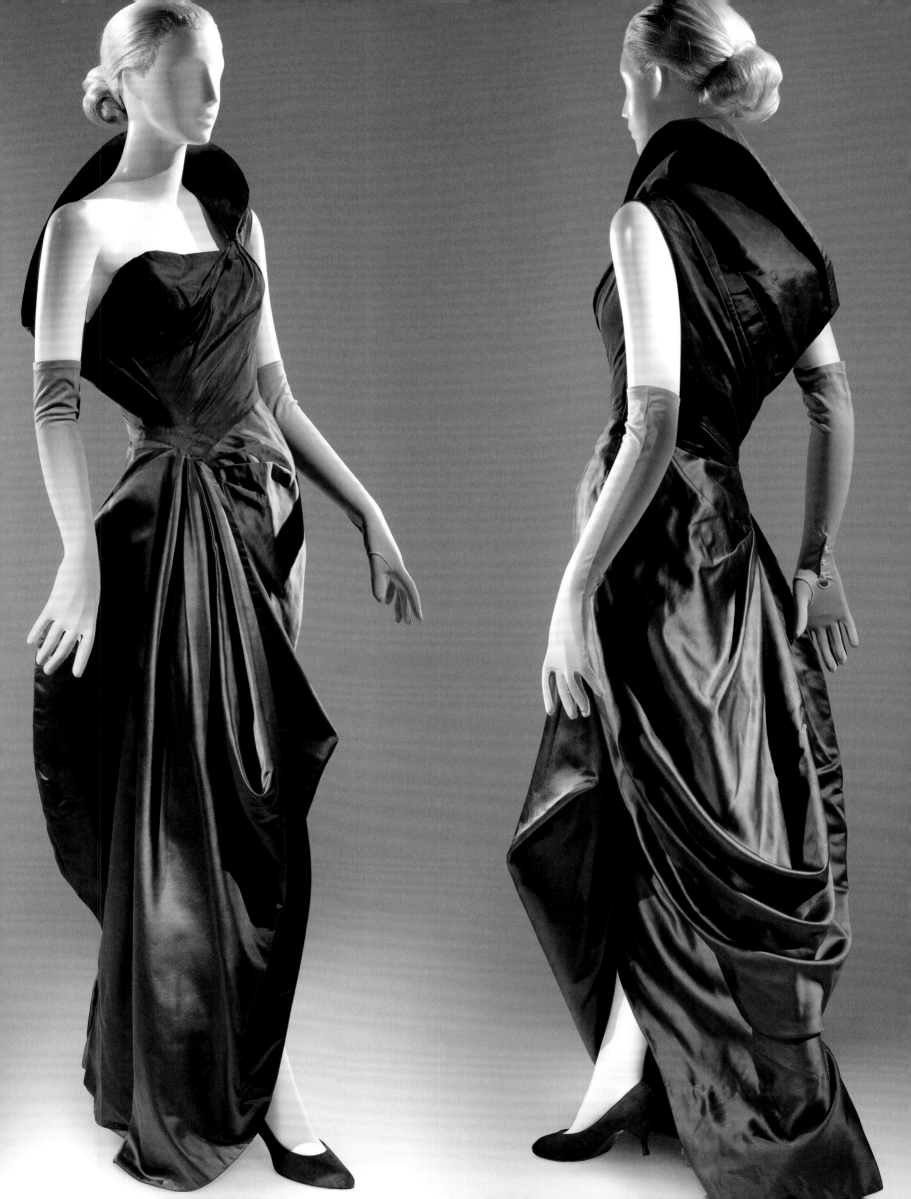

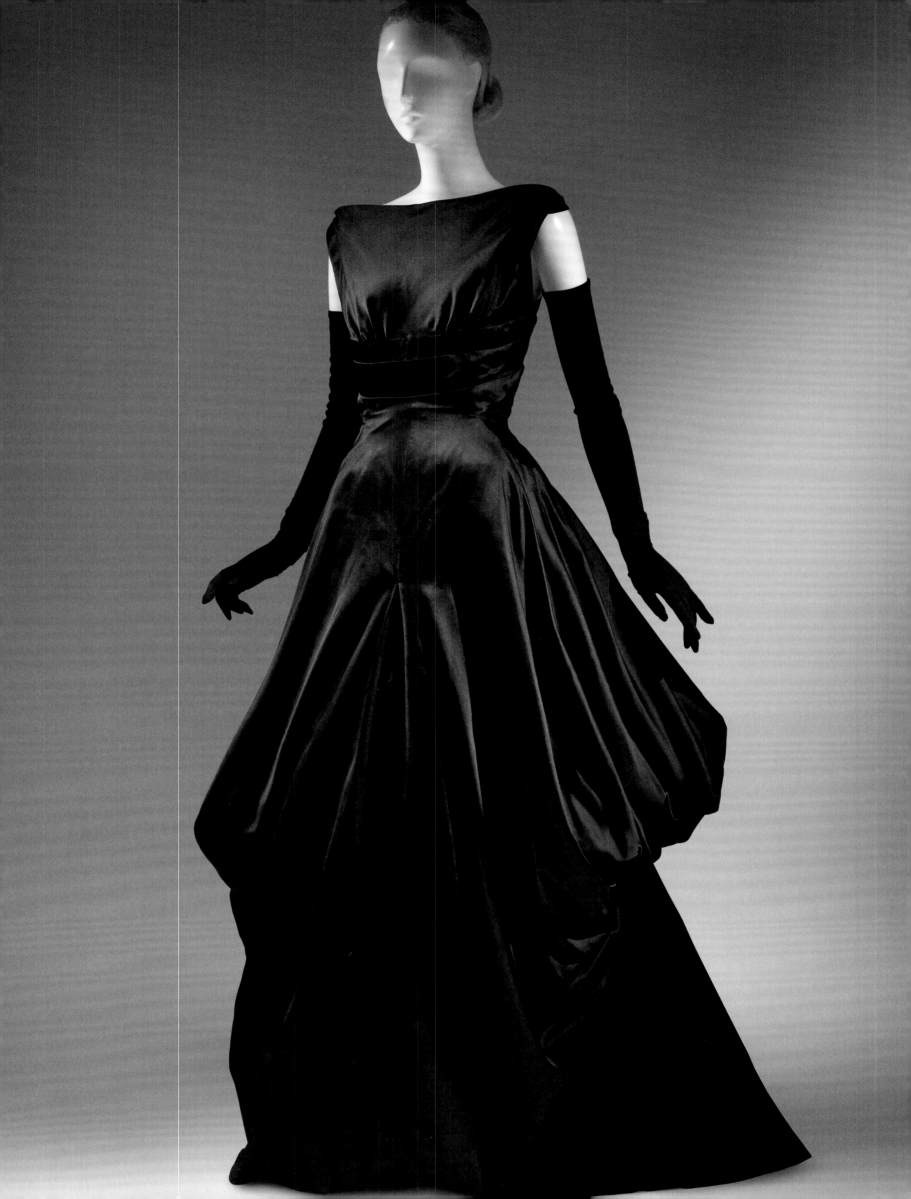

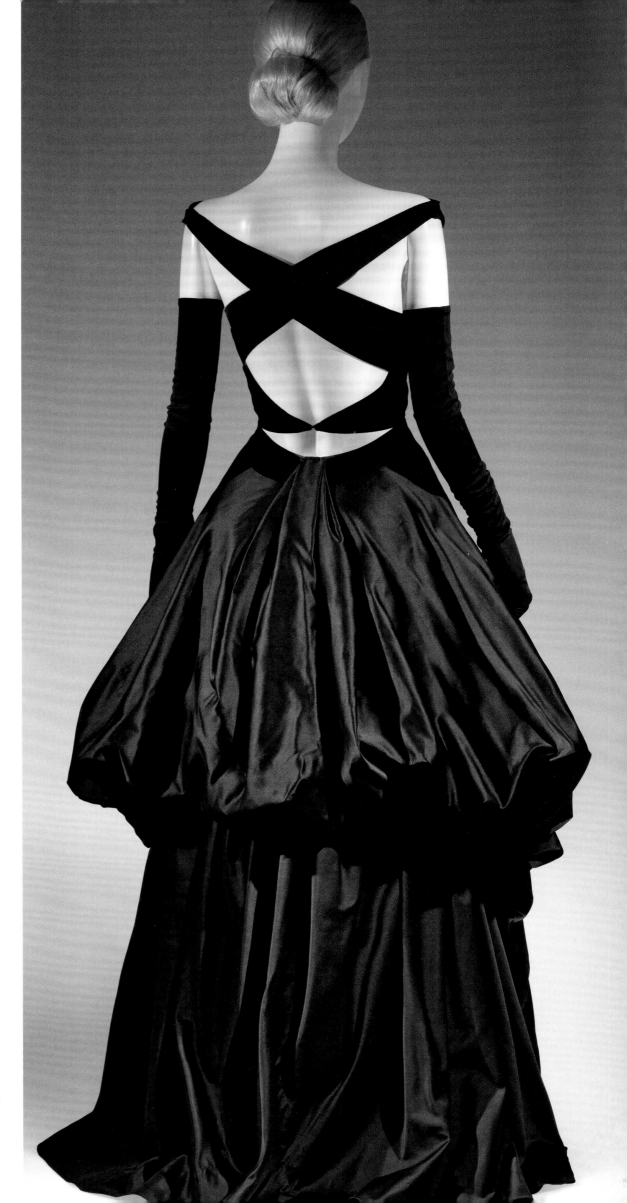

Evening Dress, 1948. *Black silk satin and velvet*
Retaining some of the fluid characteristics of James's 1930s designs, this evening dress is among the most unstructured of his volumetric silhouettes from the postwar period. The high bateau neckline is almost modest in its coverage, in contrast to the exposed back, which is crisscrossed by acute triangles of black velvet. James incorporated into one gown crisp, graphic outlines (the harnessed back) and soft, airy fullness (the poufed skirt).

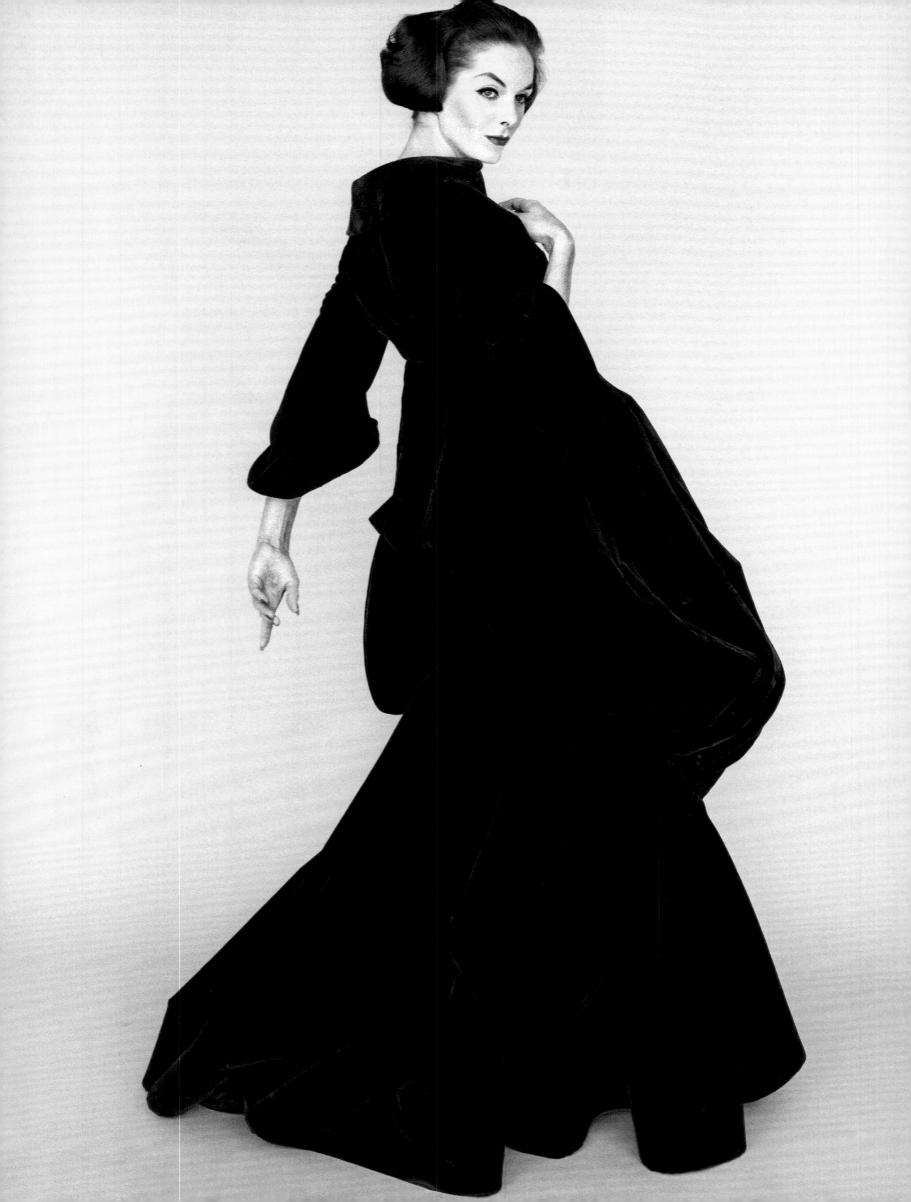

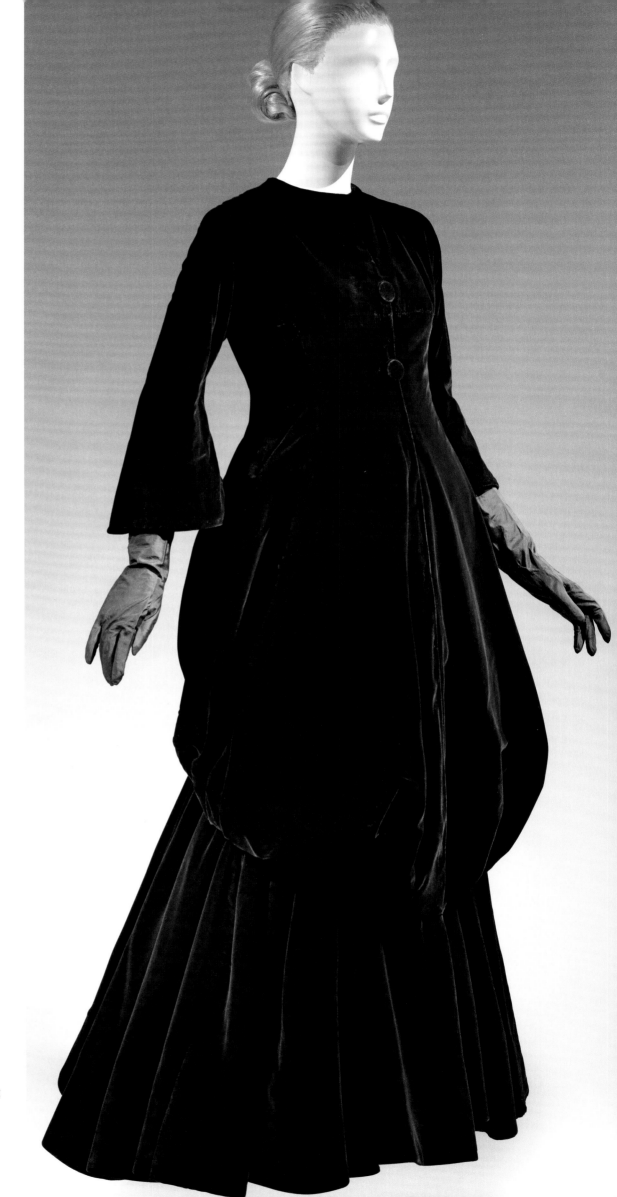

Balloon Opera Coat or Evening Dress, 1956.
Black silk-acetate velvet
James considered the balloon silhouette one of
his most ambitious designs, and he developed it
simultaneously as an opera coat and an at-home
dress. This coat is similar to one given to The
Costume Institute by Dorothy Shaver, the president
of Lord & Taylor, except that it has been stitched
together at the hem of the front opening, essentially
converting it into an evening dress.

opposite: The model's backward-leaning pose
underscores the coat's pouf in a photo accompanying
James's article, titled "The Shape." Photo by Jerrold
Schatzberg. *Fashion,* Fall–Winter 1956, p. 24

Balloon At-Home Dress, ca. 1956. *Black silk faille*
The voluminous design of this dress lent itself to a
maternity version that James made for Lane Bryant,
in which the faille exterior is attached to a taffeta
underslip that is cut to expand gradually from under
the bust to accommodate a pregnancy. To develop
the design, James established the angle of the
expansion with tapes passed through staples tacked
into a wooden platform. Despite the design's origins
in complicated engineering, the final dressmaking
solution for the blouson was a simple horizontal
welt tuck circling the skirt, angled high at back and
lower at front.

above: Sketch by Charles James, 1968. Ink on paper
opposite, near right: A padded-out dress form in the
shape of the Balloon dress. Photo by Gerri Mindell,
ca. 1955

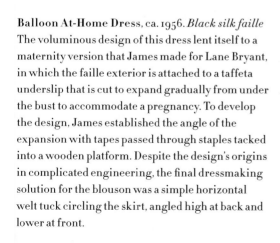

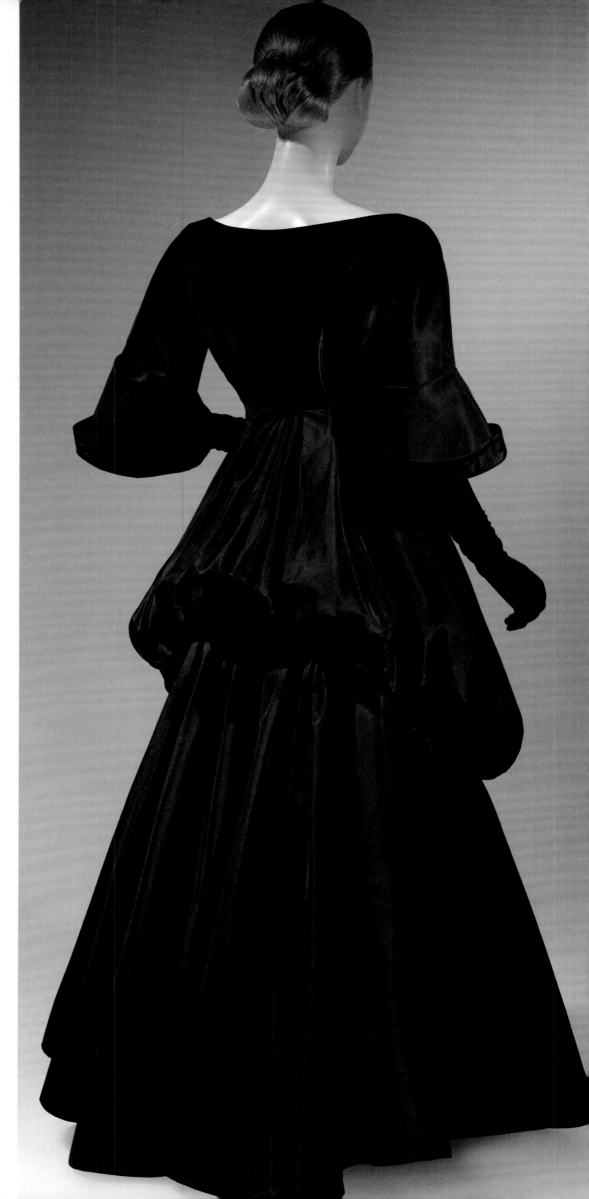

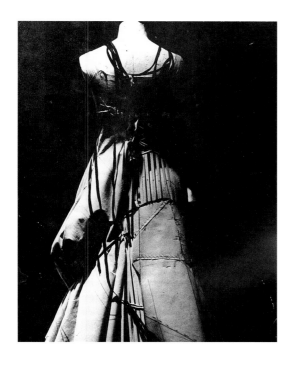

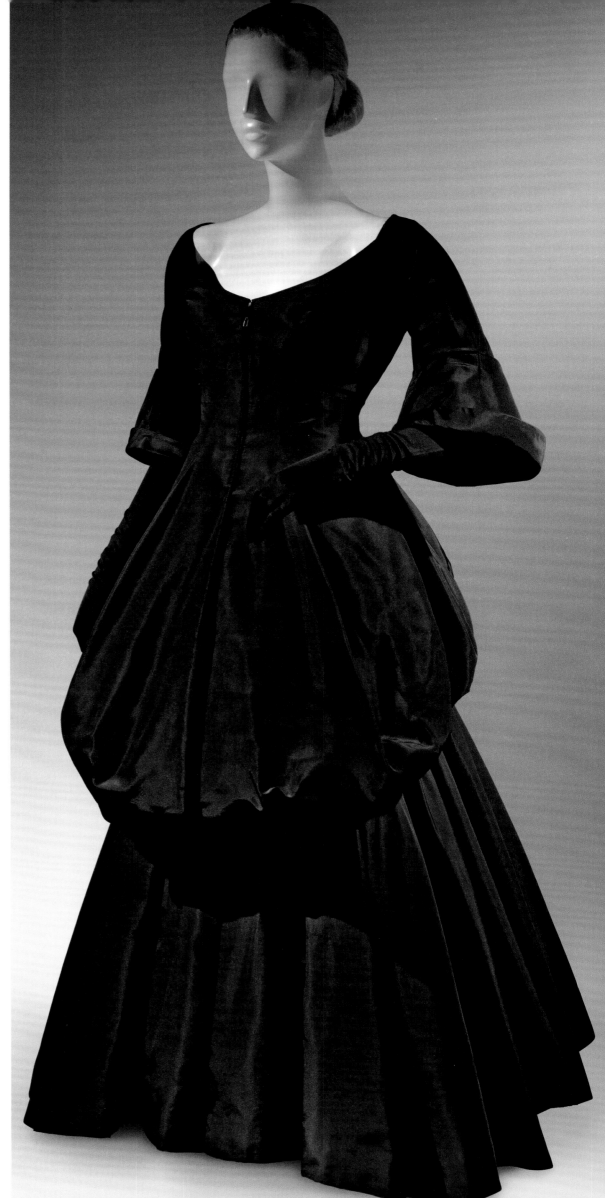

ANATOMICAL CUT & PLATONIC FORM

Especially in his tailoring, James constructed an idealized form that encases the wearer and imposes a silhouette that has little to do with her actual contours. He created what he described as a "pillow of air"[1] between his clients' bodies and his designs. As in the work of the Spanish-born master couturier Cristóbal Balenciaga, James's sleight of hand rested literally on the shoulders of his patrons. Balancing his garments there meant that, like Balenciaga's, they could be suspended to sheathe the body without constricting it, often resting at two or three points, or only lightly at the hips. Although James's engineering is apparent in the lithe body-conscious designs of the prewar period, his signature ideas of altered proportions of the anatomy reveal themselves most explicitly in his work of the 1940s and 1950s.

The James figure shares the modest bustline and fecund abdomen, hips, and thighs of a Cranach Eve or a Directoire Merveilleuse. While James throughout his career referenced the body in his designs, he was equally interested in ameliorating deviations from his platonic ideal of the female silhouette by asserting a perfected form through strong contours. As he provocatively stated early in his career, "the feminine figure is intrinsically wrong, and can be corrected only by good posture and fashion. The Venus de Milo . . . would be most unfashionable unless she had a good dressmaker."[2]

Arguably all of his designs express his anatomical cut, his characteristic seaming and shaping that refer to the body while also introducing the curvaceous volumes he saw as a feminine ideal. However, it is his tailoring—where the weightiness of his fabrics combines with his structural implementation of seaming to both cleave to and arc away from the body—that elevates James's pattern pieces and the resulting designs to a high art.

A James tailleur can be simultaneously prosaic and perverse, relying on the past while willfully deviating from any known practice. In his lines the designer alluded to historical precedents from the great age of tailoring in the late nineteenth century, but in terms of cut James was completely without antecedent. He employed displaced darts with such abandon that they are a signature element of his work. While other designers on occasion cut their garments with "ease," a surplus of fabric to enhance comfort and accommodate movement, James often used the excess fabric to create a carapace-like silhouette. Broad backs, arching shoulders, armorlike sleeves, and rounded hips evoke an almost Surrealist exaggeration of the human form.

Although there are notable exceptions—the Pagoda suit, for example, with its flaring peplum in profile (see p. 42, fig. 42)—most James designs are most dramatic when seen from the front, the vantage point that best displays the designer's aesthetic affinities. Of all his hallmarks, the rounded hipline, emphasized slightly or exaggerated beyond shoulder width, occurs with greatest regularity. James loved the curve of an arcing seam and a burgeoning hipline—an implied fecundity that he intended as a sublimated erotic allure.

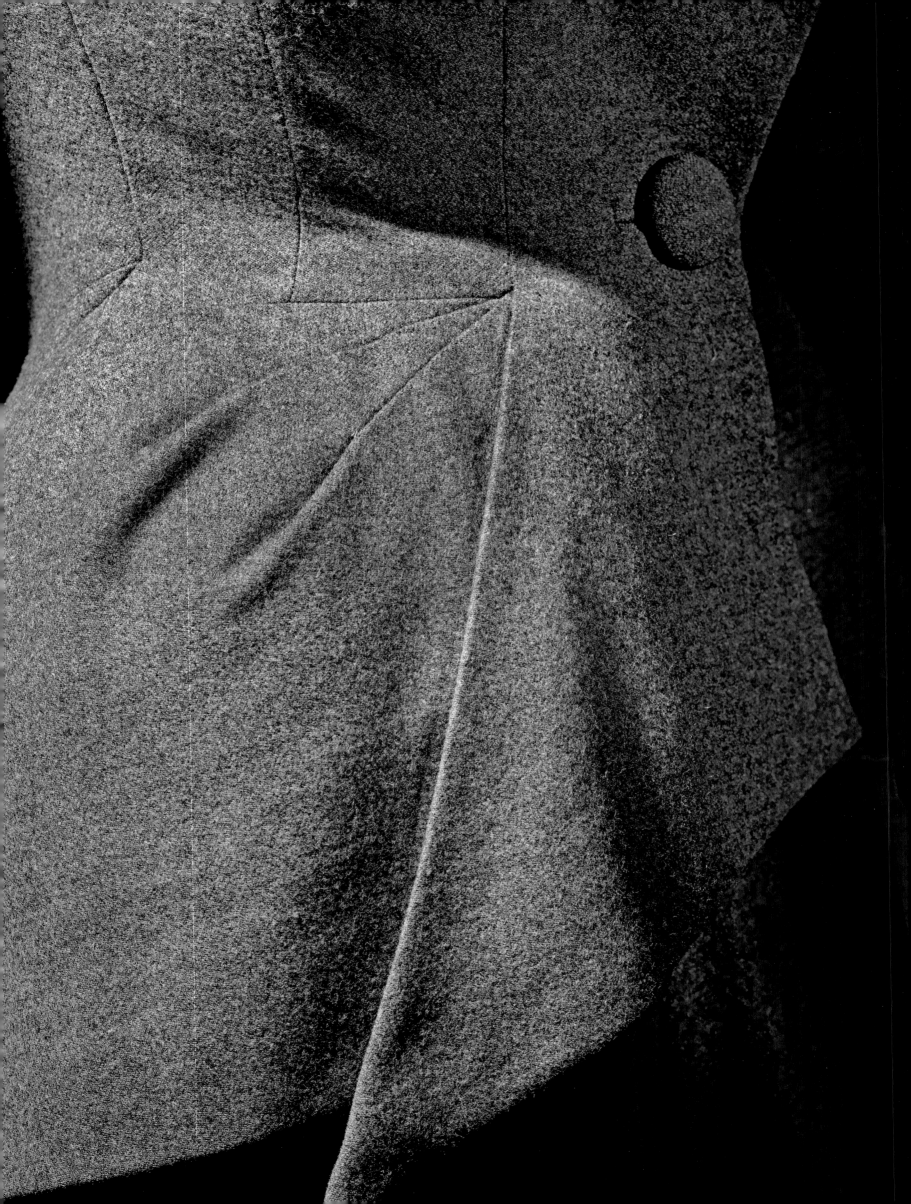

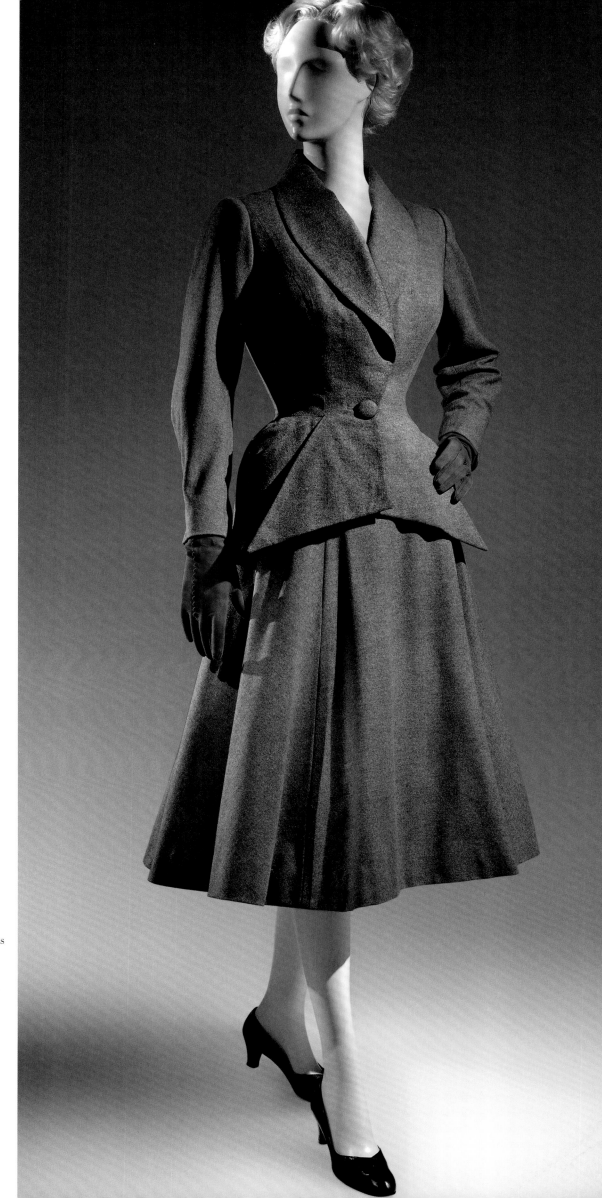

Suit, 1948. *Gray wool flannel*

This suit, made for Millicent Rogers, has characteristics associated with Christian Dior's "New Look": a full skirt, a defined waist, and softened shoulders. (Dior reputedly said that James inspired his influential 1947 collection.) But in this design James introduced the innovative construction details that are his signature, distinct from any precedent in the haute couture. The eccentric pattern pieces—often the consequence of a displaced seam—the angled darts, and the molding of the fabric by steaming and pressing in shape are hallmarks of the designer's hands-on reinvention of his métier. *detail:* Right waist

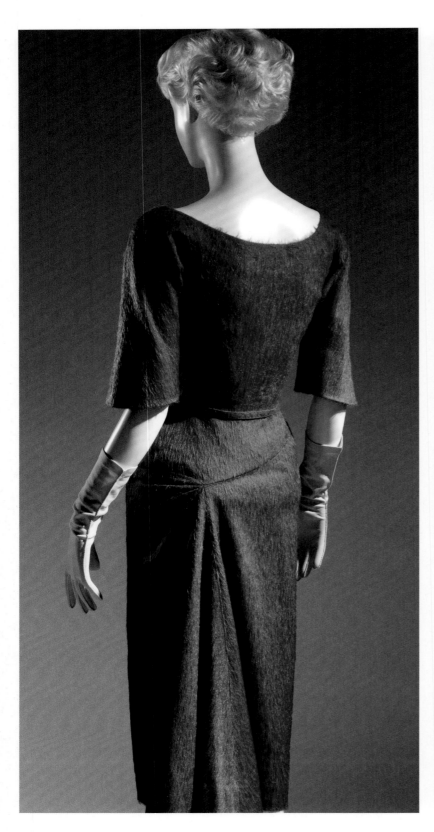
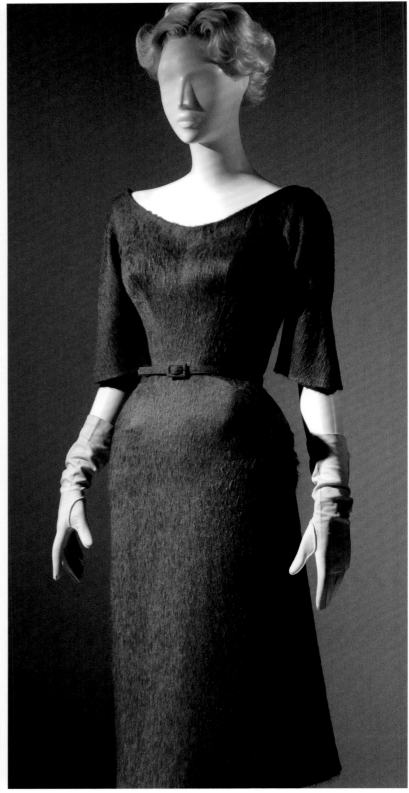

Dress, 1952–53. *Green wool mohair*
This body-conscious sheath is shaped at the bodice with curving seams that are closer together at the apex of the bust than typical princess seams and are angled to the center waist. The skirt, with a right side seam conventionally placed and a left side seam shifted far to the left back and hidden in a carefully draped flare, demonstrates James's flair for asymmetry and the unexpected. The dress was part of the ready-to-wear collection James designed for Samuel Winston. *detail:* Left back hip

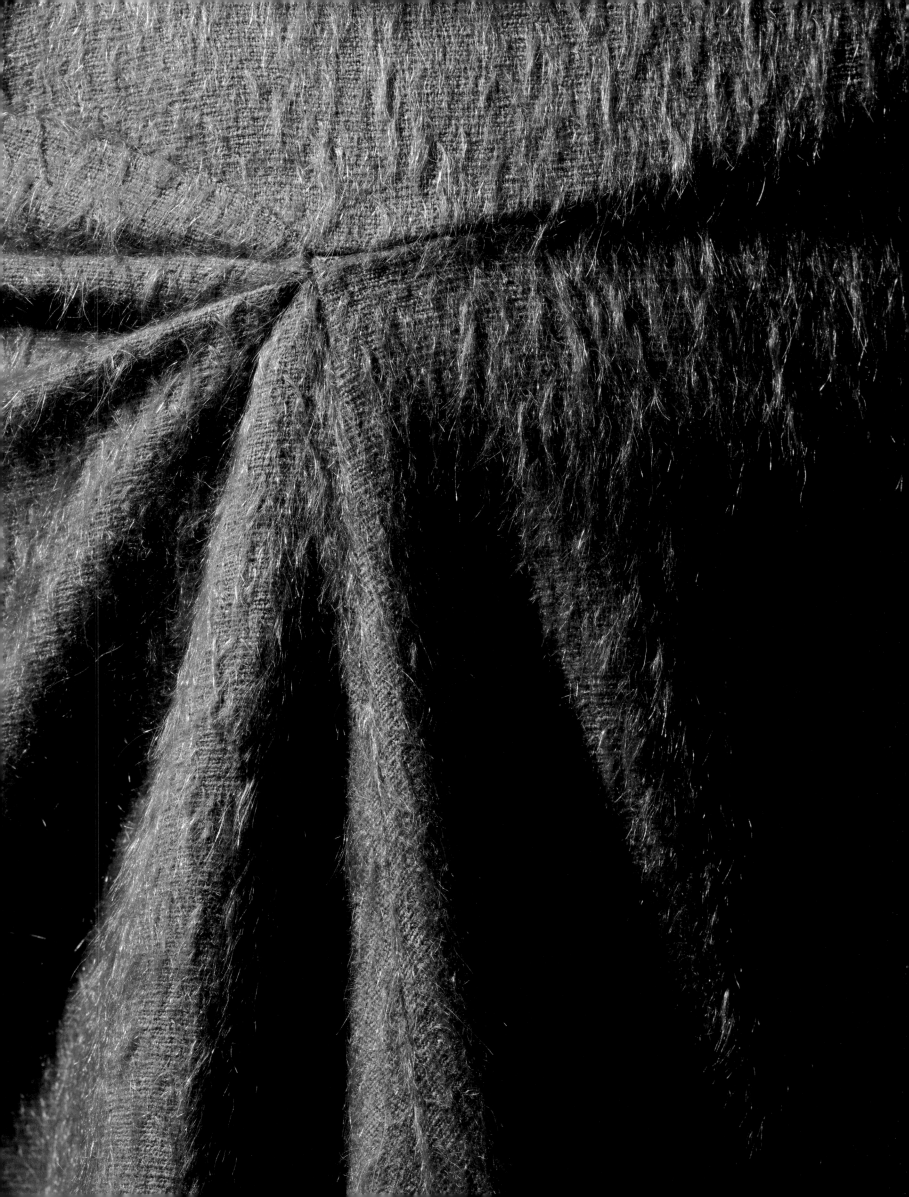

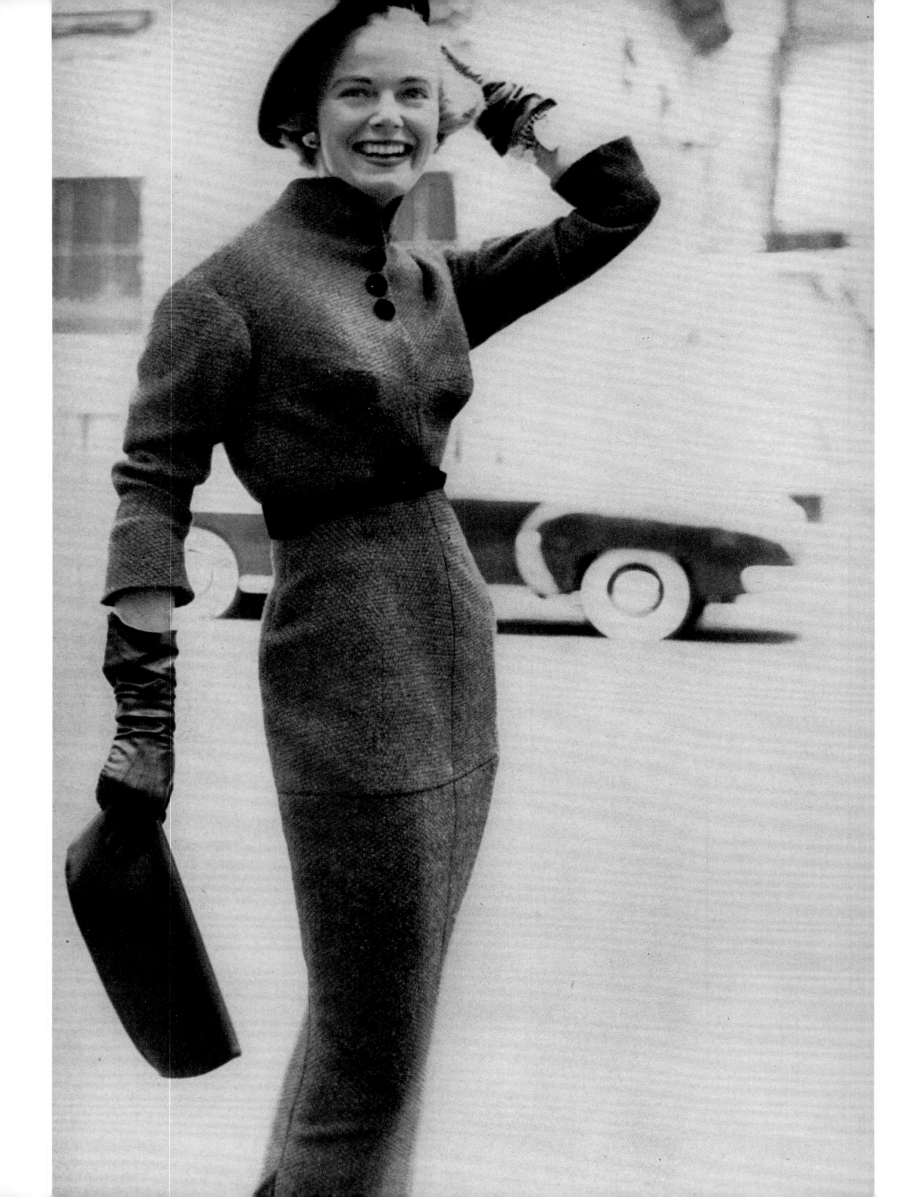

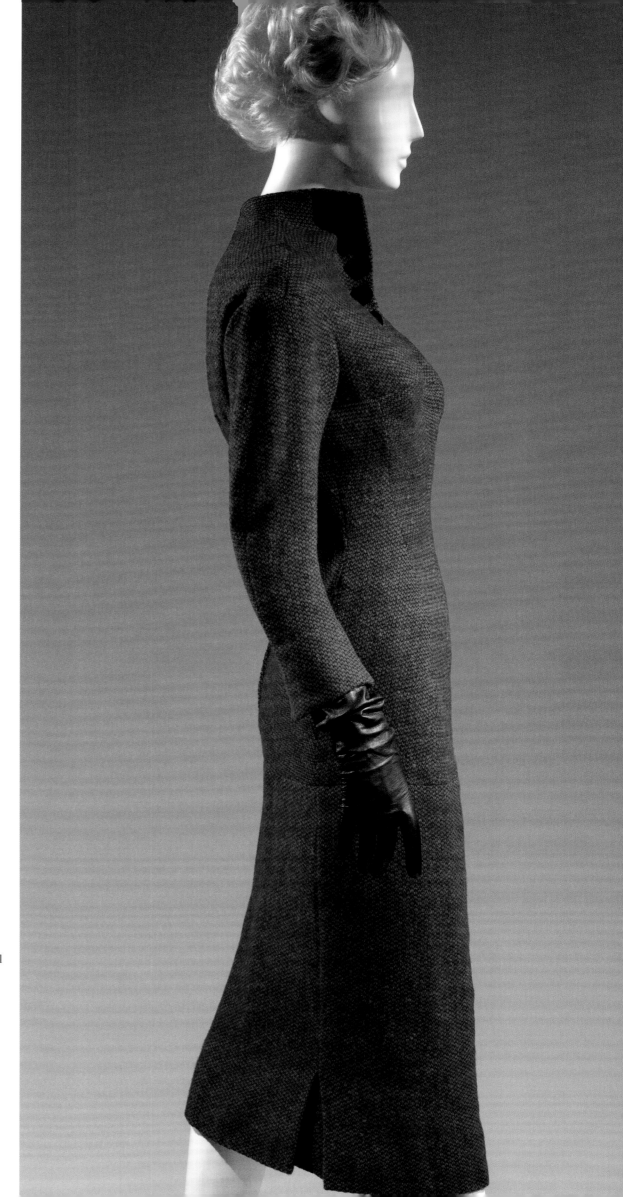

Dress, 1953. *Orange and black wool twill*
This narrow dress, designed for the Samuel Winston
line, is literally molded to the figure at the bustline.
The seams that cleave the cloth to the rest of the body
segment it into atypical pattern pieces. The horizontal
seams across the bust and at the upper thigh are
connected by vertical seams. What would normally
be princess seams are shifted to the side of the bust
while, at the back, long darts from the shoulder yoke
enhance the glovelike fit.

opposite: Mrs. Augustin Jay Powers Jr. models the
dress in Rodier wool on Manhattan's Fifth Avenue.
Photo by Desmond Russell. *Town & Country*, August
1953, p. 80

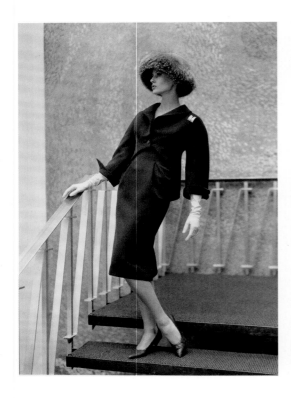

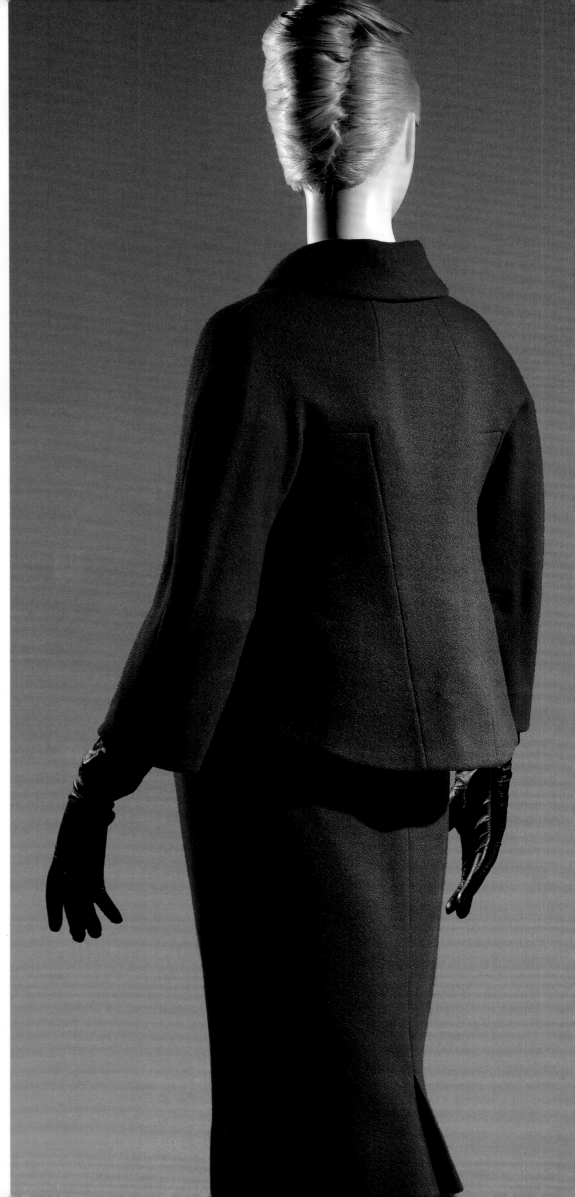

Suit, 1961–62. *Green wool twill*
James placed a favored lyre-shaped seam on this
suit jacket and mirrored its curve in the opposing
cutaway front hem. The cropped front of the jacket
frames two of four splayed release darts from the
waist of the skirt, which introduce ease to the zone
of the abdomen and hips. Curving side seams shifted
to the back result in the skirt's narrowing taper. The
suit was part of a travel wardrobe James made for
Lee Krasner, the artist and wife of Jackson Pollock.

above: A model wearing the suit, ca. 1962.
Photographer and source unknown

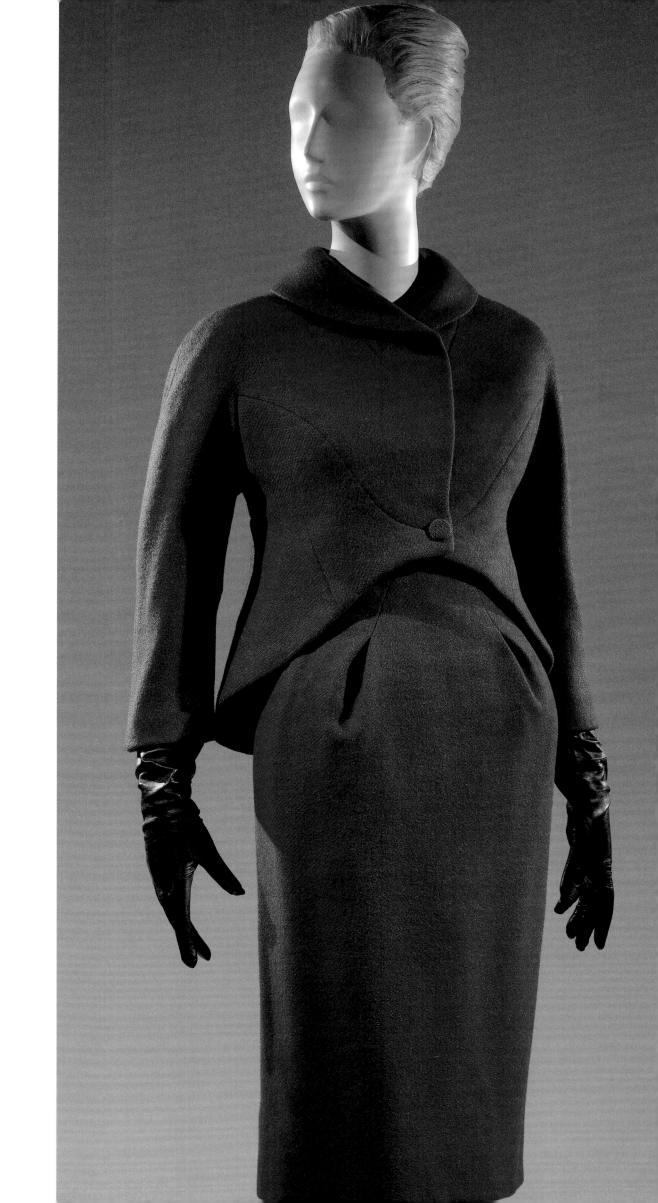

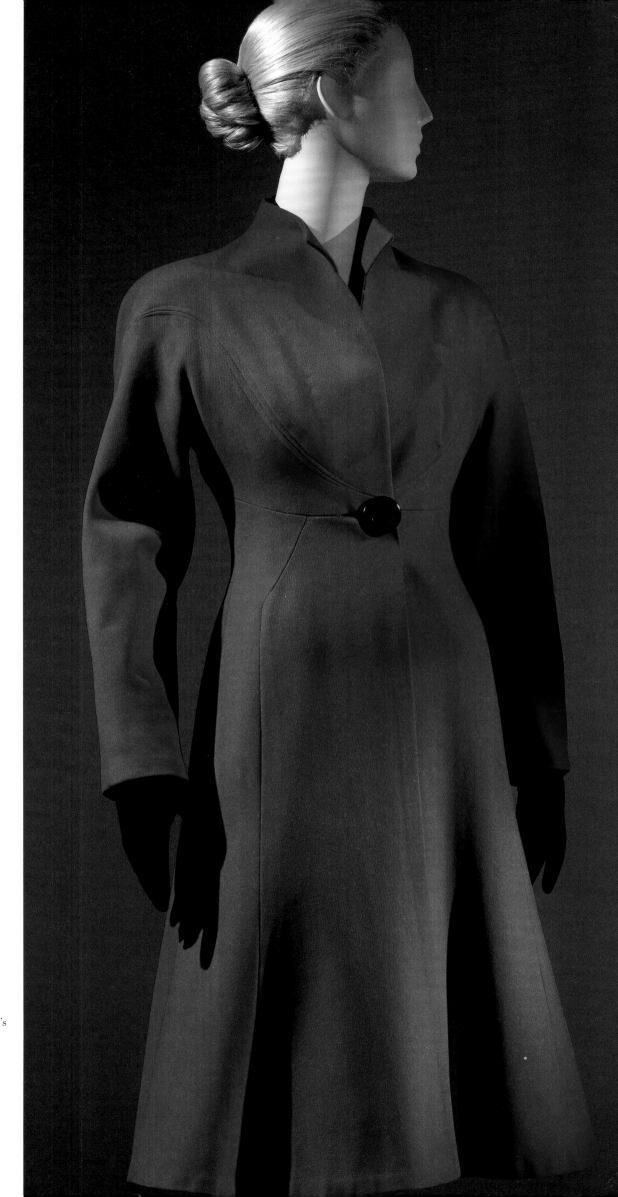

Lyre Coat, 1945. *Red wool cavalry twill*
The beautiful lyre-shaped front seaming of this coat
functions simultaneously as a decorative motif and
a structural shaping device. But the essence of James's
ingenious engineering is seen at the back, where the
shoulder panel is cut in one with the side panel of
the skirt. The designer here moved the rigor of
traditional tailoring in a direction of personal
interest: the elimination of unessential seaming.
detail: Right front bodice

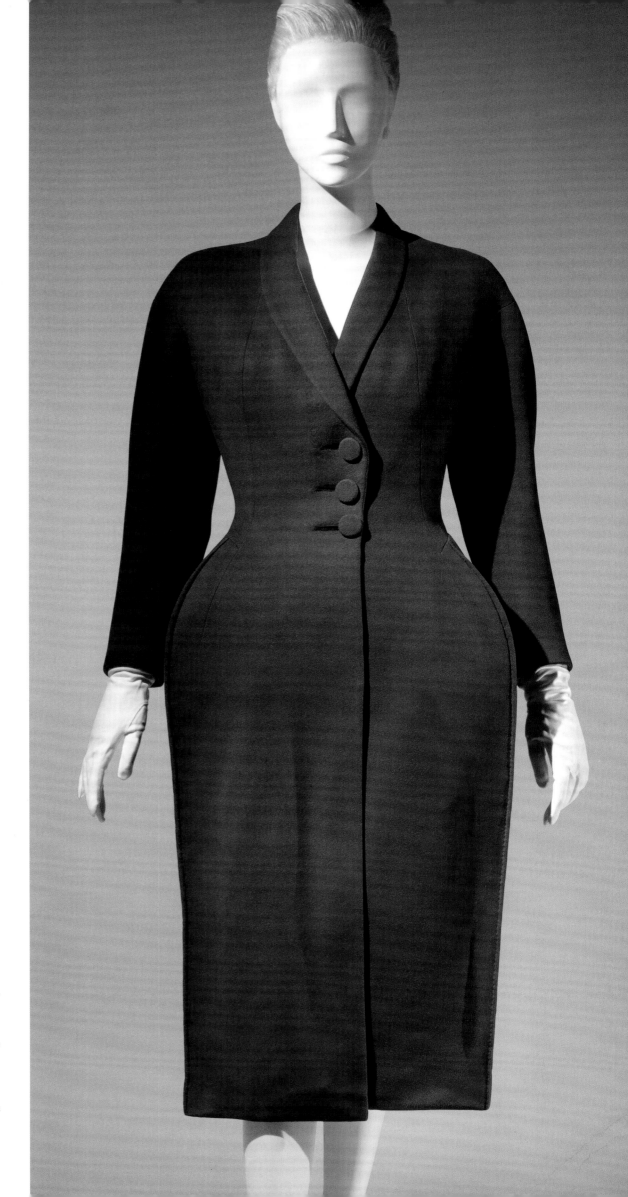

Coat Ensemble, early 1950s. *Purple-brown
brushed wool*
James was proud of this coat's tailoring details,
especially the use of the hand-stitched welts to
highlight the arching curve of the side waist seams.
Of greater interest, however, is the coat's assertion
of an amplified hourglass shape onto the body of
the wearer. The waist is raised to the lower rib cage,
a point on the body with a relatively immutable
dimension. The coat then burgeons at the hips with
the planarity of a cutout paper doll. The emphatic
silhouette makes the shape of the real body beneath
difficult to ascertain. *detail:* Left front hip

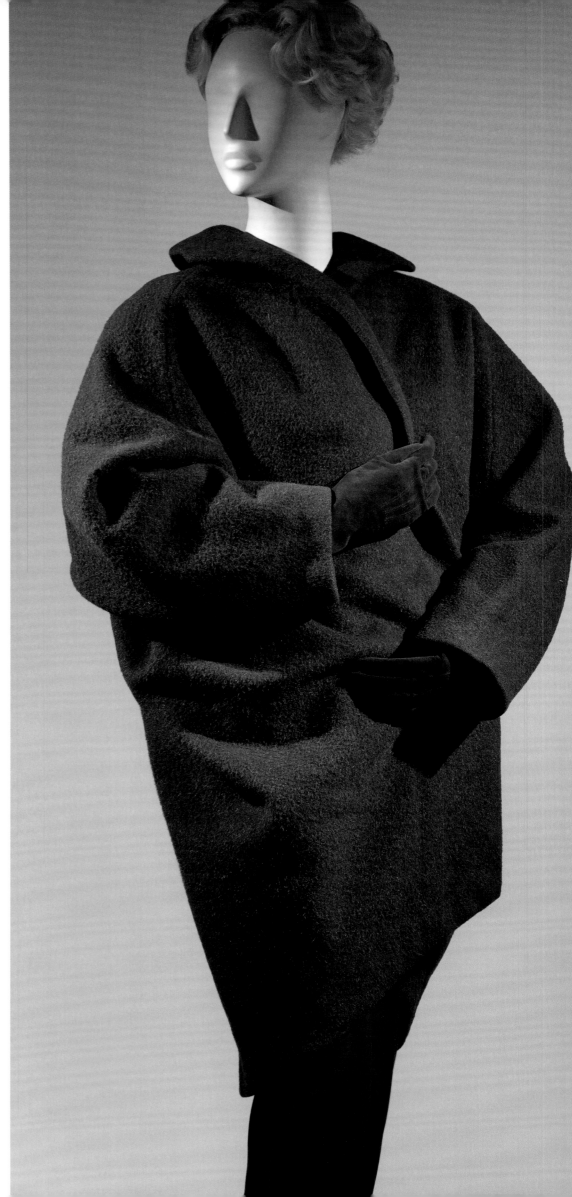

Dolman Coat, early 1950s. *Dark green wool tweed*
Like Paul Poiret's capacious cocoon coats of the
1910s, this James design is meant to wrap around
the wearer, completely concealing her figure.
Constructed with exaggerated raglan sleeves and
a center back seam but no side seams, the coat is
draped to create a deep dolman and to taper to the
hem. James claimed that the cut eliminated the need
for fundamental changes in proportion, no matter
his client's shape, size, or height.

top: Sketch by Charles James, annotated "for Lily
Pons," 1947. Graphite on paper
above: The photo of this mohair version of the
coat is accompanied by a quotation from James
that reads, in part: "The idea . . . nourished by hard
work, self-punishment, finally flowers for the whole
world." Photographer unknown. *American Fabrics,*
Summer 1956, p. 43

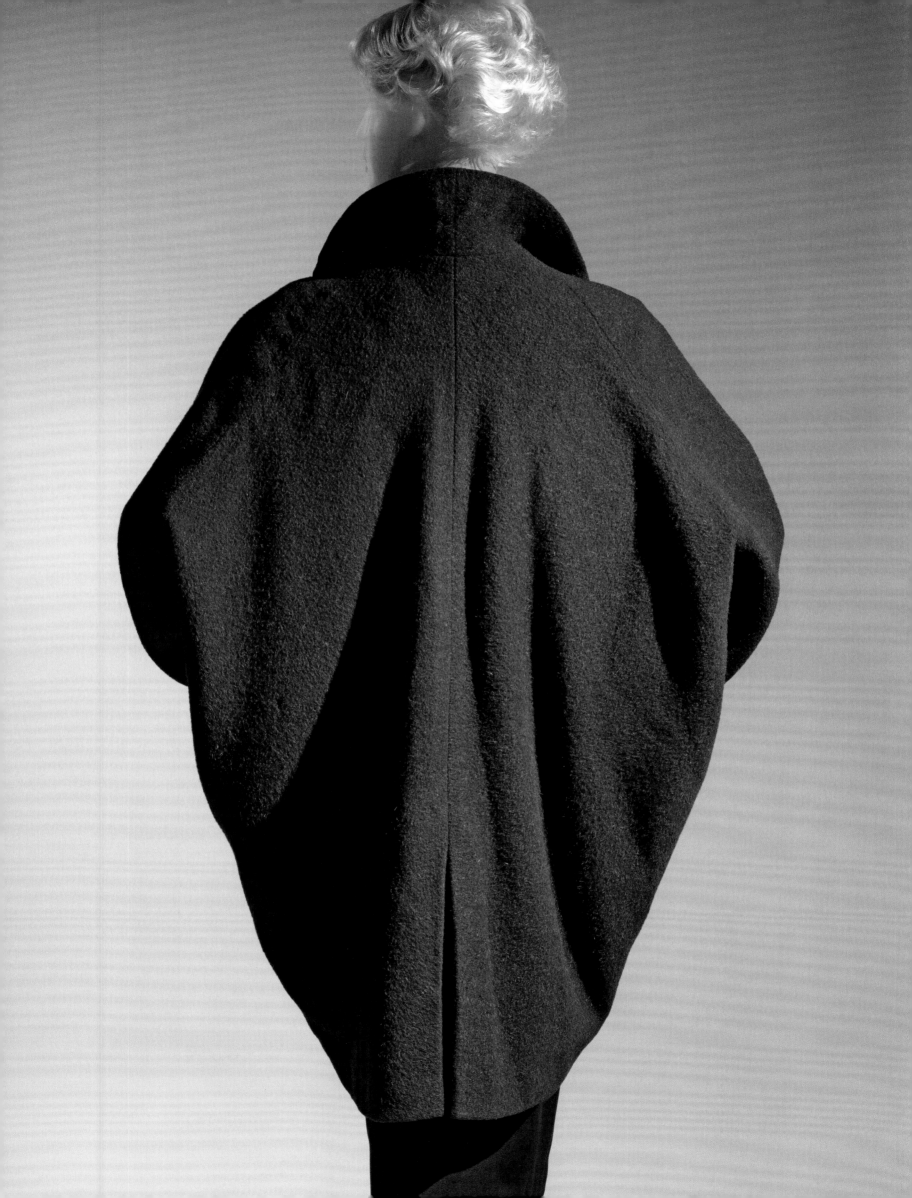

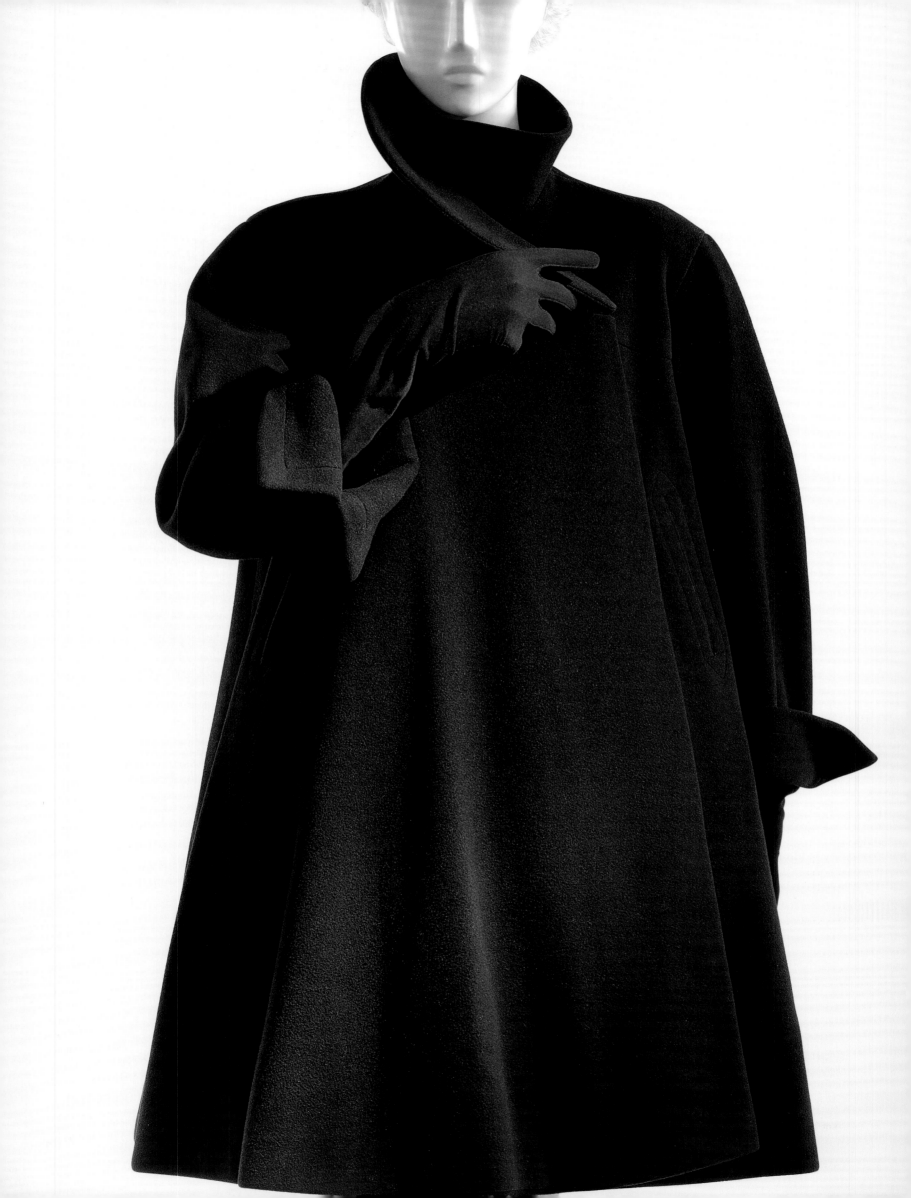

One-Sided Collar Coat, 1951. *Navy wool melton*

The great art patron and collector Dominique de Menil was among James's most loyal clients. To what was for him a surprisingly traditional swing coat he added a charming innovation for her: an asymmetrical collar. The collar was cut narrow at the left and fanned wider at the right, specifically so that Mrs. de Menil could raise it as she disembarked a plane, to protect her face from the wind generated by the propellers. The coat shown here was made for another couture client.

above: Sketch by Charles James, 1956–57. Graphite and ink on paper

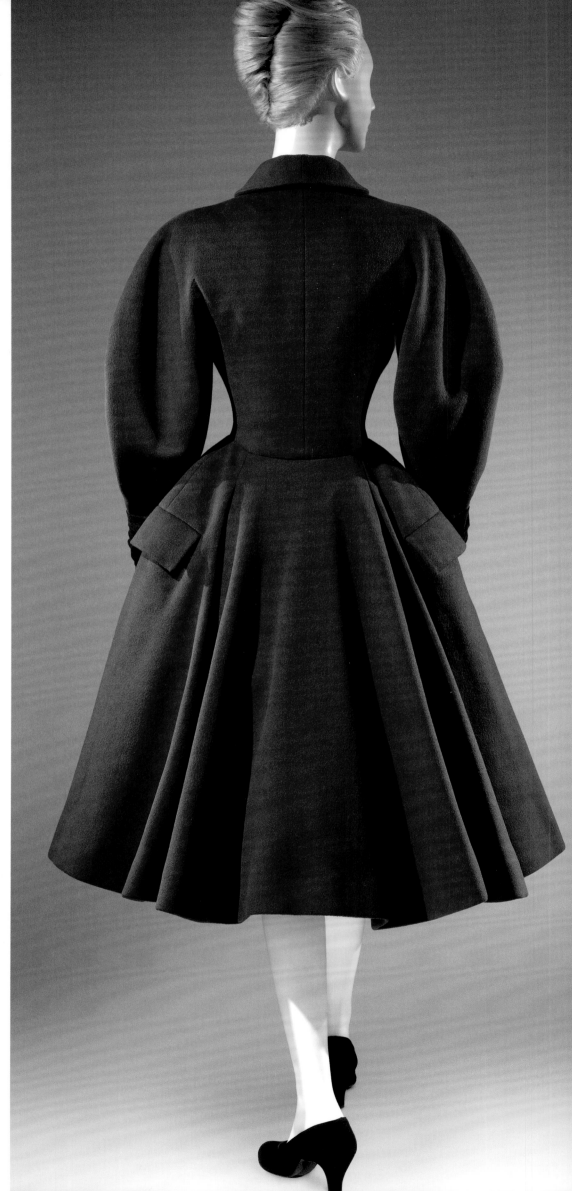

Cossack Coat, 1952. *Dark brown wool melton*
This design's beautifully arcing sleeve silhouette
harks back to the styles of the 1860s. The wideness at
the elbows both accommodates movement and serves
as a foil for the figure: The amplitude contrasts with
and optically diminishes the dimensions of the waist.
The fullness of the skirt is created by shifting the side
seams to a center back panel. The seams themselves
are hidden in the carefully modulated folds.

above: Advertisement for Lord & Taylor's copy of
James's original Cossack coat. Illustration by
Dorothy Hood. *Vogue*, October 1, 1951, p. 7

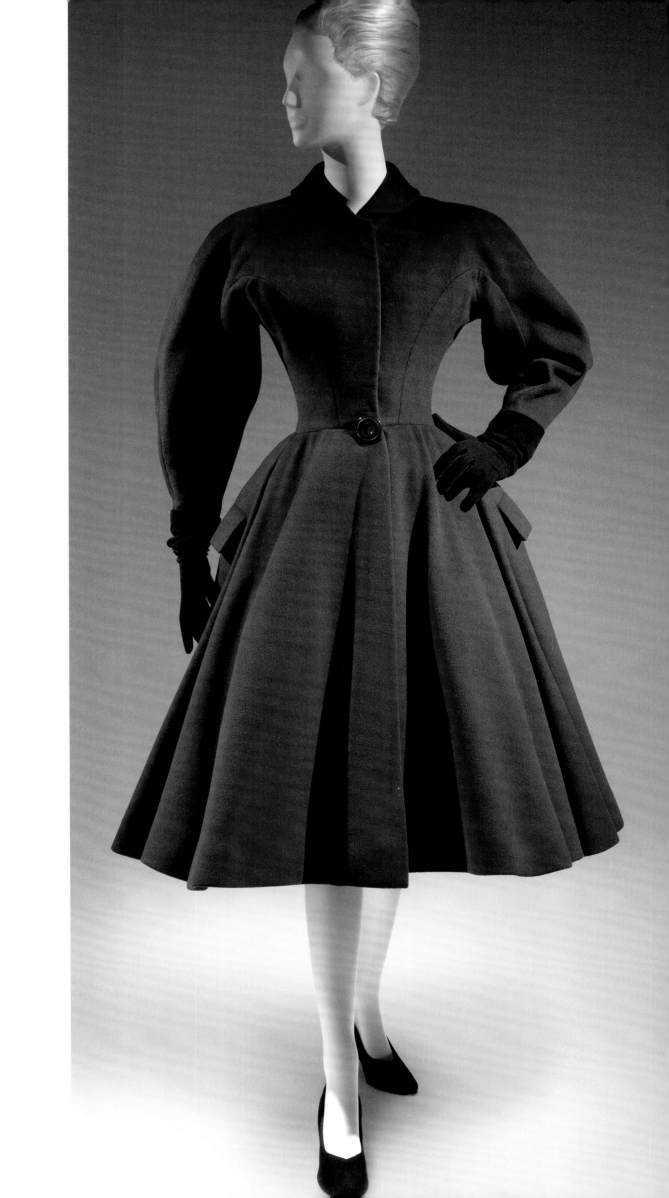

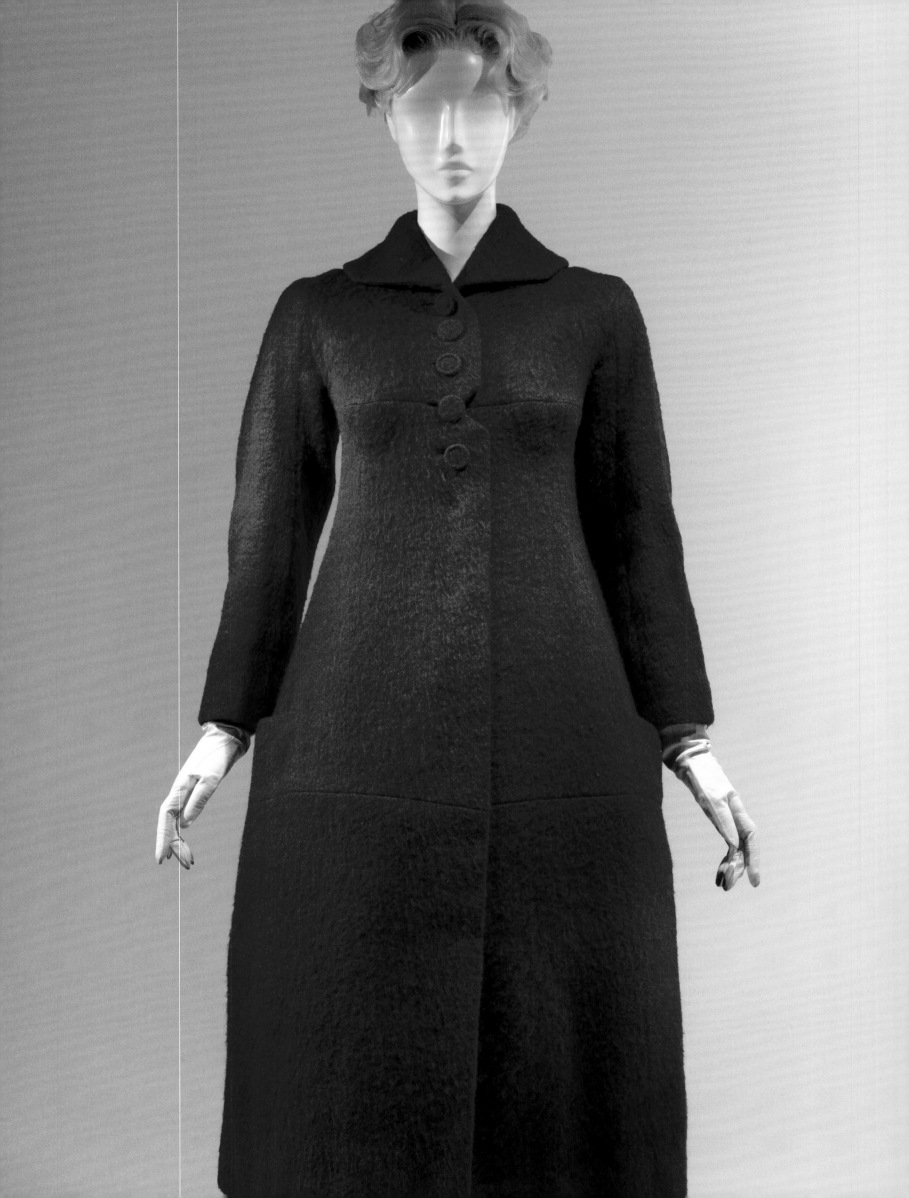

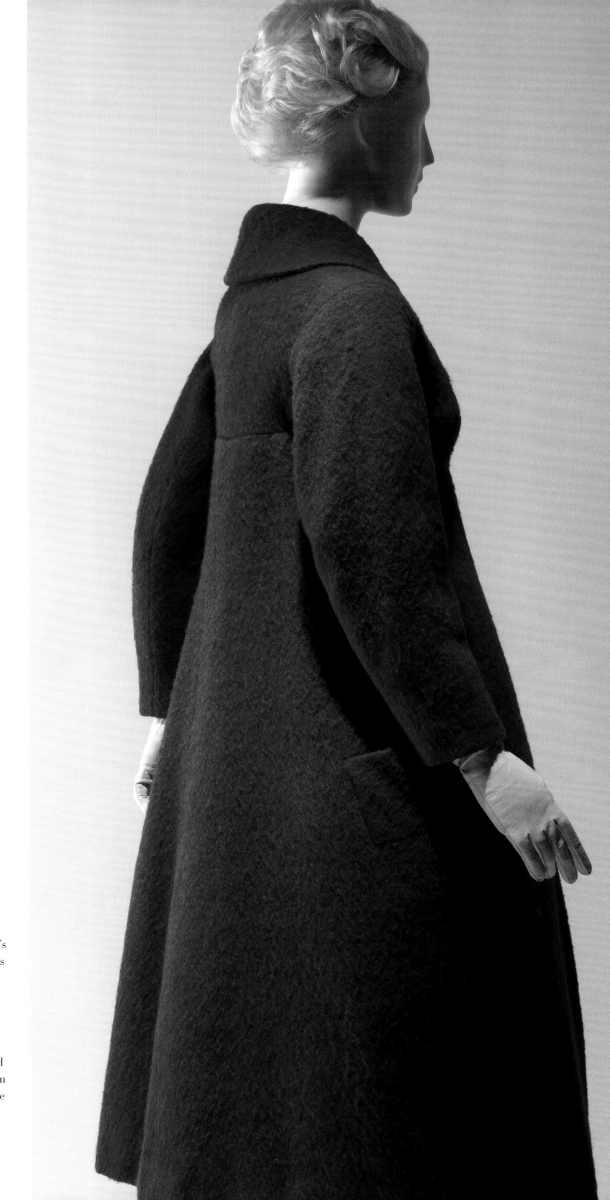

Bluebell Coat, 1954. *Red brushed wool*
A recurring Jamesian detail is the placement of a
seam across the apex of the bust and back. This coat's
remarkable silhouette evokes the paintings of Lucas
Cranach. It is accomplished primarily by princess
seams that curve from the bust to the side hip and
disappear into pockets, and by the molding of the
fabric over the breasts through steaming, pressing,
and pulling. The bell-shaped silhouette is the result
of especially eccentric patternmaking. An L-shaped
panel wraps from the back yoke to the princess seam
at the torso and from the lower hipline around to the
front skirt in one piece, thereby avoiding the need
for side seams.

"A great designer does not seek acceptance. He challenges popularity, and by the force of his convictions renders popular in the end what the public hates at first sight."

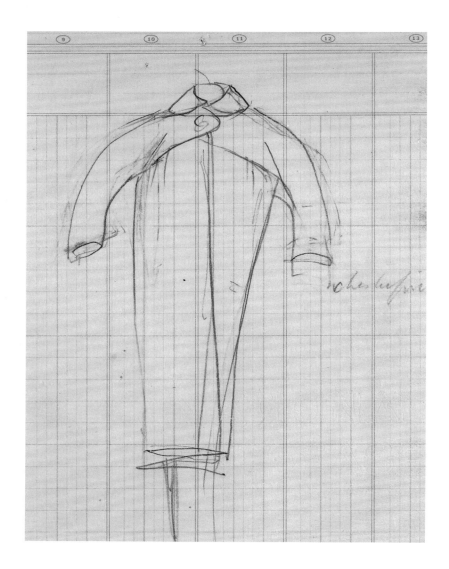

Gothic Coat, 1954. *Pink cashmere*

One of a series of high-waisted, bell-shaped coats, this design alludes to James's affinity for William Hogarth's theory of the serpentine line of beauty. The collar, cut in one with the front shoulder yoke, suggests an Empire Spencer jacket and introduces a sinuous curve where it pulls away from the body of the coat. But the most graceful detail is obscured by the arms: The elegant back seam of the underarm panel scrolls in a reverse S-curve over the hip. The fullness of the coat is so balanced that it falls in symmetrical flutes at the back.

above: Sketch by Charles James, ca. 1957. Graphite on paper

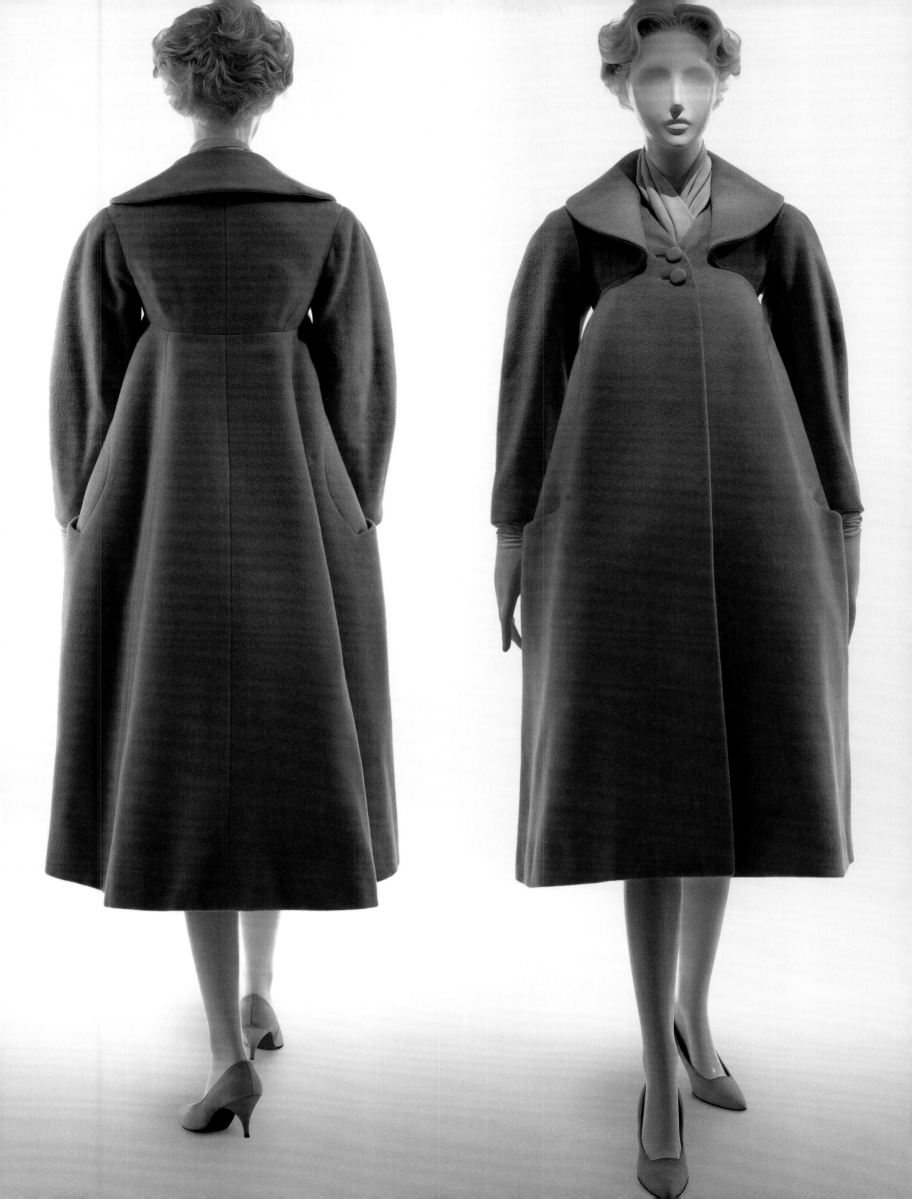

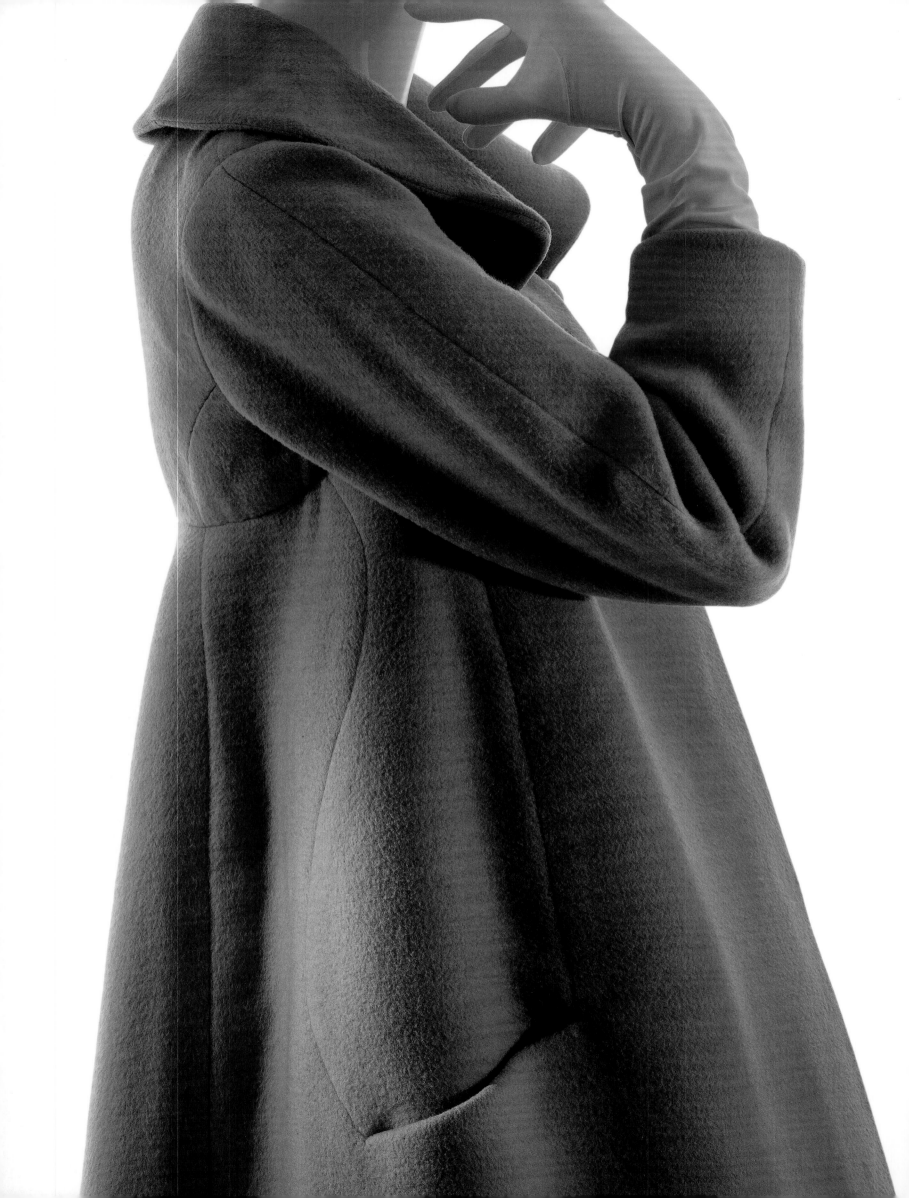

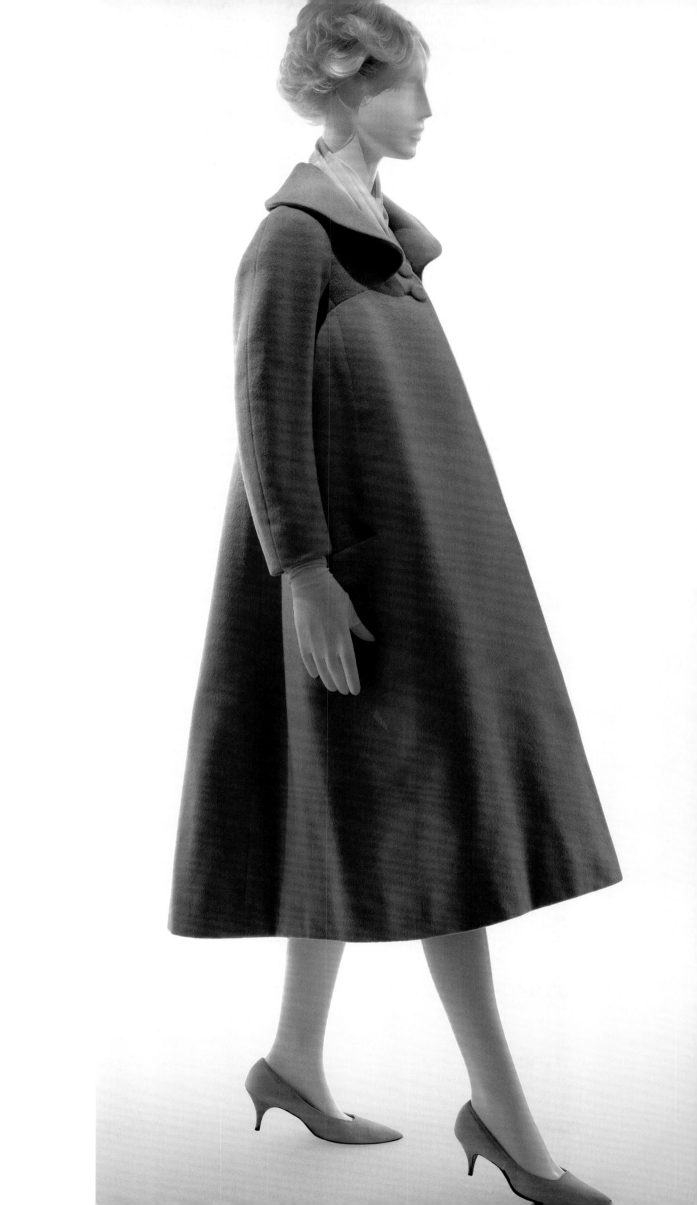

"My most important contribution was always in tailoring; coats, jackets, wool dresses . . . so few of which went into the magazines."

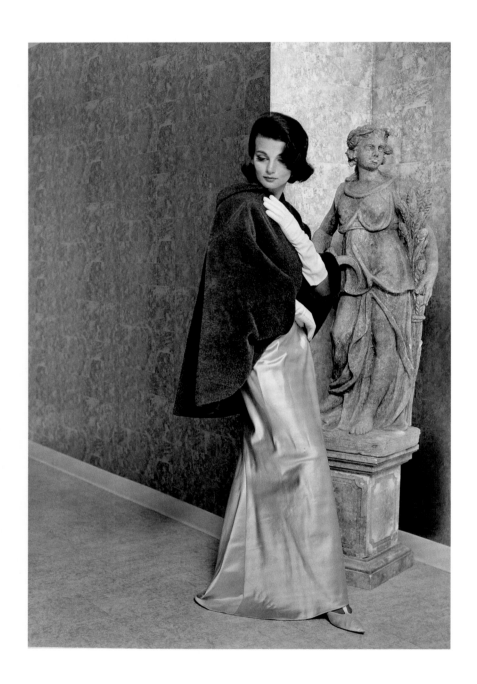

Cocoon Coat, 1956. *Flecked red brushed wool*

This short coat or jacket is similar in concept to late nineteenth-century dolmans, which were capelike wraps with sleeves. The prototype for James's design was a cape for his infant son, Charles Jr. It had elliptically cut armholes to help the child orient his arms upward instead of splaying outward. When the designer adapted the style for adults, he replaced the infant's sleeve pattern with one derived from the connecting elbow joint of a sewer pipe.

above: The Cocoon coat worn as evening attire, late 1960s. Photographer and source unknown

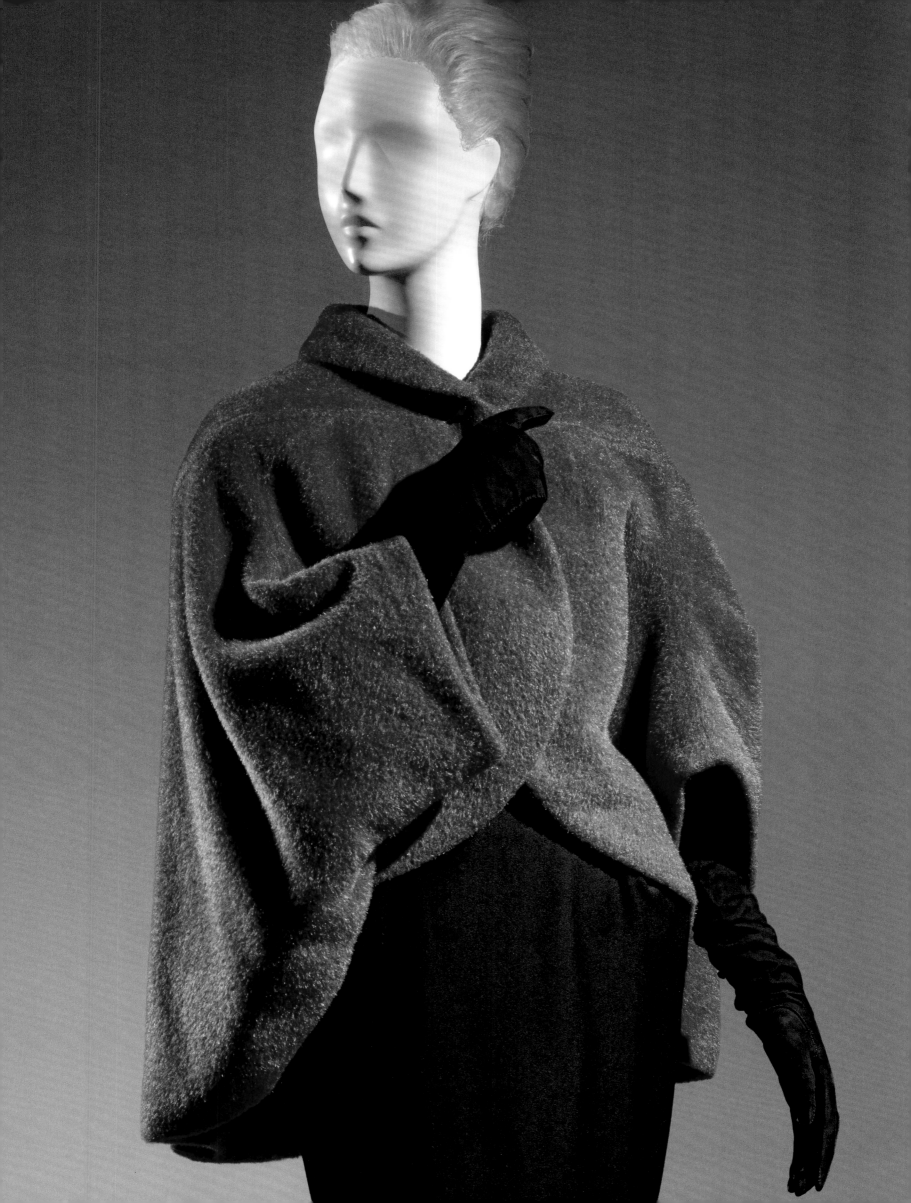

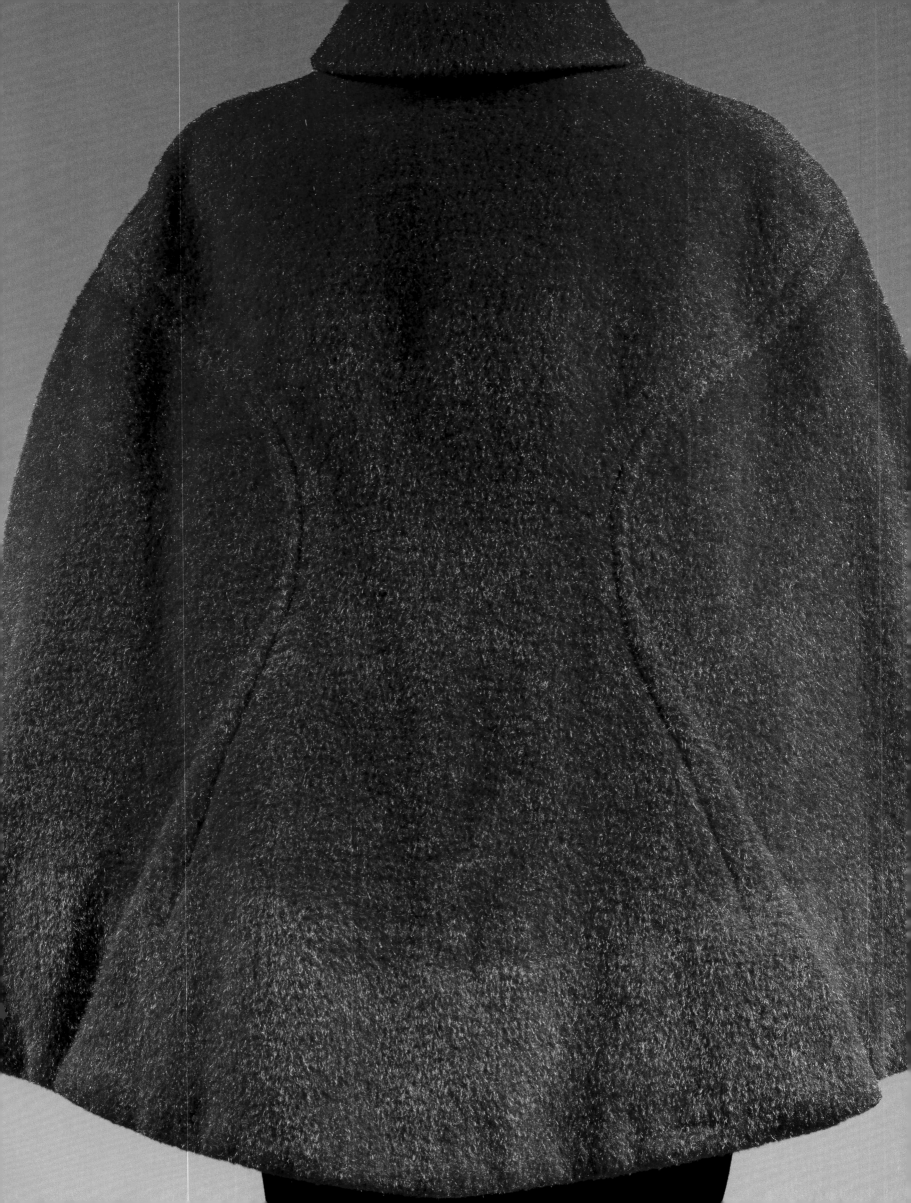

"I have sometimes spent twelve hours working on one seam; utterly entranced and not hungry or tired till finally it had as if of its own will found the precise place where it should be placed."

above: Sketch by Charles James, 1954. Crayon and ink on paper

"All my seams have meaning—they emphasize something about the body."

Great Coat, ca. 1961. *Red and black wool plaid*
The complex cut of this coat is reflected and amplified by the fabric's pattern. The plaid makes it possible to see the disposition of the lengthwise and cross grains, and it also emphasizes any deviation of the seams from the linear and orthogonal. But for all the curvature he modeled into his design, James never lost control of the pattern, which aligns symmetrically, both vertically and horizontally. *detail, above left:* Right bodice. *detail, page 166:* Right back

above right: Sketch by Charles James, 1959. Graphite, ink, and watercolor on paper
page 167: A model on a New York City terrace wearing a version of the Great coat in emerald green tweed. Photographer unknown. *The Sculpture of Style* (program for the Wadsworth Atheneum's fashion show), April 30, 1964

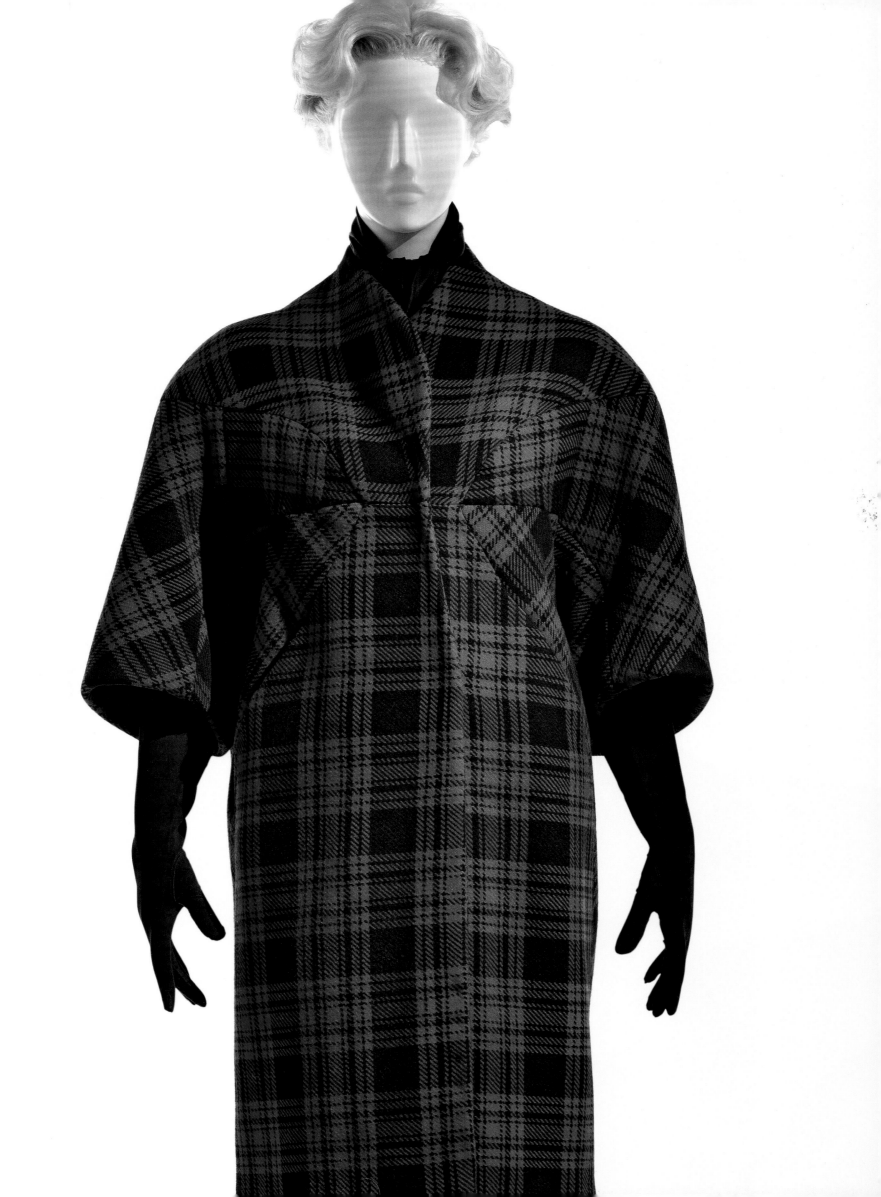

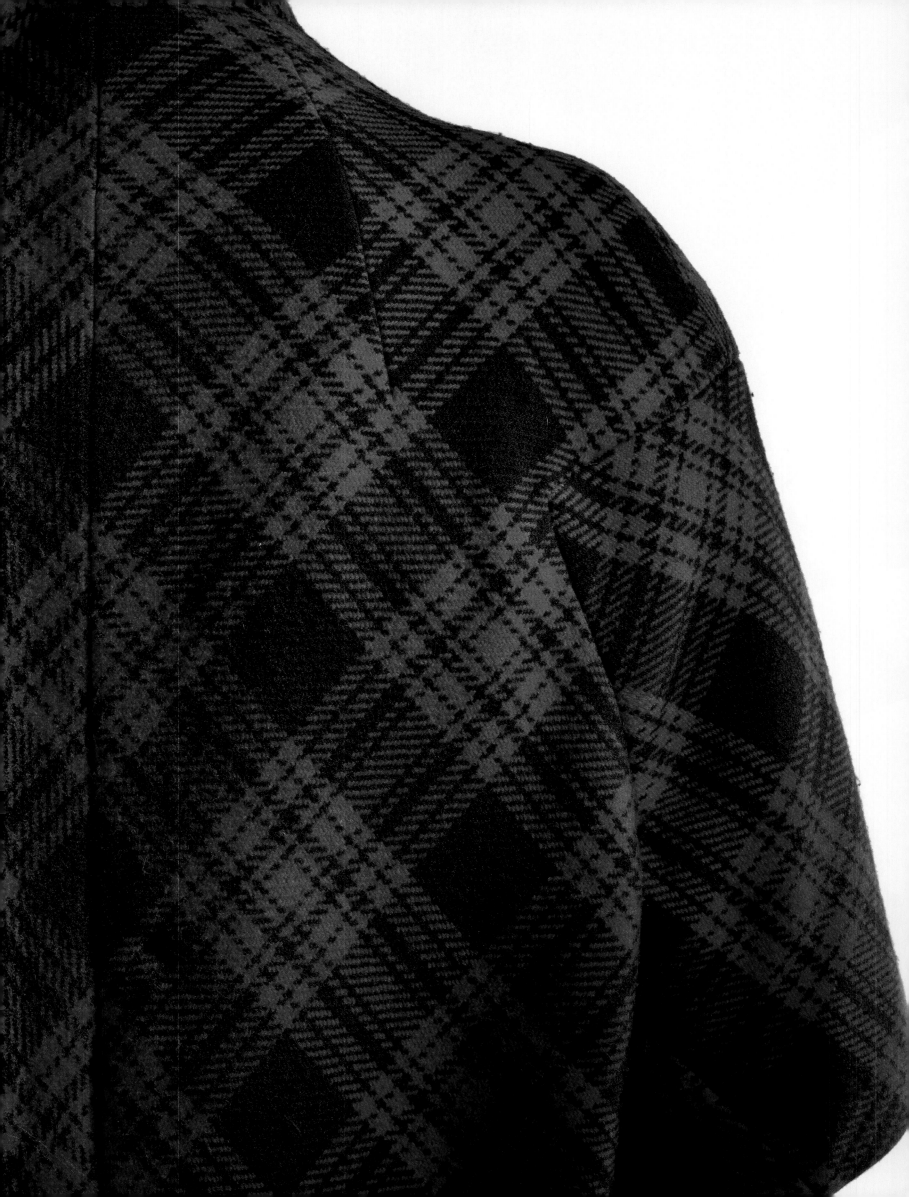

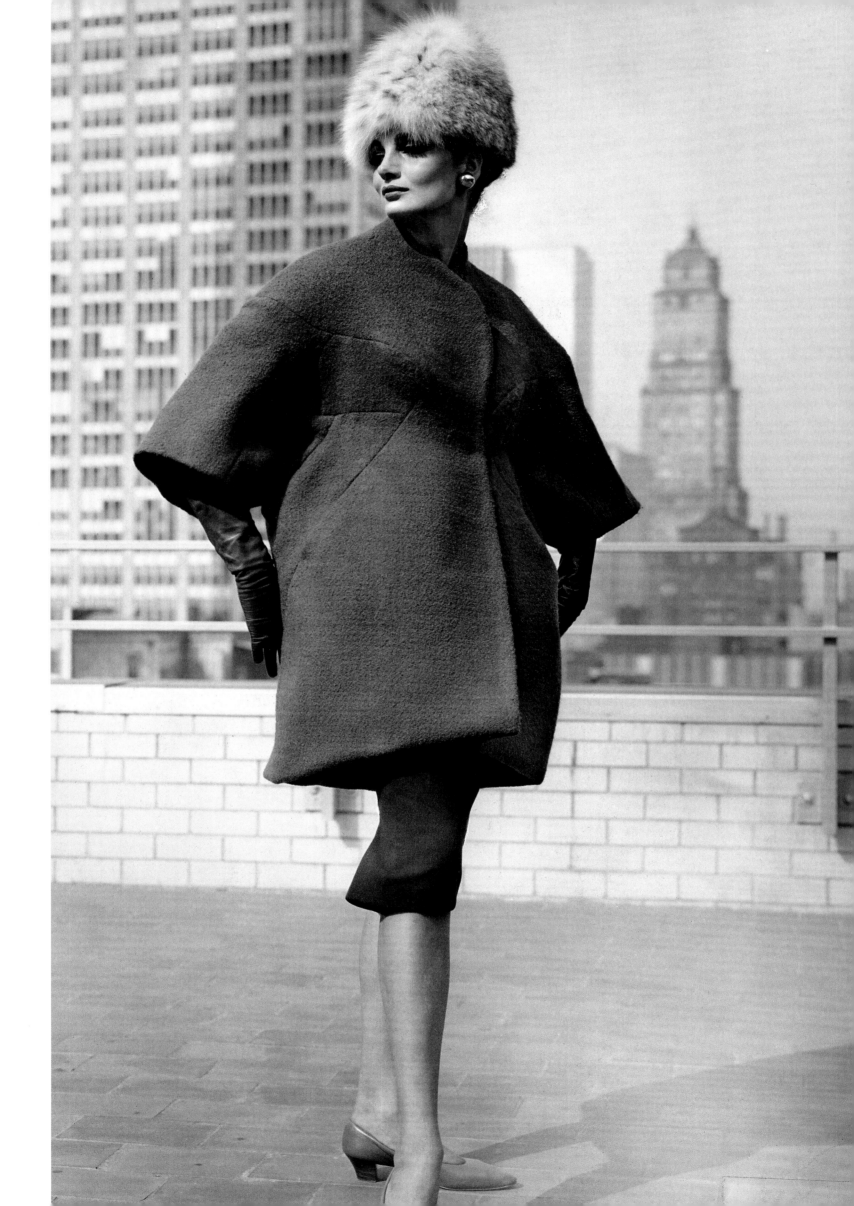

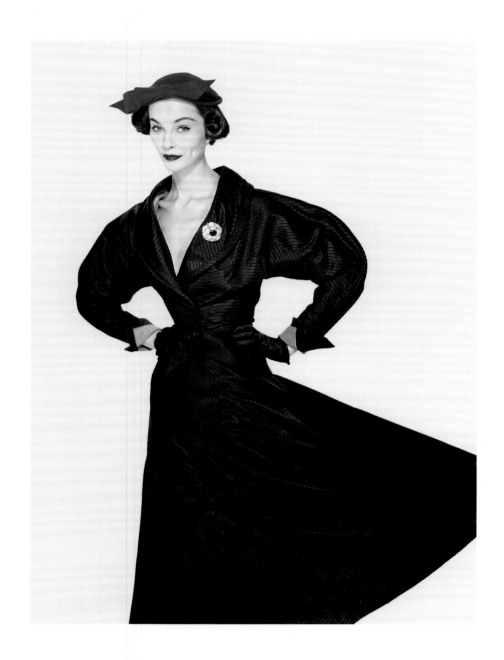

Dinner Suit, 1951. *Blue-green silk rep*

The décolleté jacket of this dinner suit asserts several aspects of James's imposition of his aesthetic ideal on the natural silhouette, including arcing sleeves with deep armholes, an extended but rounded shoulder line, a lengthened back, and a waistline set high at the lower rib cage. The seemingly simple flared skirt has a contoured waist yoke, hidden by the jacket's peplum, to accommodate the abdomen without breaking the strict line of the flare.

above: "Charles James . . . is about as disinterested in a suit's special cut as an engineer is in a bridge," noted the editorial accompanying this photo. Photo by Erwin Blumenfeld. *Vogue*, July 1, 1951, p. 31

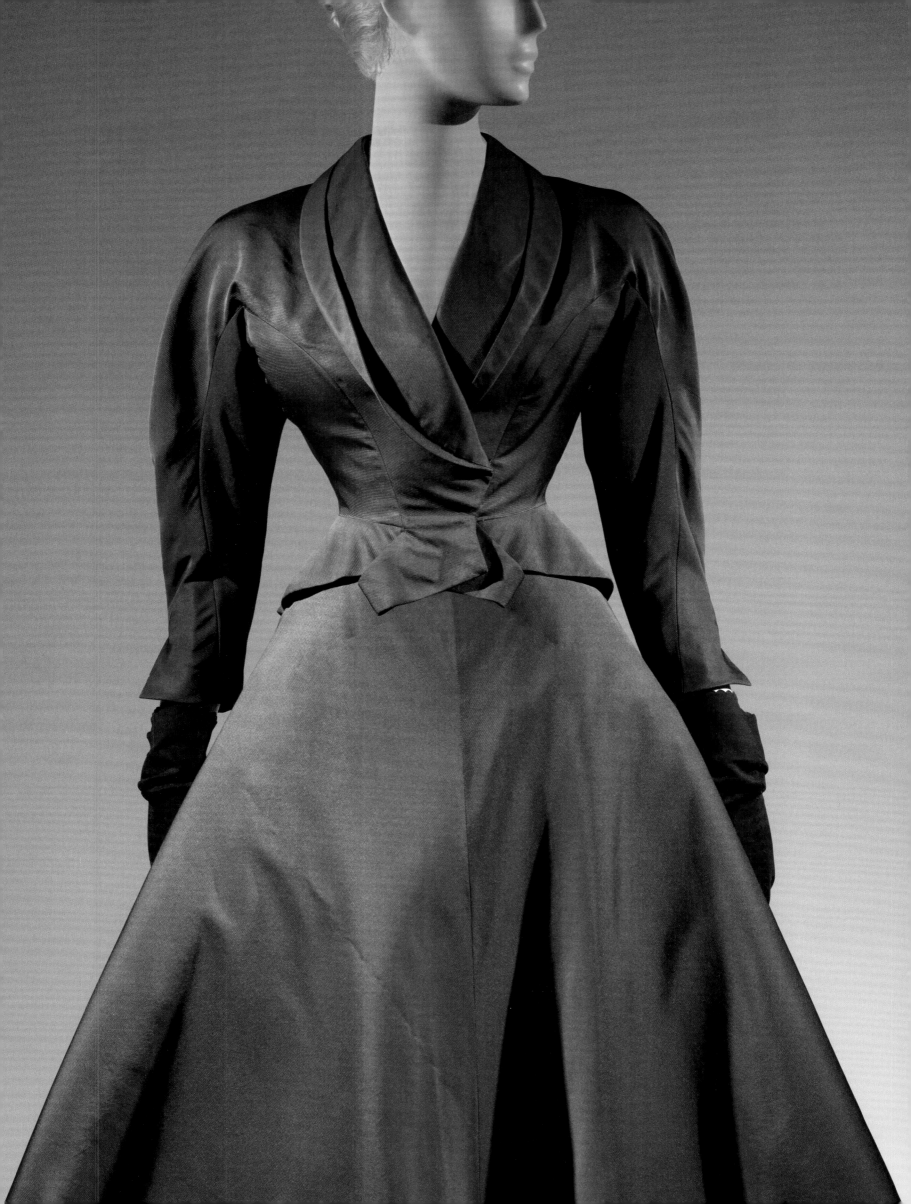

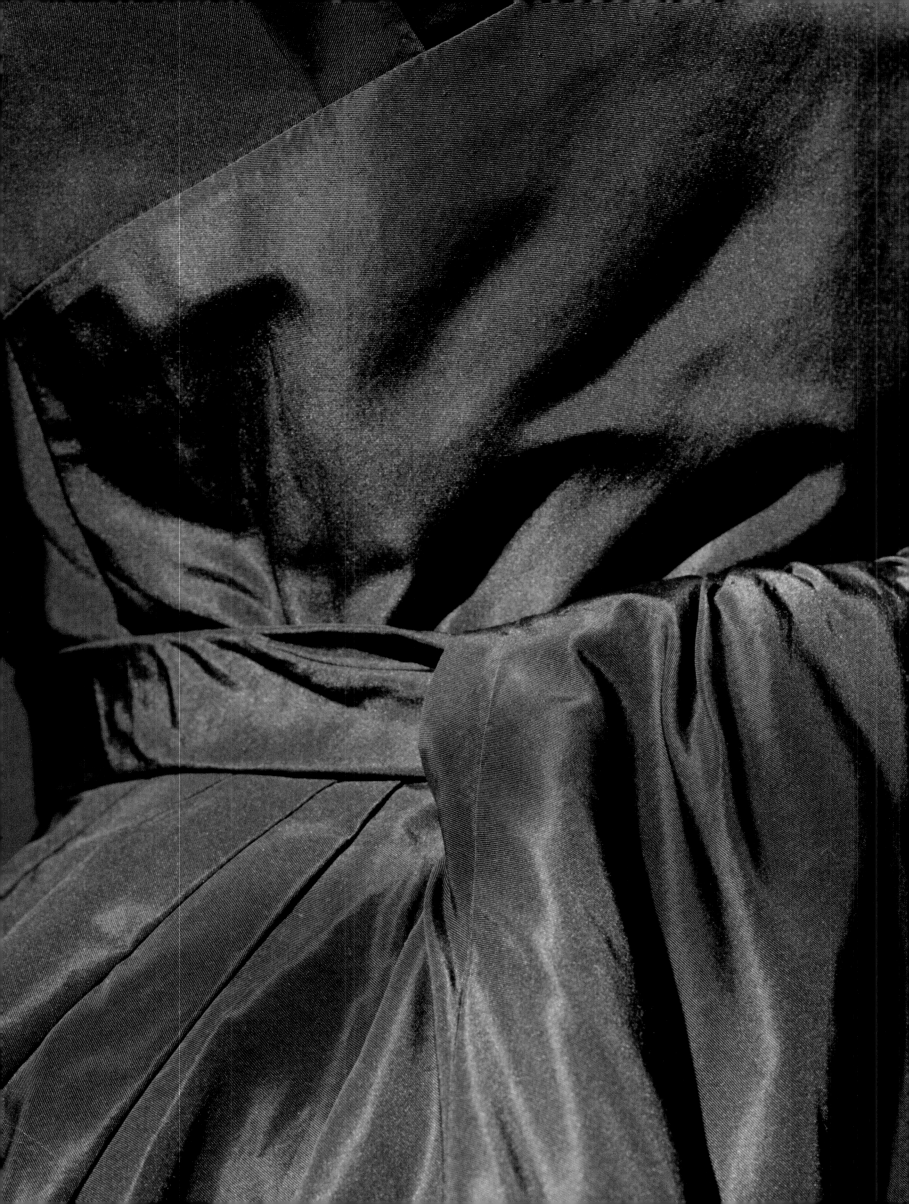

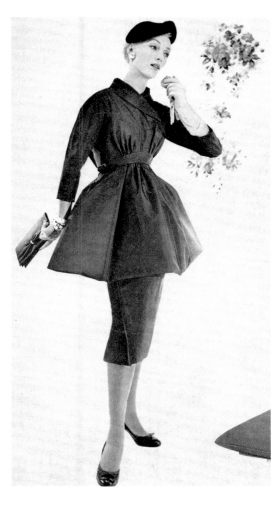

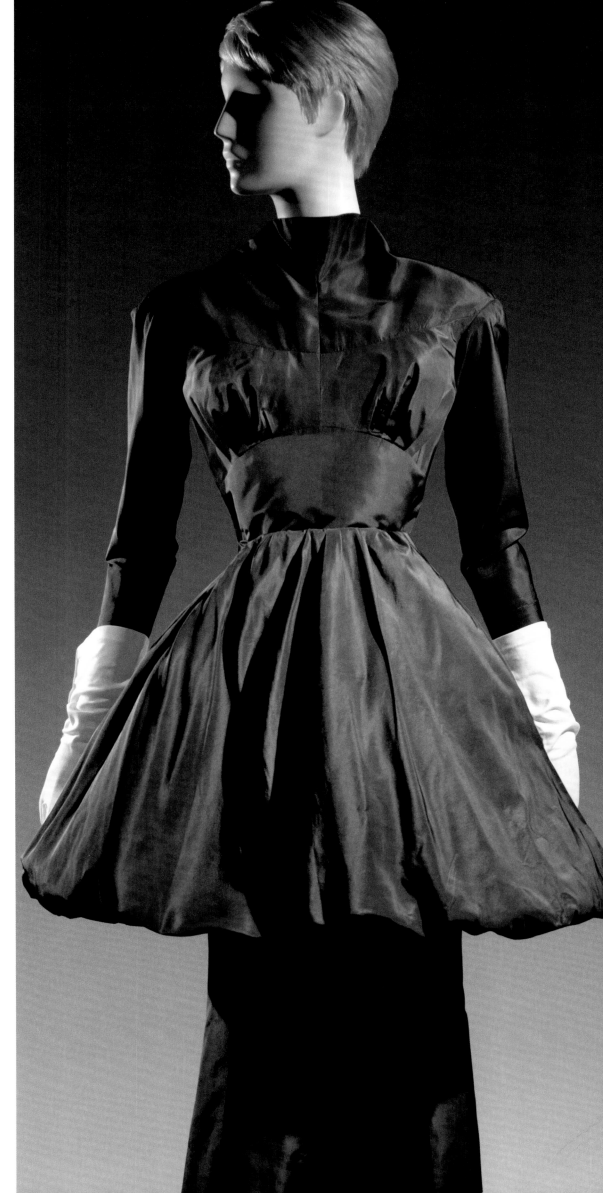

Tunic Dress, 1954. *Brown silk taffeta*
This dress is related to a series of James designs
that address the challenge of accommodating a
pregnant woman's changing figure. He created
it for the Samuel Winston line the same year he
designed maternity dresses for Lane Bryant. Like
the maternity version (above), it features a harem-
hemmed peplum that is stiffened with crinoline
petticoats. But where the maternity dress has an
expandable waistline, the Tunic dress has a fixed
midriff panel. Its peplum's detached front waist,
with a folded-under waistband (see detail), has
become a stylistic gesture rather than a functional
requirement. *detail:* Right front waist

above: This maternity dress was probably the
prototype for the Tunic dress. James placed the
peplum's contoured waistband at the high upper
seam of the midriff, which then angles down to the
small of the back. The slanted waistline, the hidden
expandable closure, and the crinoline providing
fullness in the front demonstrate what *Vogue* termed
"a new principle" for maternity clothes. Photo by
Roger Prigent. *Vogue*, November 1, 1954, p. 144

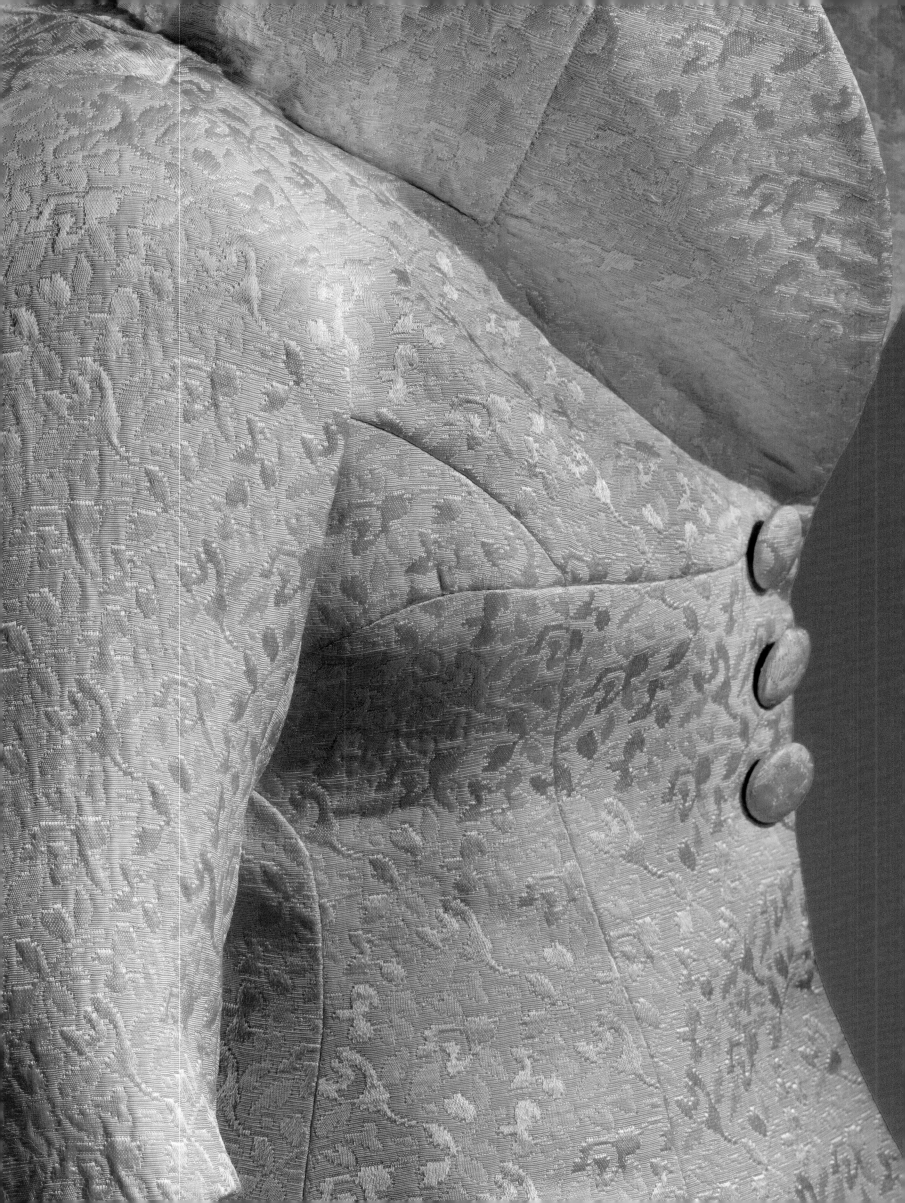

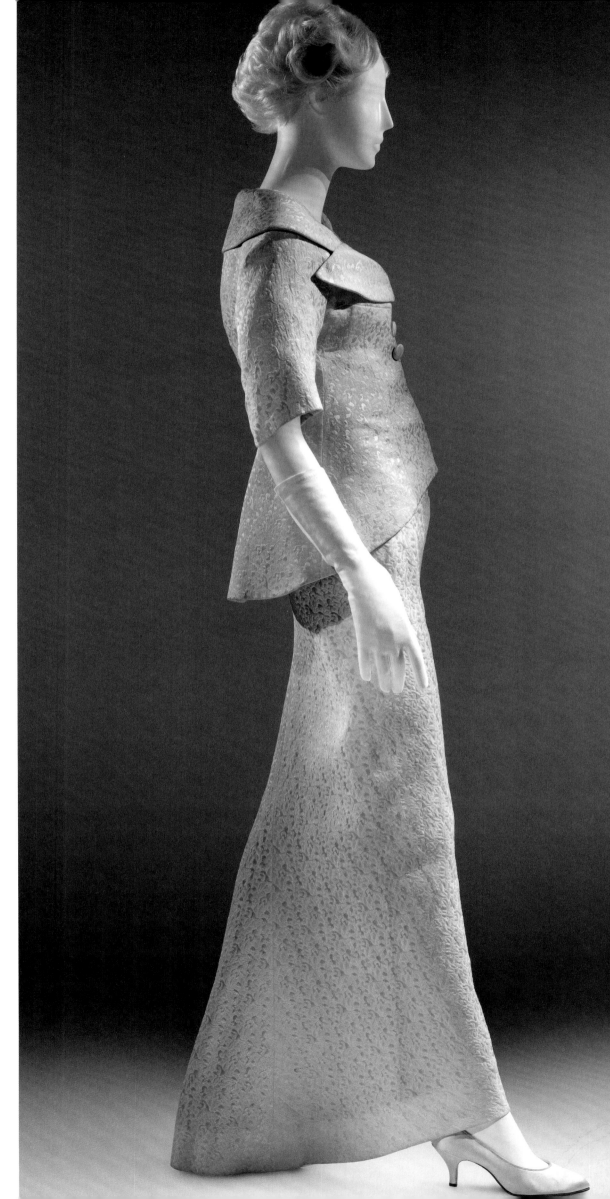

Dinner Suit, 1956. *Ivory rayon-cotton matelassé*
The clean lines of this dinner suit are the result of a
complex piecing of the jacket, which hugs the torso
in front and across the upper back and flares away
from the body at the back hem. The wide winglike
collar that extends to the armhole and the canted
curve of the jacket's skirt are prominent aesthetic
decisions. Less apparent are the structural details
James used to reference the body, such as the
forward curve of the sleeves and the undulation
of the horizontal seam across the bust. *detail:*
Right bodice

above: Sketch by Charles James, 1960–78. Graphite
on paper

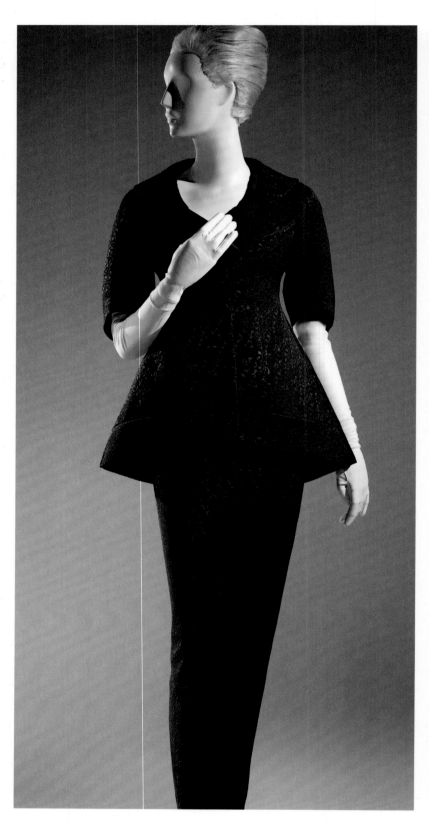
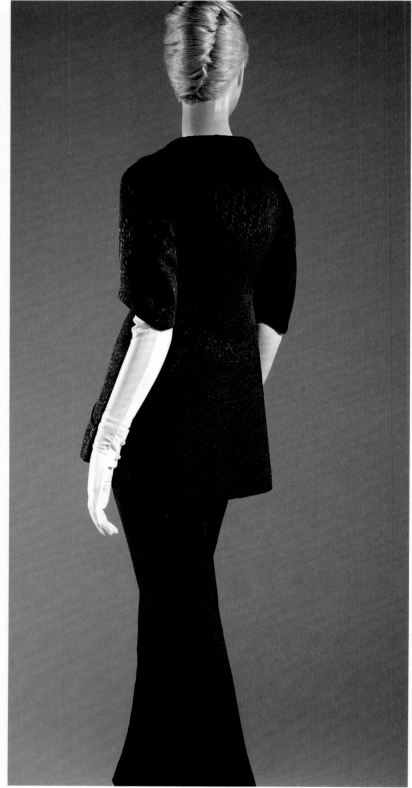

Dinner Suit, 1956. *Black rayon-cotton matelassé*
In this black version of the previous design, the resolution of the bust shaping is different. James eliminated seams wherever and whenever he could, but here he simply pivoted what was a continuation of a princess seam in a new direction—toward the side seam. With that gesture James deviated from the conventional to the ingeniously idiosyncratic. The skirt has a shaped hip yoke but otherwise is cut in one unbroken piece. *detail:* Left front bodice

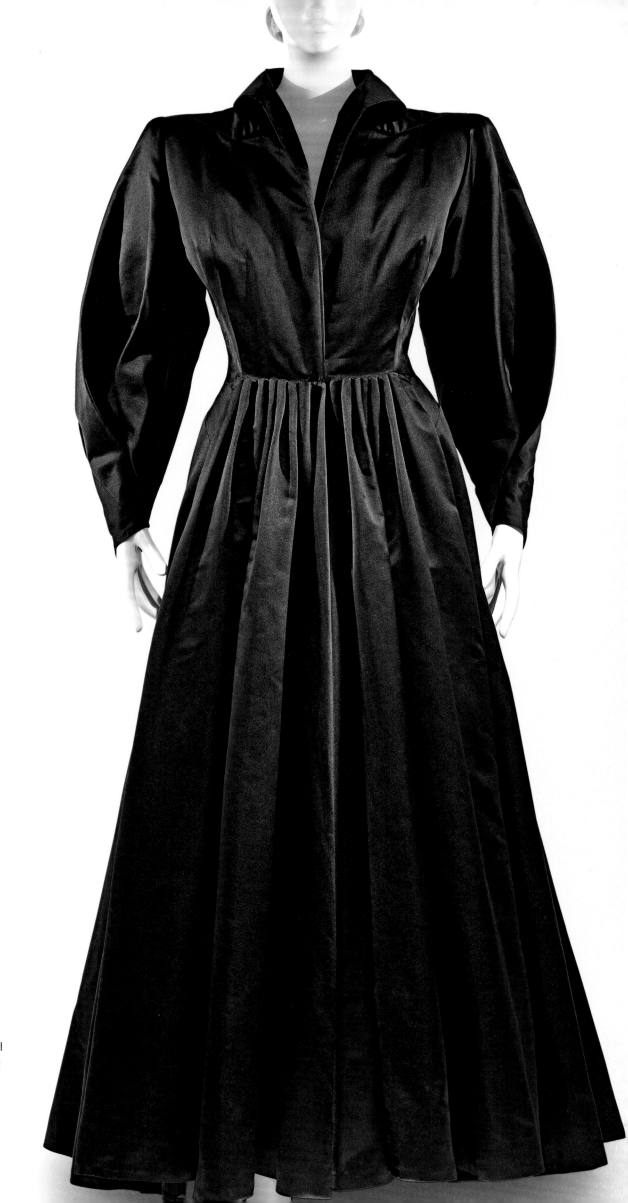

Evening Coat, 1946. *Black silk satin*
This dramatic evening coat introduces cartridge pleats, a simple technique, along the front waist as its primary decorative focus. The bodice, however, is a masterpiece of dressmaking. The front bodice, collar, and shoulder yoke are cut in one. Each draped sleeve is also cut of one piece of fabric, with shaping introduced by short darts. Because of the satin's directional surface, James was able to convey his design's complexity through the light that catches the pattern pieces' shifts. *detail:* Right front sleeve

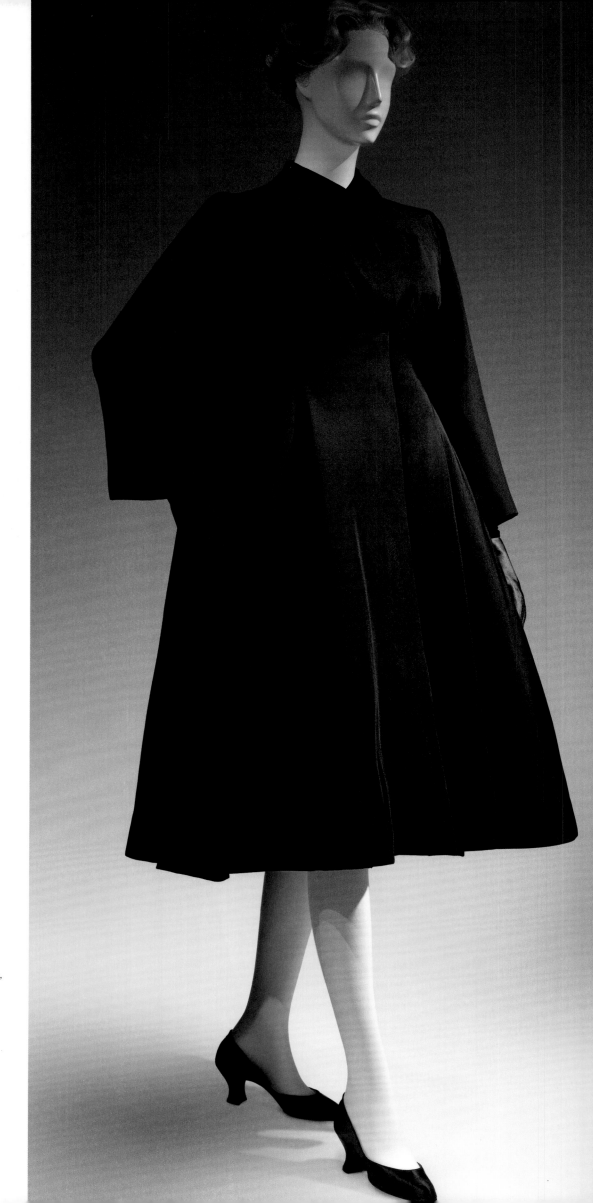

Trapeze Coat, 1947–48. *Black silk bengaline*
This coat alludes to the body at the bust and rib cage,
then extends away from it with two deep reverse
pleats at the front and an unfitted and flaring back.
The perfectly mounted sleeves are cut in one piece,
without the undersleeve panel seen in custom-
tailored coats of the time, so their forward-angled
curve occurs not with shaped panels but with the
introduction of darts at the inner elbow. Though
this is primarily a tailored garment, James used
soft release darts, a dressmaking detail, at the bust.

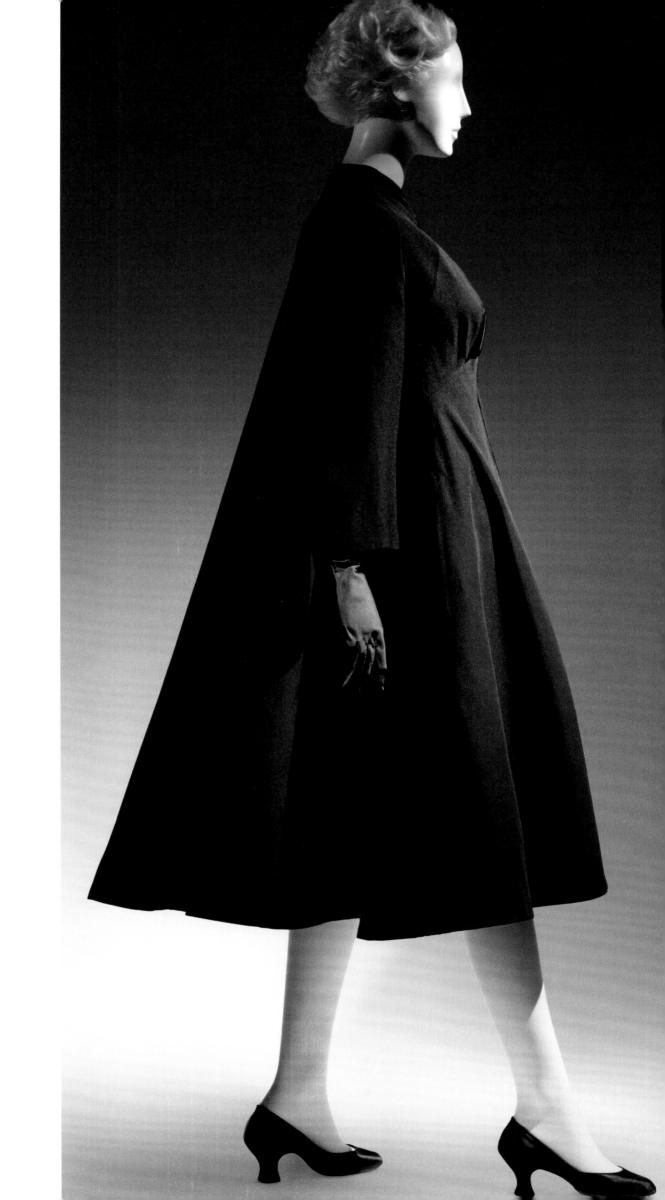

Great beauties, great news:
the Charles James coats

Gothic Evening Coat, 1954. *Black wool broadcloth and silk satin*
Completely suspended from the shoulders, this coat barely suggests the dimensions of the bust and upper back. The shape obliterates the wearer's flaws—or, in this case, attributes, as the coat belonged to Gypsy Rose Lee, the statuesque ecdysiast, who wore James's Sirène evening dress (see p. 107) with seductive glamour. Like a tuxedo, which uses similar materials, this coat is an elegant equalizer of women of every size and shape.

above: With an economy of line, the illustrator captured the coat's sculptural essence. Illustration by Carl "Eric" Erickson. *Vogue*, August 1, 1954, p. 130
far right: Harper's Bazaar featured the coat as one of "Three Black Silhouettes to Wear over Glazed White." Photograph by Louise Dahl-Wolfe as it appeared in *Harper's Bazaar*, September 1954, p. 181

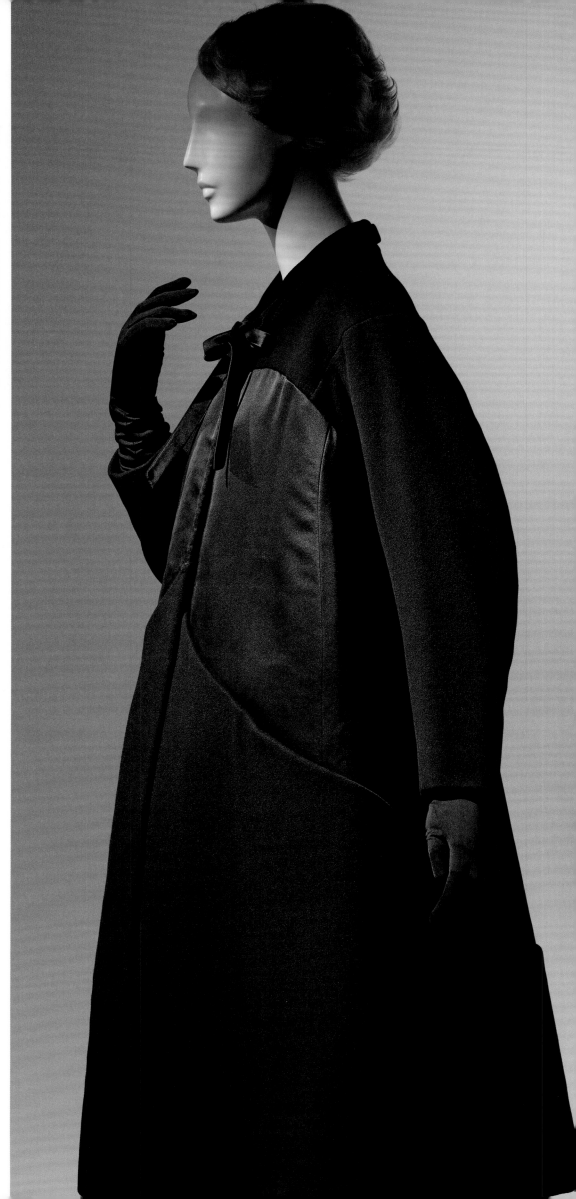

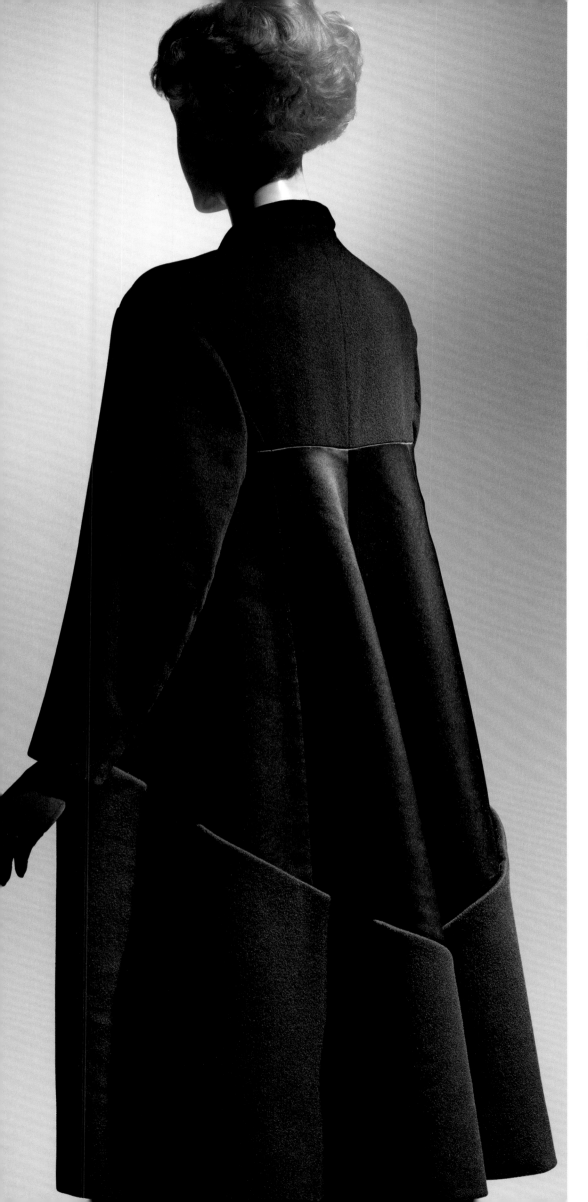
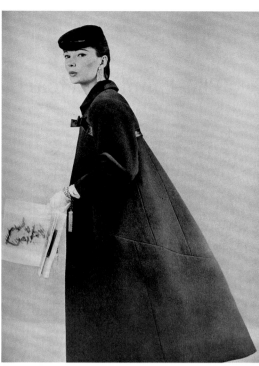

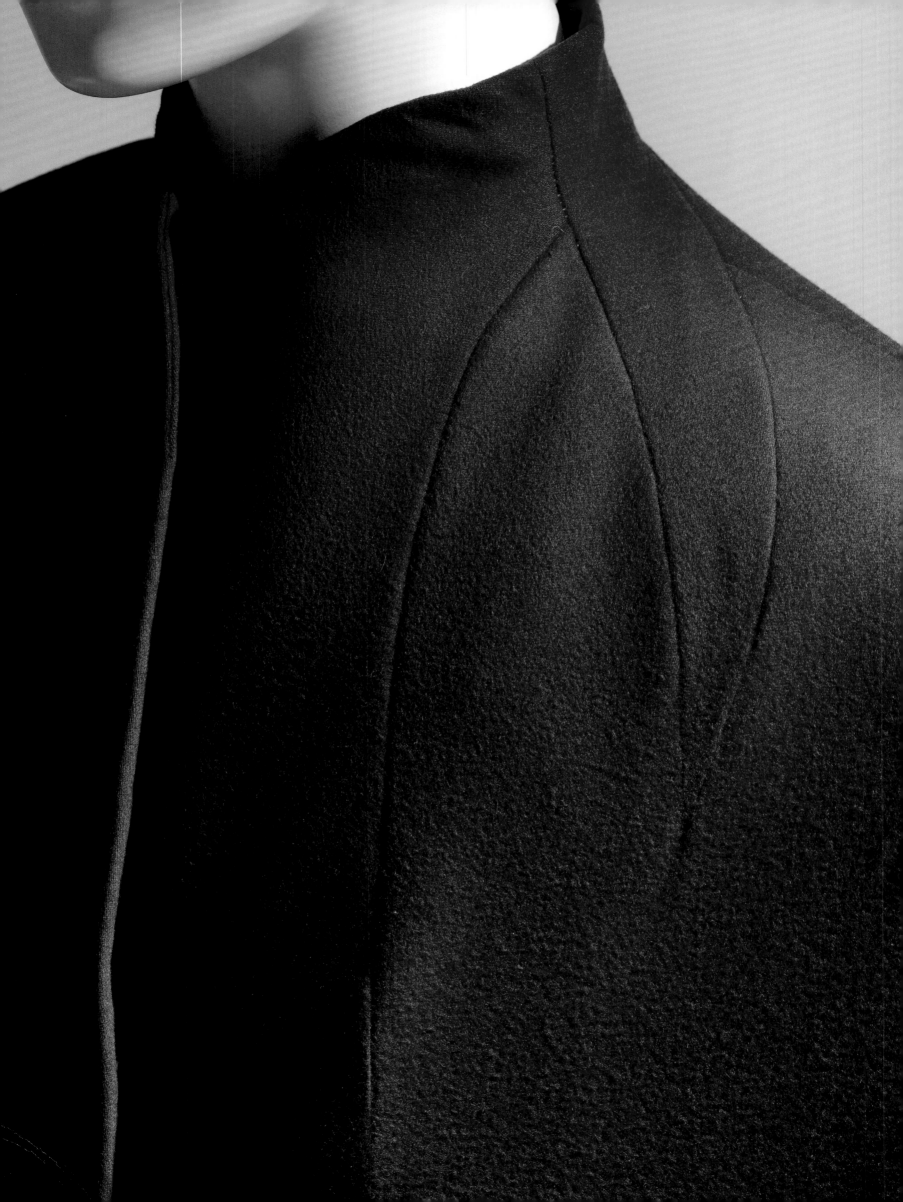

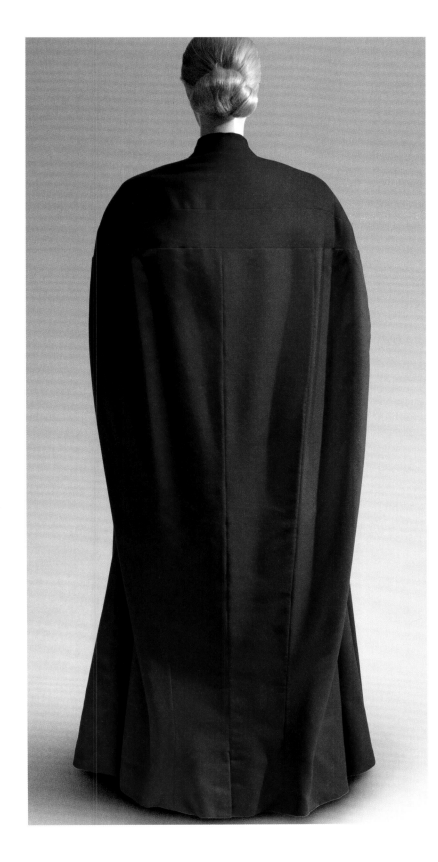
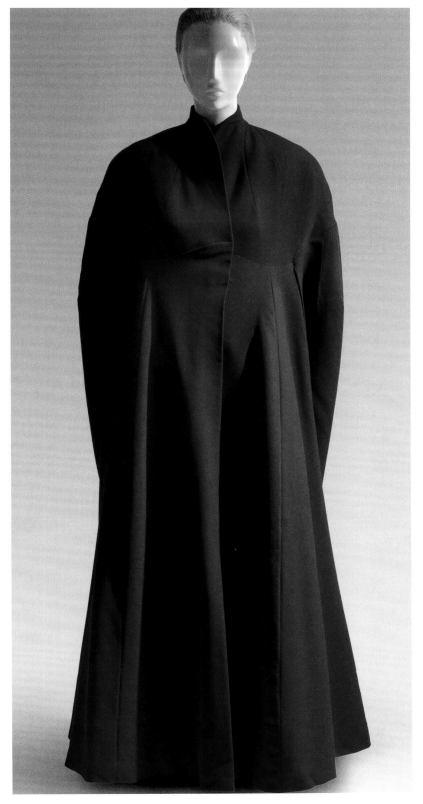

Cocoon Evening Cape, 1957–59. *Red wool broadcloth*
This evening cape is related to James's sculptural designs shown in Cecil Beaton's surrealistic 1936 photograph of the actress Ruth Ford and others posed both facing and with their backs to the camera (see pp. 26–27). In the earlier designs, however, the coats are fitted to the back in the fashion of the 1890s. Here James reversed his earlier strategy, giving a glancing fit to the upper front of the torso while creating a back that suggests the tucked wings of a bird. *detail:* Left front shoulder

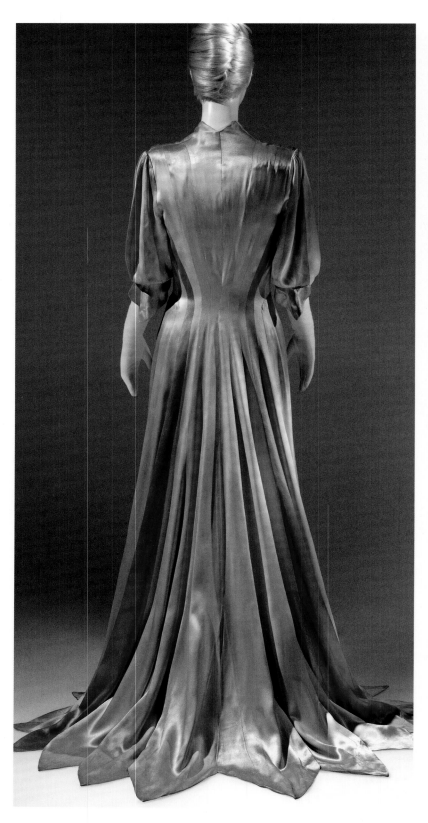
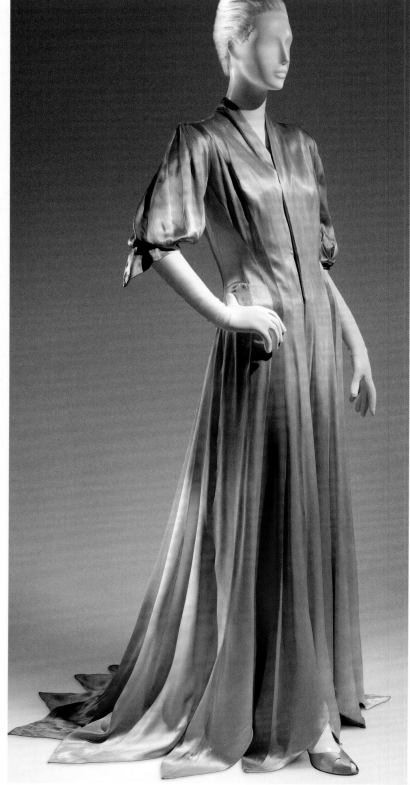

Ribbon Dressing Gown, 1938–40. *Peach, gold, yellow, and ivory silk satin ribbons*
Designers known for their focus on the architecture of apparel often favor the use of stripes and plaids; the patterns graphically demarcate the manipulation of two-dimensional cloth into three-dimensional garments. Here James went a step further by using wide ribbons, in varying hues but related shades, to articulate the contoured expansion and reduction of fabric as it is shaped to the body. This dressing gown's fit, which is typically accomplished by seams and darts in conventional pattern pieces, is achieved exclusively by varying the width of the ribbons.

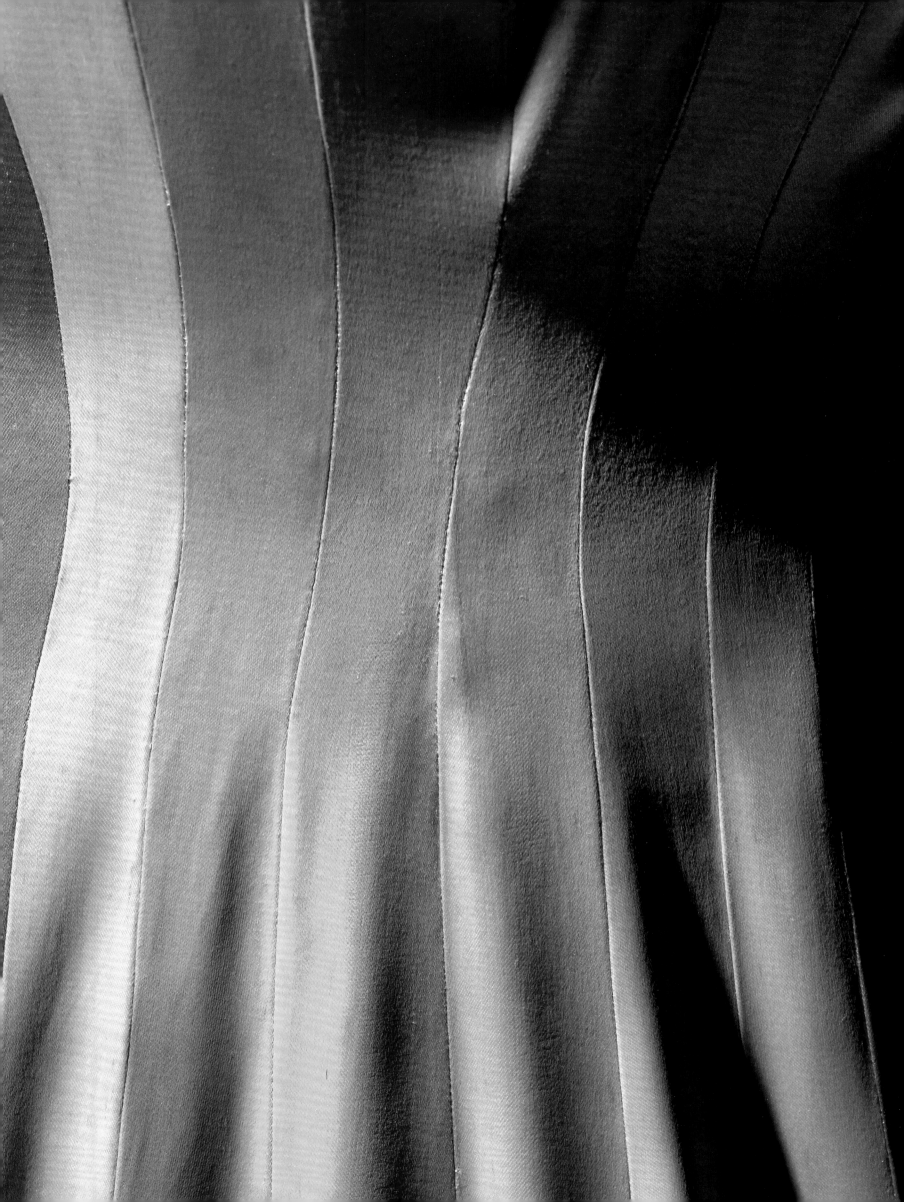

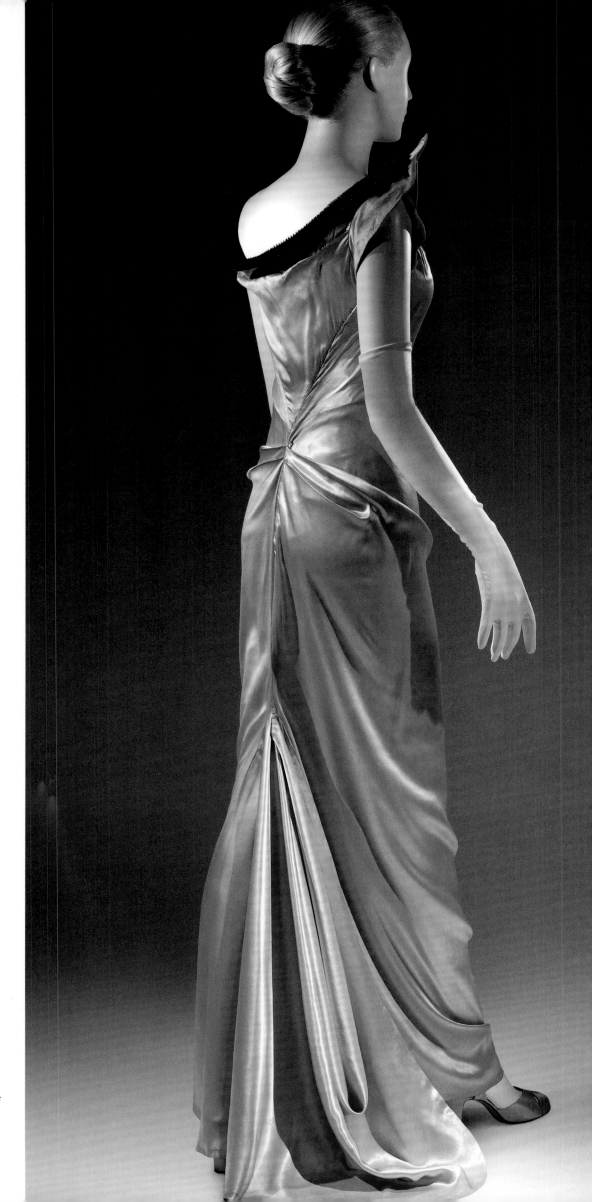

Theater Costume, 1935. *Pale pink acetate-rayon satin with black cellophane-cotton trim*
Although this dress was designed for the stage and meant to be seen only from a distance, James treated its construction with the same conceptual rigor and technical virtuosity he applied to designs for his private clients. The bodice has a U-shaped bib panel and V-shaped back panels; however, what would ordinarily be separate side bodice panels are cut in one with the one-piece skirt. With the exception of the train, which was added to extend the width of the cloth, the larger part of the gown was executed with a single draped panel of satin.

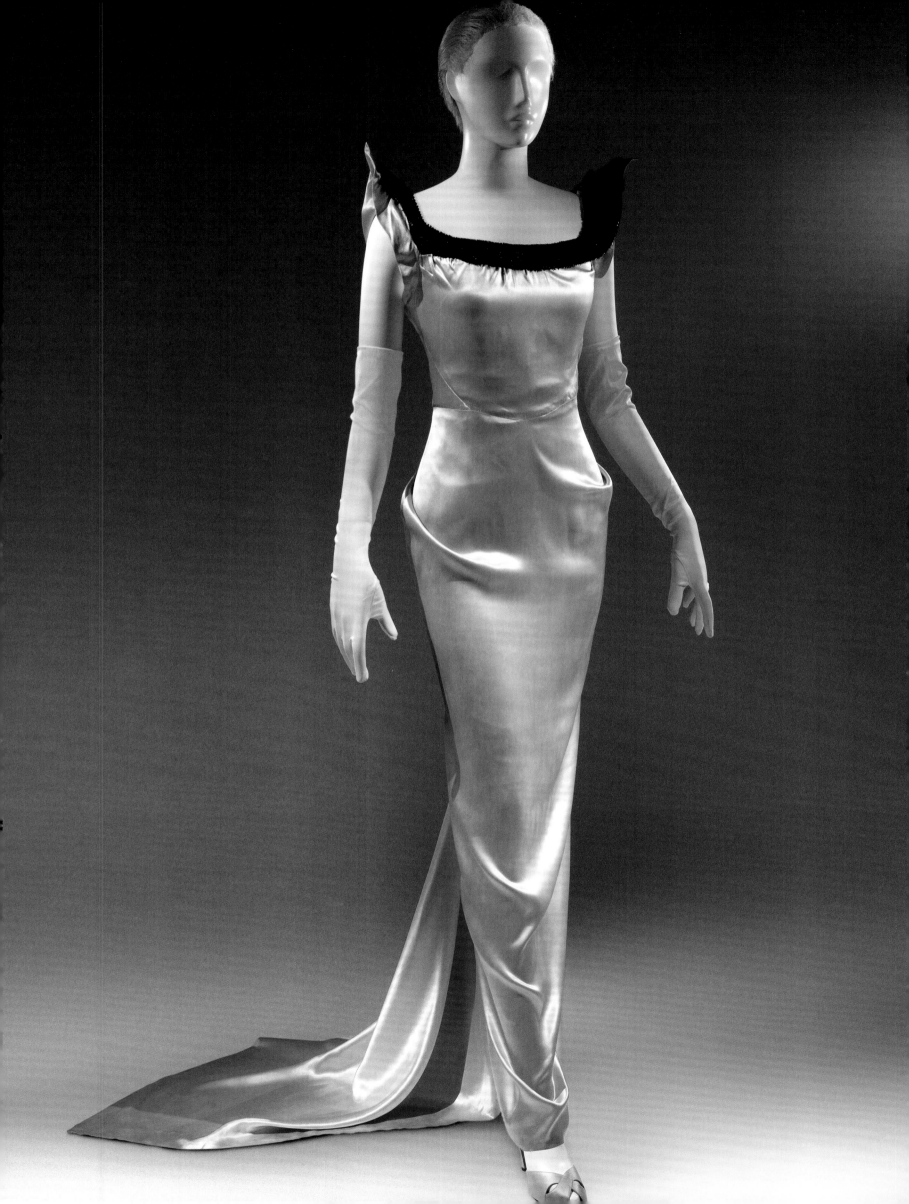

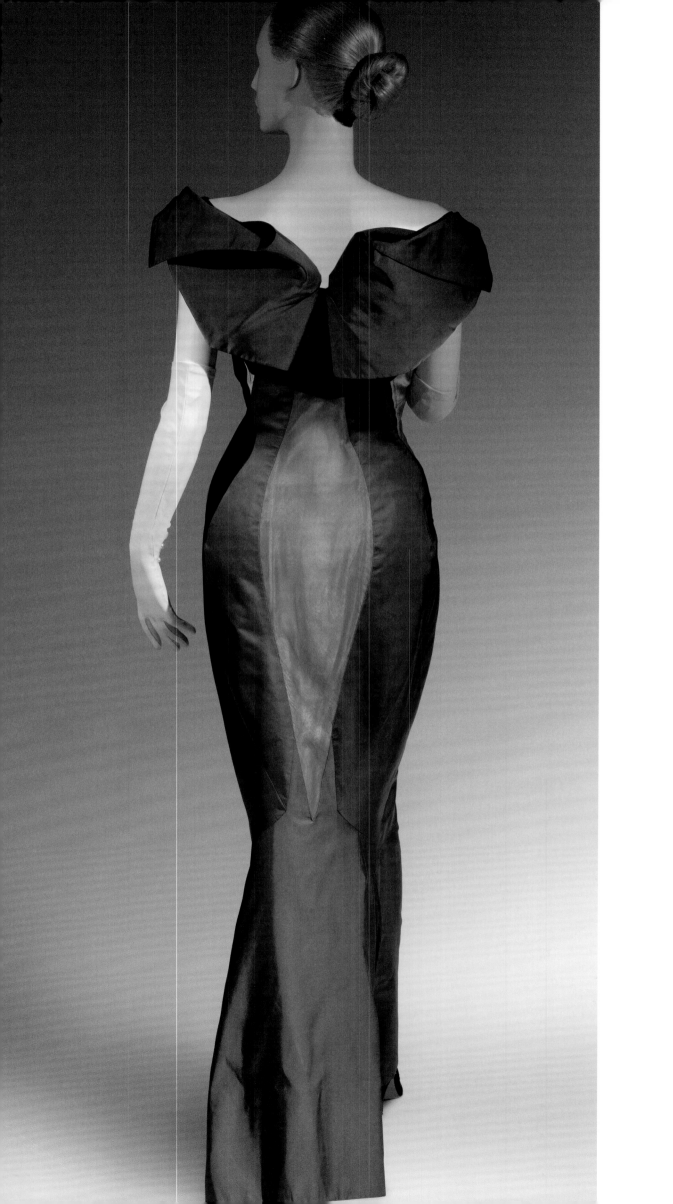

Evening Dress, ca. 1960. *Beige silk satin, taupe silk faille, and brown silk chiffon*
The cuts of this evening dress and the Diamond (see p. 190) are explicit in their anatomical shaping, especially from the back, suggesting the designer's intention for them to project an erotic allure. This version has a fall-away neckline that discloses a structured, chiffon-covered modesty panel beneath. The horizontal drapery at the pelvis highlights the area around the lap, a James signature. His contrast of fabrics exaggerates the vase-shaped form of the back center panel, which is at once petaline, foliate, and yoni-like.

above: Sketch by Charles James, annotated, in part, "cross better than straight," ca. 1965. Ink on paper

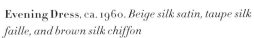

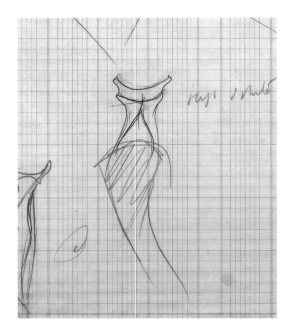

Diamond Evening Dress, 1957. *Ivory silk satin, beige silk twill, and black rayon velvet*
The Diamond's hourglass fit takes its cues from fin-de-siècle fashions and sensual Surrealist biomorphism. This design incorporates a number of nontraditional seam contours, but all that is required to underscore the provocative shaping at the back are a simple realignment of conventional princess seams and the use of contrasting fabrics. James's designs often display a similar, if less explicit, focus on the waist and hips.

above: Sketch by Charles James, 1950. Graphite on paper

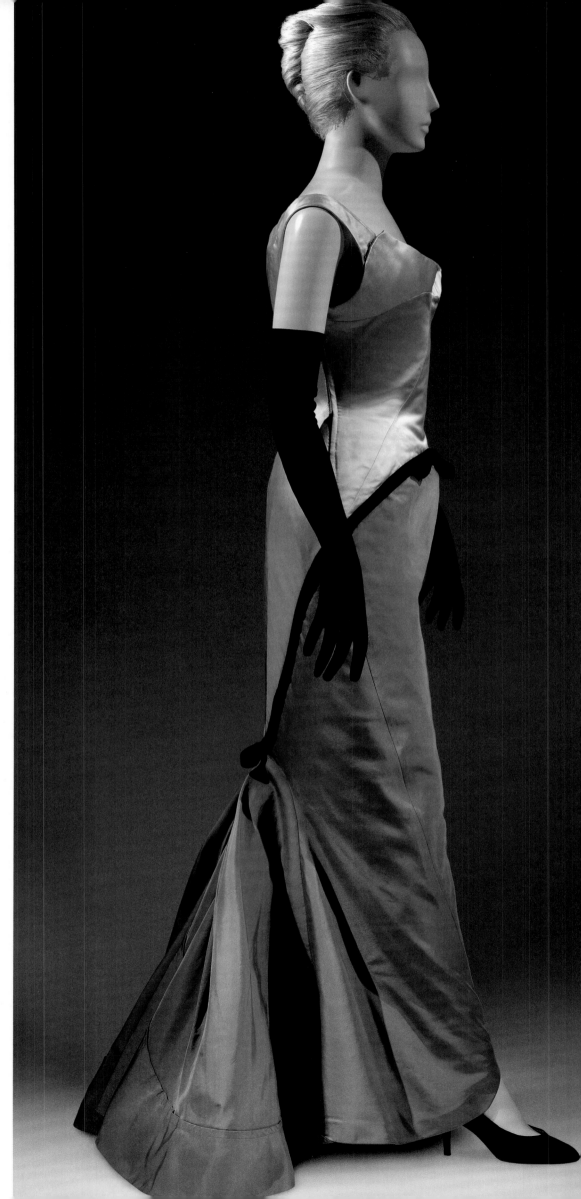

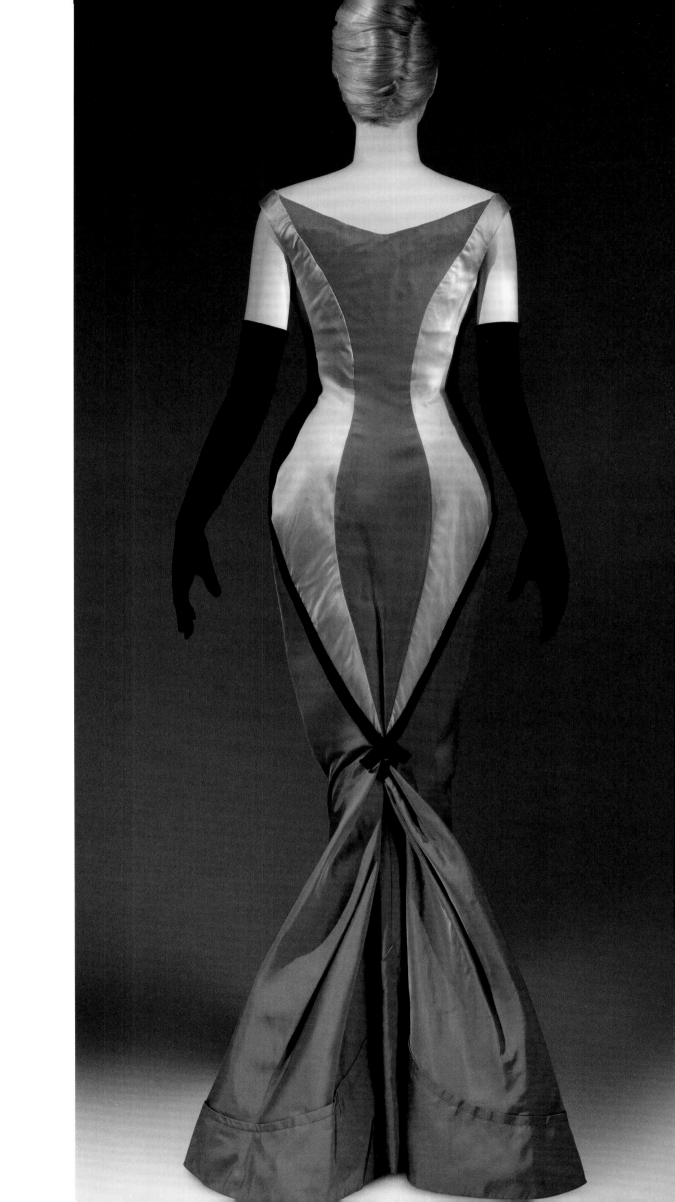

ARCHITECTURAL SHAPING

James's virtuosity is most extravagantly expressed in his ball gowns of the postwar period. With the resumption of grand balls and charity soirées in the late 1940s and 1950s came the opportunity for opulent display and dresses of riveting elegance, giving free rein to the designer's natural impulse to astonish. Because of their distinctive glamour and audacious silhouettes, the ball gowns often overshadow the other innovations of James's career. For James himself, one ball gown, his Clover Leaf, or Abstract (see p. 226), was not only the culmination of his lifelong interests and his investigations in technique but also the sublime manifestation of his aesthetic principles.

In many of the evening dresses James marshaled technical and artistic strategies that originated in earlier works: They were an emboldened application of his drapes and folds, his asymmetrical spirals, and his anatomical and platonic fit. With a lavish use of silk twill, satin, and taffeta, these designs advanced his interest in cascading, gathering, or ballooning fabric to transform the wearer's silhouette.

As a group the postwar works repudiate the body-skimming languor of his 1930s designs. Even the most airily constructed gown's basic silhouette evokes grand historical styles, with a torso-cleaving bodice and full skirt. Although James took inspiration throughout his career from Directoire, Empire, and Regency dress, his references in these evening toilettes are the boned bodices of Charles Frederick Worth, the crinoline hoops and bustles of the 1860s–70s, the padded hips of the 1880s, and the long, straight back epitomized by beauties like Consuelo Vanderbilt in the 1890s. But if James appears entranced by the refined lines of the Belle Époque and Gilded Age, he always found his own way, as manifested in the unprecedented and idiosyncratic execution of his designs.

For example, a James gown's underbodice at first appears to conform to nineteenth-century precedents and to the designs of Christian Dior and other contemporaries working in the French haute couture. However, his shaping of the bust defied the prevailing conventions; instead of using a pointed cone, James created a tapered ovoid, narrow at the cup's top and bottom. Instead of a straight line across the midsection, the waistline, arcing over the hips, is invariably pointed at the center front and back. Likewise, the supporting underskirts are not the usual boned hoops of flexible wands but multilayered canopies of boning, net, buckram, Pellon, and canvas sandwiched into shape.

James treated the fixed contours of these engineered understructures as an architectural form that he ornamented without constraint, like a milliner trimming a hat. He pieced together a gown's surface by juxtaposing materials that are not especially compatible with each other or with the cantilevered and form-retaining volumes he desired. In the Clover Leaf gown, for example, the wide band of black velvet encircling the skirt is a separate piece attached to ivory satin at the top and faille at the bottom, despite the fabrics' different tensions, weights, grains, and hand. The gown's graphic power is possible because the seams that join the textiles are freed from structural requirements by the ingenious support system below. In this masterwork James thus elevated fashion to a fine art, merging the science of engineering with aesthetics. The result is architecture for the body.

Ribbon Ball Gown, 1946. *Pale yellow rayon-wool satin and pastel polychrome silk faille, taffeta, charmeuse, and satin*

The strapless bodice of this gown appears to conform to traditional techniques, but its innovative seaming is a James signature. Similarly, what at first seems to be a skirt of striped fabric is actually composed of ribbons of varying colors, luster, and weight. The ribbons, wide enough to be cut in curves, torque into smooth, molded contours where they taper over the hips. In one of James's more explicitly sexual details, the bodice comes to a point just above the pubis, terminating above a deep reverse pleat down the center front of the skirt.

above: Mrs. Ernest (Esther Sisson) Beaton wearing one of the first versions of the ribbon ball gown, accessorized with a mauve tulle stole. Photo by Cecil Beaton. *Vogue*, March 15, 1947, p. 178

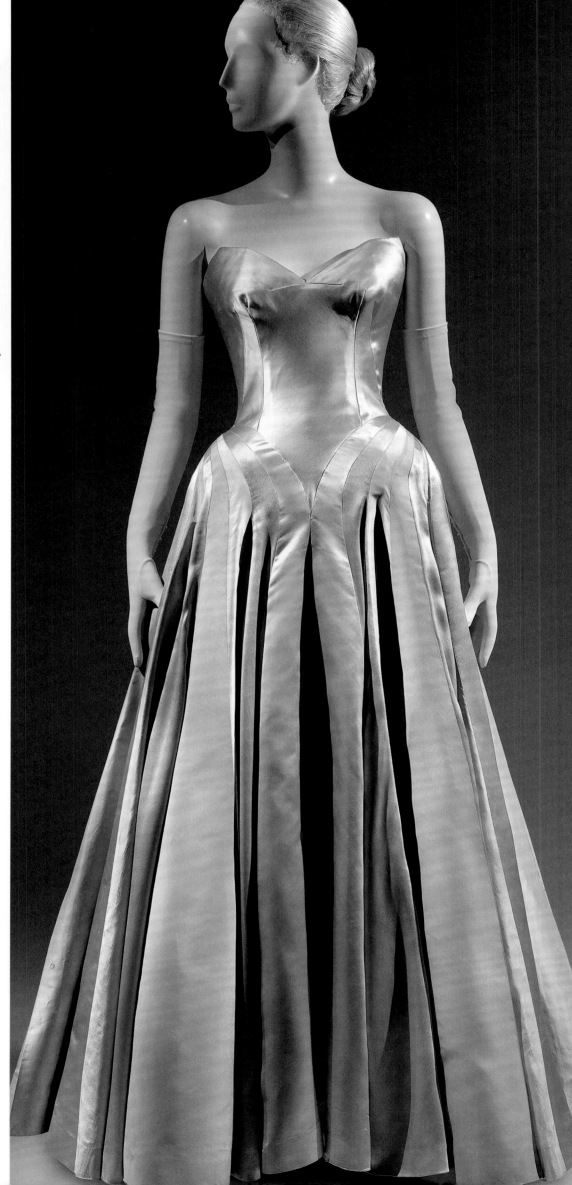

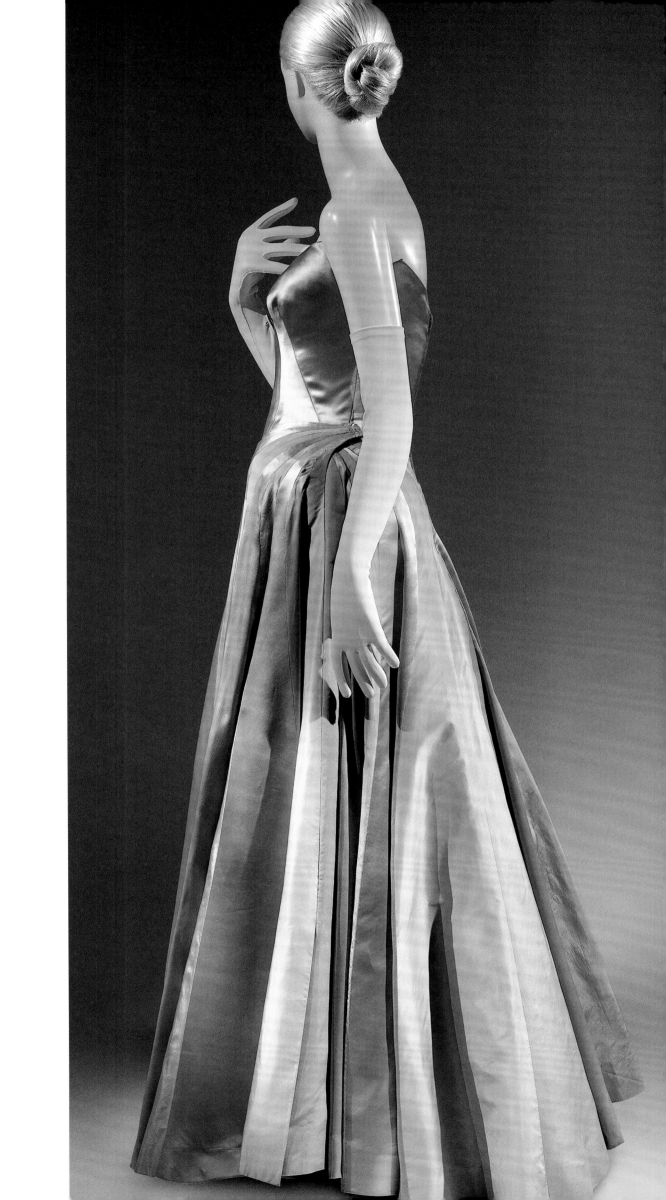

> *"I have always felt the body itself does not have a horizontal waistline . . . which is a concept of manufacturers and sketch artists."*

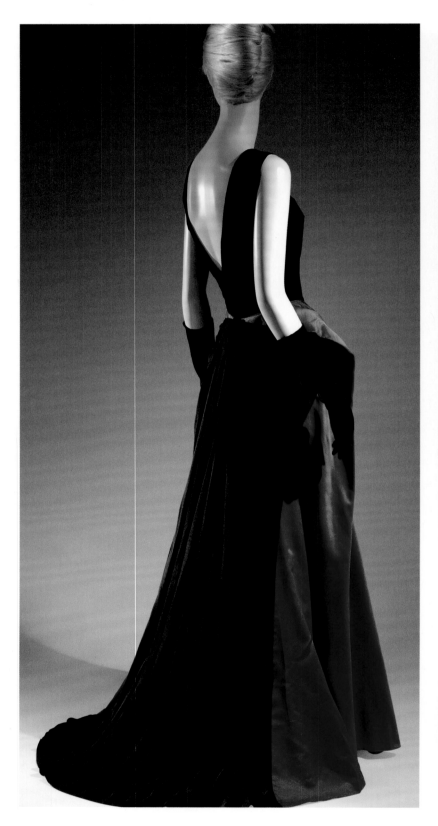 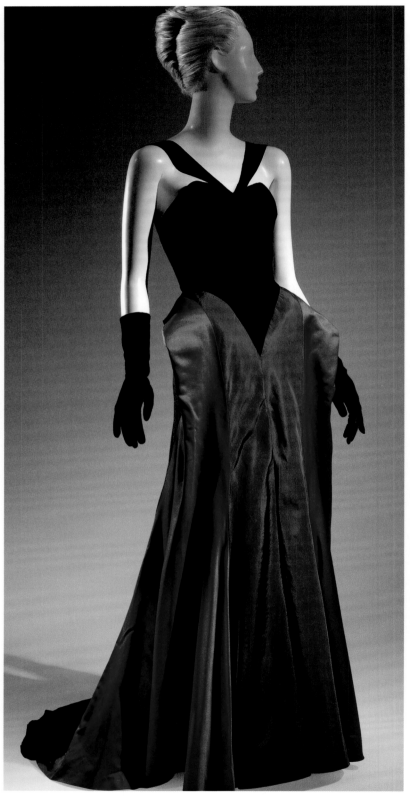

Ball Gown, 1946 . *Black silk-rayon velvet, red silk satin, brown silk faille, and black silk crepe*
In a Surrealist inversion, James shifted the weight and fullness generally seen at the back of a gown to the front and used a softly draped fabric at the back, giving the uncanny impression of a gown worn backward. The architectural shaping of the front skirt panels was achieved simply by folding the triangular terminus of the satin panel back on itself. The shoulder straps, which originate from the back bodice panels and attach at the center front of the bodice, highlight the cleavage even as they obscure it. The gown's pointed waist is directed to mid-pelvis for a hardly prurient, but clearly intended, eroticism.

opposite: Mrs. George P. (Marta de Cedercrantz) Raymond posing among richly patterned textiles, late 1940s. Photographer and source unknown

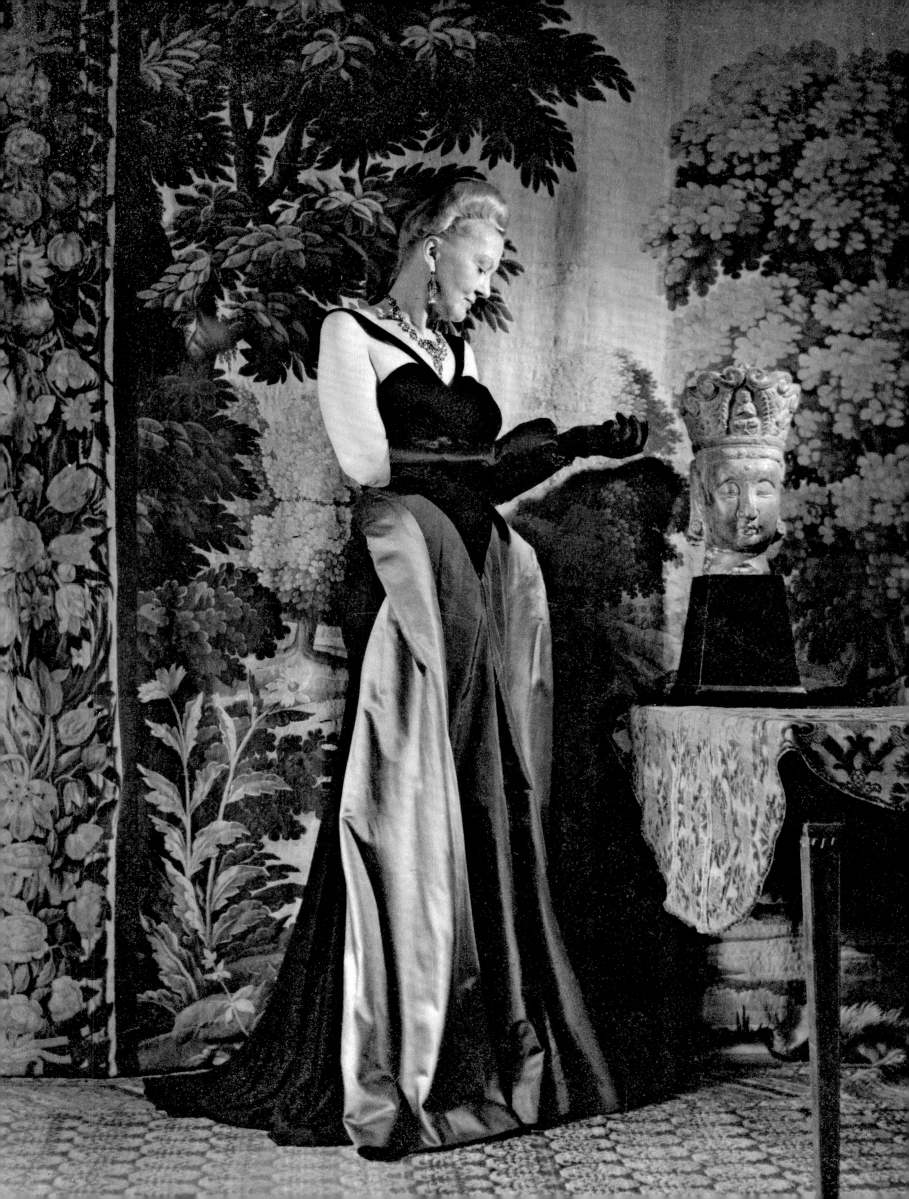

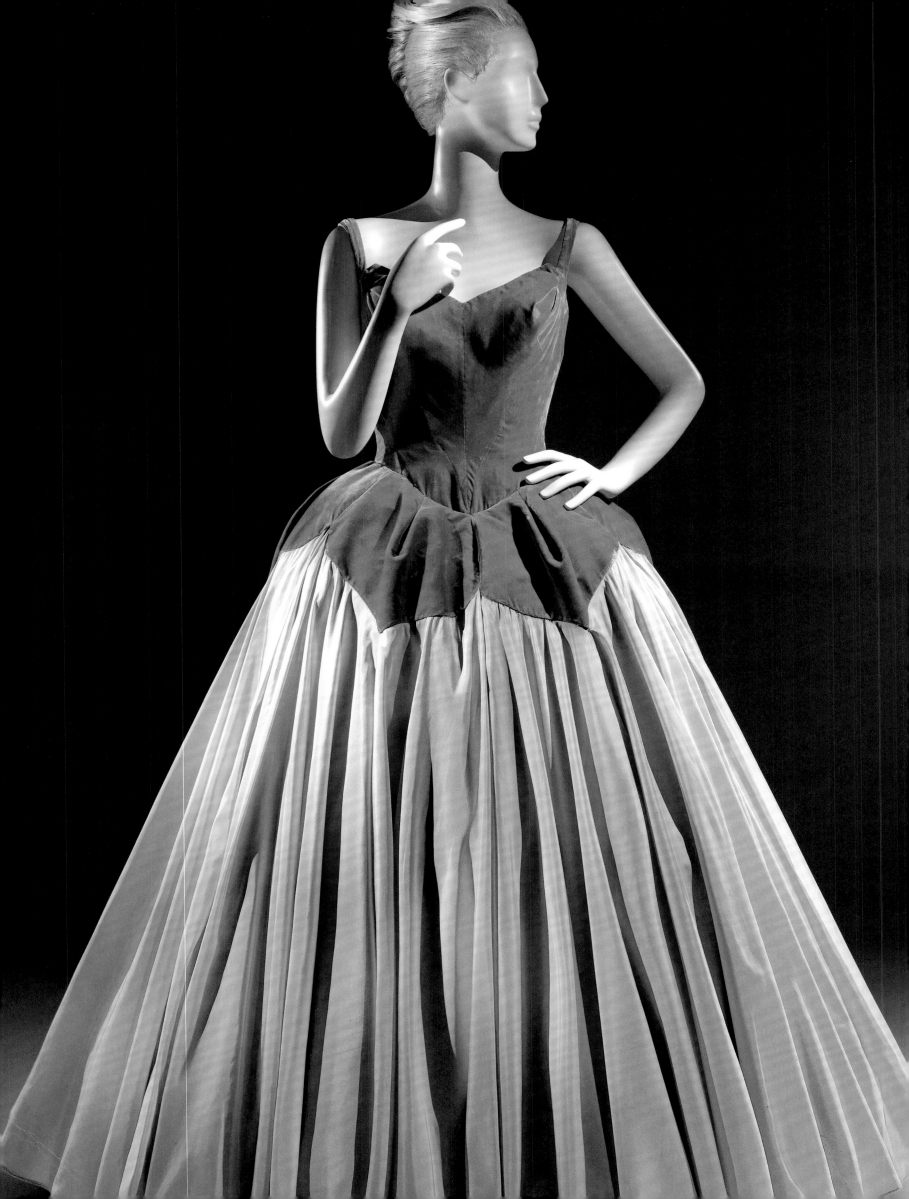

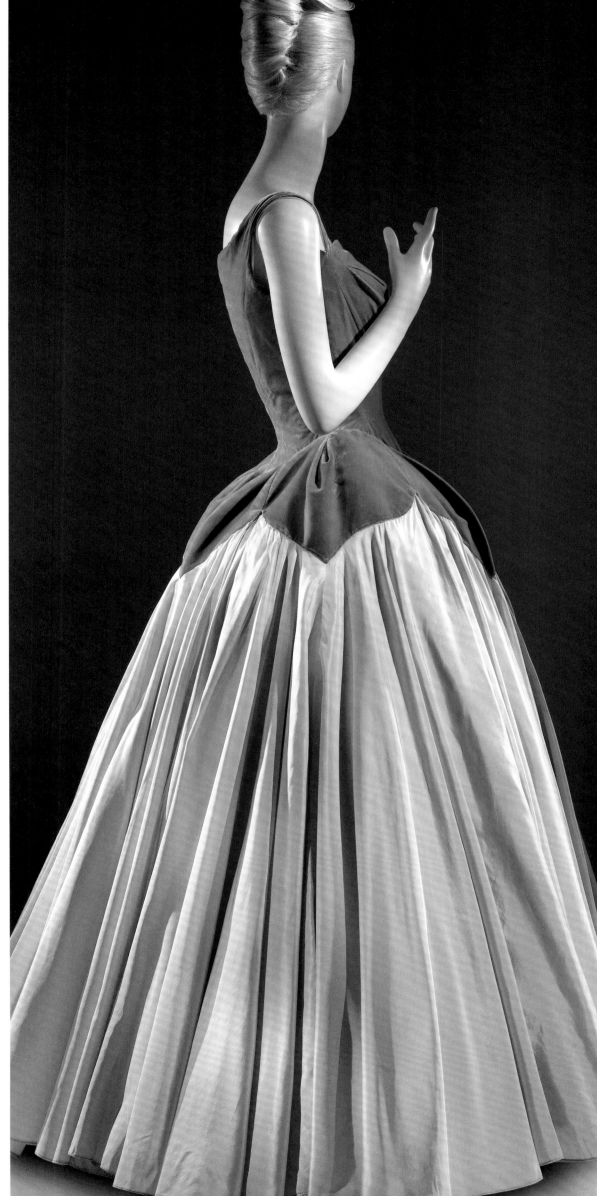

Petal Ball Gown, 1951. *Green silk velvet and ivory silk taffeta*

While this design's literal citation of the form of an inverted blossom is not representative of James, who generally preferred oblique references, its construction typifies James's technical mastery. He created a taffeta skirt of huge volume without distorting the outline of the velvet hip yoke that represents the flower's sepals. Seven varied triangulated gores are required to shape the skirt, which has a hem circumference of almost seventy-eight feet.

above: The text accompanying this photo poetically described this black-and-white version of the gown as "a night blooming rose" with "a long curving stem of black velvet above petals of black satin." Photo by Horst. *Vogue*, November 1, 1951, p. 89

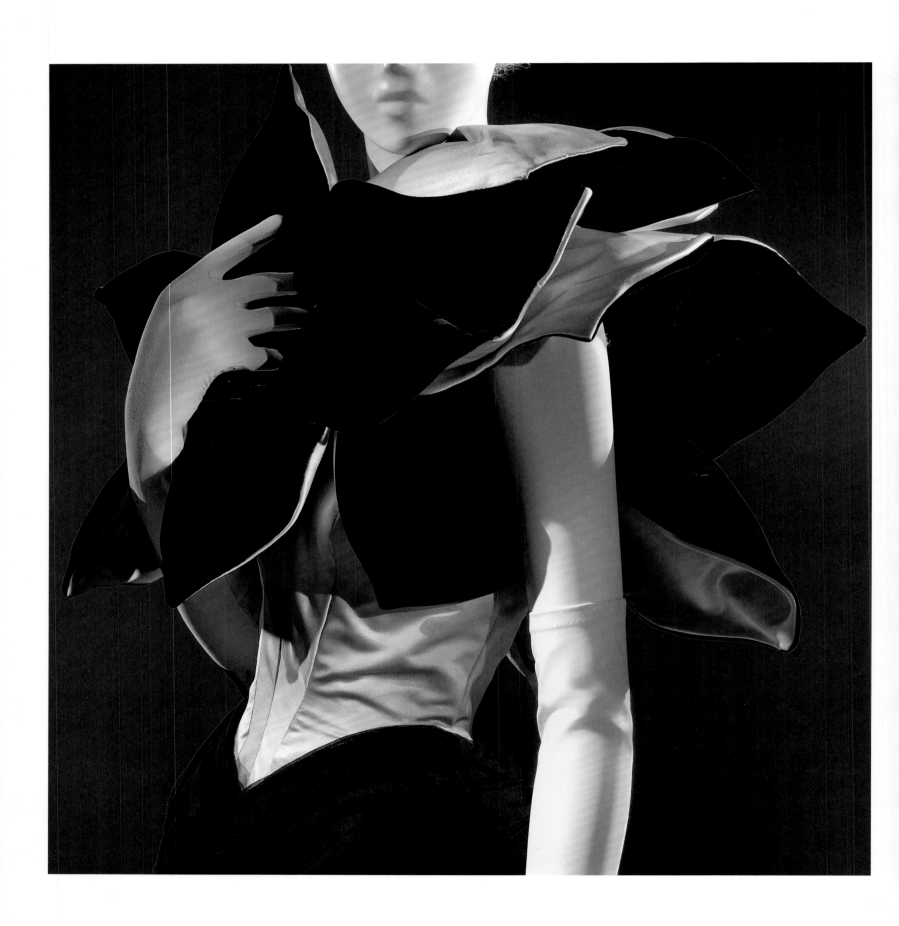

Petal Evening Stole, 1956. *Black silk-rayon velvet and white silk satin*
James created a number of scarves and stoles to accessorize his ensembles. For evening he created this petal-shaped wrap, adapted from the hip yoke pattern piece of his Petal ball gown (see p. 199). The designer's love of contrasts is apparent in his selection of fabrics of oppositional visual and tactile qualities. On one side the cool, smooth white silk satin reflects light with its high luster; on the reverse, the warm, napped black silk velvet absorbs the light, appearing blacker than black by contrast.

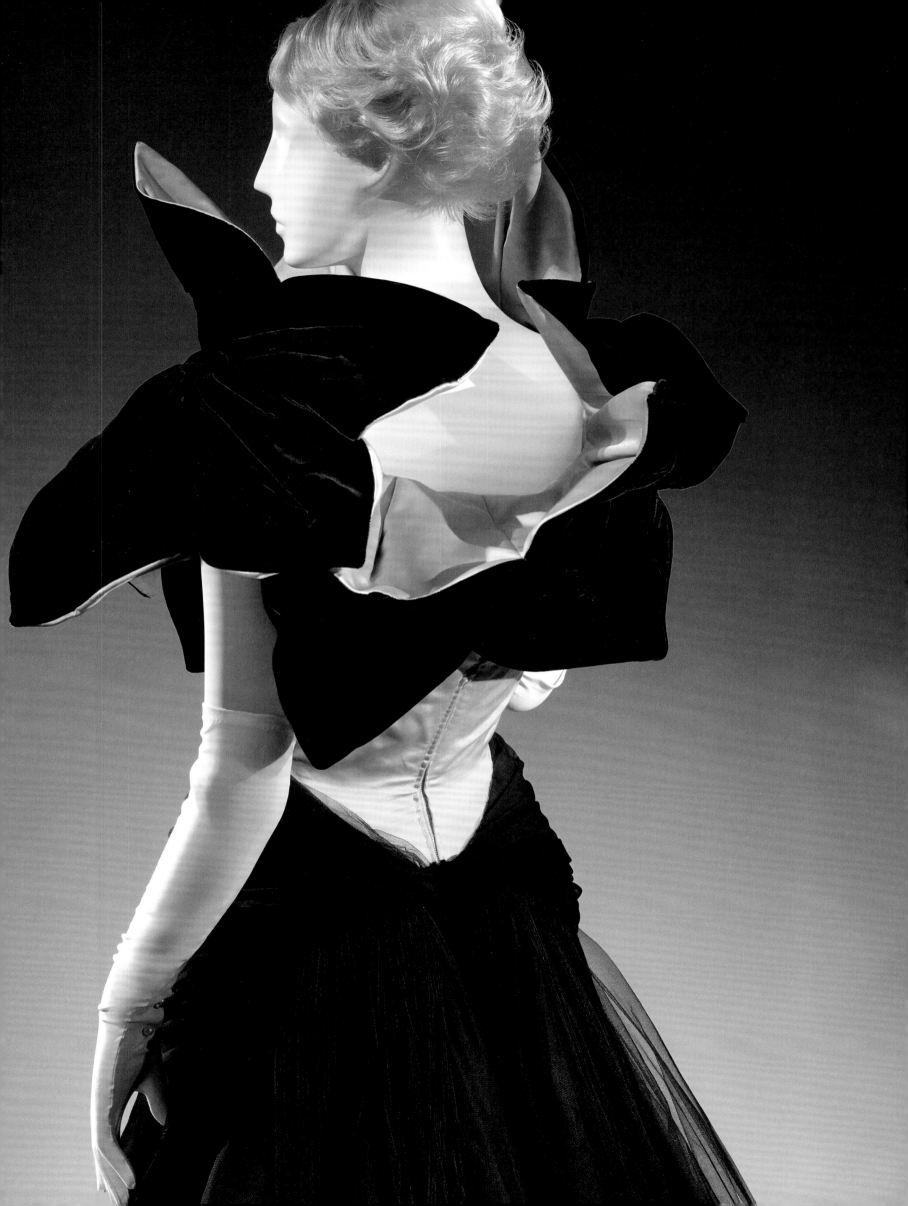

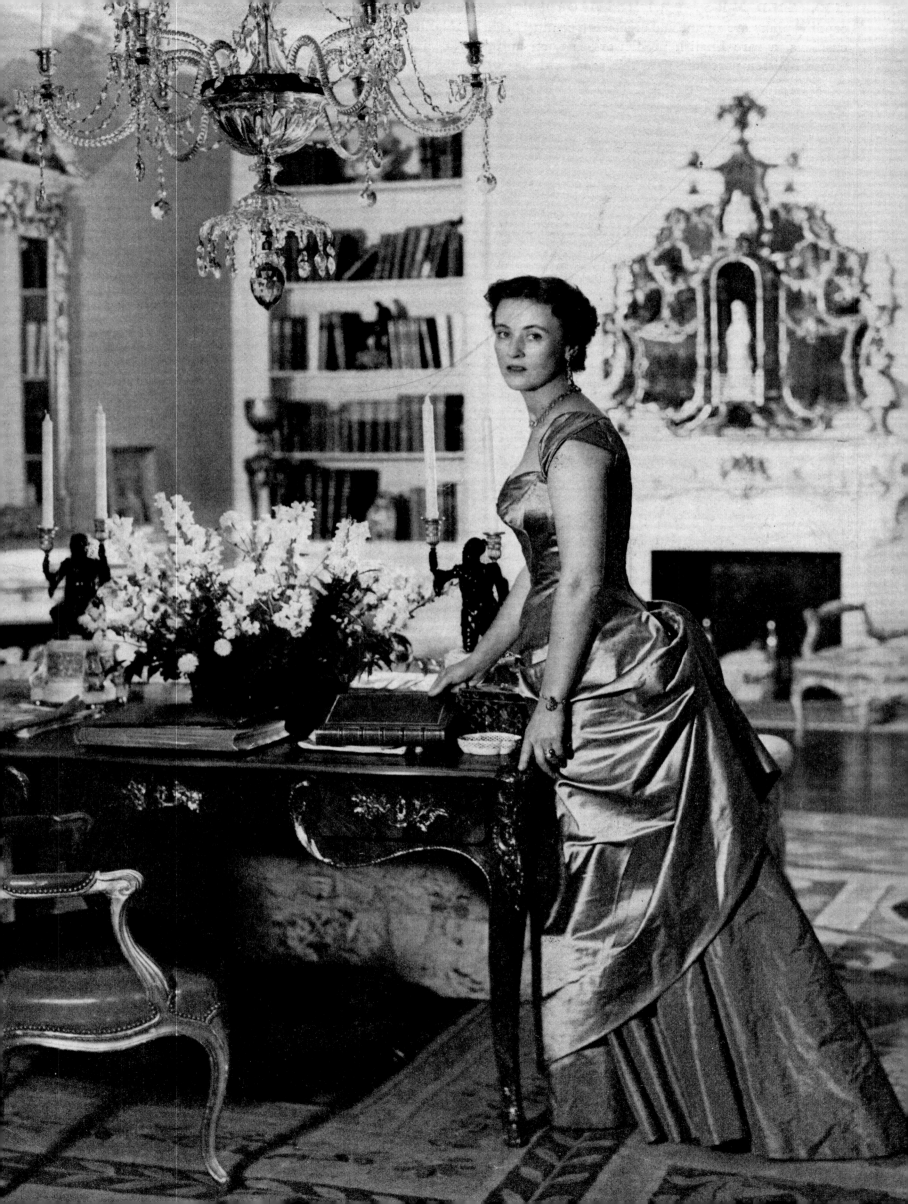

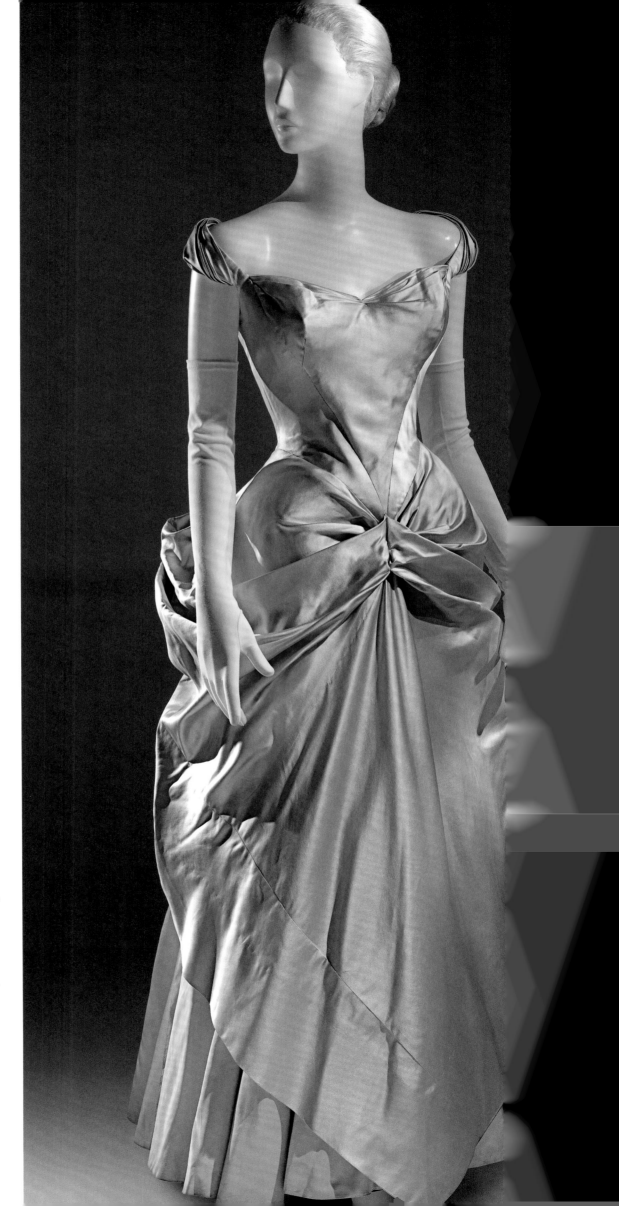

Ball Gown, 1948–49. *Pale pink silk satin and ivory silk twill*

Another example of this design appears in "Drapes & Folds" (see p. 111), but its silhouette situates it equally well among James's architectural dresses inspired by the bustled gowns of the 1880s. Although the bodices of James's ball gowns share some characteristics with the heavily boned corsets of that time, they are in fact much less rigid and have far fewer stays. His great achievement in his poetic evocations of romantic Belle Époque and Edwardian gowns was the surprising lightness, even airiness, of his designs. He deftly referred to historical precedent without replicating it. The gown shown here was purchased and worn as a wedding dress.

opposite: Mrs. Ronald (Marietta Peabody) Tree, wearing the gown in the drawing room of her home in New York. Photo by Cecil Beaton. *Vogue,* November 1, 1954, p. 113

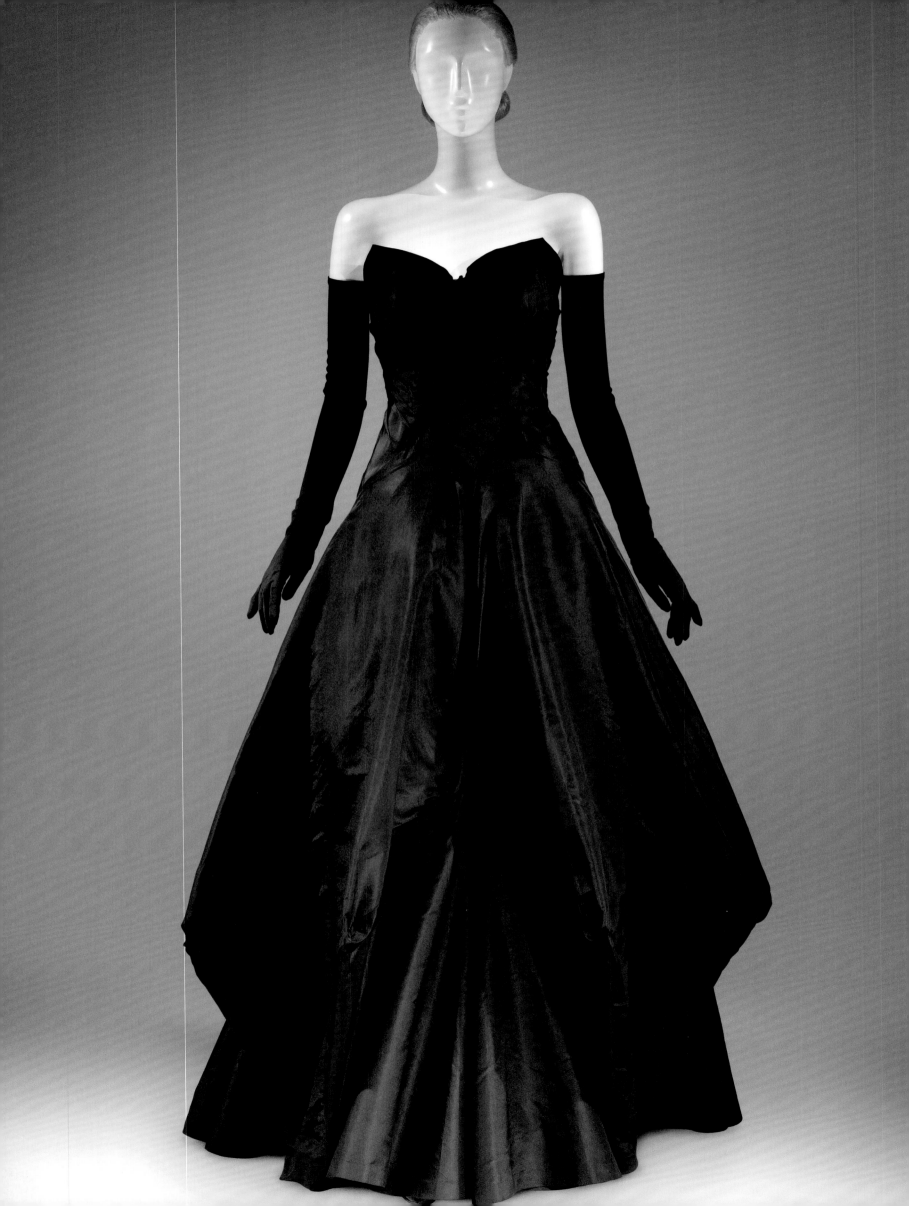

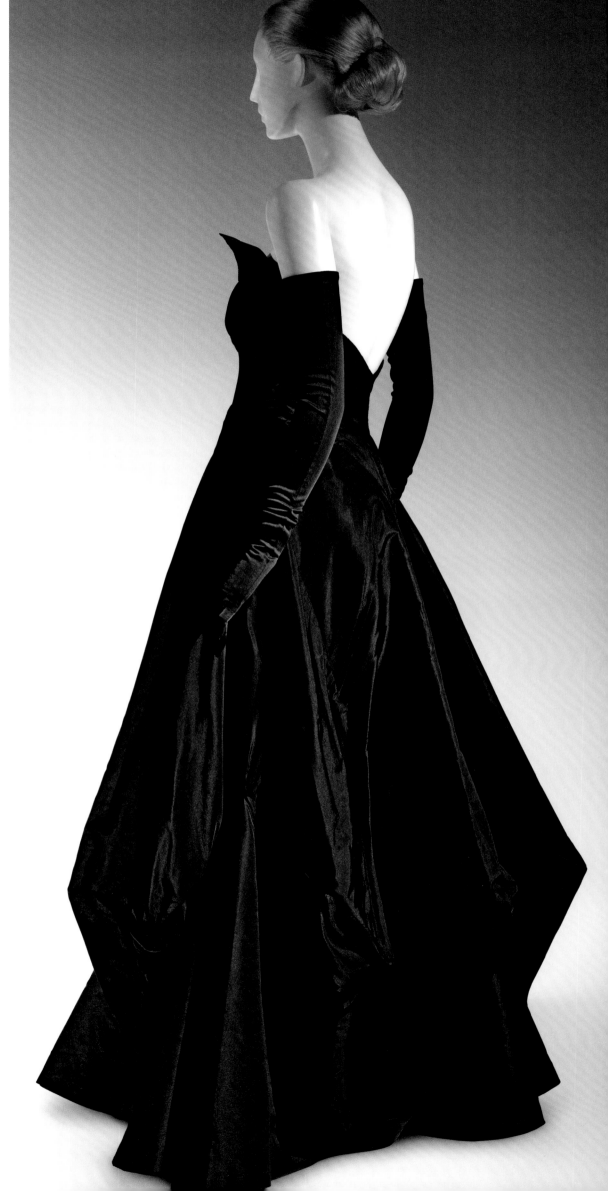

Umbrella Evening Dress, 1938. *Black silk faille*
One of the first strapless designs of the 1930s, this dress was created on a lightly stiffened foundation in grosgrain to support the bodice. Silk-encased ribs, like those of an umbrella, are the understructure that supports the fullness of the skirt, created by eight gores. The long darts horizontally placed at the mid-calf take up the fabric to form the pointed lobes. Horizontal interior bones support the silhouette of the skirt while amplifying its sway in movement.

above: Rendering of Mrs. Arturo (Patricia) Lopez-Willshaw wearing the Umbrella evening dress in an editorial entitled "What the Smart Woman Wears in Paris." *British Vogue,* February 8, 1939, p. 44

"My structures . . . look as if the body were no more ambulatory than a mermaid's yet permit large reckless movement."

Lampshade Evening Dress, ca. 1955. *Black rayon velvet and black silk-cotton satin*
Cecil Beaton once described the affectations of Pauline de Rothschild as becoming completely natural, and the same might be said of James's designs in the 1950s. So completely had the designer mastered the construction of even the most outsize and eccentric shapes that examples of his architectural amplification of the body are pleasantly astonishing rather than confounding in their unexpected forms. To the period ideal of the sheathed female figure James here appended a wide bell-shaped hem, as if the panniers of an eighteenth-century court gown had slipped down around the legs.

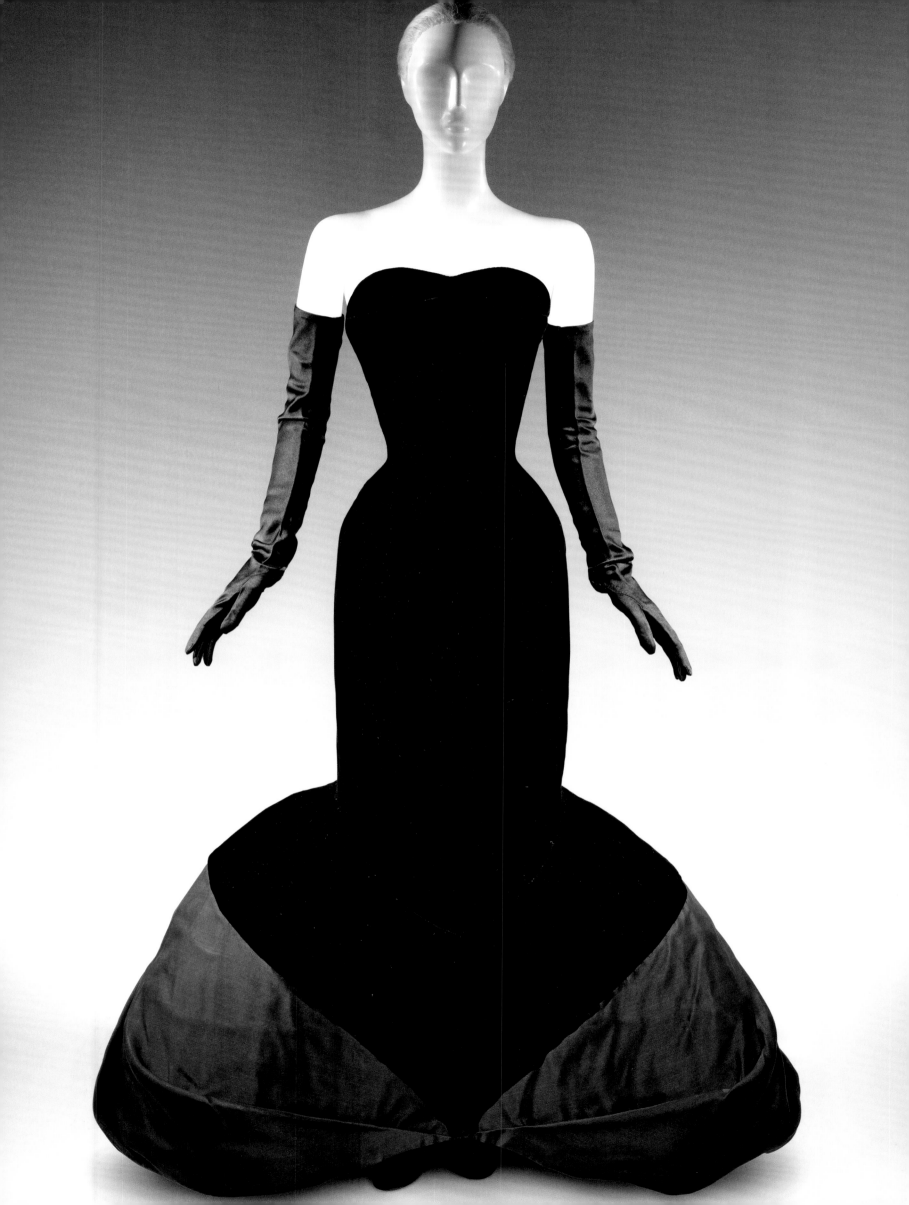

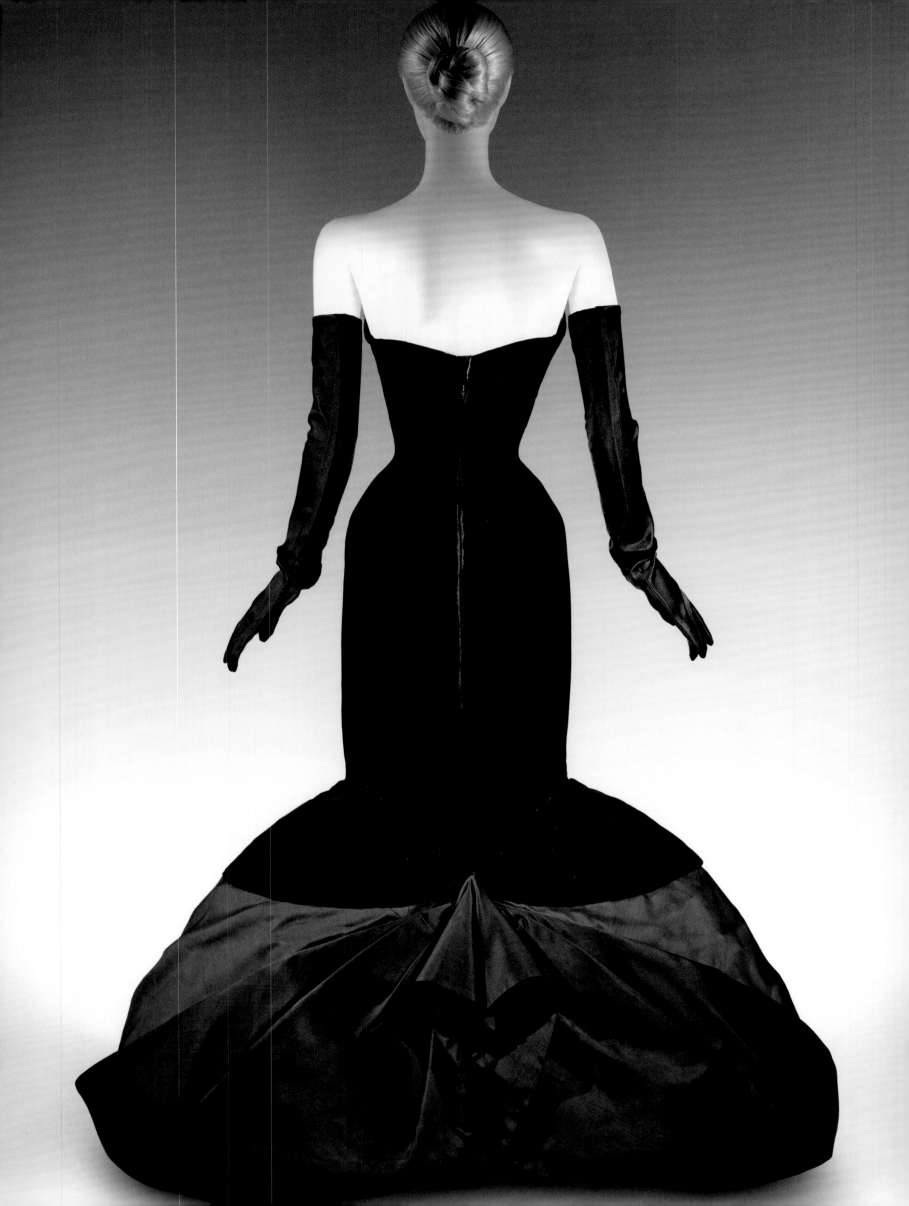

above: Sketch by Charles James, 1955. Graphite on paper

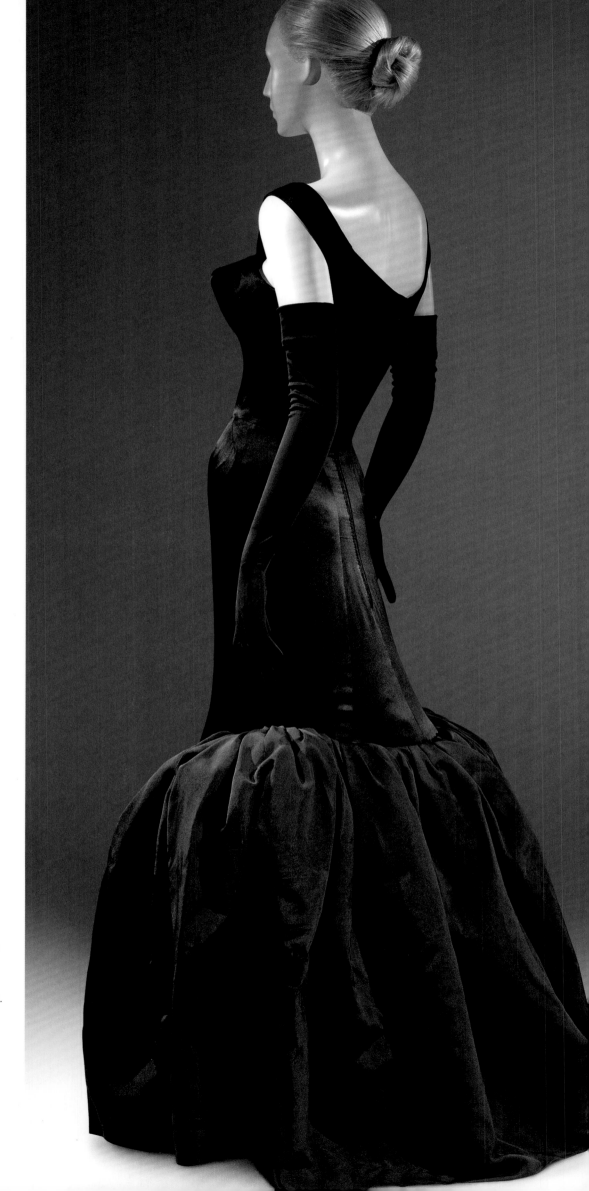

Tulip Evening Dress, 1949. *Black silk satin and faille*
James considered this one-of-a-kind dress among
the most the challenging of his career. The dress's
torso is composed of black satin mounted on organza.
The form-fitting bodice is constructed with a boned
satin foundation extending to below the waist. The
straps at the center front neckline are extensions of
the back bodice. The wide, gathered tulip hem at the
back releases the legs, allowing the wearer to walk
relatively unimpeded while retaining the tapered
silhouette at the front.

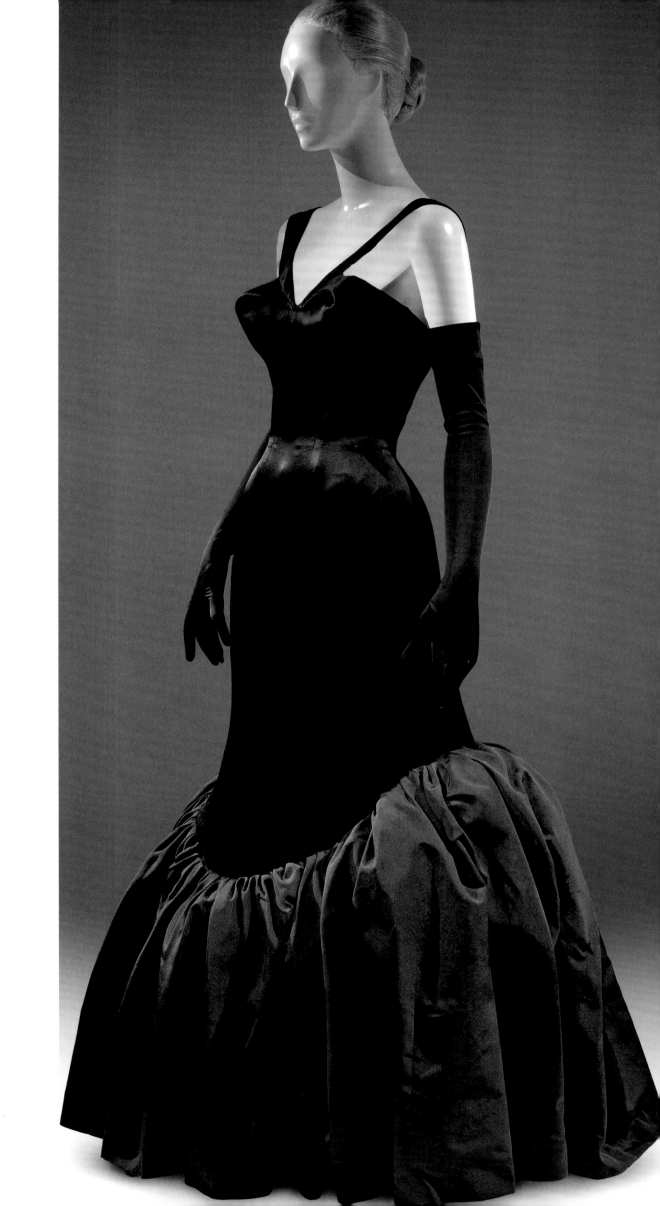

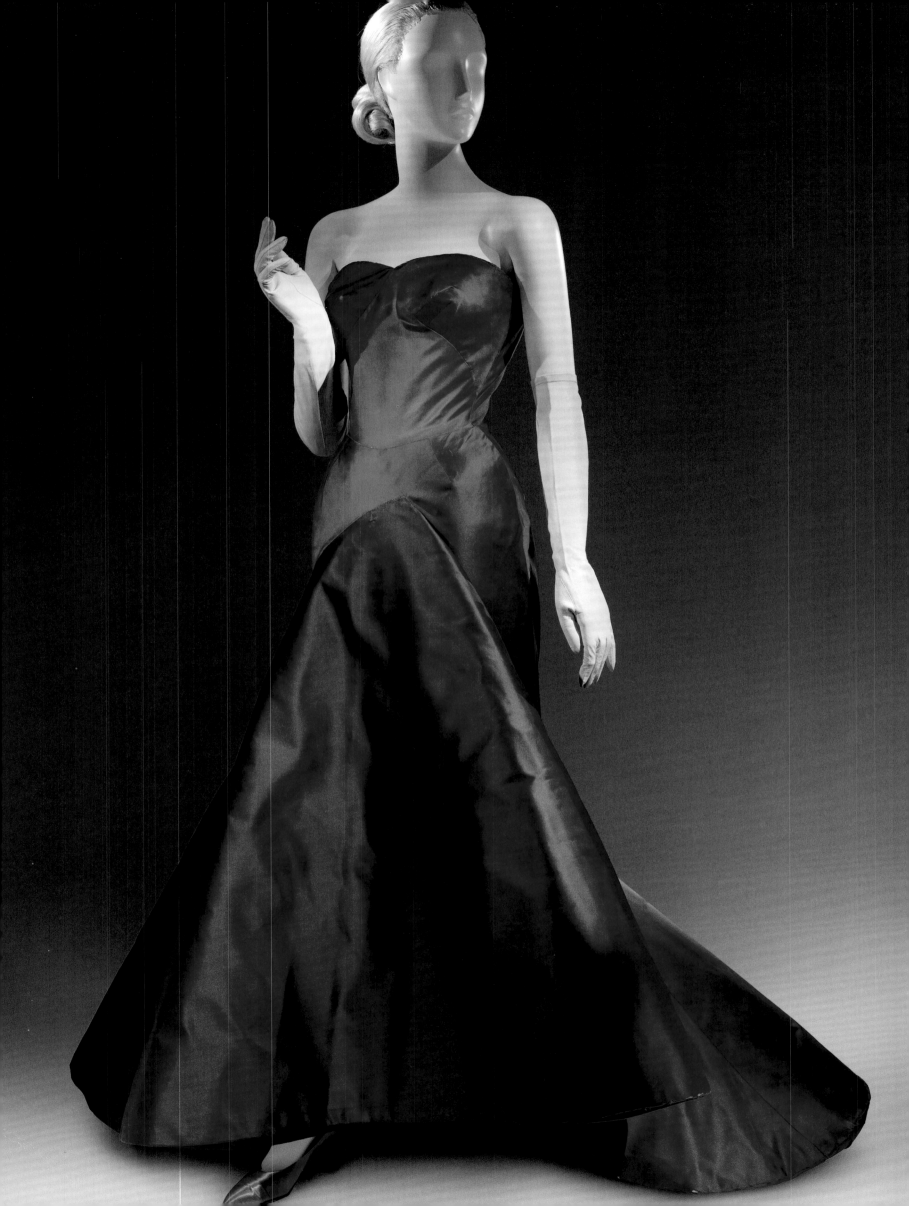

"The excitement of new fashions is for us to know what lies within and beneath clothes; this being hinted at . . . by the sway of the figure as it moves against and into the flow of material . . . [the] cocoon in which the body is enclosed."

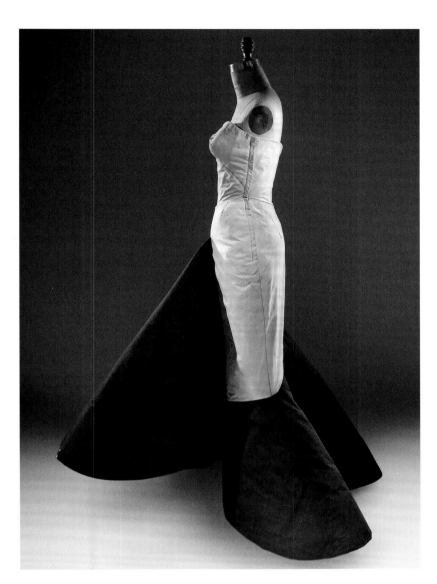

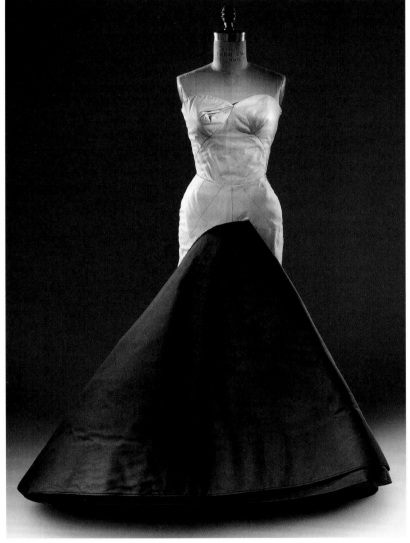

Ball Gown, 1954. *Green silk satin*

As James sought to consolidate his legacy and to devise a curriculum around some of his most important works, he created a series of draped study pieces. These full-sewn muslins, or toiles, as such prototypes of black and white cotton muslin are also known, graphically render the complexities of his approach, and the contrasting fabrics simplify an analysis of his techniques. This intricate gown's toile (above) reveals the skirt's hem as a wide contoured circle that is pulled up and folded over on itself to form the dramatic front flute.

above: Full-Sewn Muslin, 1954. Black and white cotton muslin

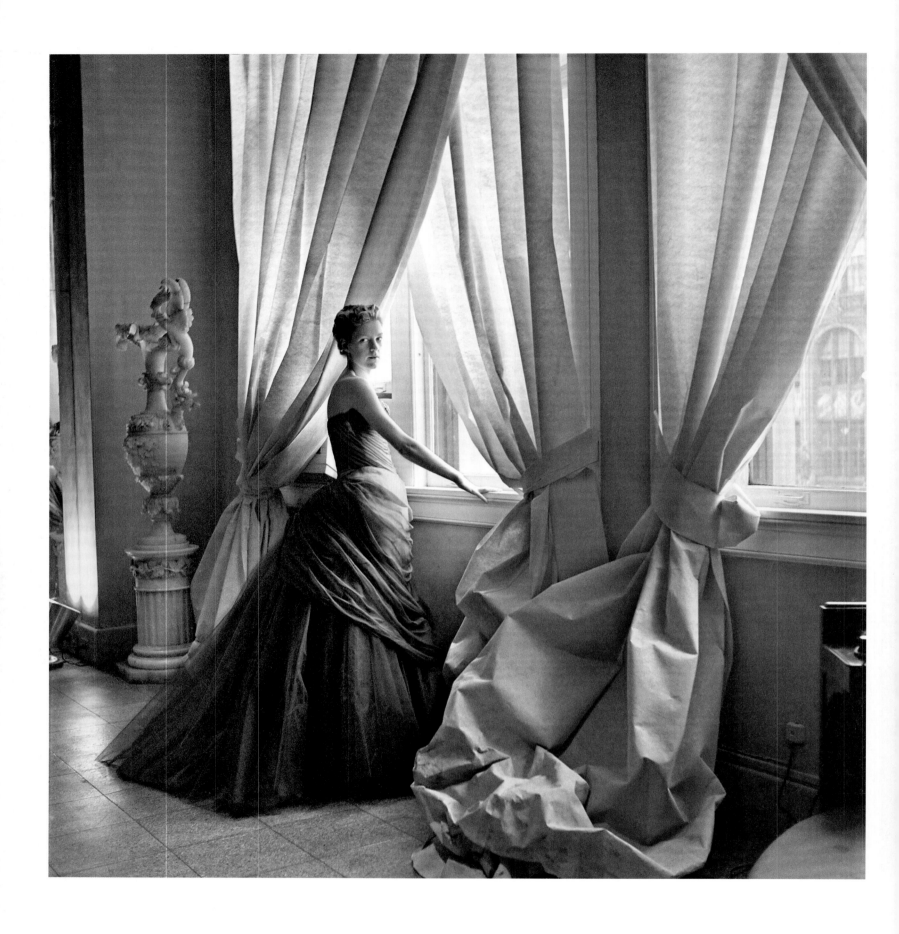

Swan Ball Gown, ca. 1954. *Brown silk chiffon, cream silk satin, and yellow, purple, light brown, and brown nylon tulle*
James's Swan shares a Belle Époque elegance with his Tree and Butterfly gowns (see pp. 221, 222). Of his architectural works, they are among the most historicist in their evocation of late nineteenth-century silhouettes and lush romanticism. The infrastructure of the Swan is as complex as his poetic juxtaposition of delicate materials on its surface. The tucked chiffon of the bodice is placed over a cream silk satin ground, making the painstaking handwork more clearly visible; the draped apron is manipulated so that its folds are not fixed but difficult to disrupt; and layers of variously colored tulle combine to give depth and luminosity to the skirt, especially in motion. *detail, page 216:* Right bodice

above: Mrs. Charles (Nancy) James in James's showroom at 12 East Fifty-Seventh Street, one of a series of photographs Cecil Beaton shot as a wedding gift to the couple, 1955

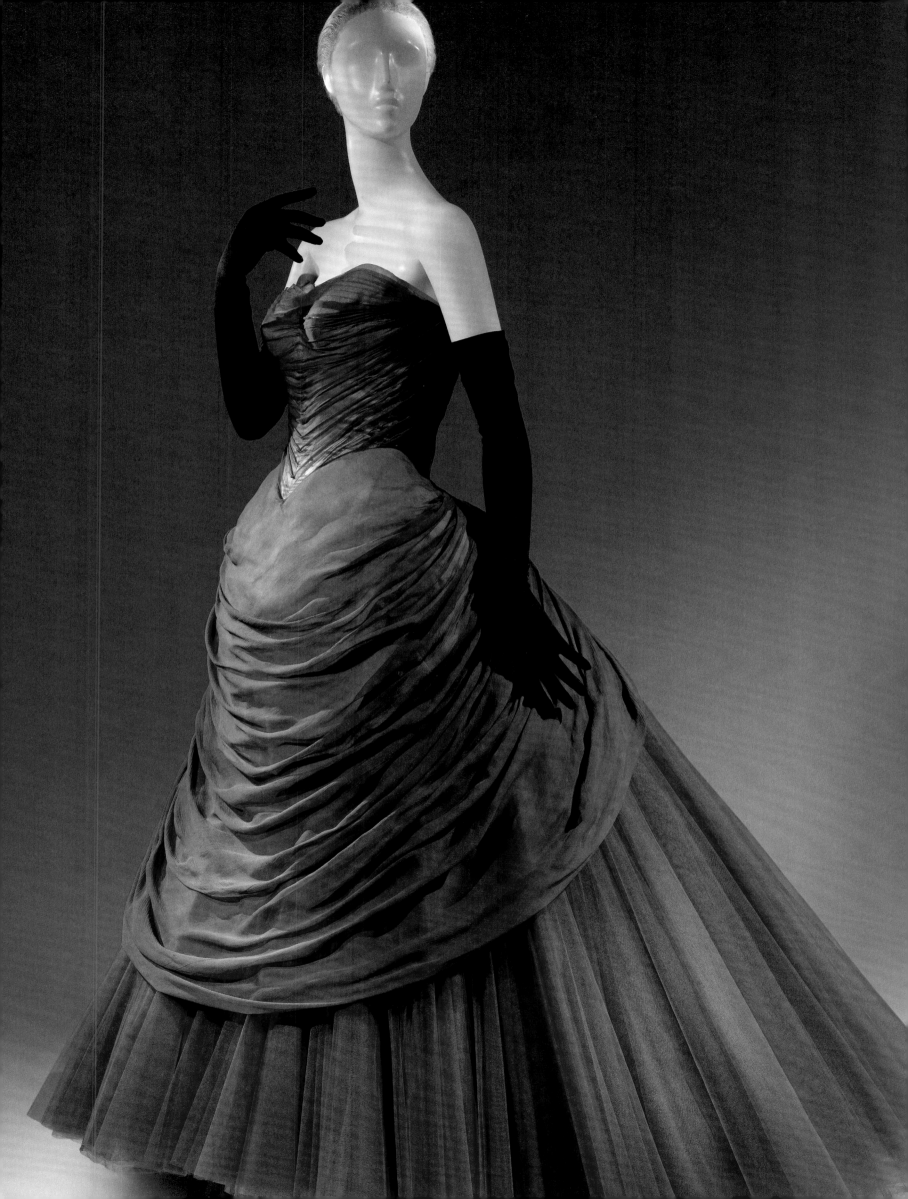

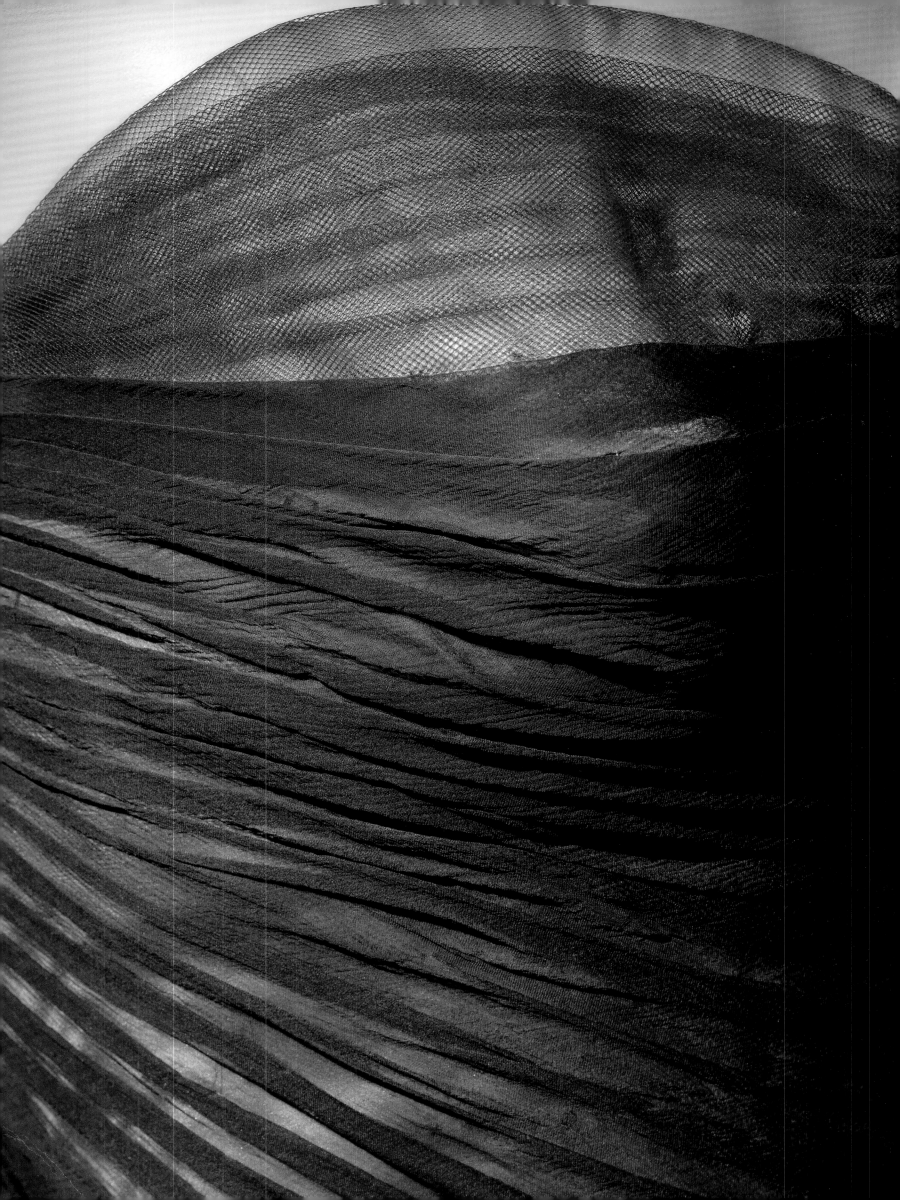

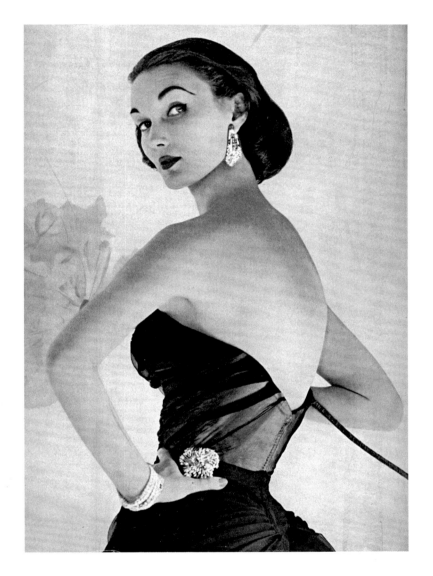

above left: A model posing in the Swan dress highlights the signature curve of James's ball gown bodices. Photo by Horst. *Vogue,* November 15, 1951, p. 86
above right: Sketch by Charles James, 1954. Graphite on paper

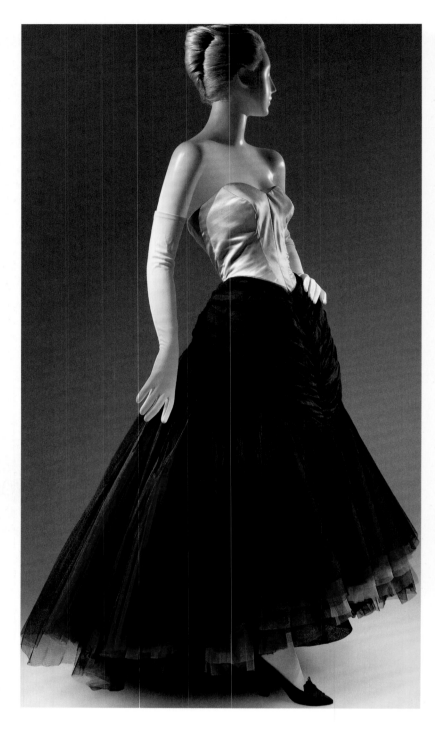
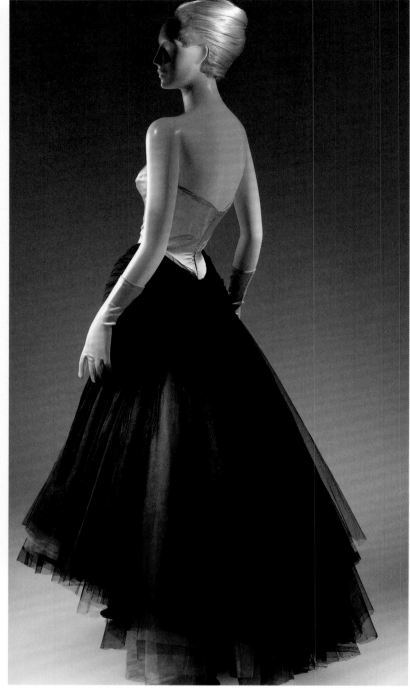

Swan Ball Gown, 1951. *Ivory silk-acetate satin, black and brown synthetic tulle, and black acetate fringe*
This version of the Swan eliminates the chiffon skin tucked over the bodice. James also diminished the gown's apronlike drape to match the proportion of the cropped hemline. As a result, the contrast of the ivory satin bodice and black skirt highlights the high arch over the hipbone, the pointed front waistline, and the *quadratus lumborum*, the inverted triangle below the small of the back.

opposite: **Evening Cape**, 1951. *Black rayon net, black silk faille, and brown polyester tulle*
At first this evening cape of multiple layers of net and tulle appears to be a circle folded over by a third to form a cape collar and body, with openings for the arms and a tiny band collar at the fold line. Splaying it open, however, reveals that the circle cannot be flattened, as it undulates along its edge. James has created paradox: a circle of tulle incorporating more fabric than its diameter would suggest.

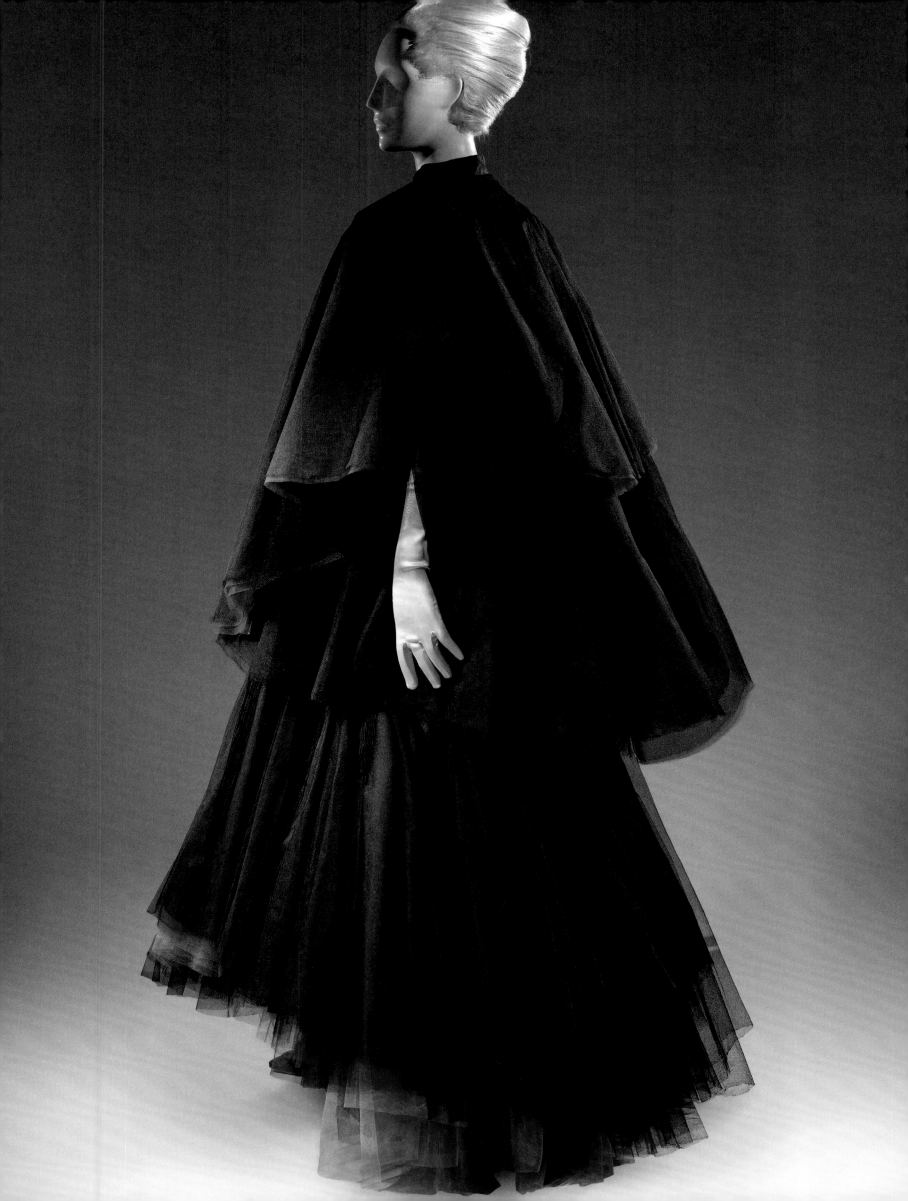

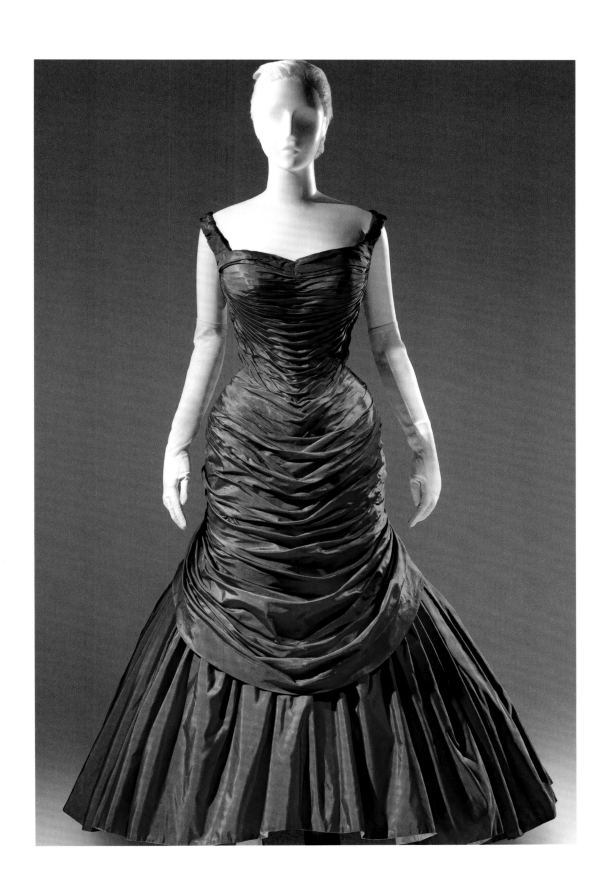

Tree Ball Gown, 1955. *Dark pink silk taffeta and red, pink, and white nylon tulle*

The name of this dress refers not to textured bark but to Marietta Tree, the socially prominent client for whom it was designed. The details of several designs appear to have percolated through James's development process, resulting in similar but distinctive alternatives. Unlike the Swan (see p. 214), this dress merges bodice and skirt in one continuous downward drift of folds. Whereas the Swan features narrow tucks at the bodice and soft drapery at the skirt, the Tree relies on a seemingly less controlled V-shaped cascade throughout. *detail:* Front skirt

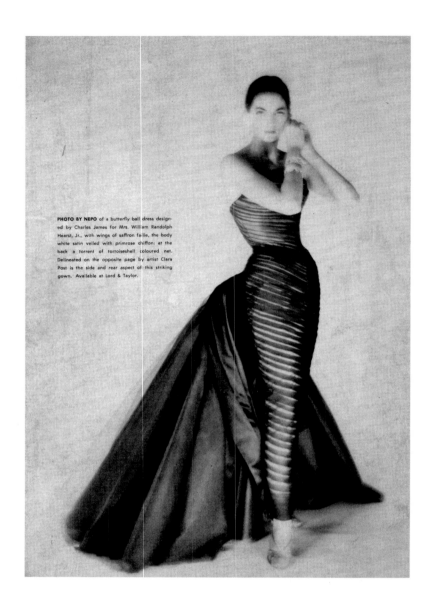

Butterfly Ball Gown, ca. 1955. *Brown silk chiffon, cream silk satin, brown silk satin, and dark brown nylon tulle*
The Butterfly extends the labor-intensive tucking treatment seen on the bodice of the Swan (see p. 214) to cover the whole of the narrow, body-hugging sheath. A folded wide satin band loops over and controls the exuberant volume of tulle released at the back; it also obscures the structural attachment of the various parts. As in many of his tulle skirts, James here exploited the transparency of net by layering unexpected combinations of colors, which together accrue a richly complex depth of tone. The Butterfly was manufactured at James's facility on East Fifty-Seventh Street and sold at Lord & Taylor. *detail, page 224:* Right hip

above left: A model wearing Mrs. William Randolph (Austine) Hearst Jr.'s version of the Butterfly gown, ca. 1955. Her pose emphasizes the contrast between the gown's shapely body and what the editorial called a "torrent" of colored net. Photo attributed to Arik Nepo. Source unknown
above right: Sketch by Charles James, 1959. Graphite on paper

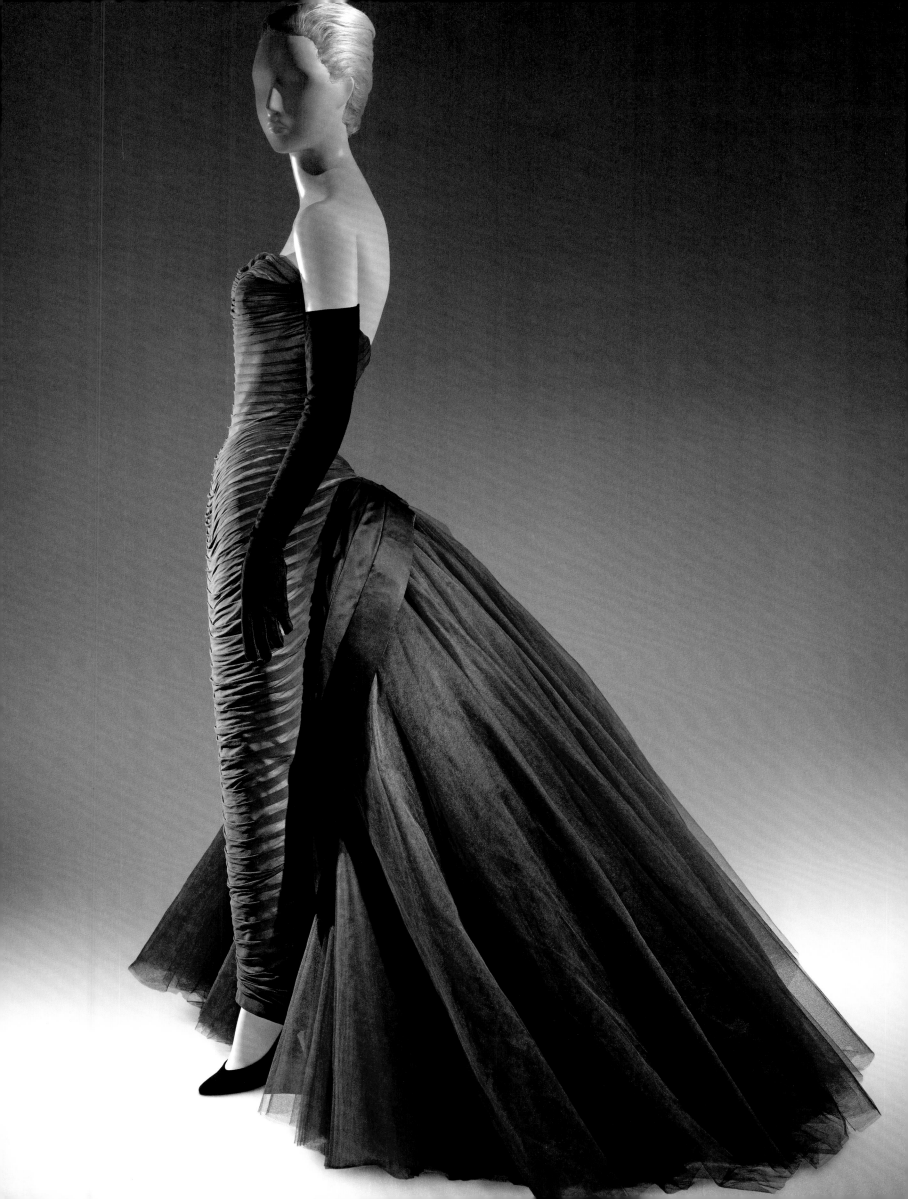

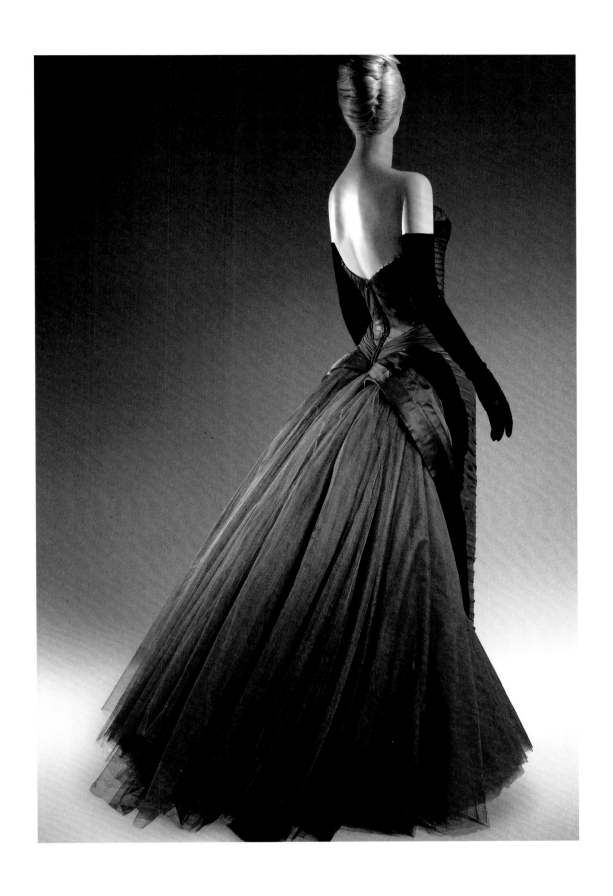

Clover Leaf Ball Gown, 1953. *White silk satin and faille and black silk-rayon velvet*
James considered this design his crowning achievement. A sequence of undulating curves that work in symphony, it is an aesthetic and technical masterwork. The strapless bodice is curved up slightly under the arms, only to dip in a reverse curve to the low center back. A subtle asymmetry is introduced to the severely fitted top with a splay of release tucks at the center front bust. The waistline curves up over the side waist, a characteristic Jamesian gesture, and dips very low in the front and back. The coup de grace is the skirt of four separate lobes, longer and fuller in back. The cantilevered skirt is in three structurally distinct parts: an upper skirt of ice white satin matching the bodice; a wide band of black velvet, with top and bottom curves undulating in opposite directions; and a hem of white silk faille. Deep inverted pleats at the sides of the lower skirt animate the hem when in movement. The bodice is buttressed from the waist, and the skirt is balanced on the hips and does not touch the ground. It is intended to lift on the dance floor like an ice skater's skirt in pirouette.

top: Sketch by Charles James, ca. 1970. Charcoal on paper
above: Sketch by Charles James, ca. 1970. Ink on paper

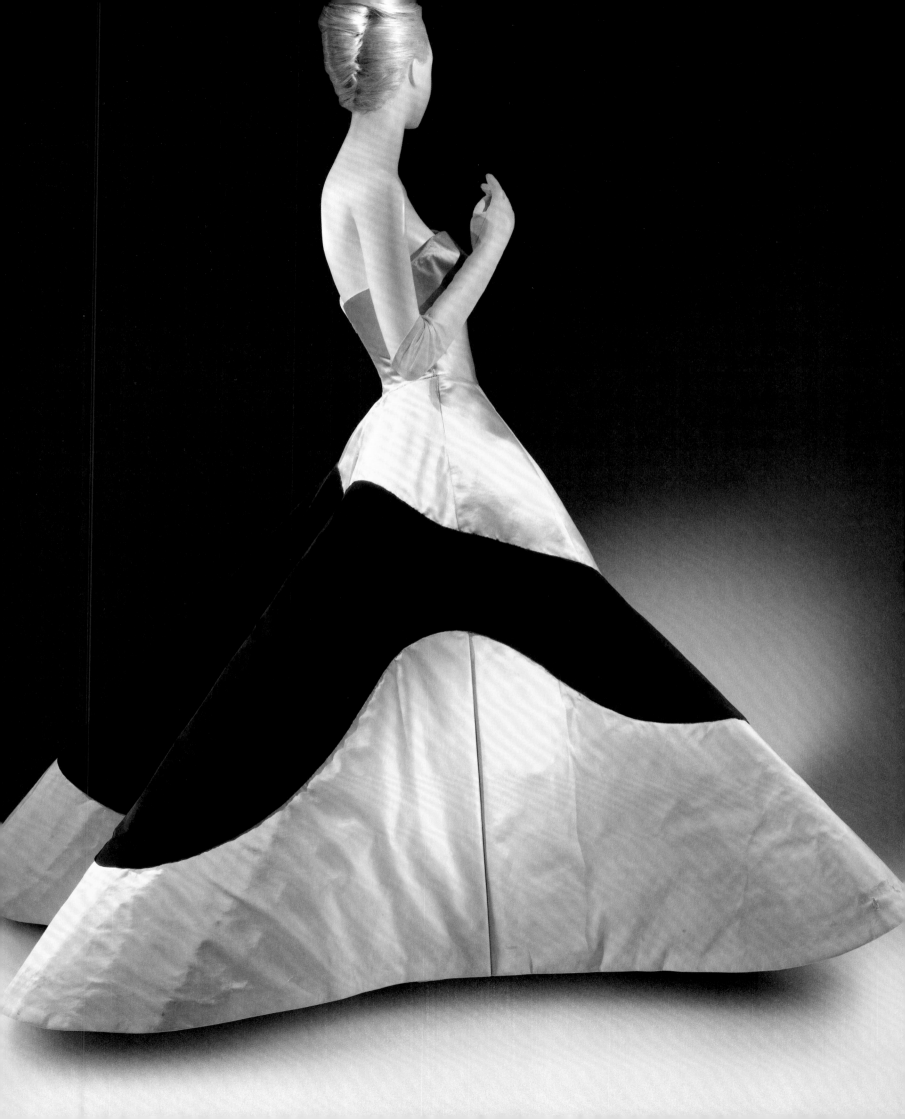

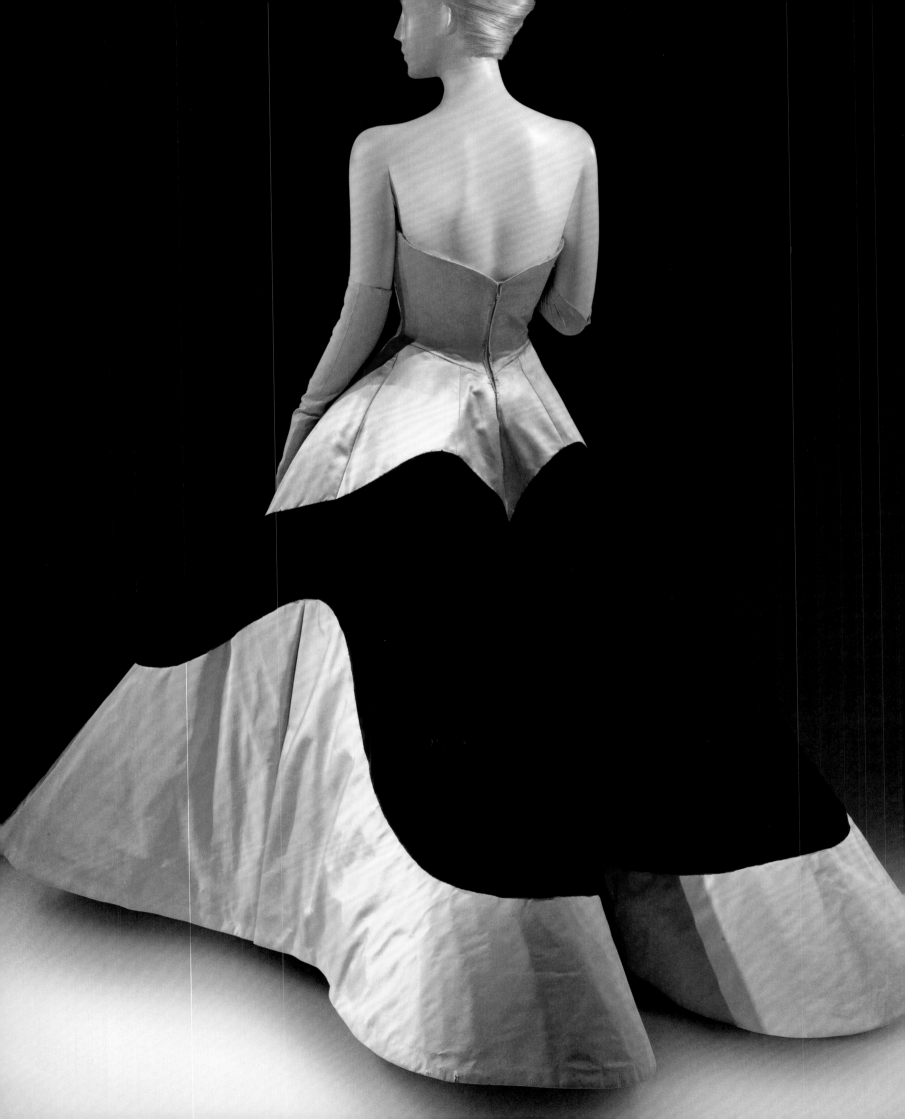

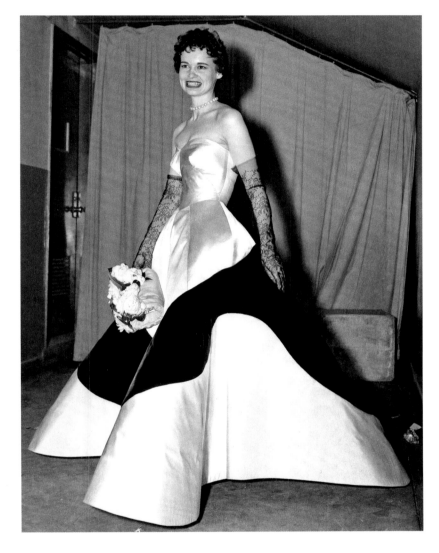 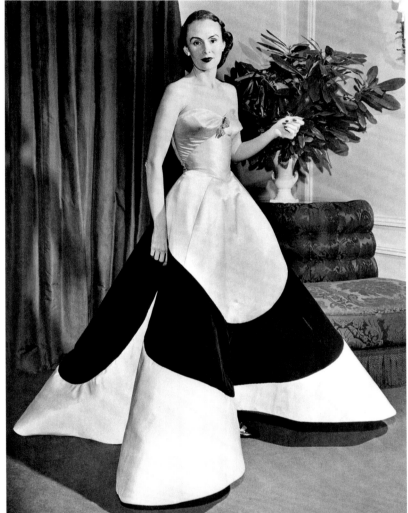

above left: Mrs. Leopold (Gloria Vanderbilt) Stokowski at the opening of the Ringling Bros. and Barnum & Bailey Circus, April 1, 1953. Photographer and source unknown
above right: Mrs. William Randolph (Austine) Hearst Jr. wearing the original Clover Leaf gown, which James designed for her, 1953. Photographer and source unknown

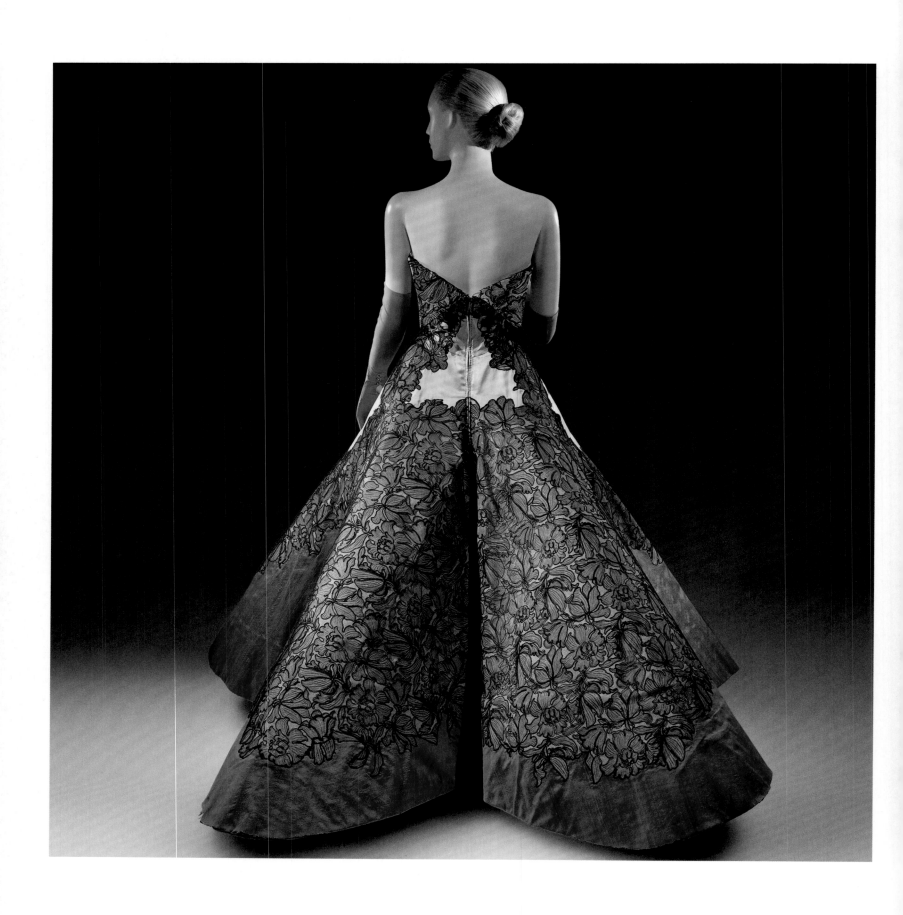

Clover Leaf Ball Gown, 1953. *Pink silk faille, copper silk shantung, and black silk lace with ivory silk faille backing*
James's architectonic virtuosity tends to subordinate his decorative details. Here the graphic black-and-white modernity of the original Clover Leaf design has evolved into a more romantic iteration. The unexpected color combination of shell pink with copper is classic James. A black lace overlay with an ivory silk backing spreads across the gown like moss. At the front bodice, the lace optically narrows the waist, while at the back it frames the erotic zone above the buttocks and below the small of the back, a frequent point of focus for the designer.

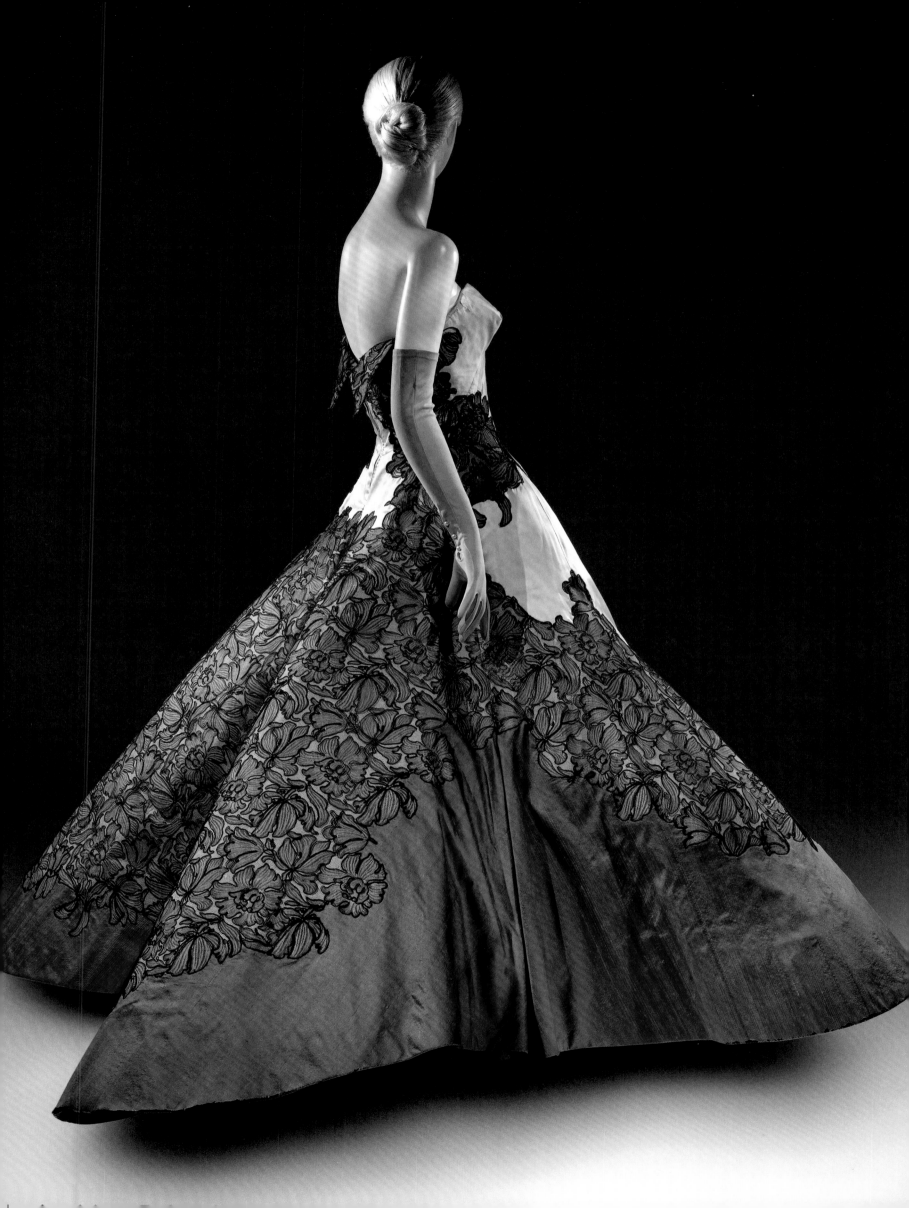

SARAH SCATURRO AND
GLENN PETERSEN

INHERENT VICE

Challenges and
Conservation

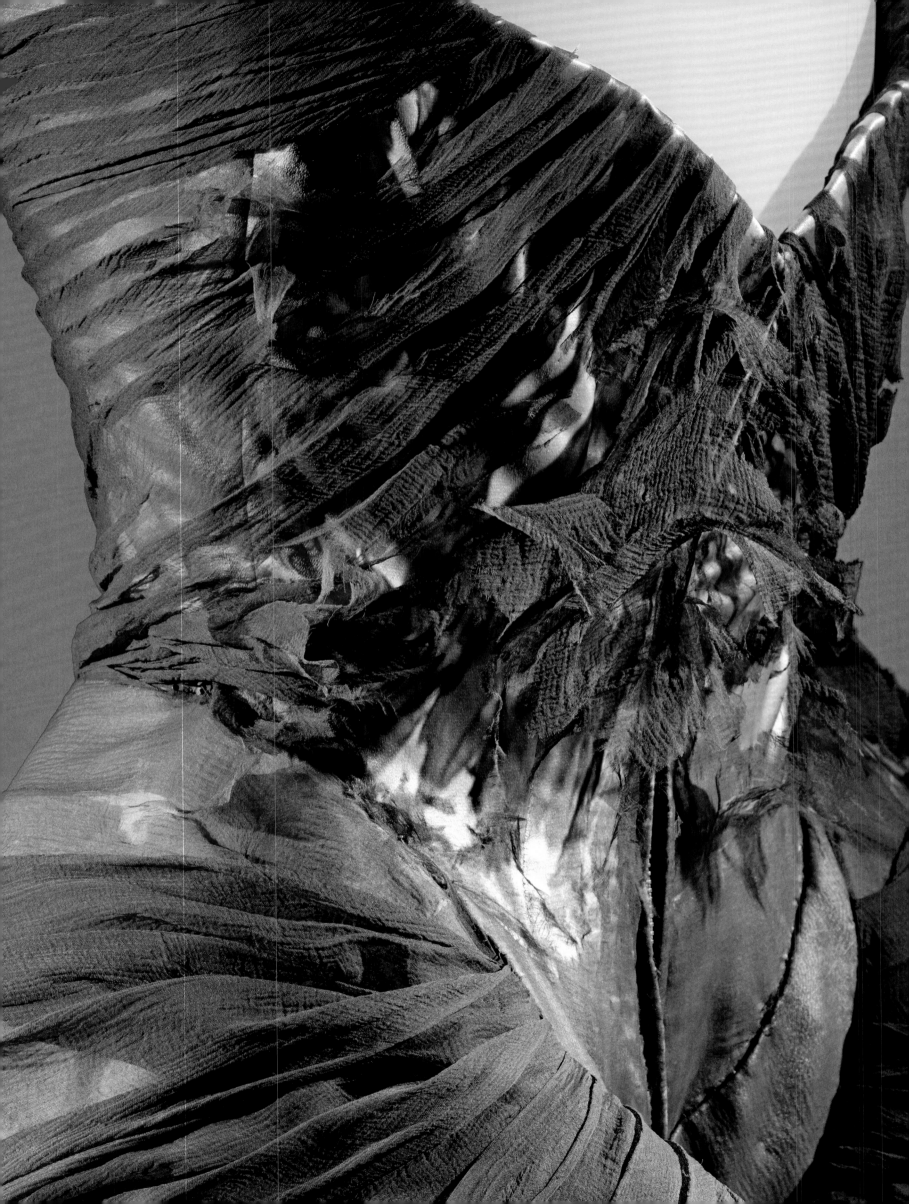

Decades after Charles James captivated the fashion world with his innovative designs, his creations continue to enchant, his sculptural ball gowns in particular conveying an eternal glamour. Yet many of those gowns are not aging well; often the very elements that make them spectacular cause them to deteriorate more quickly than James's other works. That is because James diverged from standard dressmaking techniques and fabrics to create his expansive and architectural ball gowns, choosing unproven methods and materials that he forced beyond their innate capacities. Consequently, the many artistic virtues of James's most iconic and daring designs come at the cost of inherent vice.

What Is Inherent Vice?

Art conservators use the term "inherent vice" to refer to a quality intrinsic to an artifact that is the very cause of the artifact's ruin. A form of built-in self-destruction, inherent vice cannot be removed from the object that contains it. For example, iron gall ink, used for writing and drawing from ancient times to the twentieth century, can be highly acidic; it eats away at paper over time, causing written characters literally to fall out of the page.

In clothing, inherent vice may stem from the garment's material or the way the material has been treated, its construction, its use, or its maintenance (or lack thereof). An example of vice in the fabric might be the type of dye that was used, especially when the dye was combined with mordants (metallic salts and other inorganic materials that fix the color in the fabric). Many eighteenth- and nineteenth-century fabrics, particularly those made of silk, are shattering or crumbling into dust because of the use of mordanted dyes.

Even untreated fibers have the capacity to self-destruct. Some of the synthetic polymers that came of age in the mid-twentieth century, like polyvinyl chloride and polyurethane, can decay spectacularly, their plasticizers oozing, foams crumbling, and layers peeling. In organic fibers like silk and cotton, susceptibility to oxidation, light, and changes in humidity and temperature can be catalysts for inherent vices in the fabric or construction.

The most significant vices related to clothing construction are weight and incompatible materials, exemplified by a 1920s gown that has heavy, hard beadwork attached to a sheer, fragile silk foundation. Over time the weight of the beads can cause the silk to tear at stress points, such as the shoulders, or wherever the embellishment is applied to the ground fabric. For that reason, historical beaded gowns are usually stored flat to avoid the damaging effects of weight and gravity.

Even normal use and handling are considered inherent vices in the case of clothing, which exists solely to clad the body and is damaged every time it is put on and worn. Seams are stressed and strained, and the materials are exposed to environmental factors like sunlight, dirt, stains, and sweat. Maintenance of clothing, intended to prolong its use, may have the opposite effect: Laundering or dry cleaning can affect dyes, shrink fabrics, strain seams, and ruin embellishments. However, allowing grime to stay in garments can also have a deleterious effect. For example, fabric that has absorbed perspiration, which is often acidic, may discolor, split, or drop away at the underarms. While such problems may bedevil any garment, they are especially challenging to resolve in the sculptural gowns designed by Charles James (fig. 1).

The Charles James Conservation Campaign

James's designs may still appear fresh decades after their inception, but the physical garments are now fifty to eighty years old. Owing to imperfect storage before entering The Metropolitan Museum of Art's collection, previous use for study and display, and the natural decomposition of materials over time, every one of the garments in the Charles James exhibition has some degree of damage that must be identified, evaluated, and addressed in order to safely present it. Numerous other garments in the Museum's James collection are so weakened that they could not withstand being dressed on a mannequin and displayed even if repaired.

The conservators of the Museum's Costume Institute have two primary goals in conserving Charles James's work: first, to ensure the objects' stability for short-term exhibition and long-term storage; second, to correct disfiguring problems that could alter perceptions of the objects aesthetically. As advocates for the preservation of cultural heritage—and the hands-on, trained professionals directly responsible for it—conservators seek foremost to do no harm to an object's integrity. The leading ethical guidelines for conservation are that every treatment must be reversible (i.e., it will not permanently alter the object) and it must be the least invasive, most holistic approach possible. Therefore, damage sometimes may be impossible to correct, especially if repairs would entail taking apart the object or removing original material.

A detailed examination of James's gowns reveals the unprecedented complexity of their design and assembly, exposes the vices inherent to his innovations, and provides a behind-the-scenes look at possible conservation solutions. Two of James's most important designs, the Swan gown of 1949–55 and the Clover Leaf (or Abstract) gown of 1952, exemplify the issues facing many of his sculptural gowns and serve here as case studies.

The Swan and the Clover Leaf: Construction, Consequences, and Care

The Costume Institute is fortunate to possess multiple versions of the Swan and the Clover Leaf. A mature version of the Swan from about 1954 (fig. 2; 2009.300.8523) in its most popular color scheme of brown, cream, and russet was selected for study. The Clover Leaf is represented not by the famous black-and-white version but by a less familiar iteration from 1953 featuring black lace (fig. 3; 2009.300.784). An investigation of the gowns' surface and interior materials, their construction, and their use and storage over the past sixty years reveals their many inherent vices.

Surface Materials: The exteriors of the Swan and Clover Leaf feature standard luxury fabrics of the period. The staple of James's eveningwear, as for that of his contemporaries, was silk: satin, chiffon, taffeta, faille, and velvet. While he used textiles of high quality, often in unusual colors or combinations, James favored plain fabrics, seldom using patterned, embellished, or highly textured fabric that would distract from his clothing's sculptural lines. He prominently featured nylon tulle, which was frequently used in the voluminous skirts and petticoats of contemporary gowns, on several designs.

The Clover Leaf features three different silk fabrics: satin, faille, and shantung. While faille and shantung are relatively robust fabrics, the long floating threads of the satin on the Clover Leaf's bodice are vulnerable to abrasion and loss, as can be seen at the edges of the bodice top, where the satin is tightly wrapped around to the interior, and in the back alongside the zipper, where the fabric

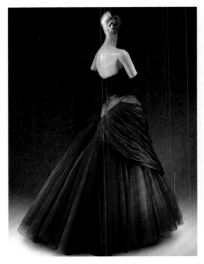

fig. 2. The Swan was one of James's most popular models and remains one of his most recognizable designs. He produced it in various lengths and color schemes over a number of years. Its combination of materials makes it prone to damage and deterioration.

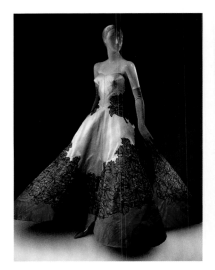

fig. 3. James considered the Clover Leaf gown the culmination of his career. The quantity and combination of materials that allow for its sculptural shape are, unfortunately, the very causes of the gown's condition problems.

fig. 4 (opposite). Over time the acidification of perspiration stained and badly damaged the Clover Leaf's bodice at the underarms. In some areas the silk satin was destroyed, revealing the muslin underlayer.

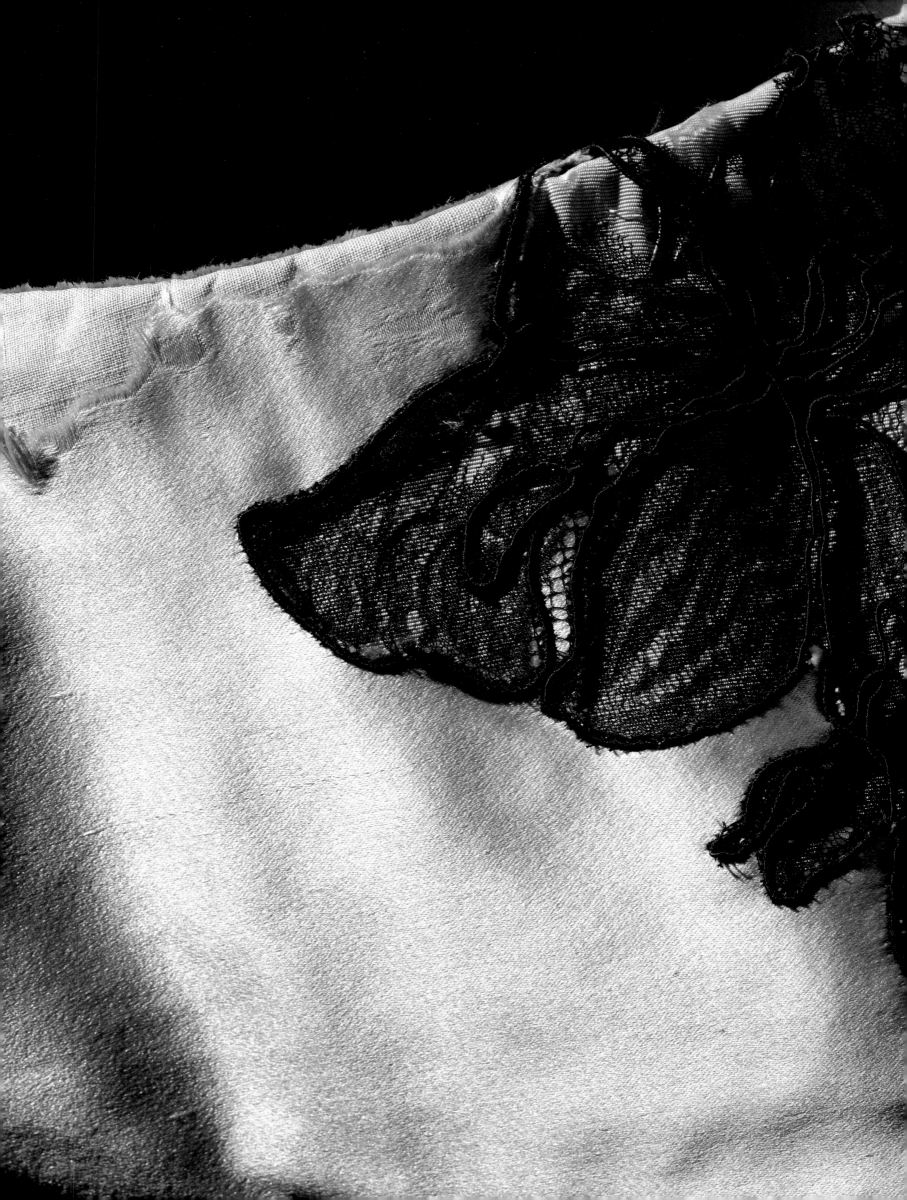

fig. 5 (opposite). The petticoat of the
Swan features James's typical mix of
nontraditional materials: fine nylon
mesh quilted to light cotton buckram
(left), two layers of heavy millinery
blocking net backed with coarse nylon
mesh (right), and millinery willow
backed with coarse nylon mesh (top).

is pulled when the zipper opens and closes. All Clover Leafs in The Costume Institute's collection exhibit loss and abrasion of the satin on the bodice, with the underarm areas especially damaged because of the acidifying effects of perspiration (fig. 4).

Treatment options include using custom-dyed fabric overlays (patches) or underlays to provide support in the weak area while minimizing the appearance of damage. Support fabrics are typically either similar in weave structure, appearance, and weight to the damaged satin or a very sheer silk fabric like crepeline, which is barely noticeable. The support fabrics are stitched to the damaged areas using fine custom-dyed silk filament thread. If the fabric is too fragile to accept a needle without further damage, an alternative to stitching would be to affix a support fabric with a reversible adhesive. The least invasive option for preserving this Clover Leaf's bodice is to apply an overlay, as accessing the back of the silk fabric for an underlay would entail undoing many seams and lines of stitching.

Understructure Materials: James's use of unconventional materials in the foundations of his architectural gowns significantly contributed to their roster of vices. In addition to standard dressmaking and tailoring stiffening materials like hair canvas, polyester horsehair braid, and heavy silk faille, James turned to millinery materials (blocking net and willow, used to create rigid, molded hat foundations) and nylon mesh (similar to window screen but primarily used in water filtration) to stiffen broad expanses and localized areas of his gowns (fig. 5).

Both the Swan and the Clover Leaf feature petticoats constructed from multiple layers of nylon mesh and millinery blocking net to provide volume. On the Swan gown James also used millinery willow, supporting the extended back flare with a shield-shaped panel composed of multiple layers of willow and plastic mesh (fig. 6). Unfortunately, willow becomes brittle with age and manipulation, readily breaking and flaking. Its decomposition is only accelerated by the skirt's extreme weight and repeated flexing, which willow—fabricated as a featherweight support for light millinery fabric—was not designed to withstand (fig. 7).

The willow is not accessible for direct treatment because it is configured in a quilted lamination. New stiffening material can be tacked over the surface of the shield to compensate for the willow's disintegration, and a layer of transparent silk crepeline can be stitched over the surface to contain the flaking fragments. The original stay tapes that flex the willow into the desired curve will need to be detached so the shield can be laid flat for treatment.

In search of materials of superior performance, James employed numerous modern synthetics, particularly in the understructures. One material that appears abundantly throughout the Clover Leaf is an early nonwoven interfacing known by the leading brand name Pellon, which was introduced to the American market in 1950. A blend of cotton, acetate, and nylon bonded with a synthetic rubber, Pellon provided stiffness, body, and shaping and was typically used for suiting. Seeing its structural potential for his gowns, James used Pellon (or a generic substitute) as piece lining in all parts of the Clover Leaf's skirt, sandwiching it directly behind the top silk layer in each tier, on top of the millinery blocking net, nylon mesh, and polyester horsehair. Over time the Pellon has hardened, yellowed, acidified, and in some Clover Leaf gowns even begun cracking and crumbling. The fabric's proximity to the silk exteriors allows its acid to transfer into the silk (which is naturally acidic), weakening it more quickly than usual, and also causes the silk to develop holes,

fig. 6. To support the Swan's extended back, James used panels of millinery willow, stiffened with steel boning and flexed into the desired curved shape with stay tapes of cotton twill ribbon. Bustle pads with stiffened net ruffles are visible above the willow panels. The taffeta inner slip, which protected the wearer's legs from the rough foundation materials, has been tucked up inside the bodice.

fig. 7 (overleaf). Repeated flexing caused considerable loss of the Swan's aged and embrittled willow beneath its facing of cotton mesh.

fig. 8 (opposite). James used Pellon interfacing to provide stiffness and support to the exterior fabric on the Clover Leaf's skirt. Originally ivory in color, the Pellon has yellowed, acidified, and become deformed over time.

slits, tears, and abrasions more easily and possibly much sooner than if Pellon had not been used (fig. 8). Since Pellon is used throughout all the skirt layers and is secured at all seams, it would be impossible to remove it without dismantling the garment and permanently altering a significant aspect of its construction and shaping. The best conservation option in this case is to use silk patches and stabilizing stitches where abrasion and loss have occurred in the silk fabric.

Surface Construction: Beyond the materials themselves, the gowns' complex construction and fabric combinations open the door to complications. In the couture tradition, James avoided obvious stitching that would distract from the surfaces' beauty and delicacy, but his inventive and elegant treatments on both the Swan and the Clover Leaf have inherent vices.

James's deft manipulation of chiffon into nested chevron-shaped tucks on the Swan's bodice is at once masterful and problematic. The tucks curve around the body and are secured by tacking stitches. Because of the fabric's transparency, very small stitches were used, catching only a few threads of the chiffon, but chiffon's delicate threads easily break, especially with age. Where stitches have broken through the fabric, the bodice exhibits dozens of small holes and the tucks have slipped out of alignment (fig. 9).

The holes in the chiffon do not seriously threaten the object's stability and are best left alone, as manipulating the fabric for their repair would risk additional damage. The positioning of the tucks in the chiffon is a serious aesthetic concern, however. The tucks can be restitched with silk filament much finer than the original thread, as the garment will no longer be subject to the stress of being worn; since the silk filament thread will be invisible, the stitching can cover a greater expanse, spreading out the stress of the stitches and minimizing the chance that they will break through the chiffon.

fig. 9. Originally tacked in precise V-shaped tucks, the chiffon on the front of the Swan has broken away from the stitching, resulting in a jumble of crumpled folds.

Another concern is that the chiffon is drawn tightly over the edges of the bodice and held taut across the surface. The tension on the delicate fabric weakens it, particularly along the edges, which additionally are vulnerable to abrasion, chemical deterioration from body oils and cosmetics, and long-term damage from dirt and light exposure, resulting in numerous holes and losses to the chiffon along the back neckline. This type of damage is difficult to correct in an aesthetically satisfactory way, owing to chiffon's sheerness. However, new silk chiffon can be dyed to match the original and used to fill in the holes like puzzle pieces, with fine silk filament thread stitching into the satin backing along the junction of the new and old fabrics.

Tautness has similarly caused the unpleated back panel of many Swans, including this one, to suffer extreme weakness and subsequent tearing. The tension in the Swan's design is exacerbated by the weight of the back skirt, stress from operation of the zipper, and failure of internal stitching to the foundation. Neither patching nor stitched mending of the torn areas is recommended, as stitching will likely cause additional tearing of the weak fabric; in addition, chiffon patches are difficult to make invisible. The proposed treatment is to overlay the back section of the bodice with an opaque panel of matching new satin and chiffon, completely camouflaging the damaged area. Edges of the overlay can be hidden beneath the pleats in the chiffon, and the panel can be stitched around its edges through to the satin, which is still in strong condition. This overlay will also support and protect the underlying original fabric (fig. 10).

Intricacy of construction likewise afflicts the surface of the Clover Leaf gown. In typical Jamesian style, the lace that extends up the skirt, around the waist, and on to the back of the bodice is not simply grafted onto the ivory silk satin exterior of the bodice and upper skirt; instead, the satin ground has been cut away underneath the lace, with ivory silk faille filling the void. The silk faille is strategically placed beneath the silk satin, barely touching the satin's roughly cut edges and not touching the lace at all. This subtle layering provides a sense of depth and movement that would not have been possible had the floating lace been applied directly over the satin and tacked down throughout. It introduces weaknesses, however: So much satin has been cut away that it cannot provide structural support; the lace is unsupported except at the edges and thus floats free throughout its expanse; and the faille, which is attached only at sporadic spots at the edge of the satin, is unable to support either the lace or the satin. As a result, the lace and satin have torn in areas where flexing and rubbing have occurred, and the faille has partially detached (fig. 11). Unless the lace is removed, options for treating it are limited to localized stitched stabilization, with underlays of similar lace to compensate for any losses.

In the Swan vice arises from the quantity of fabric James employed in the voluminous skirt flounce, which is composed of six layers of nylon tulle in fourteen half-circle segments of graduated length—approximately 1,080 square feet of tulle in total. Small crescents cut out at the center of each semicircle's straight edge form the top edge of the flounce. In the longest sections of the flounce, 5 inches of fabric stitched at the top edge support 150 inches along the hemline—a great stress and weight that make the tulle along the top vulnerable to tearing. Tulle typically remains reasonably strong and can be successfully mended, but its sheerness and regular mesh pattern require the repair to be done with meticulous alignment, extremely fine sewing thread, and the careful interworking of stitches into the mesh to make the work unnoticeable (fig. 12).

The weight of the tulle has also resulted in extensive creasing, especially of the two inner layers of magenta and chartreuse, which have been compressed under four outer layers (two of them russet, one tan, and one peach). Nylon tulle usually responds very well to steaming; with careful treatment of each layer, the Swan's skirt can be restored almost to its original voluminous appearance.

Interior Construction: James's most complicated constructions are the supportive structures beneath his gowns' relatively plain surfaces. His structured gowns like the Swan and Clover Leaf required, in addition to the traditional boned foundation bodice of heavy satin and a taffeta half-slip, multiple layers of intermediary interfacing and elaborately constructed petticoats. To provide a smooth transition between the rigid boned foundation and the surface fabric, James interlined the bodices with layers of flannel and muslin. Upper edges of the foundations were interfaced with hair cloth or heavy silk faille for added rigidity. Although the Swan and the Clover Leaf have streamlined surfaces, other James gowns with draped or puffed surface fabrics were frequently interfaced with taffeta, silk organza, or cotton organdy to increase their body. Poufs and other heavy sculptural elements were interlined with Pellon or nylon mesh.

To create the smooth surface of the Clover Leaf's skirt, James backed the exterior fabric with one layer of nonwoven interfacing, one to two layers of millinery blocking net, one layer of

fig. 10. The chiffon on the back of the Swan was originally stretched taut, stressing and eventually tearing the delicate fabric, which now hangs somewhat loosely.

fig. 11. The haute couture method of painstakingly cutting away the silk satin beneath the Clover Leaf's lace overlay, without attaching the overlay to a firm foundation, ultimately caused the unsupported lace to tear.

fig. 12 (opposite). The Swan's tulle flounce is stitched on beneath a draped apron of chiffon, which is bunched up to form a bustle. The weight of the great quantity of tulle used caused pieces to tear away at the top.

fig. 13 (opposite). The interior of the
Clover Leaf's flared petticoat reveals
a laminated shell constructed of hoop
wire, strategically placed polyester
horsehair, nylon mesh, millinery
blocking net, nonwoven interfacing,
and facing fabrics of silk taffeta and
shantung.

nylon mesh, and strategically placed lengths of six-inch-wide polyester horsehair braid stitched on to the nylon mesh, seaming together and sometimes machine quilting all the layers. Each layer of fabric was buried under the others, becoming inaccessible. While contemporary designers interfaced their fabrics and added localized supporting materials such as boning and horsehair braid, James is unique in his exhaustive layering of fabric into stiffened, laminated shells. In doing so, he essentially created hybrid materials that offered qualities no single fabric possessed.

The unsympathetic mix of materials making up each laminated layer of the understructure leads to abrasion and loss of the exterior understructure fabrics, as can be seen in the Clover Leaf, which has a laminated four-lobed petticoat attached at hip level on top of another laminated domed petticoat. With slight variations, each of the Clover Leaf skirt's understructure laminations is composed of five to seven layers of materials, including naturally weaker silk fabrics and harder structural materials: one layer of exterior silk fabric and, successively beneath it, one layer of nonwoven interfacing, one to two layers of millinery blocking net, and/or one layer of nylon mesh, and/or one layer of polyester horsehair and/or hoop wire (fig. 13). The differences in each fabric's movement and how it changes dimensionally with age have stressed the silks on the exteriors of each layer, causing tears, holes, and abrasions. Additionally, the rigid structural materials' stiff, sharp edges have lacerated and abraded the silk after constant contact. Conservation treatments would typically employ stitching a similar fabric as an overlay that could both support and camouflage the damaged areas of silk (fig. 14).

fig. 14. The Clover Leaf's Pellon under-layer is revealed in areas of the petticoat where the fragile silk layered above it has been abraded away. Also note the sharp deformation of the hoop wire caused by improper storage.

Wearing: The formidable act of wearing James's ball gowns stimulated the vices inherent in their size, weight, and cumbersome layers of fabrics and boning. Their extreme architecture imposed upon the wearer a body shape and spatial projection beyond her peripheral perception. In a James ball gown, a woman had to be cognizant of her every movement, both to protect the dress from harm and to navigate within her immediate environment. A semirigid dress like the Clover Leaf took up an enormous amount of space, exceeding six feet in width; for the wearer, moving from her dressing room, in and out of an automobile, through a doorway, into an elevator, up and down stairs, and throughout a party venue—standing, sitting, dancing, and eating—had to be a tightly orchestrated and considered performance. The gown was likely damaged every time it was worn.

The physical expansiveness of James's gowns also made them vulnerable to tears and soiling at the hems because of their lengths and multiple layers; inevitably, some part would be rubbed, dragged, stepped on, or crushed. The numerous tears and small losses in the tulle around the hemline of the Swan testify to the challenges the dress posed to the wearer. Tulle's rough texture and open mesh structure only increased the likelihood that it would catch on things and tear under stress (fig. 15).

Should a James gown become soiled or stained, cleaning was no simple matter. Like most haute couture, James ball gowns were never meant to have immersive cleaning. Their physical volume and rigidity made placing them into typical cleaning machines impossible, but the real problem was their layering of numerous materials, many hidden from view and unidentifiable without taking apart the dress. Hard synthetics are sandwiched together with coarse and diaphanous natural fabrics—each with differing laundering requirements. Cleaning could prove

disastrous, as materials could shrink, swell, or bleed if the appropriate method were not chosen for every material in a lamination. Yet not cleaning a James gown would also contribute to its decay, as body oils, dirt, sweat, food stains, makeup, and other contaminants weaken fibers over time. For conservation purposes, surface cleaning using a low-suction vacuum and minimal stain removal are often the only ethical options, as any other type of cleaning would require the gown to be taken apart layer by layer.

Storage: Each of James's gowns was designed for a particular client, and its specific sizing and complex construction precluded simple alteration to allow the dress to be worn by someone else. That and the fact that the gowns were intended for the most special occasions meant that they were rarely worn and have spent the majority of their lives in storage—and in storage inherent vice reappears. A James gown is heavy, weighing as much as ten pounds. Much of the weight is in the skirt; if the gown is stored hanging, without adequate support, the shoulder areas and waist seams endure great strain as gravity pulls the skirt ever downward. Many of James's gowns today have distressed or detached waist seams and torn shoulder areas after decades of improper hanging before entering the Museum's collection. Gravity could also cause a heavy skirt to compress, as the vast expanses of structural materials collapse under their own weight over time. In addition, the gowns' large footprint made providing adequate storage space a challenge. As a result, the gowns might rub against other garments, abrading and snagging their surfaces, or be compressed, eventually deforming their sculptural quality permanently. Storing the garments flat is also problematic, as their weight would crush the side at the bottom.

The Clover Leaf's sheer size precluded proper storage for most of its pre-Museum life. In addition, its surprising flexibility—despite the skirt's many layers of stiff, structural materials—likely contributed to the misperception that it could be stored with the skirt compressed, either hung in a space smaller than its actual footprint or laid flat. Over time the resulting compression permanently deforms structural materials like Pellon, polyester horsehair, and nylon mesh. Even more important, the metal hoop wires in the skirt (typically eleven but as many as eighteen hoops in some versions of the Clover Leaf) become deformed, altering James's intended shape. Deformed hoops sometimes break through or stress the various lining fabrics, causing tears and holes (fig. 16).

The best way to store these sculptural gowns is to create a custom torso from archival materials. Such an internal support, which must be fit exactly to the dress's shape and inner dimensions, extends from shoulder to thigh, so that the weight evenly spreads instead of concentrating on areas like the waist. The torso can be mounted on a stand like a dress form or suspended from embedded loops in a space large enough to accommodate the gown's footprint.

The vices inherent in Charles James's ball gowns, and the lives the gowns led before entering the Museum's collection, have left their marks over the last fifty years—scars that can never be fully erased. But by comprehensively studying James's construction techniques and analyzing his materials, conservators have been able to craft a program for preservation, display, and appropriate storage that will mitigate further damage, ensuring that the timeless beauty of James's fragile masterworks will endure for generations.

fig. 15. The ragged hemline in the Swan's tulle flounces, mended at some point with mismatched thread, attests to the challenges of maneuvering when wearing this voluminous, vulnerable gown.

fig. 16 (opposite). Deformations to the Clover Leaf's hoop wire have caused it to break through the bodice's lining fabric.

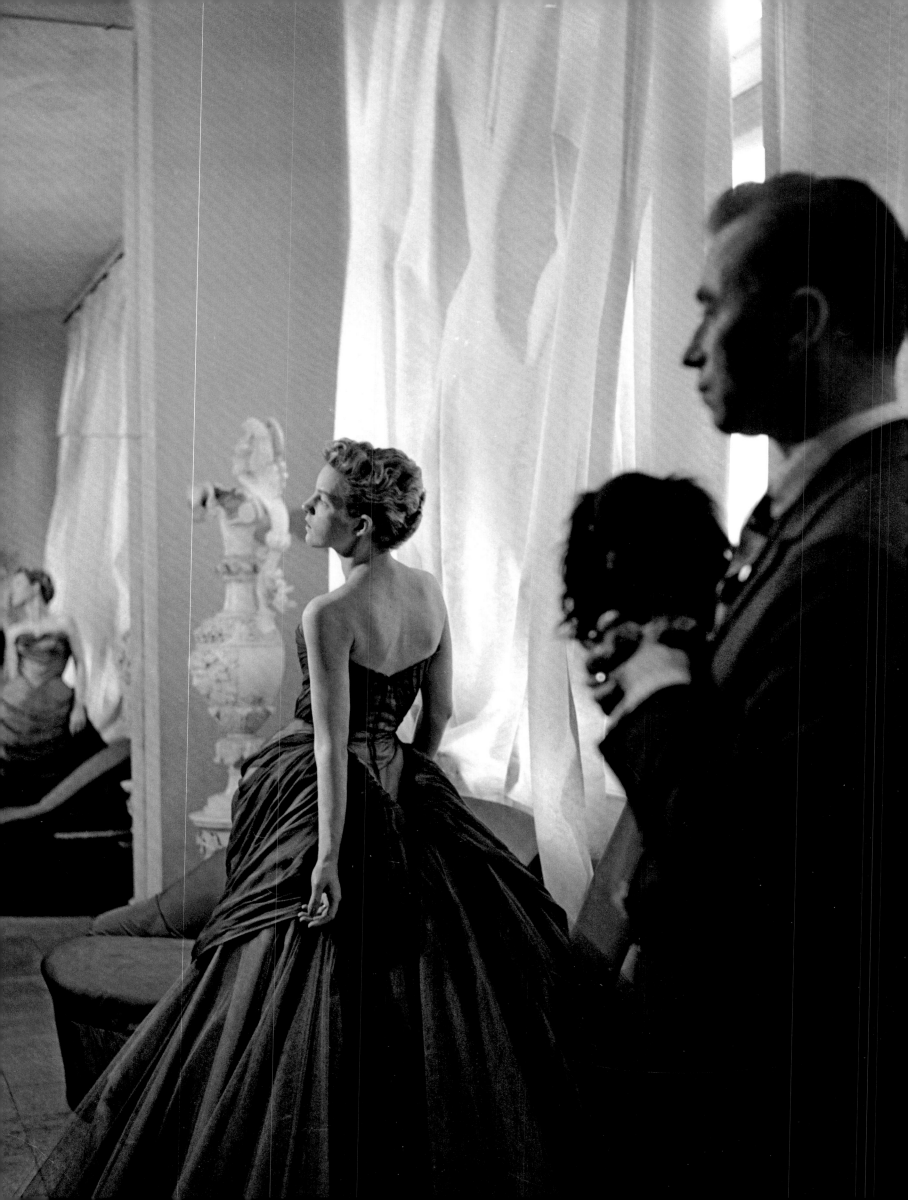

NOTES

An Appreciation of Charles James

p. 8 Cristóbal Balenciaga quoted in telegram from Thomas Gosselin to Charles James, June 6, 1973. Gift of the Brooklyn Museum, Charles James Collection, The Irene Lewisohn Costume Reference Library, The Costume Institute, The Metropolitan Museum of Art, New York.

Christian Dior quoted in Bill Cunningham, "Charles James," *The Soho Weekly News*, September 28, 1978, p. 34.

James Galanos to Charles James, quoted in Elizabeth Ann Coleman et al., *The Genius of Charles James*, exh. cat., Brooklyn Museum; Chicago Historical Society (Brooklyn: Brooklyn Museum; New York: Holt, Rinehart and Winston, 1982), p. 9.

Introduction

1. Elizabeth Ann Coleman to Harold Koda, in conversation, October 16, 1982.

Metamorphology: The Personal and Professional Life of Charles James

1. Marit Guinness Aschan quoted in Elizabeth Ann Coleman et al., *The Genius of Charles James*, exh. cat., Brooklyn Museum; Chicago Historical Society (Brooklyn: Brooklyn Museum; New York: Holt, Rinehart and Winston, 1982), p. 9.
2. Review of *A Midsummer-Night's Dream*, *The Harrovian* 34, no. 3 (May 28, 1921), p. 32.
3. Charles James to Jerry Tallmer Esq., June 2, 1978. Gift of Homer Layne, Charles James Collection, The Irene Lewisohn Costume Reference Library, The Costume Institute, The Metropolitan Museum of Art, New York (hereafter Layne gift, James Collection).
4. Charles James to George Robinette, February 28, 1965. Layne gift, James Collection.
5. James to Tallmer, June 2, 1978.
6. B. J. Perkins, "Charles James, a Former Architect, Uses Structural Idea in Designing," *Women's Wear Daily* (hereafter *WWD*), February 21, 1933, p. 17.
7. The Fashion Co-Ordinator, "The Line's the Thing in Clothes by James," *Philadelphia Inquirer*, June 3, 1934.
8. Charles James, manuscript for autobiography "Beyond Fashion," ca. 1958, typescript, first section, p. 7. Layne gift, James Collection.
9. James to Tallmer, June 2, 1978.
10. Charles James, "CHARLES JAMES, COUTURIER POET AND ARTIST . . . RUINED BY OPPOSITION OF ORGANIZED SCHOOLS . . . ," typescript, 1978. Layne gift, James Collection.
11. Hugo Vickers, *Cecil Beaton: A Biography* (Boston and Toronto: Little, Brown and Company, 1985), p. 116.
12. Perkins, "Charles James, a Former Architect," p. 17.
13. Diana Vreeland quoted in Coleman et al., *Genius of Charles James*, p. 8.
14. Stephen Tennant quoted in Philip Hoare, *Serious Pleasures: The Life of Stephen Tennant* (London: Hamish Hamilton, 1990), p. 148.
15. Best & Co. advertisement, *The New York Times*, February 16, 1930, p. 7.
16. Princess Dilkusha de Rohan, "Panorama: Dilkusha by Dilkusha," manuscript autobiography, 1943–53. National Art Library, Victoria and Albert Museum, London. I would like to thank Clive Warwick for bringing this reference to my attention.
17. Perkins, "Charles James, a Former Architect," p. 17.
18. Virginia Woolf to Vita Sackville-West, February 14, [1933], in *The Letters of Virginia Woolf*, vol. 5, *1932–1935*, edited by Nigel Nicolson and Joanne Trautmann (New York and London: Harcourt Brace Jovanovich, 1979), p. 158.
19. Perkins, "Charles James, a Former Architect," p. 17.
20. Gertrude Lawrence quoted in "Charles James: The Majority of One," *American Fabrics and Fashions*, no. 98 (Fall 1973), p. 19.
21. "Charles James, London Designer, Presents Models to Trade and English Notables," *WWD*, April 12, 1933, p. 4.
22. "European Reminiscences," interview between Charles James and Princess Helene Obolensky, 1966, in "Sound of Shape and Design: An Educational Project Conceived by Charles James," audiotape collection. Layne gift, James Collection.
23. Charles James et al., "Portrait of a Genius by a Genius: Charles James as Seen by Himself and All His Friends," *Nova* (July 1974), p. 45.
24. "Lady Leucha Warner," anonymous letter in obituaries, *The Times* (London), August 27, 1947, p. 6.
25. Hermione Lee, *Virginia Woolf* (New York: Alfred A. Knopf, 1996), quoted in John Simkin, "Mary Hutchinson," in *Spartacus Educational*; www.spartacus.schoolnet.co.uk/ARThutchinson.htm (accessed August 22, 2013).
26. Interview between Helene Obolensky, Robert Fraser, Adrian Daintrey, and Mary St. John Hutchinson, ca. 1966, in "Sound of Shape and Design" audiotape collection. Layne gift, James Collection.
27. Engagement announcement, *The Tatler*, September 11, 1935. Countess of Rosse scrapbooks, Birr Castle Archives, County Offaly, Ireland.
28. Interview between Anne, Countess of Rosse, and Helene Obolensky, ca. 1966, in "Sound of Shape and Design" audiotape collection. Layne gift, James Collection.
29. "A Memoir of Charles James' Years in London by Mary St. John Hutchinson: London 1932 to 1938," typescript memoir. Layne gift, James Collection. Variant recorded as "A Tribute to Charles James," read by Mrs. Hutchinson, in "Sound of Shape and Design" audiotape collection. Layne gift, James Collection.
30. Ibid.
31. Eleanor Lambert quoted in Coleman et al., *Genius of Charles James*, p. 8.
32. "Daring Surplice Used on Pastel Jersey Gown: British Designer for Lady Asquith Startles New Yorkers," *The Washington Post*, December 9, 1933, p. 13.
33. "Life's Problems Solved," caption for illustration, *Harper's Bazaar*, no. 2655 (January 1934), p. 48.
34. The Chaperon, "Charlie James Atwit over Feud with Mrs. Letts as Fashion Show Nears," *Chicago American*, January 8, 1934, p. 7.
35. "Sensational Frocks," *Manchester* [England] *Evening Chronicle*, December 10, 1935. C. B. Cochran archive—scrapbook, THM/97, Box 95, Theatre and Performance Department, Victoria and Albert Museum, London.
36. Ibid.
37. Undated letter [Reeder and Drumright 2010 transcription #0007] from archive of letters written by Charles James from Paris to his London assistant Philippa Barnes between April and August 1939. Victoria and Albert Museum, London (hereafter Philippa Barnes letter archive).
38. Charles James, undated letter to *Vogue* editor in chief Jessica Daves, typescript, ca. 1959. Gift of the Brooklyn Museum, Charles James Collection, The Irene Lewisohn Costume Reference Library, The Costume Institute, The Metropolitan Museum of Art, New York (hereafter Brooklyn Museum gift, James Collection).
39. Charles James to Mrs. Jean Eddy at Bonwit Teller, February 1973. Layne gift, James Collection.
40. Charles James, "Chicago papers were all full of Paul Poiret's imminent visit . . . ," typescript. Layne gift, James Collection.
41. Ibid.
42. Charles James to Philippa Barnes, April 18, 1939 [transcription #0104–6]. Philippa Barnes letter archive.
43. Anne, Countess of Rosse, quoted in Coleman et al., *Genius of Charles James*, p. 112.
44. Charles James notes on designs drawn by Antonio Lopez prior to Electric Circus show, ca. 1969. Charles James donor files, Victoria and Albert Museum, London.
45. Ibid.
46. Ibid.
47. Charles James to Philippa Barnes, undated letter, 1939 [transcription #0019]. Philippa Barnes letter archive.
48. Virginia Pope, "Created by Distinguished Designers," *The New York Times*, November 10, 1940, p. D8 [68]; Virginia Pope, "Formal Fashions by New York Couturiers," *The New York Times*, November 9, 1941, p. D3 [59].
49. Virginia Pope, "New Pajama-Skirt Is Exhibited Here," *The New York Times*, January 3, 1941, p. 12.
50. Charles James, "The Romantic Life and Tragic Death of Millicent Rogers," *The American Weekly*, March 22, 1953, p. 12.
51. "Charles James Re-Creates Dress Silhouettes Keyed to 'A New Posture,'" *WWD*, May 5, 1944, p. 3.
52. March of Dimes fashion show cue sheet notes. March of Dimes Archives, Fundraising Collection, Series 3: Fashion Show, 1945–1970; Program and Radio Broadcast, 1945. March of Dimes, White Plains, N.Y.

53. "Cholly Knickerbocker Says: Society Sees N. Y. Dress Institute's Scintillating Fashion Show for Polio Benefit—Tots in Braces Lend Poignancy," *The New York Journal-American*, date unknown, clipping. March of Dimes Archives, Fundraising Collection, Series 3: Fashion Show, 1945–1970; Publicity, 1945.

54. Charles James quoted in R. Couri Hay, "Charles James," *Andy Warhol's Interview*, November 1972, p. 30; reproduced in *Andy Warhol's Interview*, vol. 1, bk. 5, *The Fashion*, edited by Sandra J. Brant and Ingrid Sischy (Paris: Edition 7L, 2004), p. 24.

55. Charles James quoted in Lois Long, "Prophet . . . with Honor," *Town and Country* 103, no. 4325 (October 1949), p. 106.

56. Francis [Cyril] Rose, *Saying Life: The Memoirs of Sir Francis Rose* (London: Cassell and Company, 1961), p. 338.

57. Charles James quoted in Eileen Callahan, "Nothing New in New Look, Says Designer, Proving It," *Sunday News* [*Daily News*] (New York), April 4, 1948.

58. Amy Porter, "Young Man of Fashion," *Collier's* 120 (September 20, 1947), pp. 100, 101, 104.

59. Long, "Prophet . . . with Honor," p. 106.

60. James, "Beyond Fashion," typescript, "TEXTILE SUBSIDY" section, p. 7.

61. "Hat News: Size, Small; Outlines, Various," *Vogue* 112 (August 15, 1948), p. 159.

62. Elizabeth Ann Coleman, "Abstracting the 'Abstract' Gown," *Dress: The Journal of the Costume Society of America* 8, no. 1 (January 1982), pp. 27–31.

63. Charles James to Aimee and Roddy de Heeren, June 15, 1965. Layne gift, James Collection.

64. "Cap-a-pie," *Harper's Bazaar*, no. 2835 (March 1948), p. 178.

65. Bill Cunningham, "Charles James: The Man," in Coleman et al., *Genius of Charles James*, pp. 107–8.

66. Eugenia Sheppard, "Charles James Advocates New Lines in Styles," *New York Herald Tribune*, January 2, 1950, p. 17.

67. Ibid.

68. Virginia Pope, "Fashion Designer Marks 25th Year," *The New York Times*, January 4, 1955, p. 22.

69. Ibid.

70. "The Charles James Cut: Dinner, Theatre Dress," *Vogue* 116 (November 15, 1950), p. 79.

71. Coleman et al., *Genius of Charles James*, p. 68.

72. Charles James quoted in "Charles James . . . Designs Sofas and Redesigns Women," *Look* 16, no. 20 (September 23, 1952), p. 93.

73. Charles James quoted in Harriet Morrison, "Radical New Sofa Shaped to Conform to Body's Lines," *New York Herald Tribune*, September 13, 1954, p. 12.

74. Glenn Fowler, "Ohrbach's Will Launch James Fashions Nov. 1," *WWD*, September 13, 1950, p. 8.

75. Coleman et al., *Genius of Charles James*, p. 93.

76. "An Unknown Wins a 'Winnie': Fashion Critics Pick Charles James Who Has Small Public, Big Influence," *Life* 29, no. 17 (October 23, 1950), pp. 129–30, 132.

77. "The Full Skirt Is the New Skirt," *Vogue* 118 (July 1, 1951), p. 31.

78. "Judge Calls for Action To Curb Style Piracy," *New York Herald Tribune*, November 21, 1956, section 2, p. 1.

79. Charles James, undated letter to Marylin [*sic*]

80. Charles James quoted in "Charles James . . . Designs Sofas and Redesigns Women," p. 93.

81. Bill Cunningham, "Charles James," *The Soho Weekly News*, September 28, 1978, p. 34.

82. Charles James, "The Shape," *Fashion: American Styles for American Living* 1 (Fall–Winter 1956), pp. 27, 86.

83. "1953 Neiman-Marcus Award Winners," *WWD*, August 10, 1953, p. 4.

84. Charles James quoted in Hay, "Charles James," p. 30; reproduced in *Andy Warhol's Interview*, vol. 1, bk. 5, p. 24.

85. Charles James quoted in Laura Jacobs, "Gowned for Glory," *Vanity Fair*, no. 459 (November 1998), p. 124.

86. Charles James, undated letter to Thomas Colt Esq. Layne gift, James Collection.

87. Eugenia Sheppard, "American Designers Win Fashion Awards: Galanos Gets 'Winnie' for His Fashions," *New York Herald Tribune*, October 12, 1954, p. 16.

88. Lord & Taylor advertisement, *Vogue* 124 (October 1, 1954), p. 15.

89. Dorothy Hawkins, "Californian Gets a Fashion Trophy," *The New York Times*, October 12, 1954, p. 31.

90. Charles James quoted in "People," *Time* 65, no. 7 (February 14, 1955), p. 36.

91. Charles James to Madeleine Ginsb[u]rg, July 24, 1971. Charles James donor files, Victoria and Albert Museum, London.

92. Coleman et al., *Genius of Charles James*, p. 94.

93. Eugenia Sheppard, "Inside Fashion," *New York Herald Tribune*, July 9, 1957, p. 14.

94. "Life's Problems Solved," p. 48.

95. Phyllis Lee Levin, "Paris Sets Pace, but Creative Fashion Talent, Critics Agree, Exists in U.S.," *The New York Times*, May 20, 1958, p. 37.

96. Coleman et al., *Genius of Charles James*, p. 98.

97. M[ary] E[llen] Hecht, "The Cutting Edge," *Vogue* 201 (April 2011), p. 146.

98. "'The Calculus of Fashion' To Be Taught," *New York Herald Tribune*, October 17, 1960, p. 16.

99. "Charles James Launches College Fashion Seminars," *WWD*, October 17, 1960, p. 4.

100. Cunningham, "Charles James: The Man," p. 108.

101. Florence Turner, *At the Chelsea* (San Diego, New York, and London: Harcourt Brace Jovanovich, [1986]), p. 90.

102. Cunningham, "Charles James," pp. 33–34.

103. James to Robinette, February 28, 1965.

104. Charles James quoted in Coleman et al., *Genius of Charles James*, p. 84.

105. Charles James, "Working Title of a Program Being Worked Out with the Institute of Sound," early proposal for "Sound of Shape and Design." Brooklyn Museum gift, James Collection.

106. Bernadine Morris, "At Halston, New Fashion Team," *The New York Times*, June 16, 1970, p. 56.

107. Ibid.

108. Cunningham, "Charles James: The Man," p. 110.

109. Cecil Beaton quoted in Vickers, *Cecil Beaton*, p. 567.

110. Cecil Beaton, manuscript diary, August 1973, quoted in Vickers, *Cecil Beaton*, p. 568.

111. James, "Portrait of a Genius by a Genius," p. 46.

112. Charles James, application for Guggenheim Fellowship. Layne gift, James Collection.

113. "Robert Motherwell Talks about Fashion as Fantasy with Roberto Polo," *Andy Warhol's Interview* 6, no. 1 (December 1975), p. 19.

114. Charles James quoted in Gay Bryant, "Charles James, 1906–1978," *Harper's and Queen* (September 1979), p. 198.

115. Cunningham, "Charles James," p. 31.

116. Austine Hearst, "Charles James: The Couturier, II," in Coleman et al., *Genius of Charles James*, pp. 112–13.

117. Charles James, "WITH GREAT PRIDE I CAN SAY POIRET WAS MY FRIEND . . . ," typescript sent to Stella Blum, November 12, 1973. Charles James correspondence, Costume Institute Records, The Metropolitan Museum of Art Archives, New York.

The Calculus of Fashion

1. Charles James quoted in "'The Calculus of Fashion' To Be Taught," *New York Herald Tribune*, October 17, 1960, p. 16.

2. Ibid.

3. Charles James quoted in Eugenia Sheppard, "Charles James Advocates New Lines in Styles," *New York Herald Tribune*, January 2, 1950, p. 17.

4. Ibid.

5. Bill Cunningham, "Charles James," *The Soho Weekly News*, September 28, 1978, p. 34.

The Calculus of Fashion: Anatomical Cut & Platonic Form

1. Charles James, "THE SHAPE OF FASHION . . . ," typescript, n.d. Gift of Homer Layne, Charles James Collection, The Irene Lewisohn Costume Reference Library, The Costume Institute, The Metropolitan Museum of Art, New York.

2. "Daring Surplice Used on Pastel Jersey Gown: British Designer for Lady Asquith Startles New Yorkers," *The Washington Post*, December 9, 1933, p. 13.

The Calculus of Fashion: Quotations

All quotations are from Charles James.

p. 65 B. J. Perkins, "Charles James, a Former Architect, Uses Structural Idea in Designing," *Women's Wear Daily*, February 21, 1933, p. 17.

p. 68 Charles James to Diana Vreeland, October 4, 1973. Charles James correspondence, Costume Institute Records, The Metropolitan Museum of Art Archives, New York.

p. 73 Jeffrey Barr, "Charles James, Master of Couture," *Fashion World Daily* 1, no. 1 (August 1978), p. A1.

p. 76 B. J. Perkins, "Charles James, a Former Architect," p. 17.

p. 83 "The World of Fashion," *Coronet* 25, no. 2 [no. 146] (December 1948), p. 79.

p. 107 "Charles James: The Majority of One," *American Fabrics and Fashions*, no. 98 (Fall 1973), p. 19.

p. 116 Ibid.

p. 122 Charles James, drawing annotation reproduced in *Harper's Bazaar* (U.K.) (March 1938), p. 50, and in Elizabeth Ann Coleman et al., *The Genius of Charles*

James, exh. cat., Brooklyn Museum; Chicago
Historical Society (Brooklyn: Brooklyn Museum;
New York: Holt, Rinehart and Winston, 1982), p. 81.

p. 156 Charles James, "WITH GREAT PRIDE I CAN SAY POIRET
WAS MY FRIEND . . . ," typescript sent to Stella Blum,
November 12, 1973. Charles James correspondence,
Costume Institute Records.

p. 160 Charles James to Eugenia Sheppard, December
19, 1963. Gift of Homer Layne, Charles James
Collection, The Irene Lewisohn Costume Reference
Library, The Costume Institute, The Metropolitan
Museum of Art, New York (hereafter Layne gift,
James Collection).

p. 163 Charles James to Richard Oldenburg Esq., Director
of the Museum of Modern Art, September 24, 1973.
Layne gift, James Collection.

p. 164 Coleman et al., *Genius of Charles James,* p. 84.

p. 196 Charles James, "AT RANDOM NOTES FOR SIGMUND
ROTHSCHILD . . . Working #7 1937 . . . BLACK VELVET,"
typescript. Layne gift, James Collection.

p. 206 Charles James, "An important design shown for the
first time at the opening of the El[i]zabeth Arden
Fashion [f]loor [1944]," partial typescript. Layne gift,
James Collection.

p. 213 Charles James, "POIRET. The point lost in most
reminiscence . . . ," typescript. Layne gift, James
Collection.

SELECTED BIBLIOGRAPHY

Als, Hilton. "The Insider's Outsider." *The New Yorker* 74, no. 28 (September 21, 1998), pp. 96–105.

Alston, Gary. "Charles James: 'A Personal Memoir with Nancy James' as Told to Gary Alston." *House of Retro*, January 25, 2013; http://houseofretro.com/index.php/2013/01/25/charles-james-a-personal-memoir-with-nancy-james-as-told-to-gary-alston/.

Ballard, Bettina. *In My Fashion.* New York: David McKay Company, 1960.

Barnes, Philippa. Archives. Victoria and Albert Museum, London.

Beaton, Cecil. *The Book of Beauty.* [London]: Duckworth, 1930.

Beaton, Cecil. Donor files. Victoria and Albert Museum, London.

Beaton, Cecil. Papers. St. John's College Library, Cambridge.

Beaton, Cecil, and Madeleine Ginsburg. *Fashion: An Anthology by Cecil Beaton.* Exh. cat., Victoria and Albert Museum, London. London, 1971.

Bryant, Gay. "Charles James, 1906–1978." *Harper's and Queen* (September 1979), pp. 198–203, 290–91.

Burns, Cherie. *Searching for Beauty: The Life of Millicent Rogers.* New York: St. Martin's Press, 2011.

Coleman, Elizabeth Ann. "Abstracting the 'Abstract' Gown." *Dress: The Journal of the Costume Society of America* 8, no. 1 (January 1982), pp. 27–31.

Coleman, Elizabeth Ann, et al. *The Genius of Charles James.* Exh. cat., Brooklyn Museum; Chicago Historical Society. Brooklyn: Brooklyn Museum; New York: Holt, Rinehart and Winston, 1982.

Cunningham, Bill. "Charles James." *The Soho Weekly News,* September 28, 1978, pp. 31–34.

Danville, Bea. *Dress Well on $1 a Day.* New York: Wilfred Funk, [1956].

De la Haye, Amy, Lou Taylor, and Eleanor Thompson. *A Family of Fashion: The Messels, Six Generations of Dress.* London: Philip Wilson Publishers, 2005.

Drury, John. *Old Chicago Houses.* Chicago and London: The University of Chicago Press, 1941.

Duka, John. "The Ghost of Seventh Avenue." *New York Magazine* 11, no. 42 (October 16, 1978), pp. 81–84, 88, 91.

Frankel, Noralee. *Stripping Gypsy: The Life of Gypsy Rose Lee.* New York: Oxford University Press, 2009.

Gross, Elaine, and Fred Rottman. *Halston: An American Original.* New York: Harper Collins Publishers, 1999.

Hay, R. Couri. "Charles James," *Andy Warhol's Interview,* November 1972, pp. 30–33. Reproduced in *Andy Warhol's Interview,* vol. 1, bk. 5, *The Fashion,* edited by Sandra J. Brant and Ingrid Sischy, pp. 24–27. Paris: Edition 7L, 2004.

Hecht, M[ary] E[llen]. "The Cutting Edge." *Vogue* 201 (April 2011), pp. 140–46.

Hoare, Philip. *Serious Pleasures: The Life of Stephen Tennant.* London : Hamish Hamilton, 1990.

Hughes, Graham. *Marit Guinness Aschan: Enamellist of Our Time.* London: Starcity, 1995.

Hyde, Nina S. "Madcap Genius of Fashion; Charles James— The Designer's Designer." *The Washington Post,* October 8, 1978, pp. L1, L4–L5.

Jacobs, Laura. "Gowned for Glory." *Vanity Fair,* no. 459 (November 1998), pp. 114–16, 121–29.

James, Charles. "Charles James at Large." *Metropolis Magazine* (1975), pp. 4–5.

James, Charles, Collection. The Irene Lewisohn Costume Reference Library. The Costume Institute. The Metropolitan Museum of Art, New York.

James, Charles. Correspondence. Costume Institute Records, The Metropolitan Museum of Art Archives, New York.

James, Charles. Donor files. Victoria and Albert Museum, London.

James, Charles, et al. "Portrait of a Genius by a Genius: Charles James as Seen by Himself and All His Friends." *Nova* (July 1974), pp. 44–51.

James, Nancy. Archives. Victoria and Albert Museum, London.

"Lady Leucha Warner." *The Times* (London), August 27, 1947, p. 6.

"The Lake Placid School: Autumn and Spring Terms [1919–20]." Essex County, N.Y.: [The Lake Placid School, 1919].

Lewis, Alfred Allan, and Constance Woodworth. *Miss Elizabeth Arden: An Unretouched Portrait.* New York: Coward, McCann and Geoghegan, 1972.

Long, Lois. "Prophet . . . with Honor." *Town and Country* 103, no. 4325 (October 1949), pp. 70–74, 106, 108, 111.

Long, Timothy A. *Charles James: Genius Deconstructed.* Exh. cat., Chicago History Museum. Chicago: Chicago Historical Society, 2011.

March of Dimes Archives, Fundraising Collection, Series 3: Fashion Show, 1945–1970. March of Dimes, White Plains, N. Y.

Martin, Richard. *Charles James.* Universe of Fashion. New York: Universe Publishing; Vendome Press, 1999.

McKenna, Joe. "I [heart] CJ: An Interview Appreciation of Charles James, American Couturier, 1906–78." *Interview* 22, no. 7 (July 1992), pp. 88–97.

Middleton, William. "'There is a fantasy that propels his mind forward': How the American Couturier Charles James Left His Sumptuous Mark on the de Menils." *System,* no. 2 (Autumn–Winter 2013), pp. 108–31.

Moir, James W. *The Harrow School Register, 1885–1949.* 5th ed. London: Rivingtons, 1951.

O'Higgins, Patrick. "The Customer is Always Wrong: Remembering Charles James." *Quest: Manhattan Properties and Country Estates* 15, no. 10 (October 1995), pp. 36–39, cover illus.

Parmal, Pamela A., and William DeGregorio. *Scaasi, American Couturier.* Exh. cat., Museum of Fine Arts, Boston. Boston, 2010.

Perkins, B. J. "Charles James, a Former Architect, Uses Structural Idea in Designing." *Women's Wear Daily,* February 21, 1933, p. 17.

Pochina, Marie-France. *Christian Dior: The Man Who Made the World Look New.* Translated by Joanna Savill. 1994. New York: Arcade Publishing, 1996.

Porter, Amy. "Young Man of Fashion." *Collier's* 120 (September 20, 1947), pp. 100, 101, 104.

Preminger, Erik Lee. *My G-String Mother: At Home and Backstage with Gypsy Rose Lee.* Berkeley: Frog, 2003.

"Prize List, 1921." *The Harrovian* 35, no. 3 (May 27, 1922), p. 37.

Reeder, Jan Glier. *High Style: Masterworks from the Brooklyn Museum Costume Collection at The Metropolitan Museum of Art.* Exh. cat., The Metropolitan Museum of Art, New York; Brooklyn Museum. New York: The Metropolitan Museum of Art, 2010.

Review of *A Midsummer-Night's Dream. The Harrovian* 34, no. 3 (May 28, 1921), p. 32.

de Rohan, Princess Dilkusha. "Panorama: Dilkusha by Dilkusha." Manuscript autobiography, 1943–53. National Art Library. Victoria and Albert Museum, London.

Rose, Francis [Cyril]. *Saying Life: The Memoirs of Sir Francis Rose.* London: Cassell and Company, 1961.

"The School [group photograph]." *The Migrator* [The Lake Placid School] 12, no. 5 (March 1920), p. 11.

Sewell, Dennita, et al. *Fashion Independent: The Original Style of Ann Bonfoey Taylor.* Exh. cat., Phoenix Art Museum. Phoenix, 2011.

Theatre and Performance Collections. Victoria and Albert Museum, London.

Turner, Florence. *At the Chelsea.* San Diego, New York, and London: Harcourt Brace Jovanovich, [1986].

Vickers, Hugo. *Cecil Beaton: A Biography.* Boston and Toronto: Little, Brown and Company, 1985.

Viladas, Pilar. "Style, 10.10.99: They Did It Their Way." *The New York Times Magazine,* October 10, 1999, pp. SM85–SM94.

Wadsworth Atheneum. *The Sculpture of Style, April 30, 1964.* Catalogue for fashion show organized by J. Herbert Callister and Robert J. Jaczko. Hartford, Conn.: Wadsworth Atheneum, 1964.

Wood, Ghislaine. *The Surreal Body: Fetish and Fashion.* Exh. cat., Victoria and Albert Museum, London. London, 2007.

Wood, Ghislaine, et al. *Surreal Things: Surrealism and Design.* Exh. cat., Victoria and Albert Museum, London; Museum Boijmans Van Beuningen, Rotterdam; Guggenheim Museum, Bilbao. London: Victoria and Albert Museum, 2007.

WORKS IN THE CATALOGUE

Front endpapers
Brooklyn Museum Costume Collection at The Metropolitan
Museum of Art, Gift of the Brooklyn Museum, 2009
2009.300.8521

Frontispiece, page 265, and back endpapers
Brooklyn Museum Costume Collection at The Metropolitan
Museum of Art, Gift of the Brooklyn Museum, 2009
2009.300.8508

Metamorphology
Fig. 1
Gift of Homer Layne, Charles James Collection, The Irene
Lewisohn Costume Reference Library, The Costume
Institute, The Metropolitan Museum of Art

Fig. 2
Gift of Homer Layne, Charles James Collection, The Irene
Lewisohn Costume Reference Library, The Costume
Institute, The Metropolitan Museum of Art

Fig. 3
Gift of Homer Layne, Charles James Collection, The Irene
Lewisohn Costume Reference Library, The Costume
Institute, The Metropolitan Museum of Art

Fig. 4
Gift of Homer Layne, Charles James Collection, The Irene
Lewisohn Costume Reference Library, The Costume
Institute, The Metropolitan Museum of Art

Fig. 6
Gift of Homer Layne, Charles James Collection, The Irene
Lewisohn Costume Reference Library, The Costume
Institute, The Metropolitan Museum of Art

Fig. 11
Gift of Homer Layne, Charles James Collection, The Irene
Lewisohn Costume Reference Library, The Costume
Institute, The Metropolitan Museum of Art
© Charles B. H. James and Louise D. B. James

Fig. 23
Gift of Homer Layne, Charles James Collection, The Irene
Lewisohn Costume Reference Library, The Costume
Institute, The Metropolitan Museum of Art

Fig. 31
Gift of Homer Layne, Charles James Collection, The Irene
Lewisohn Costume Reference Library, The Costume
Institute, The Metropolitan Museum of Art

Fig. 35 (center)
Brooklyn Museum Costume Collection at The Metropolitan
Museum of Art, Gift of the Brooklyn Museum, 2009
2009.300.2936

Fig. 35 (foreground and background)
Brooklyn Museum Costume Collection at The Metropolitan
Museum of Art, Gift of the Brooklyn Museum, 2009
2009.300.8498a, b

Fig. 36
Gift of Homer Layne, Charles James Collection, The Irene
Lewisohn Costume Reference Library, The Costume
Institute, The Metropolitan Museum of Art

Fig. 44
Brooklyn Museum Costume Collection at The Metropolitan
Museum of Art, Gift of the Brooklyn Museum, 2009; Gift of
Mrs. John de Menil, 1957
2009.300.3580

Fig. 46
Gift of Homer Layne, Charles James Collection, The Irene
Lewisohn Costume Reference Library, The Costume
Institute, The Metropolitan Museum of Art

Fig. 47
Gift of Homer Layne, Charles James Collection, The Irene
Lewisohn Costume Reference Library, The Costume
Institute, The Metropolitan Museum of Art

Fig. 48
Gift of Homer Layne, Charles James Collection, The Irene
Lewisohn Costume Reference Library, The Costume
Institute, The Metropolitan Museum of Art

Fig. 49
Gift of Homer Layne, Charles James Collection, The Irene
Lewisohn Costume Reference Library, The Costume
Institute, The Metropolitan Museum of Art
© Charles B. H. James and Louise D. B. James

Fig. 50
Gift of Homer Layne, Charles James Collection, The Irene
Lewisohn Costume Reference Library, The Costume
Institute, The Metropolitan Museum of Art

Fig. 51
Gift of Homer Layne, Charles James Collection, The Irene
Lewisohn Costume Reference Library, The Costume
Institute, The Metropolitan Museum of Art

The Calculus of Fashion
Fig. 1
Gift of Homer Layne, Charles James Collection, The Irene
Lewisohn Costume Reference Library, The Costume
Institute, The Metropolitan Museum of Art

Fig. 2 (left)
Brooklyn Museum Costume Collection at The Metropolitan
Museum of Art, Gift of the Brooklyn Museum, 2009; Gift of
Mrs. John de Menil, 1957
2009.300.2806

Fig. 2 (right)
Brooklyn Museum Costume Collection at The Metropolitan
Museum of Art, Gift of the Brooklyn Museum, 2009
2009.300.8516

Fig. 3
Gift of Homer Layne, Charles James Collection, The Irene
Lewisohn Costume Reference Library, The Costume
Institute, The Metropolitan Museum of Art

Fig. 4
Brooklyn Museum Costume Collection at The Metropolitan
Museum of Art, Gift of the Brooklyn Museum, 2009; Gift of
Mrs. William Randolph Hearst, Jr., 1953
2009.300.2775

Fig. 5
Brooklyn Museum Costume Collection at The Metropolitan
Museum of Art, Gift of the Brooklyn Museum, 2009; Gift of
Mrs. William Randolph Hearst, Jr., 1953
2009.300.2780a, b

Fig. 6
Brooklyn Museum Costume Collection at The Metropolitan
Museum of Art, Gift of the Brooklyn Museum, 2009
2009.300.8507

The Calculus of Fashion: Spirals & Wraps
Pages 60–61
Purchase, Costume Institute Benefit Fund, Friends of
The Costume Institute Gifts, and Acquisitions Fund, 2013
2013.418

Pages 62–63
Purchase, Costume Institute Benefit Fund, Friends of
The Costume Institute Gifts, and Acquisitions Fund, 2013
2013.307

Page 64
Purchase, Alan W. Kornberg Gift, 2013
2013.309

Page 65
Gift of Homer Layne, Charles James Collection, The Irene
Lewisohn Costume Reference Library, The Costume
Institute, The Metropolitan Museum of Art
© Charles B. H. James and Louise D. B. James

Pages 66–67
Brooklyn Museum Costume Collection at The Metropolitan
Museum of Art, Gift of the Brooklyn Museum, 2009; Gift of
Erik Lee Preminger, in memory of his mother, Gypsy Rose
Lee, 1993
2009.300.592

Pages 68–69
Courtesy of Sir Brendan Parsons, seventh Earl of Rosse,
Birr Castle, Ireland

Page 70
Brooklyn Museum Costume Collection at The Metropolitan
Museum of Art, Gift of the Brooklyn Museum, 2009; Gift of
Mrs. William Randolph Hearst, Jr., 1953
2009.300.167

Page 72
Brooklyn Museum Costume Collection at The Metropolitan
Museum of Art, Gift of the Brooklyn Museum, 2009; Gift of
Mrs. Clive Runnels and Mrs. Edward L. Ryerson, 1957
2009.300.1947
© Charles B. H. James and Louise D. B. James

Page 73
Brooklyn Museum Costume Collection at The Metropolitan
Museum of Art, Gift of the Brooklyn Museum, 2009; Gift of
Arturo and Paul Peralta-Ramos, 1954
2009.300.180

Pages 74–75
Brooklyn Museum Costume Collection at The Metropolitan
Museum of Art, Gift of the Brooklyn Museum, 2009; Gift of
Mrs. R. A. Bernatschke, 1955
2009.300.213a, b

Page 77
Purchase, Costume Institute Benefit Fund, Friends of
The Costume Institute Gifts, and Acquisitions Fund, 2013
2013.401

Pages 78–79
Purchase, Costume Institute Benefit Fund, Friends of
The Costume Institute Gifts, and Acquisitions Fund, 2013
2013.308

Page 80 (top left)
Gift of Homer Layne, Charles James Collection, The Irene
Lewisohn Costume Reference Library, The Costume
Institute, The Metropolitan Museum of Art
© Charles B. H. James and Louise D. B. James

Pages 80–81 (center of spread)
Purchase, Annette de la Renta Gift, 2013
2013.301

Page 81 (top right)
Science, Industry & Business Library, The New York Public
Library, Astor, Lenox and Tilden Foundations

Pages 82–83
Purchase, Costume Institute Benefit Fund, Friends of
The Costume Institute Gifts, and Acquisitions Fund, 2013
2013.406

Pages 84–85
Brooklyn Museum Costume Collection at The Metropolitan
Museum of Art, Gift of the Brooklyn Museum, 2009; Gift of
Mrs. George P. Raymond, 1981
2009.300.1359

Pages 86–87
Gift of Mrs. William Woodward Jr., 1964
C.I.64.74.1

Pages 88–89
Courtesy of Sir Brendan Parsons, seventh Earl of Rosse,
Birr Castle, Ireland

The Calculus of Fashion: Drapes & Folds
Pages 92–93
Purchase, Costume Institute Benefit Fund, Friends of
The Costume Institute Gifts, and Acquisitions Fund, 2013
2013.412a, b

Pages 94–95
Brooklyn Museum Costume Collection at The Metropolitan
Museum of Art, Gift of the Brooklyn Museum, 2009; Gift of
Millicent Huttleston Rogers, 1949
2009.300.134

Pages 96, 97 (right)
Purchase, Costume Institute Benefit Fund, Friends of
The Costume Institute Gifts, and Acquisitions Fund, 2013
2013.383

Page 98
Polaire Weissman Fund, 1997
1997.193.1

Pages 100–101
Courtesy of Sir Brendan Parsons, seventh Earl of Rosse,
Birr Castle, Ireland

Pages 102, 103 (right)
Purchase, Costume Institute Benefit Fund, Friends of
The Costume Institute Gifts, and Acquisitions Fund, 2013
2013.399

Page 103 (top left)
Gift of Homer Layne, Charles James Collection, The Irene
Lewisohn Costume Reference Library, The Costume
Institute, The Metropolitan Museum of Art
© Charles B. H. James and Louise D. B. James

Page 104
Gift of the Brooklyn Museum, Charles James Collection,
The Irene Lewisohn Costume Reference Library, The
Costume Institute, The Metropolitan Museum of Art

Page 105
Brooklyn Museum Costume Collection at The Metropolitan
Museum of Art, Gift of the Brooklyn Museum, 2009;
Bequest of Marta C. Raymond, 1989
2009.300.576

Page 107
Brooklyn Museum Costume Collection at The Metropolitan
Museum of Art, Gift of the Brooklyn Museum, 2009; Gift of
Mrs. Emmet Whitlock, 1983
2009.300.2915

Pages 108 (right), 109
Brooklyn Museum Costume Collection at The Metropolitan
Museum of Art, Gift of the Brooklyn Museum, 2009; Gift of
Arturo and Paul Peralta-Ramos, 1954
2009.300.1860

Pages 110, 111 (right)
Gift of Marietta Tree, 1965
C.I.65.36.1

Pages 112–13
Gift of Eleanor Searle Whitney McCollum, 1975
1975.246.8a, b

Page 115
Brooklyn Museum Costume Collection at The Metropolitan
Museum of Art, Gift of the Brooklyn Museum, 2009; Gift of
Arturo and Paul Peralta-Ramos, 1954
2009.300.3516

Page 117
Brooklyn Museum Costume Collection at The Metropolitan
Museum of Art, Gift of the Brooklyn Museum, 2009; Gift of
Mr. and Mrs. Robert Coulson, 1964
2009.300.1311

Pages 118–19 (center of spread)
Brooklyn Museum Costume Collection at The Metropolitan
Museum of Art, Gift of the Brooklyn Museum, 2009; Gift of
Millicent Huttleston Rogers, 1949
2009.300.751

Pages 120, 123
Brooklyn Museum Costume Collection at The Metropolitan
Museum of Art, Gift of the Brooklyn Museum, 2009; Gift of
Arturo and Paul Peralta-Ramos, 1954
2009.300.2787

Page 122
Brooklyn Museum Costume Collection at The Metropolitan
Museum of Art, Gift of the Brooklyn Museum, 2009; Gift of
Millicent Huttleston Rogers, 1949
2009.300.746

Pages 124, 125 (right)
Brooklyn Museum Costume Collection at The Metropolitan
Museum of Art, Gift of the Brooklyn Museum, 2009; Gift of
Arturo and Paul Peralta-Ramos, 1954
2009.300.2786

Pages 126 (right), 127
Gift of Eleanor Searle Whitney McCollum, 1975
1975.246.7a

Pages 128–29
Brooklyn Museum Costume Collection at The Metropolitan
Museum of Art, Gift of the Brooklyn Museum, 2009; Gift of
Millicent Huttleston Rogers, 1949
2009.300.734

Page 131
Brooklyn Museum Costume Collection at The Metropolitan
Museum of Art, Gift of the Brooklyn Museum, 2009; Gift of
Mrs. John de Menil, 1957
2009.300.822

Page 132 (top left)
Gift of Homer Layne, Charles James Collection, The Irene
Lewisohn Costume Reference Library, The Costume
Institute, The Metropolitan Museum of Art
© Charles B. H. James and Louise D. B. James

Pages 132 (right), 133 (right)
Purchase, Costume Institute Benefit Fund, Friends of
The Costume Institute Gifts, and Acquisitions Fund, 2013
2013.327

Page 133 (top left)
Private collection

The Calculus of Fashion: Anatomical Cut & Platonic Form

Pages 136–37
Brooklyn Museum Costume Collection at The Metropolitan Museum of Art, Gift of the Brooklyn Museum, 2009; Gift of Arturo and Paul Peralta-Ramos, 1955
2009.300.199a, b

Pages 138–39
Purchase, Costume Institute Benefit Fund, Friends of The Costume Institute Gifts, and Acquisitions Fund, 2013
2013.334a, b

Page 141
Purchase, Costume Institute Benefit Fund, Friends of The Costume Institute Gifts, and Acquisitions Fund, 2013
2013.343

Page 142 (top)
Gift of Homer Layne, Charles James Collection, The Irene Lewisohn Costume Reference Library, The Costume Institute, The Metropolitan Museum of Art

Pages 142 (right), 143
Gift of Lee Krasner Pollock, 1975
1975.52.5a, b

Pages 144–45
Brooklyn Museum Costume Collection at The Metropolitan Museum of Art, Gift of the Brooklyn Museum, 2009; Gift of Millicent Huttleston Rogers, 1949
2009.300.133

Pages 146–47
Purchase, Costume Institute Benefit Fund, Friends of The Costume Institute Gifts, and Acquisitions Fund, 2013
2013.375a, b

Page 148 (top left)
Brooklyn Museum Costume Collection at The Metropolitan Museum of Art, Gift of the Brooklyn Museum, 2009; Gift of Mrs. Clive Runnels and Mrs. Edward L. Ryerson, 1957
2009.300.3698
© Charles B. H. James and Louise D. B. James

Pages 148 (right), 149
Purchase, Costume Institute Benefit Fund, Friends of The Costume Institute Gifts, and Acquisitions Fund, 2013
2013.380

Page 150
Purchase, Costume Institute Benefit Fund, Friends of The Costume Institute Gifts, and Acquisitions Fund, 2013
2013.367

Page 151
Brooklyn Museum Costume Collection at The Metropolitan Museum of Art, Gift of the Brooklyn Museum, 2009; Gift of Mrs. Clive Runnels and Mrs. Edward L. Ryerson, 1957
2009.300.3703
© Charles B. H. James and Louise D. B. James

Pages 152–53
Brooklyn Museum Costume Collection at The Metropolitan Museum of Art, Gift of the Brooklyn Museum, 2009; Gift of Muriel Bultman Francis, 1966
2009.300.402

Pages 154–55
Brooklyn Museum Costume Collection at The Metropolitan Museum of Art, Gift of the Brooklyn Museum, 2009; Gift of Mrs. William Randolph Hearst, Jr., 1960
2009.300.274

Page 156
Gift of Mrs. Clive Runnels and Mrs. Edward L. Ryerson, Gift of The Brooklyn Museum, Charles James Collection, The Irene Lewisohn Costume Reference Library, The Costume Institute, The Metropolitan Museum of Art
© Charles B. H. James and Louise D. B. James

Pages 157–59
Brooklyn Museum Costume Collection at The Metropolitan Museum of Art, Gift of the Brooklyn Museum, 2009; Gift of Mrs. John de Menil, 1957
2009.300.3572

Page 160
Gift of Homer Layne, Charles James Collection, The Irene Lewisohn Costume Reference Library, The Costume Institute, The Metropolitan Museum of Art

Pages 161–62
Purchase, Costume Institute Benefit Fund, Friends of The Costume Institute Gifts, and Acquisitions Fund, 2013
2013.410

Page 163
Gift of Homer Layne, Charles James Collection, The Irene Lewisohn Costume Reference Library, The Costume Institute, The Metropolitan Museum of Art
© Charles B. H. James and Louise D. B. James

Pages 164 (left), 165–66
Brooklyn Museum Costume Collection at The Metropolitan Museum of Art, Gift of the Brooklyn Museum, 2009; Gift of Muriel Bultman Francis, 1967
2009.300.451

Page 164 (right)
Brooklyn Museum Costume Collection at The Metropolitan Museum of Art, Gift of the Brooklyn Museum, 2009; Gift of Mrs. Clive Runnels and Mrs. Edward L. Ryerson, 1957
2009.300.3696
© Charles B. H. James and Louise D. B. James

Page 169
Brooklyn Museum Costume Collection at The Metropolitan Museum of Art, Gift of the Brooklyn Museum, 2009; Gift of Mrs. R. A. Bernatschke, 1955
2009.300.214a, b

Pages 170, 171 (right)
Purchase, Costume Institute Benefit Fund, Friends of The Costume Institute Gifts, and Acquisitions Fund, 2013
2013.337a, b

Pages 172, 173 (right)
Brooklyn Museum Costume Collection at The Metropolitan Museum of Art, Gift of the Brooklyn Museum, 2009; Gift of Mrs. John de Menil, 1957
2009.300.824a, b

Page 173 (top left)
Gift of Homer Layne, Charles James Collection, The Irene Lewisohn Costume Reference Library, The Costume Institute, The Metropolitan Museum of Art
© Charles B. H. James and Louise D. B. James

Pages 174–75
Purchase, Costume Institute Benefit Fund, Friends of The Costume Institute Gifts, and Acquisitions Fund, 2013
2013.281a, b

Pages 176–77
Brooklyn Museum Costume Collection at The Metropolitan Museum of Art, Gift of the Brooklyn Museum, 2009; Gift of Mrs. Joseph Love, 1967
2009.300.457

Pages 178–79
Purchase, Costume Institute Benefit Fund, Friends of The Costume Institute Gifts, and Acquisitions Fund, 2013
2013.376

Pages 180–81 (center of spread)
Brooklyn Museum Costume Collection at The Metropolitan Museum of Art, Gift of the Brooklyn Museum, 2009; Gift of Erik Lee Preminger, in memory of his mother, Gypsy Rose Lee, 1993
2009.300.582

Pages 182–83
Brooklyn Museum Costume Collection at The Metropolitan Museum of Art, Gift of the Brooklyn Museum, 2009; Gift of Muriel Bultman Francis, 1966
2009.300.403

Pages 184–85
Brooklyn Museum Costume Collection at The Metropolitan Museum of Art, Gift of the Brooklyn Museum, 2009; Gift of Edalgi Dinsha, 1944
2009.300.674

Pages 186–87
Purchase, Costume Institute Benefit Fund, Friends of The Costume Institute Gifts, and Acquisitions Fund, 2013
2013.305

Pages 188, 189 (right)
Brooklyn Museum Costume Collection at The Metropolitan Museum of Art, Gift of the Brooklyn Museum, 2009; Gift of Erik Lee Preminger, in memory of his mother, Gypsy Rose Lee, 1993
2009.300.589

Page 189 (top left)
Gift of Homer Layne, Charles James Collection, The Irene Lewisohn Costume Reference Library, The Costume Institute, The Metropolitan Museum of Art
© Charles B. H. James and Louise D. B. James

Page 190 (top left)
Brooklyn Museum Costume Collection at The Metropolitan Museum of Art, Gift of the Brooklyn Museum, 2009; Gift of Mrs. Clive Runnels and Mrs. Edward L. Ryerson, 1957
2009.300.1941
© Charles B. H. James and Louise D. B. James

Pages 190 (right), 191
Brooklyn Museum Costume Collection at The Metropolitan Museum of Art, Gift of the Brooklyn Museum, 2009; Gift of Marguerite Piazza, 1984
2009.300.1015a, b

The Calculus of Fashion: Architectural Shaping
Pages 194 (right), 195
Brooklyn Museum Costume Collection at The Metropolitan Museum of Art, Gift of the Brooklyn Museum, 2009; Gift of Arturo and Paul Peralta-Ramos, 1954
2009.300.1187

Page 196
Brooklyn Museum Costume Collection at The Metropolitan Museum of Art, Gift of the Brooklyn Museum, 2009; Gift of Arturo and Paul Peralta-Ramos, 1954
2009.300.795

Page 197
Gift of the Brooklyn Museum, Charles James Collection, The Irene Lewisohn Costume Reference Library, The Costume Institute, The Metropolitan Museum of Art

Pages 198, 199 (right)
Gift of Marietta Tree, 1965
C.I.65.36.2

Pages 200–201
Brooklyn Museum Costume Collection at The Metropolitan Museum of Art, Gift of the Brooklyn Museum, 2009; Gift of Mrs. William Randolph Hearst, Jr., 1964
2009.300.885

Page 203
Gift of Jane Love Lee, 1993
1993.427

Pages 204, 205 (right)
Purchase, Costume Institute Benefit Fund, Friends of The Costume Institute Gifts, and Acquisitions Fund, 2013
2013.402

Pages 207–8
Brooklyn Museum Costume Collection at The Metropolitan Museum of Art, Gift of the Brooklyn Museum, 2009
2009.300.8522

Page 209
Brooklyn Museum Costume Collection at The Metropolitan Museum of Art, Gift of the Brooklyn Museum, 2009; Gift of Mrs. Clive Runnels and Mrs. Edward L. Ryerson, 1957
2009.300.3612
© Charles B. H. James and Louise D. B. James

Pages 210–11
Courtesy of Elizabeth de Cuevas (Strong-Cuevas)

Page 212
Brooklyn Museum Costume Collection at The Metropolitan Museum of Art, Gift of the Brooklyn Museum, 2009; Gift of Jean de Menil, 1955
2009.300.3522

Page 213
Brooklyn Museum Costume Collection at The Metropolitan Museum of Art, Gift of the Brooklyn Museum, 2009; Gift of Jean de Menil, 1955
2009.300.796

Pages 215–16
Brooklyn Museum Costume Collection at The Metropolitan Museum of Art, Gift of the Brooklyn Museum, 2009
2009.300.8523

Page 217 (right)
Gift of Mrs. Clive Runnels and Mrs. Edward L. Ryerson, Gift of The Brooklyn Museum, Charles James Collection, The Irene Lewisohn Costume Reference Library, The Costume Institute, The Metropolitan Museum of Art
© Charles B. H. James and Louise D. B. James

Page 218
Brooklyn Museum Costume Collection at The Metropolitan Museum of Art, Gift of the Brooklyn Museum, 2009; Gift of Mrs. William Randolph Hearst, Jr., 1961
2009.300.850

Page 219 (Evening Cape)
Brooklyn Museum Costume Collection at The Metropolitan Museum of Art, Gift of the Brooklyn Museum, 2009; Gift of Mrs. William Randolph Hearst, Jr., 1959
2009.300.839

Pages 220–21
Brooklyn Museum Costume Collection at The Metropolitan Museum of Art, Gift of the Brooklyn Museum, 2009; Gift of Mrs. Douglas Fairbanks, Jr., 1981
2009.300.991

Page 222 (right)
Gift of Homer Layne, Charles James Collection, The Irene Lewisohn Costume Reference Library, The Costume Institute, The Metropolitan Museum of Art
© Charles B. H. James and Louise D. B. James

Pages 223–25
Purchase, Friends of the Costume Institute Gifts, 2013
2013.591

Page 226 (top)
Gift of Homer Layne, Charles James Collection, The Irene Lewisohn Costume Reference Library, The Costume Institute, The Metropolitan Museum of Art
© Charles B. H. James and Louise D. B. James

Page 226 (bottom)
Gift of Homer Layne, Charles James Collection, The Irene Lewisohn Costume Reference Library, The Costume Institute, The Metropolitan Museum of Art
© Charles B. H. James and Louise D. B. James

Pages 227–28
Gift of Elizabeth Fairall, 1953
C.I.53.73

Pages 230–31
Brooklyn Museum Costume Collection at The Metropolitan Museum of Art, Gift of the Brooklyn Museum, 2009; Gift of Josephine Abercrombie, 1953
2009.300.784

Page 233
Courtesy of Texas Fashion Collection, College of Visual Arts and Design, University of North Texas

ACKNOWLEDGMENTS

We are grateful to the many people who provided such generous support for the exhibition "Charles James: Beyond Fashion" and this associated publication. In particular, we were fortunate to have over the many months of the project's development the advice and encouragement of Thomas P. Campbell, Director of The Metropolitan Museum of Art; Emily Kernan Rafferty, President; Jennifer Russell, Associate Director for Exhibitions; Carrie Rebora Barratt, Associate Director for Collections and Administration; Andrew Bolton, Curator of The Costume Institute; and Nina McN. Diefenbach, Vice President for Development and Membership. Anna Wintour, Editor in Chief of American *Vogue*, has been a steadfast supporter of the department, and this exhibition will mark the sixteenth of a series that has benefited from her advocacy. The exhibition's final months of preparation have taken place in the newly renovated facilities of The Costume Institute, recently named the Anna Wintour Costume Center in acknowledgment of Anna's contributions over the years. We are especially thrilled to reopen with our first exhibition in three spaces: the special exhibitions gallery on the first floor; our new Lizzie and Jonathan Tisch Gallery, reconfigured and equipped with updated technological capabilities; and the Carl and Iris Barrel Apfel Gallery. The Tisch gift has resulted in a new flexible floor plan and the ability to convey curatorial concepts with the aid of unprecedented analytical tools. The exhibition and this publication would not have been possible without the extraordinary generosity of our lead sponsor, AERIN. The company's founder and creative director, Aerin Lauder, is a longtime supporter of the department's efforts and has been an especially informed and engaged champion of its initiatives. Additional support has also been provided by the Museum's invaluable partner Condé Nast. In addition to its ongoing contribution to the department's exhibitions, the Samuel I. Newhouse Foundation, Inc., has directed its generosity to the capital project. Howard and Janet Kagan's engagement with The Costume Institute has been long-standing, and we would like to express our appreciation for their early commitment to the modernization and updating of The Costume Institute facilities.

"Charles James: Beyond Fashion" could not have been realized without the engagement of Charles B. H. James and Louise D. B. James. Their interest in their father's legacy has been ballast to the project, steadying us amid a deluge of materials and possibilities. We also extend our appreciation to Elizabeth Ann Coleman for her support of this project and her groundbreaking work on Charles James. But more than any other individual, Homer Layne, James's last assistant and the man who James claimed had the ability to resolve some designs better than the master himself, has made the realization of this exhibition and book possible. With his extraordinary gift of the designer's archives to the Museum and his generosity as a resource—explaining James's methodology and techniques, identifying the heaps of ephemera collected and retained over the designer's lifetime, and sharing anecdotal history as James himself recounted it in the last years of his life—Layne has enriched our efforts immeasurably.

Our sincerest appreciation goes to Elizabeth Diller, Riccardo Scofidio, and Charles Renfro and their team at Diller, Scofidio & Renfro, including Kumar Atre and Jaffer Kolb. In their role as exhibition designers, they have generated concepts that have informed the curatorial process. Not only have they created an environment that recalibrates the traditional measure of James's innovations, they have also introduced analytical approaches and a conceptual framework in which the appreciation of James's complex and sometimes mystifying genius is clarified and elucidated.

The direct contributions to the exhibition by Linda Sylling, Manager for Special Exhibitions and Gallery Installations; Susan Sellers, Head of Design; Daniel Kershaw and Sue Koch of the Design Department; Taylor Miller, Associate Buildings Manager, Exhibitions; Joanna Prosser, Vice President and General Manager of Merchandise and Retail; Sree Sreenivasan, Chief Digital Officer; and Christopher A. Noey of the Digital Media Department have been invaluable and enriched the result.

The Editorial Department of The Metropolitan Museum of Art, under the direction of Mark Polizzotti, Publisher and Editor in Chief, provided the expertise to realize this book. Gwen Roginsky, who has orchestrated the development and fulfillment of more Costume Institute books than she might care to remember, has once again helped us find our way through the inevitable thicket of details and delivery dates. Sincere thanks go to Peter Antony, Michael Sittenfeld, Christopher Zichello, Jane S. Tai, Crystal A. Dombrow, Penny Jones, Elizabeth Zechella, and our editor, Nancy E. Cohen, who balanced her forcefulness regarding our deadlines with an uncompromising rigor and sensitivity to our text. Karin L. Willis was gracious through the elaborate preparation and setup of James's designs in her photography studio, and she captured their sculptural poetry beautifully. Special thanks are owed to Takaaki Matsumoto for his beautiful book design and to his colleague Amy Wilkins, who shepherded the project masterfully. They have made a book of such elegant serenity that it belies the feverish pressures of our compressed schedule.

We would especially like to thank Ralph Rucci for his very personal, erudite, and insightful foreword to the book. We likewise extend our appreciation to conservators Sarah Scaturro and Glenn Petersen for their fascinating explication of the condition issues they have encountered while working with the Charles James pieces.

The participation of colleagues from various departments at The Metropolitan Museum of Art was extensive, and we would like to thank them for their invaluable assistance, including Barbara J. Bridgers, Paul Caro, Henry Casey, Kimberly Chey, Nancy Chilton, Jennie W. Choi, Aileen Chuk, Clint Ross Coller, Joseph Coscia Jr., Willa Cox, Martha Deese, Cristina Del Valle, Mikaela Dilworth, William Scott Geffert, Patricia Gilkison, Vanessa Hagerbaumer, Michelle M. Hagewood, Nadja Hansen, Doug Harrison, Sarah Higby, Harold Holzer, Staci Hou, Marilyn Jensen, Bronwyn Keenan, Jennifer Kim, Aubrey L. Knox, Molly Kysar, Richard Lichte, Thomas Ling, Paco Link, Joseph Loh, Ruben Luna, Kristin M. MacDonald, Nina S. Maruca, Ann Matson, Jennifer Mock, Katherine Nemeth, Kathy Mucciolo Savas, Tom Scally, Robin Schwalb, Alice Schwarz, Catherine Scrivo, Jessica Sewell, Soo Hee H. Song, Jacqueline Terrassa, Limor Tomer, Elyse Topalian, Miriam M. Tribble, Yer Vang, David Wargo, Donna Williams, Eileen M. Willis, Zena Wozniak, and Stephanie R. Wuertz.

We are extremely grateful to lenders to the exhibition: Elizabeth de Cuevas; Anthony Lawrence of New York City, Inc. (Joseph Calagna); Los Angeles County Museum of Art (Sharon Takeda, Clarissa Esguerra, Susan Schmalz); Museum of Art, Rhode Island School of Design; Sir Brendan Parsons, seventh Earl of Rosse, Birr Castle, Ireland; Mrs. Peter Salm; Texas Fashion Collection, College of Visual Arts and Design, University of North Texas (Myra Walker, Edward Hoyenski); and the Victoria and Albert Museum.

Among the surprising serendipities encountered in our research on James was discovering the number of people who knew him. In sharing their impressions of James, Paul Caranicas, Mary Ann Crenshaw, Elizabeth de Cuevas, Mary Ellen Hecht, Barbara Hodes, Christophe de Menil, Elsa Peretti, Fred Rottman, and Gloria Vanderbilt added revealing facets to the fascinating complexities of this charismatic talent. Bill Cunningham, whose moving tribute to James at the time of his death was the basis for much of our appreciation of the designer's contributions to the history of twentieth-century fashion, has been exceptionally generous in sharing both his experiences with James and his important photographs of James's Chelsea studio work.

We would also like to thank the following agencies and individuals for providing photographs for this publication: Artists Rights Society (Maria Fernanda Meza); British Library; Carl Perutz Archive/www.perutz.net (Pete Livingston); Cecil Beaton Studio Archive at Sotheby's (Katherine Marshall); Center for Creative Photography (Tammy Carter); Condé Nast (Leigh Montville); Condé Nast UK (Cosima Glaister); Corbis Images (Miranda Sarjeant); Mia Fonssagrives-Solow; Getty Images (Peter Kersten and Joelle Sedlmeyer); Hearst Magazines UK (Donna Roberts); Hearst Publications (Wendy Israel); Library of Congress (Margaret Kiechefer); Lizzie Himmel; R. J. Horst; Howard Greenberg Gallery (Meagan McGowan); Jerry Cooke Archives (Mary Delaney Cooke); Johnson & Johnson; Lividini & Co. (Lori Rhodes); Estate of Antonio Lopez and Juan Ramos (Paul Caranicas); Menil Collection (Robert Hernandez); New York Public Library (Thomas Lisanti); Norman Parkinson Archive (Alexandra Anthony); Orkin/ Engel Film and Photo Archive (Mary Engel); Mauricio Padilha; Staley-Wise Gallery (Etheleen Staley); Town & Country Magazine (Linda Nardi); and Trunk Archive (Gayle Taliaferro).

For their contributions, appreciation and thanks go to our London researcher, Keremi Gawade, as well as to the following individuals and organizations: Christine Ashe (Northwood School), Frank A. Bennack Jr., Hamish Bowles, Cherie Burns, Juliana Cairone, Alina Cho, Alain Dewitte, Lorna Donley (Harold Washington Library Center), Countess Lucienne von Doz, Regina Drucker, Sarah Espinosa (District of Columbia Public Library), Linda Fargo, Judith Frankfurt (Brooklyn Museum), Beth Gates (Rogers Memorial Library), Madeleine Ginsburg, Wendy Goodman, Wanda de Guébriant (Archives Matisse), Titi Halle (Cora Ginsburg), Marc Happel, Penny Hatfield (Eton College), R. Couri Hay, Amy de la Haye, Margaret and William R. Hearst III, David Hoey, Lord Hutchinson of Lullington, Carol Kregloh (Smithsonian Institution), Ariane Lopez-Huici, Katherine Marshall (Tricorne), Dr. Alastair Massie (National Army Museum), Michele Morgan Mazzola, Susan de Menil, Angharad Meredith (Harrow School), Dr. Anthony Morton (Royal Military Academy Sandhurst), Nancy North, Pamela Parmal (Museum of Fine Arts, Boston), Martin Pel (Royal Pavilion, Museums & Libraries, Brighton and Hove), Anton Perich, David Rose (March of Dimes), Chris Royer, Claire B. Shaeffer, Sandy Schreier,

Peter S. Seibert (Millicent Rogers Museum), Ivan Shaw, Richard Shone, Osvaldo da Silva (Barry Friedman, Ltd.), Emilio Sosa, Daniel Storto, Susan Sutton (Menil Collection), Dr. Michael Sze, Lou Taylor, Clive Warwick, Elettra Wiedemann, and, at the Victoria and Albert Museum, Sonnet Stanfill, Claire Wilcox, Ghislaine Wood, and Stephanie Wood.

For their ongoing support, we would like to extend our heartfelt thanks to Thom Browne, Gretchen Jordan, Alan Kornberg, Annette de la Renta, The Visiting Committee of The Costume Institute, and the Friends of The Costume Institute, chaired by Lizzie Tisch. Our colleagues in The Costume Institute have been engaged in every step of the process. For their particular dedication to the project we extend our appreciation to Joyce Fung, Amanda B. Garfinkel, and Mellissa Huber. We also extend our deepest gratitude to Elizabeth D. Arenaro, Rebecca Bacheller, Anna Barden, Elizabeth Q. Bryan, Michael Downer, Cassandra Gero, Jessica L. Glasscock, Lauren Helliwell, Tracy Jenkins, Mark Joseph, Emma Kadar-Penner, Julie Tran Lê, Bethany L. Matia, Emily McGoldrick, Marci K. Morimoto, Miriam Murphy, Won Yee Ng, Rebecca Perry, Glenn Petersen, Jessica Regan, Anne Reilly, Melanie Sanford, Sarah Scaturro, Suzanne E. Shapiro, Danielle Swanson, and Anna Yanofsky. We would like to recognize Raul Avila, Sean Driscoll, and Sylvana Ward Durrett for their exceptional support of The Costume Institute's efforts over the years.

We would also like to express our sincere appreciation to the docents of The Costume Institute: Marie Arnold, Kitty Benton, Patricia Corbin, Eileen Ekstract, Ronnie Grosbard, Ruth Henderson, Betsy Kahan, Susan Klein, Rena Lustberg, Butzi Moffitt, Ellen Needham, Wendy Nolan, Patricia Peterson, Eleanore Schloss, Nancy Silbert, and D. J. White. Additionally, The Costume Institute's ambitions would be diminished without the support and participation of its exceptional team of interns and volunteers, including Joanna Abijaoude, Emily Bennett, Shayla Black, Tonya Blazio, Julia Borden, Meredith Busey, Jane Hays Butler, Sarah Jean Culbreth, Dara Douglas, Jenna Drumright, Bithy Goodman, Ruby Hoette, Benjamin Klemes, Landis Lee, Leia Lima, Asako Mikumo, Marla Miles, Danielle Morrin, Jennifer Moss, Phyllis Potter, Mei Mei Rado, Lilah Ramzi, Jennifer Rice, Rebecca Sadtler, Lisa Santandrea, Rena Schklowsky, Bernice Shaftan, Judith Sommer, Bailey Strauss, Erica Travis, and Ilana Winter.

Harold Koda and Jan Glier Reeder

This catalogue is published in conjunction with "Charles James: Beyond Fashion," on view at The Metropolitan Museum of Art, New York, from May 8 through August 10, 2014.

The exhibition is made possible by

AERIN

Additional support is provided by

CONDÉ NAST

Published by The Metropolitan Museum of Art, New York
Mark Polizzotti, Publisher and Editor in Chief
Gwen Roginsky, Associate Publisher and General Manager of Publications
Peter Antony, Chief Production Manager
Michael Sittenfeld, Managing Editor
Robert Weisberg, Senior Project Manager

Edited by Nancy E. Cohen
Designed by Takaaki Matsumoto/Matsumoto Incorporated, New York
Production by Christopher Zichello
Bibliography and notes edited by Penny Jones
Image acquisitions and permissions by Jessica L. Glasscock and Crystal A. Dombrow

Typeset in Didot and Helvetica families
Printed on 135 gsm Gardapat Bianka
Separations by Professional Graphics, Inc., Rockford, Illinois
Printed and bound by Conti Tipocolor S.p.A., Florence, Italy

Photographs of works in the Metropolitan Museum's collection are by Karin L. Willis, The Photograph Studio, The Metropolitan Museum of Art, unless otherwise noted. Additional photography credits (all figure references are to images in "Metamorphology" except where noted): Cover, figs. 10, 17, 30, 32 and pp. 2, 106, 114, 116 left, 202: Beaton / Vogue / Condé Nast Archive. © Condé Nast; figs. 5, 7 and pp. 14, 194 left, 214, 232, 250: Courtesy of the Cecil Beaton Studio Archive at Sotheby's; fig. 8: Hoare 1991, p. 177; fig. 9: Steichen / Vogue / Condé Nast Archive. © Condé Nast; fig. 12: Naomi E. A. Tarrant. *The Development of Costume*. Edinburgh: 1996, p. 23; fig. 13: *Harper's Bazaar UK*, August 1933, p. 27; fig. 14: Photograph Courtesy Archives H. Matisse, © 2014 Succession H. Matisse / Artists Rights Society (ARS), New York; fig. 15: *Harper's Bazaar UK*, November 1934, p. 56; fig. 16: *Harper's Bazaar*, January 1934, p. 48; fig. 18 (*Harper's Bazaar UK*, April 1937, p. 87): © Norman Parkinson Ltd. / Courtesy Norman Parkinson Archive; fig. 19 (*Harper's Bazaar*, October 1938, p. 67): © Horst; fig. 20 (*Harper's Bazaar*, January 1940, p. 52): © Martin Munkacsi, Permissions Courtesy Howard Greenberg Gallery, New York; figs. 21 (*Vogue*, December 15, 1944, pp. 52–53), fig. 24 (*Vogue*, October 1, 1944, p. 126), 26 (*Vogue*, December 1, 1945, pp. 134–35) and pp. 97 left, 125 left: Rawlings / Vogue / Condé Nast Archive. © Condé Nast; figs. 22, 29 (*Harper's Bazaar*, April 1947, p. 181) and pp. 116 right, 181 right: © 2014 Center for Creative Photography, The University of Arizona Foundation; fig. 25 and pp. 119 right, 229 right: © Bettmann / Corbis; figs. 27, 28 (*Collier's*, September 20, 1947, p. 101): Photograph by Jerry Cooke, © JCA, Inc. 2013; fig. 31: © Carl Perutz; fig. 33 (*Harper's Bazaar*, April 1950, p. 178) and pp. 114, 116 left: Courtesy of Johnson & Johnson; fig. 37 (*Town & Country*, April 1950, p. 40): © 2014 Artists Rights Society (ARS), New York / ADAGP, Paris; fig. 38: Photograph by F. W. Seiders; fig. 39 and p. 111 left: © LIFE magazine 1950; fig. 40: *Town & Country*, November 1952, p. 101; fig. 41 and p. 167: Wadsworth Atheneum 1964; fig. 42: *Harper's Bazaar*, July 1955, p. 65; fig. 43: *The Chicago American*, March 5, 1955; fig. 47: Photograph by Homer Layne; figs. 48, 50, 52 and 54 figs. 1, 3: © Bill Cunningham; fig. 51: Photograph by Stephen Paley; p. 52: Photograph by Michael A. Vaccaro / Look Magazine (Photograph Courtesy of Library of Congress, Prints and Photographs Division); p. 63 top: Howard Coster / Vogue © The Condé Nast Publications Ltd.; p. 71: McLaughlin / Vogue / Condé Nast Archive. © Condé Nast; p. 99: Bouët-Willaumez / Vogue / Condé Nast Archive. © Condé Nast; pp. 108 left, 168: Blumenfeld / Vogue / Condé Nast Archive. © Condé Nast; p. 118 left: Photograph by Fernand Fonssagrives; p. 130: Jerrold Schatzberg / Trunk Archive; p. 152 left: Courtesy of Lord & Taylor; p. 171 left: Prigent / Vogue / Condé Nast Archive. © Condé Nast; p. 180 left: Erickson / Vogue / Condé Nast Archive. © Condé Nast; pp. 199 left, 217 left: Horst / Vogue / Condé Nast Archive. © Condé Nast; p. 205 left: Vogue © The Condé Nast Publications Ltd.; p. 229 left: © AP / AP / Corbis

All drawings by Charles James are © Charles B. H. James and Louise D. B. James.

Cover: Photograph by Cecil Beaton. *Vogue*, June 1, 1948, pp. 112–13; see pp. 36–37
Front endpapers: String form model (detail), ca. 1950
Frontispiece, p. 265, and back endpapers: Dress form (details), ca. 1950
p. 2: Photograph by Cecil Beaton of Charles James fitting a model, 1948
p. 3: Ball Gown (detail); see p. 125
p. 4: Photograph by Gerri Mindell of a form on which James is conceiving a ball gown shape, ca. 1955
p. 10: La Sirène Evening Dress (detail); see p. 105
p. 14: Photograph of Charles James by Cecil Beaton, late 1920s
p. 15: Butterfly Ball Gown (detail); see p. 222
p. 52: Photograph of Charles James by Michael Vaccaro, 1952
p. 53: Lyre Coat (detail); see p. 145
p. 58: At-Home Dress (detail); see p. 84
p. 90: Evening Dress (detail); see p. 108
p. 134: Cossack Coat (detail); see p. 152
p. 192: Tulip Evening Dress (detail); see p. 210
p. 232: Photograph of Charles James by Cecil Beaton, 1936
p. 233: Clover Leaf Ball Gown (detail of a damaged pink and ivory version), 1953
p. 250: Photograph of Nancy and Charles James by Cecil Beaton, 1955
p. 251: Swan Ball Gown (detail of the six-layer tulle hem flounce); see p. 214

The Metropolitan Museum of Art
1000 Fifth Avenue
New York, New York 10028
metmuseum.org

Distributed by
Yale University Press, New Haven and London
yalebooks.com/art
yalebooks.co.uk

Cataloging-in-Publication Data is available from the Library of Congress.
ISBN 978-1-58839-522-1 (The Metropolitan Museum of Art)
ISBN 978-0-300-20436-0 (Yale University Press)